OLD NEW YORK
IN EARLY PHOTOGRAPHS

OLD NEW YORK
IN EARLY PHOTOGRAPHS

1853-1901

196 Prints from the Collection of
The New-York Historical Society

Mary Black

Curator of Painting and Sculpture

DOVER PUBLICATIONS, INC.
NEW YORK

Published in Canada by General Publishing Company,
Ltd., 30 Lesmill Road, Don Mills, Toronto, Ontario.
Published in the United Kingdom by Constable and
Company, Ltd., 10 Orange Street, London WC 2.

*Old New York in Early Photographs, 1853–1901, 196
Prints from the Collection of The New-York Historical Society*
is a new work, first published by Dover Publications, Inc., in
1973.

International Standard Book Number: 0-486-22907-6
Library of Congress Catalog Card Number: 72-90527

Manufactured in the United States of America
Dover Publications, Inc.
180 Varick Street
New York, N.Y. 10014

INTRODUCTION

One of the questions the Director of the New-York Historical Society asked me when I joined the staff in July, 1970 was whether I thought I could organize an exhibition that would introduce the general public to the photographs in the Society's collection. Although neither a New Yorker nor a historian of photography, I had a good idea of the magnitude of such a project. The Society's photographic archives, formally begun in 1906, now contain more than 50,000 negatives and an even greater number of new and old photographic prints. The idea of presenting a sampling from this vast visual storehouse was an appealing one, and I agreed to take on the project almost as the first order of business in my new job. The resulting exhibition, called *Eye on the City,* was held at the Society from October, 1970 to March, 1971. The present book is an outgrowth of that exhibition, an assembling of its most significant pictures and descriptions in permanent form.

The range and theme of the selection emerged as my sifting of the Society's holdings proceeded, and as the photographs began to outline a picture of the city's appearance from 1853 on. The French photographer Victor Prevost's wax paper negatives, made in 1853 and 1854 and apparently the oldest remaining photographic views of the city, formed the starting point in time. (Although both Dr. John Draper and Samuel F. B. Morse have left descriptions of their earlier attempts to capture New York's appearance in daguerreotype, the visions they recorded have so far eluded recovery.) The close of the nineteenth century seemed like a suitable end date. I selected only views of Manhattan. But within these imposed limits were thousands of impressions of a growing, changing metropolis and of places and events forming a mosaic which began with far and near views of the harbor and Battery and proceeded north to the joining of the Hudson and Harlem Rivers at Spuyten Duyvil.

Within this geographic progression, certain focal points, like the areas around City Hall Park, Union Square, Madison Square, and Central Park, or such major north-south thoroughfares as Broadway, Fifth Avenue, and Riverside Drive, can be viewed as they appeared over a span of several decades in celebration and in mourning. In the period encompassed by the old photographs gala processions

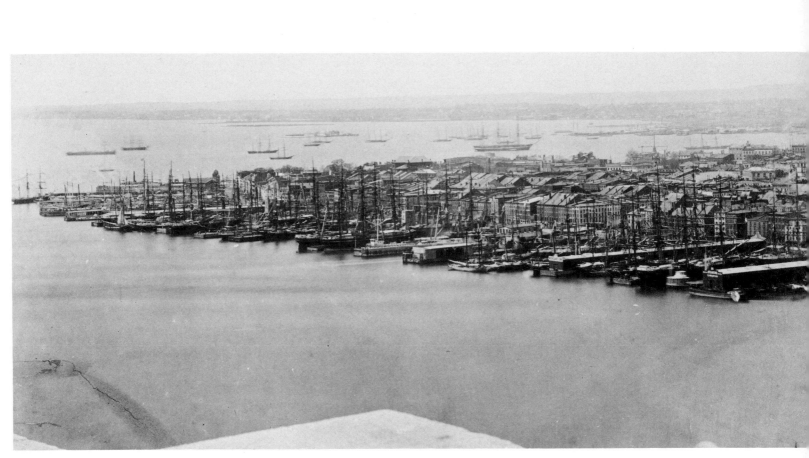

Panoramic View of New York City, 1876

As the piers for the Brooklyn Bridge rose high in the air, a new and breathtaking view of the city came into being. This sweep of five photographs, from the Battery to Pier 39 and beyond, was taken by Joshua H. Beal from the Brooklyn pier before the cables were placed. For Beal, who had his studio on Beekman Street in Manhattan but who lived in Brooklyn on St. Mark's Avenue, the completion of the bridge would have personal significance; for the entire world it was one of the greatest engineering feats of the century.

marched three times under triumphal arches along Fifth Avenue—honoring Washington in 1889, Columbus in 1892 and Admiral Dewey in 1899—while rumbling, flag-draped wagons twice drew the heavy burdens of presidential coffins—Lincoln's and Grant's—from a City Hall draped in black along streets thronged with watching crowds.

The pride that nineteenth-century New York residents took in their city is evident in the photographers' choice of subjects. The noteworthy buildings and settings that appear in many views proclaim a firm belief in the superiority of local enterprise and the ultimate importance of local wealth. But the ghettos of the lower East Side and the squatters' cabins of Central Park also attracted their share of attention in grim contrast to the prevailing theme of the beautiful city. While many of these areas may have assaulted every sense except sight, the streets appear uniformly clean and unlittered.

Most of the major concerns of early New York photographers are illustrated in this selection, but each category is admittedly a personal expression of what I found

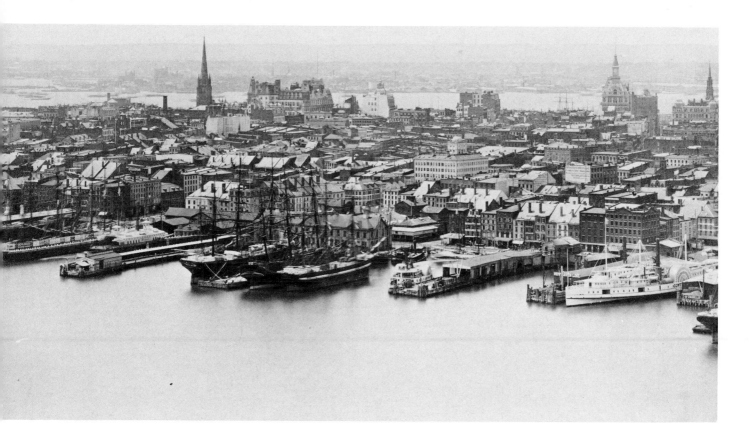

interesting and revealing in a vanished half-century of the city's history. My own delight in the changes wrought in the Flatiron Building site at the southwest corner of Madison Square is evident, as is my pleasure in the gleaming beauty of the second Madison Square Garden at the northeast corner. I responded to the bustle and business along the city's water roads as revealed in populous markets, docks, and commercial houses. And, equally, the impression of quiet churches, quiet streets, and quiet wooden store figures, many of them close by the jangle of horse-drawn jitneys and trolleys and festive crowds, prodded my nostalgia for a world I never knew.

Often the idea that the living, laughing, fooling, posing people represented in these photographs were images of personages long dead was heightened by the effects of the long plate or negative exposure necessary at the time—effects that hint at the ephemeral quality of human life. Throngs, carriages, and streetcars became mere ghosts of real things as the camera's eye stared on at a central subject. In some of the early time exposures by Prevost, uninhabited city streets with blank-windowed houses and horseless carts and carriages suggest an almost deserted village. (One exception is his record of Ottaviano Gori's marble-cutting establishment, in which the frozen white neoclassical figures enliven the scene most curiously.) In much of this there is also a romantic timelessness that seems at odds with the raw new city that replaced an old and mellow one. But despite that contrast, traces of the views caught in the camera's indiscriminate gaze in the last half of the nineteenth century may still be seen today.

I recommend that the reader take the time to let his eye wander within the margins of these old photographs. With careful observation, the figures standing at

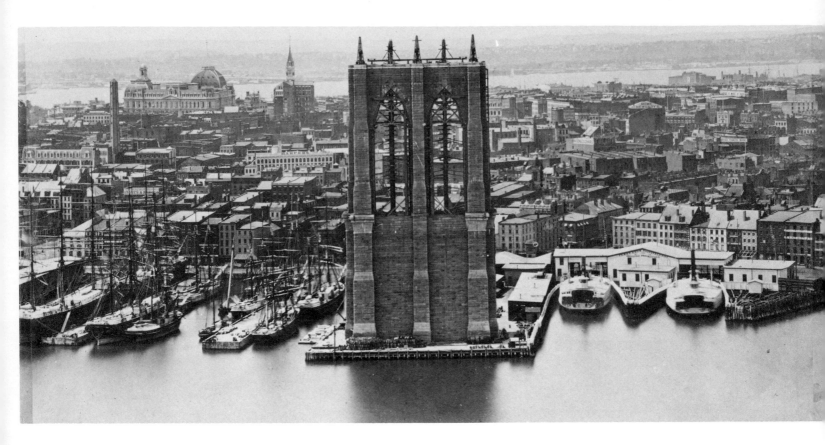

open doors and seated in windows, the buildings and passing seasons, take on life once more. Magnified details serve to emphasize the intimately identifying aspects of the nineteenth-century scene: the continuing prevalence of frame houses; the striped and plain awnings that soften the windows of residences, stores, and hotels in an attempt to control New York summer temperatures; windows shuttered inside or out, working to the same end; the lacy effect of cast-iron construction; and the lightening appearance of commercial structures as glass areas were expanded with the use of new architectural materials.

Even though this selection is not based primarily on judgments of photographic excellence, it will be evident to all who see the work of these first New York practitioners of the art of the camera that they excelled in their craft, carefully preparing their plates or negatives, carefully timing their shots, and carefully printing their work. Their care is our delight in this portrait of an almost vanished metropolis.

The New-York Historical Society's photographic archives were launched in 1906 with a gift from its president, Samuel V. Hoffman, of forty-two Prevost wax paper negatives. Some negatives and prints had already entered the Society's collection before that date, and continued to do so afterwards, first in trickles but soon in floods, so that today, more than 130 years after the introduction of the daguerreotype, its holdings number more than 100,000 items. This count is only slightly misleading since some glass plate negatives have never been catalogued or counted.

Some of the groups of pictures in the Society's collection that are not

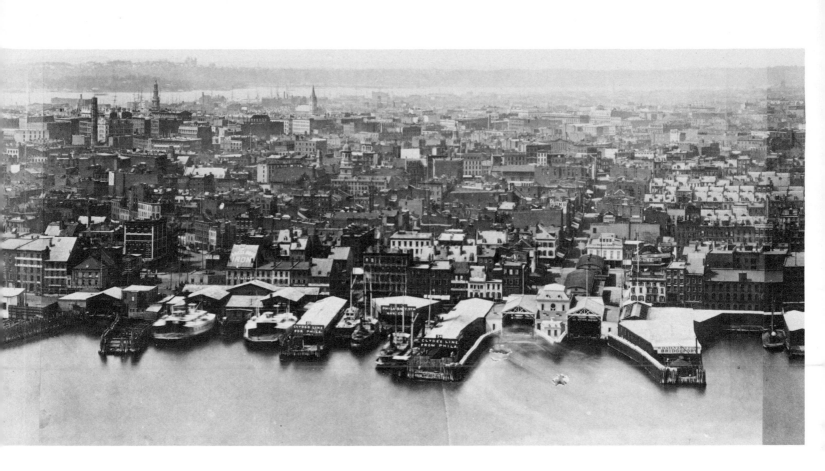

represented, or only scarcely touched, include portraits resulting from Samuel F. B. Morse's curious early experiment with three-dimensional pictures; some 1,300 portraits made at Pach Brothers Studio (its early Madison Square location prominently identified in several of the architectural photographs I chose); thousands of portraits of men by Pirie MacDonald, fortuitously balanced by numerous portraits of women included in the Harold Seton gift of full-length photographs of guests at Mrs. William K. Vanderbilt's 1883 fancy-dress ball and in the collection of theatrical portraits given in memory of Gertrude B. Weed. The Civil War, which brought both vocation and fame to so many early photographers, is amply represented in a collection of 1,200 prints given by Daniel Parish, Jr., and in the related Frederick H. Meserve collection, a gift from Samuel V. Hoffman. The Navy's part in World War II is presented in 1,700 prints; East Coast steamboats in another 900; and New York area lighthouses in some 1,200. More than 1,000 photographs in the Society's files trace the building of St. John the Divine between 1900 and 1913; 2,000 lantern slides and photographs by William L. Calver record archeological excavations in New York and elsewhere; and 40,000 images lead viewers through the maze of New York subways and elevated trains. In addition to these are 2,000 records of buildings by the prominent architectural firms of R. M. Hood and McKim, Mead and White; 4,000 photographs by Arnold Genthe; 500 by H. N. Tiemann; and 760 revealing studies by Jacob Riis and Robert Bracklow.

My guides and collaborators at the Society in this project were Dr. James J. Heslin, Director; Wilson Duprey, Curator of Maps and Prints; Martin Leifer, Assistant Curator of the Museum; Theodore Peruche, Museum Photographer; and

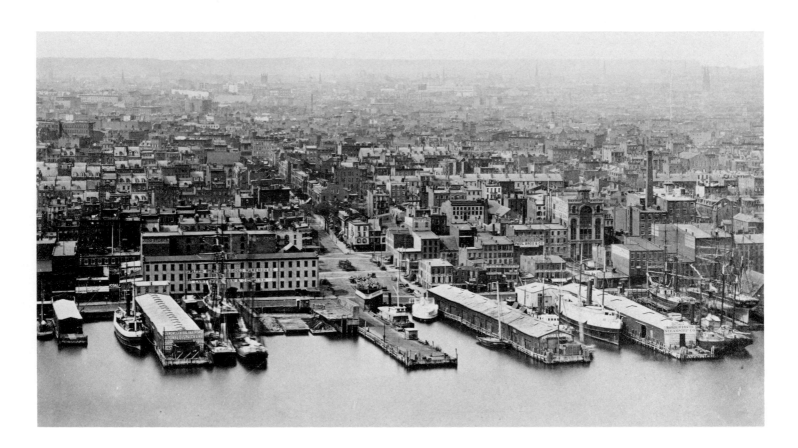

most especially Ellin Mathieu, Curatorial Assistant, who researched locations and helped me to draft many of the captions. Along the way, help came from several historians of the city scene: Richard J. Koke, Curator of the Society's museum; Albert Baragwanath, Senior Curator of the Museum of the City of New York; Henry Hope Reed, Curator of Central Park; and Andrew Alpern, Architect.

The selection of subjects for this volume was suggested by Hayward Cirker, President of Dover Publications. His interest in and knowledge of the city was helpful in setting the scenes in order. But the greatest tidying behind the scenes was accomplished by Myron J. Gladstone, who read and edited my original captions and text and helped to sharpen this particular eye on the city from 1850 to 1900.

MARY BLACK

CONTENTS

LIST OF PHOTOGRAPHS

Panoramic View of New York City (1876). *See Introduction*

I

The Battery and the East River Waterfront

II

The Broadway Area North from Bowling Green to Duane Street and the Brooklyn Bridge

III

The West Side: Locations West of Trinity Place and North to Duane Street

IV

The West Side from Broadway West to the Hudson River and North from Duane Street to Barrow and Bleecker Streets

V

The East Side from Broadway to the East River and North from Duane Street to Spring and Delancey Streets

VI

The East Side from Broadway to the East River and North from Spring and Delancey Streets to 14th Street

VII

The West Side from the Washington Square Area West to the Hudson River and North from Barrow and Bleecker Streets to 23rd Street

VIII

The Broadway Area from 14th Street to 23rd Street

IX

Broadway to the East River from 23rd Street to 40th Street

X

The East Side from Fifth Avenue to the East River between 40th Street and 59th Street

XI

The West Side from Fifth Avenue to the Hudson River between 40th Street and 59th Street

XII

North in "The Territory" from 59th Street to Spuyten Duyvil

I

THE BATTERY
AND THE EAST RIVER WATERFRONT

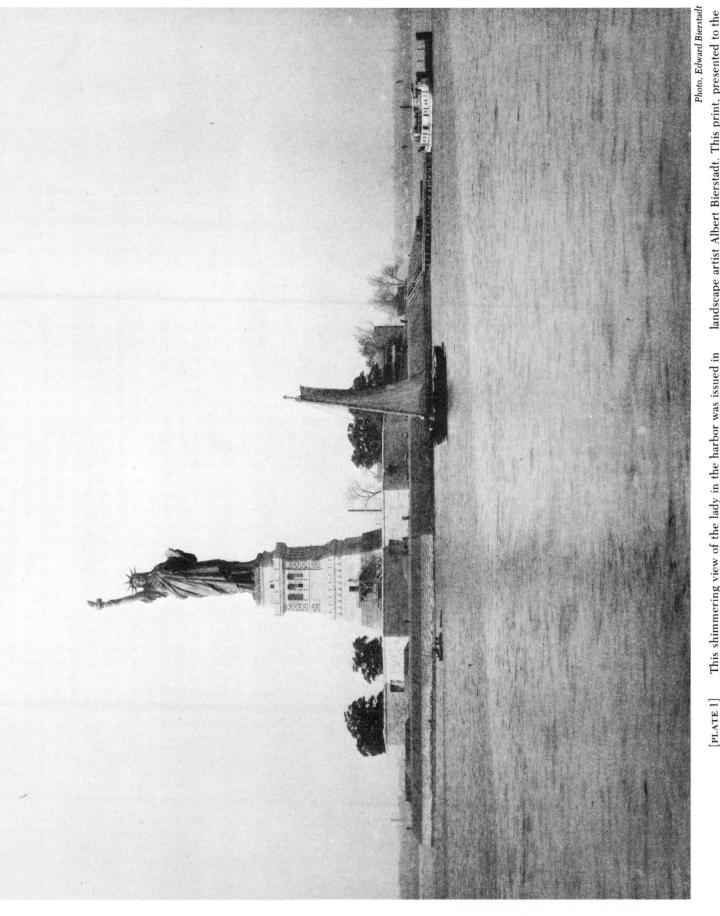

Photo, Edward Bierstadt

[PLATE 1]

Liberty Enlightening the World, c. 1886

This shimmering view of the lady in the harbor was issued in quantity by Artotype, Bierstadt's name for the multiple-print photoprocess he used. Edward Bierstadt, who was a printer as well as a photographer, was the brother of the celebrated landscape artist Albert Bierstadt. This print, presented to the Society in 1890, probably records the appearance of the figure shortly after it was dedicated in 1886.

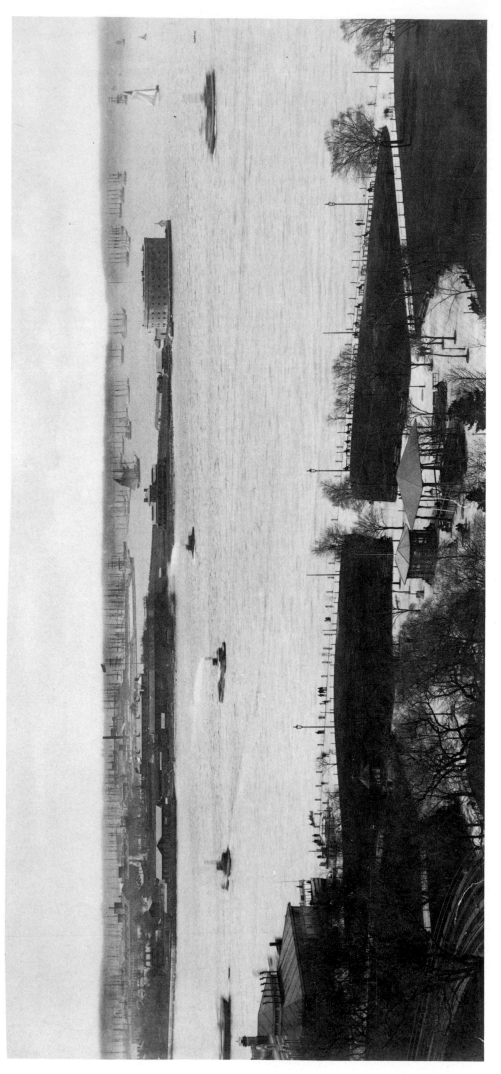

Battery Park, c. 1885

[PLATE 2]

This view of the harbor shows Battery Park in the foreground with Castle Garden at the left. Before a forest of ship masts lies Governor's Island with the fortifications of Castle Williams at right center. The fort, built to defend the harbor in 1811 in preparation for the War of 1812, was named for its architect, Lt. Col. Jonathan Williams, a nephew of Benjamin Franklin.

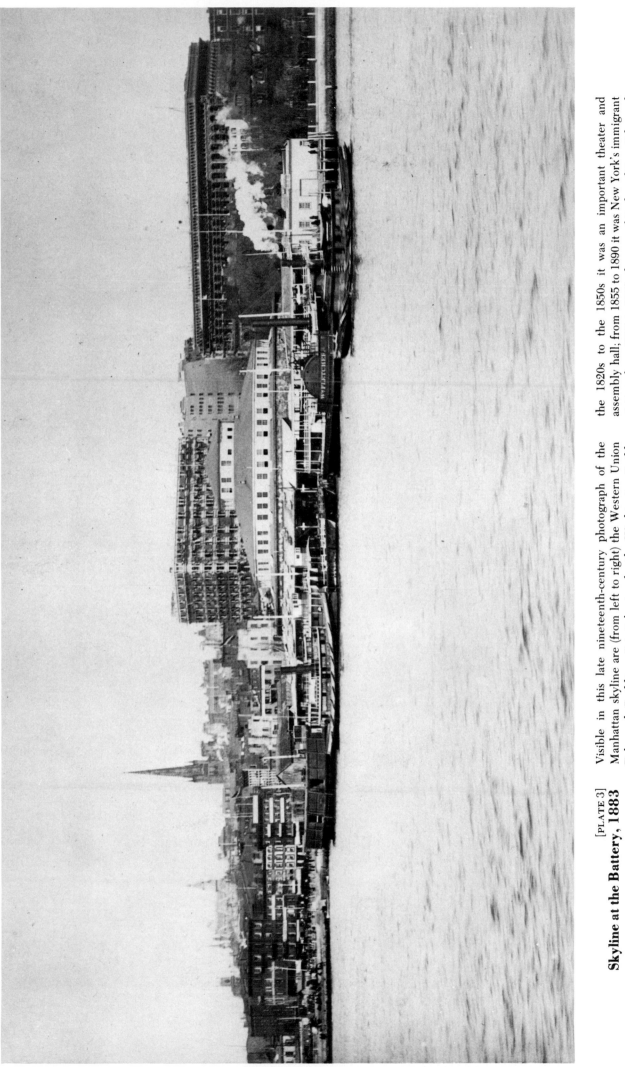

[PLATE 3]
Skyline at the Battery, 1883

Visible in this late nineteenth-century photograph of the Manhattan skyline are (from left to right) the Western Union Telegraph Building, Trinity's steeple, the Washington Building, Castle Garden, and the Produce Exchange. Castle Garden, earlier called Castle Clinton, was built c. 1807; from the 1820s to the 1850s it was an important theater and assembly hall; from 1855 to 1890 it was New York's immigrant station; from 1896 to 1942, the year of its demolition, it housed the New York Aquarium. (The side-wheeler *William Fletcher* was out of Boston.)

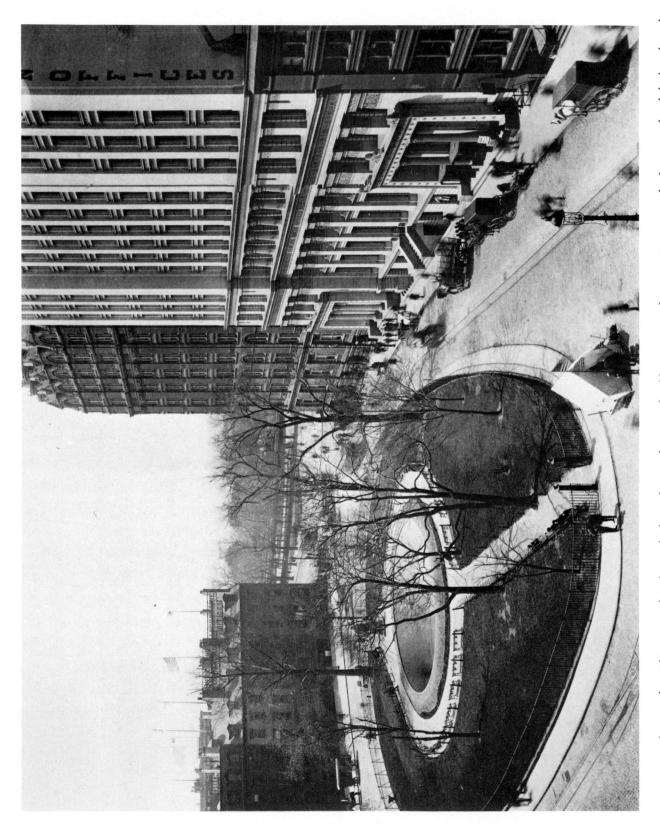

[PLATE 4]
Bowling Green, 1898

This view, taken from a high window on the east side of lower Broadway, shows Bowling Green, New York City's first park, as it appeared about 100 years after it was enclosed by the fence seen here. The buildings at the left are part of Steamship Row, and Battery Park appears in the distance. Broadway begins at the right, the second building, 7–11 Broadway, having been completed the year this picture was taken. Designed by W. G. Audsley, its impressive Egyptian Revival facade incorporates ancient pillars into the design of the

The recruiting tent in the foreground and the bare branches on the trees set the photograph date to the start of the Spanish-American War (declared April 25th). Dimly seen at the end of the park is the seated figure of Abraham de Peyster by George Edwin Bissell, installed just two years before near the spot where the equestrian statue of George III was torn down by an irate populace on July 6, 1776.

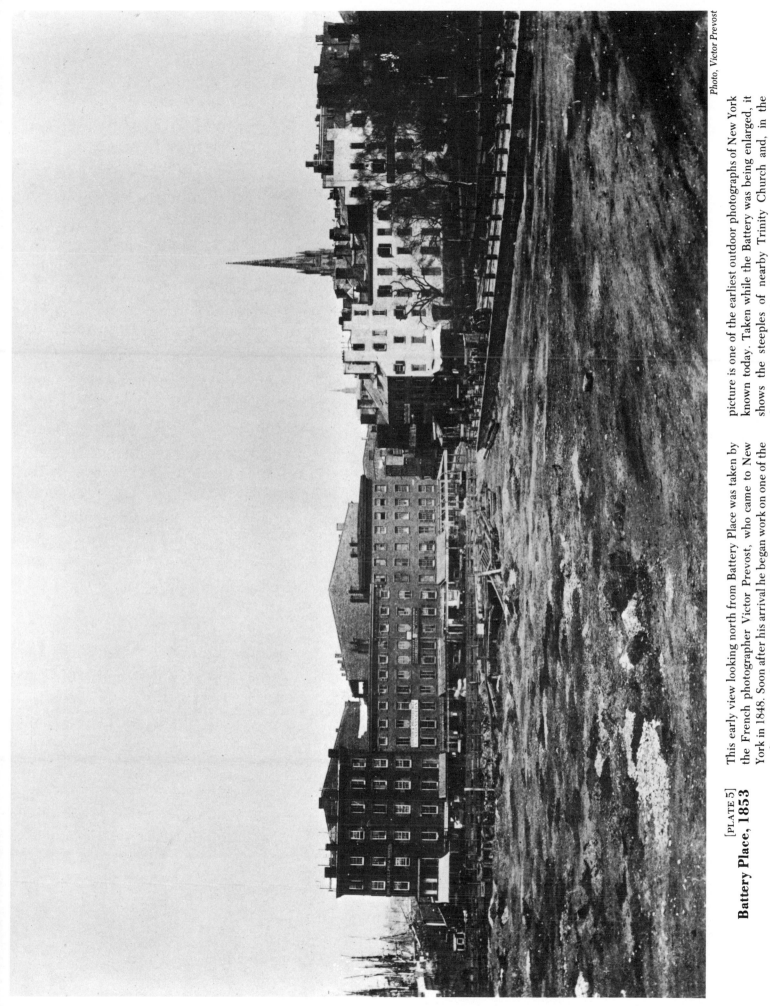

[PLATE 5]

Battery Place, 1853

This early view looking north from Battery Place was taken by the French photographer Victor Prevost, who came to New York in 1848. Soon after his arrival he began work on one of the earliest existing photographic records of the city. The present picture is one of the earliest outdoor photographs of New York known today. Taken while the Battery was being enlarged, it shows the steeples of nearby Trinity Church and, in the distance, St. Paul's Chapel.

7

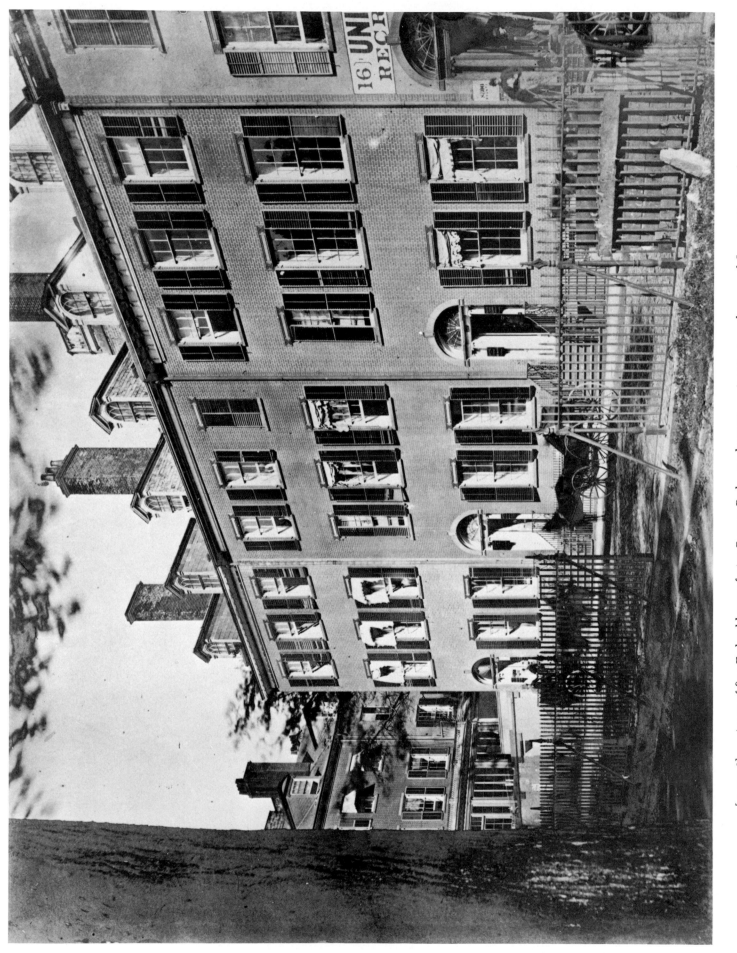

[PLATE 6]
State Street, c. 1864

A row of fine Federal houses facing Battery Park—on the west side of State Street just south of Bowling Green—is captured in this photograph of the Civil War period. A recruiting office is set up on the ground floor at No. 16, where a poster at the door offers a bounty of $800 to each enlistee. The other buildings are also in use as military offices.

[PLATE 7]
No. 7 State Street, c. 1888

Facing Battery Park and planned to fit the curve of State Street is the Federal house built for James Watson in the early nineteenth century, supposedly from designs by John McComb, Jr. At the time of this view, the facade had been painted and the windows and doors highlighted in imitation of bold Georgian architectural detail, less in keeping with the elegance of the original house than its later restoration as part of the Shrine of Blessed Mother Seton. The horse-drawn street sprinkler is an independently important detail in this late nineteenth-century photograph of an early New York mansion that is still standing.

9

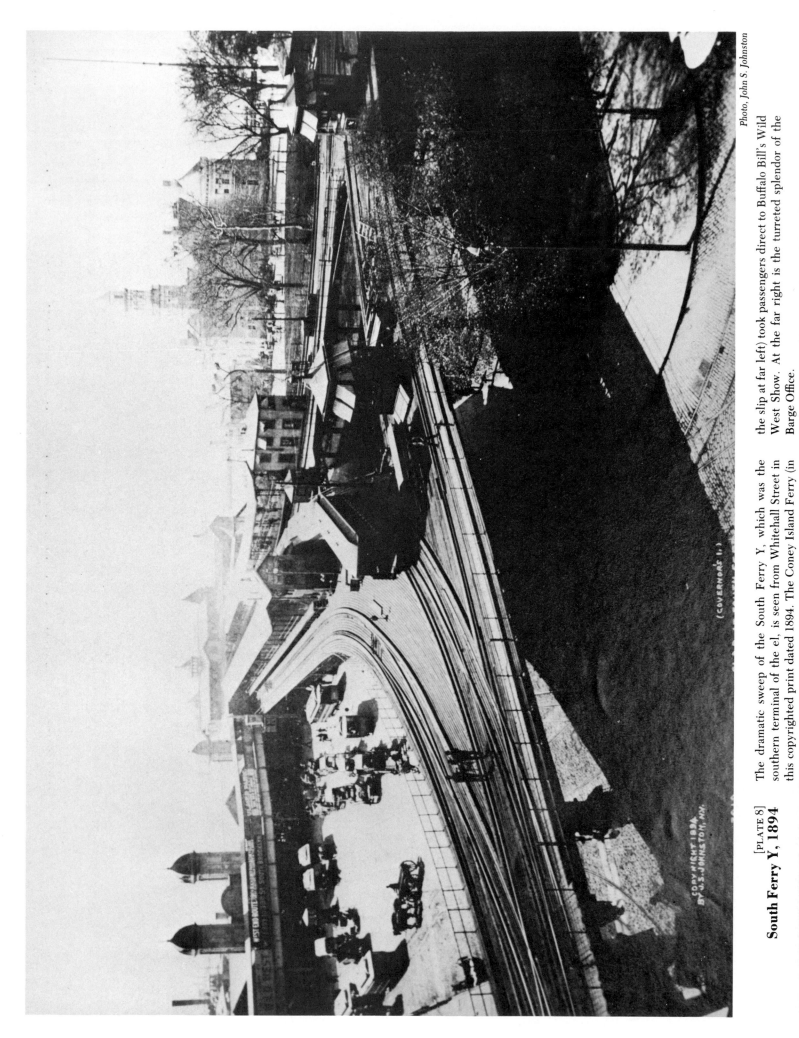

[PLATE 8]
South Ferry Y, 1894

The dramatic sweep of the South Ferry Y, which was the southern terminal of the el, is seen from Whitehall Street in this copyrighted print dated 1894. The Coney Island Ferry (in the slip at far left) took passengers direct to Buffalo Bill's Wild West Show. At the far right is the turreted splendor of the Barge Office.

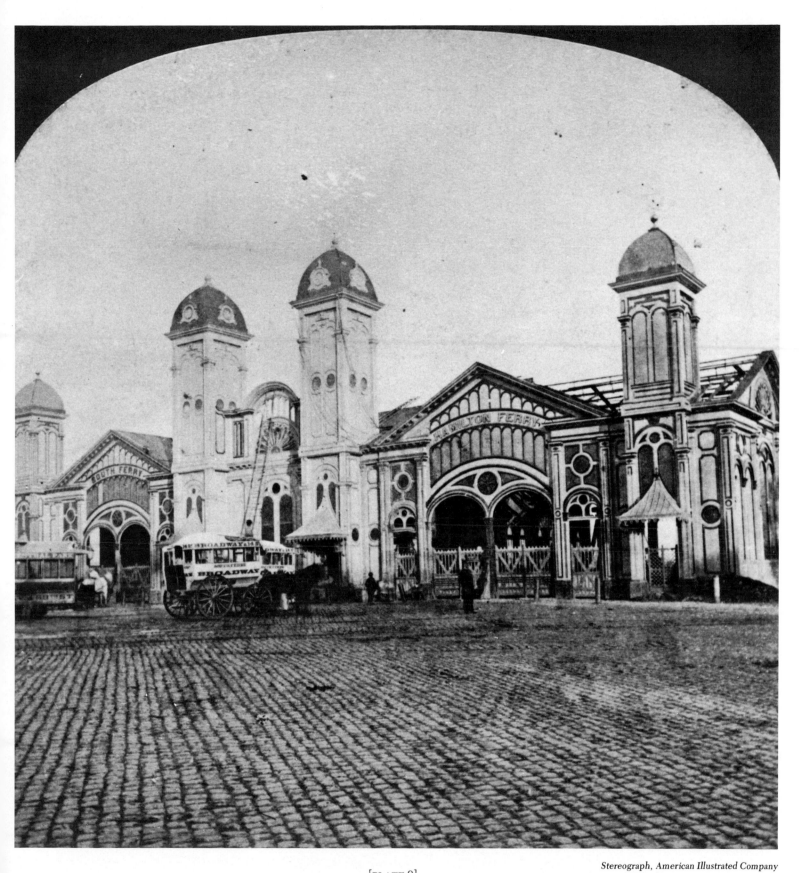

Stereograph, American Illustrated Company

[PLATE 9]
Brooklyn Ferry Stop, c. 1870

This ebullient Victorian structure marked the Manhattan landing for Brooklyn ferries at the foot of Whitehall and South Streets, east of Battery Park. The piers were the southern point for public transportation in the city, and southbound Broadway trolleys had South Ferry as their destination.

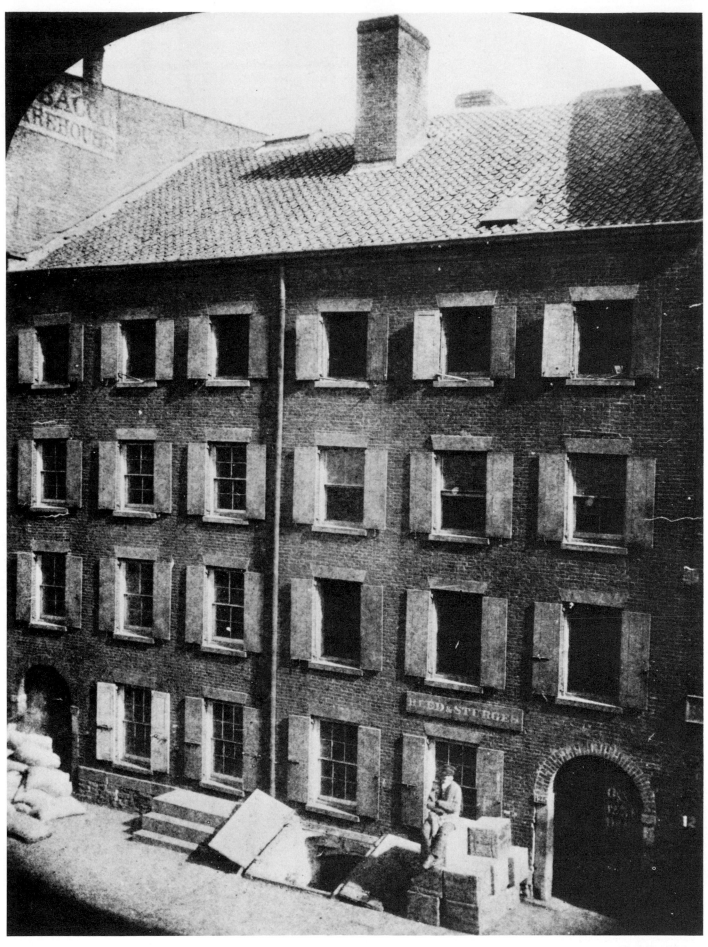

Photo, Victor Prevost

[PLATE 10]
Reed & Sturges Warehouse, c. 1855

Just west of the East River, on the east side of Front Street between Wall and Pine Streets, two identical brick buildings housed the Reed & Sturges Warehouse (shortly after, Sturges, Bennet, and Company). This time exposure is by the French photographer Victor Prevost (see No. 5).

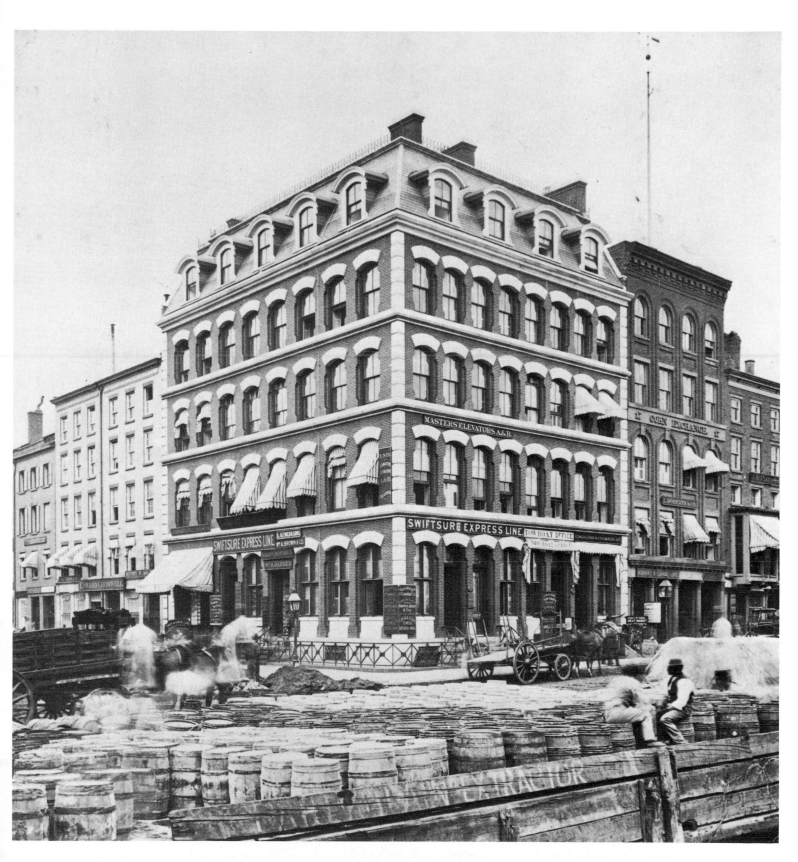

[PLATE 11]
South and Broad Streets, 1867

The hum of commerce along the East River at the foot of Broad Street (left) and South Street (right) is indicated by the varied stock of barrels lined up at the pier before the well-kept buildings seen here. They house the offices of the grain merchants, towboat owners, inspectors, and grain elevator operators who prospered from the cargo that came into the city by barge and sailing vessel.

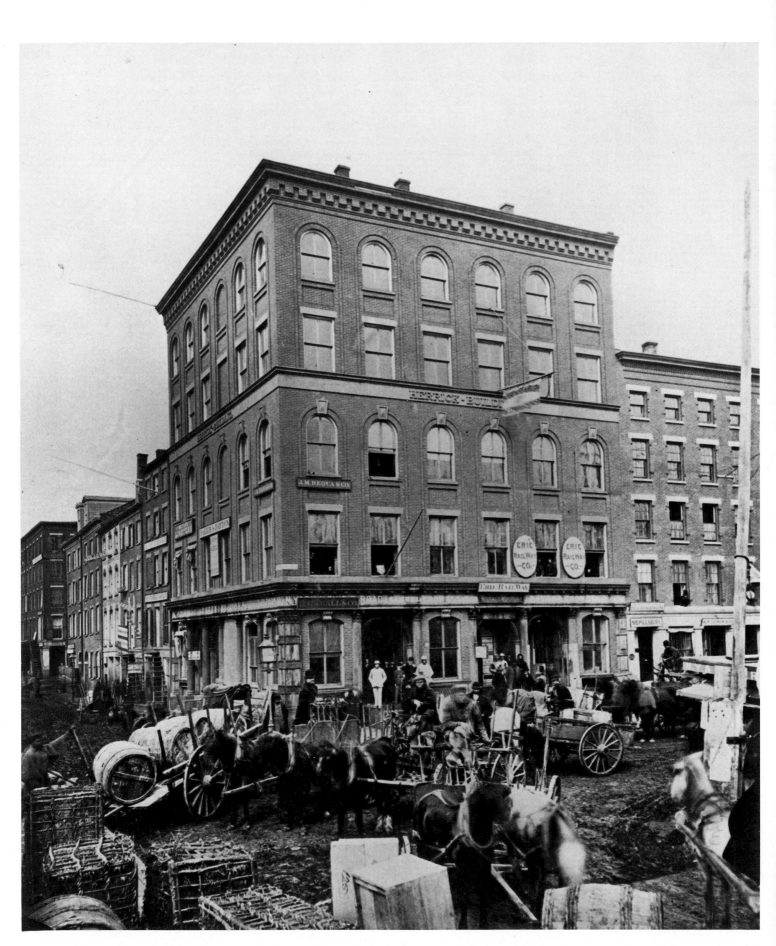

[PLATE 12]
Grain Merchants, c. 1890

Sandwiched between sail lofts and ship chandlers are provisions dealers and the offices of the Erie Railway. The Herricks, who constructed this building at the corner of South Street (right) and Coenties Slip, were grain merchants; the horse-drawn carts in the street at the edge of the East River suggest that grain-carrying barges or sailing ships stand ready to load or unload their cargo.

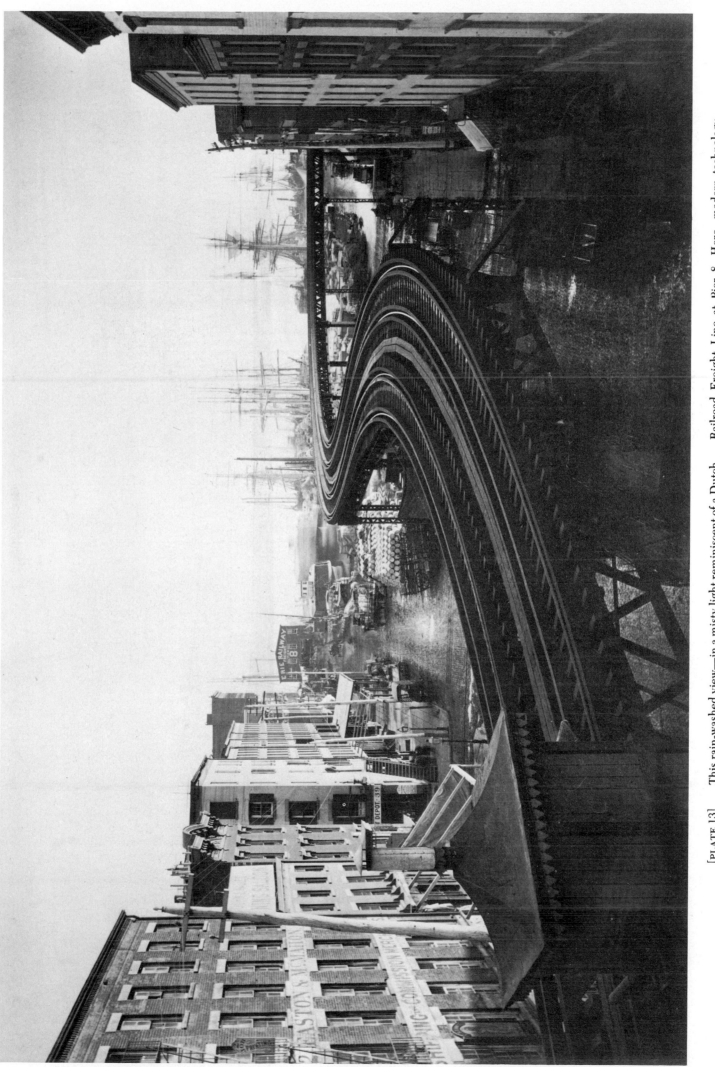

[PLATE 13]
Coenties Slip, c. 1879

This rain-washed view—in a misty light reminiscent of a Dutch landscape—shows the curve of the elevated railroad in lower Manhattan looking due east from Pearl Street to the Erie Railroad Freight Line at Pier 8. Here, modern technology contrasts with and intrudes upon traditional transportation by barge and ship.

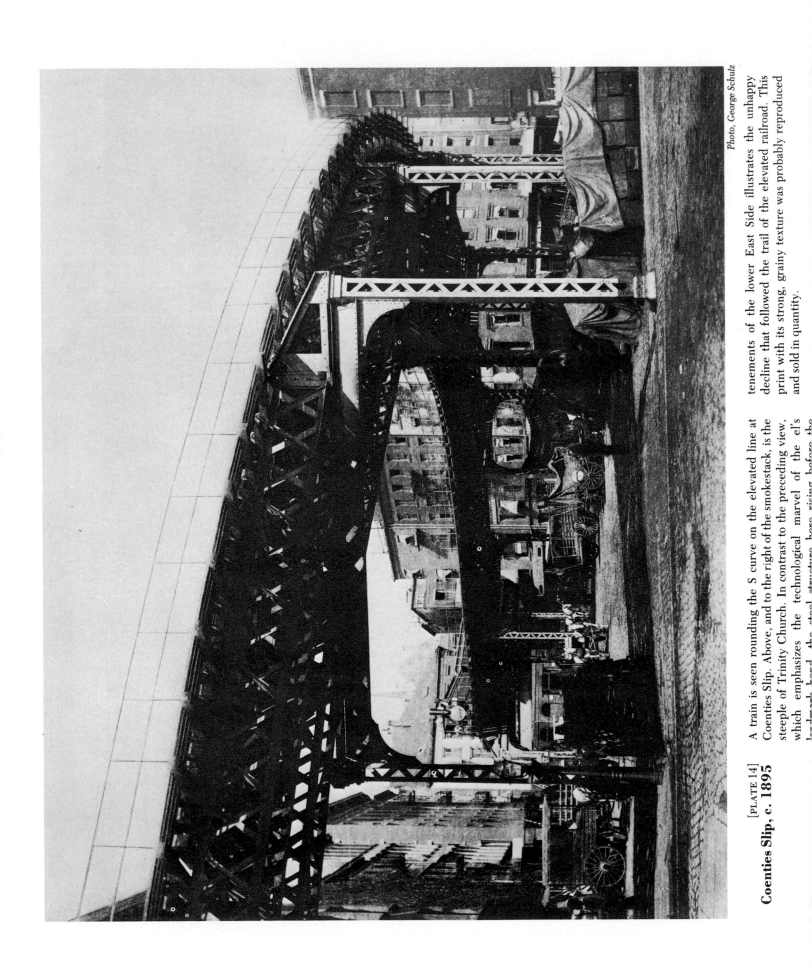

Photo, George Schulz

[PLATE 14]
Coenties Slip, c. 1895

A train is seen rounding the S curve on the elevated line at Coenties Slip. Above, and to the right of the smokestack, is the steeple of Trinity Church. In contrast to the preceding view, which emphasizes the technological marvel of the el's underpinning, the steel structure here rising before the tenements of the lower East Side illustrates the unhappy decline that followed the trail of the elevated railroad. This print with its strong, grainy texture was probably reproduced and sold in quantity.

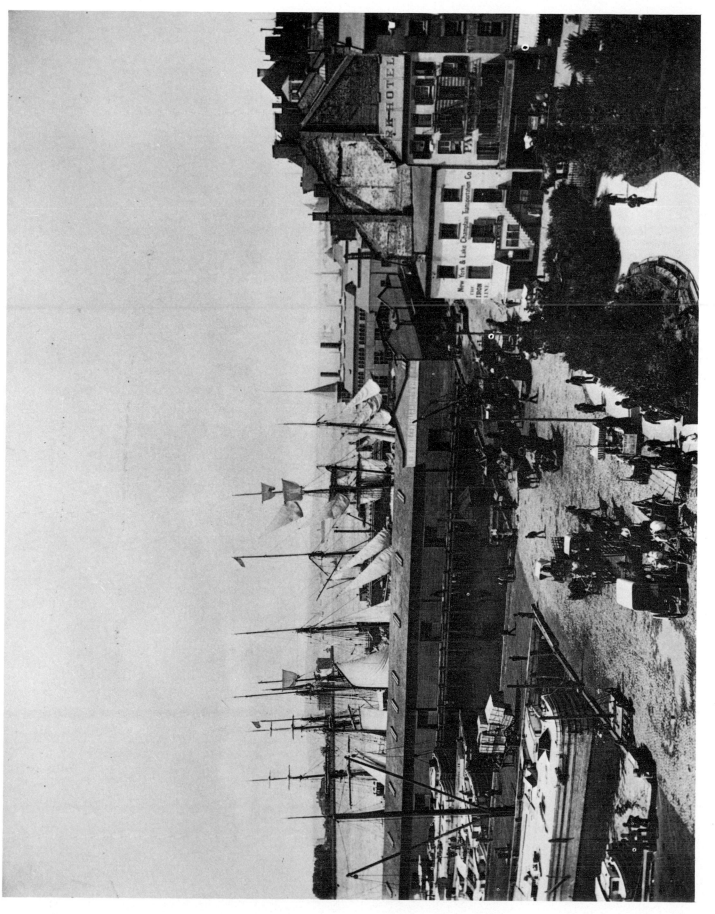

[PLATE 15]
**South Street and the Harbor,
c. 1890**

This late nineteenth-century view focuses on South Street as it joins Coenties Slip. The pleasant green island at the right is Jeanette Park, then about ten years old. Cargo ships dry their sails beyond the New York Central & Hudson pier, and the fleet of New York canal boats appears at the left. Governor's Island is seen in the left background across the East River.

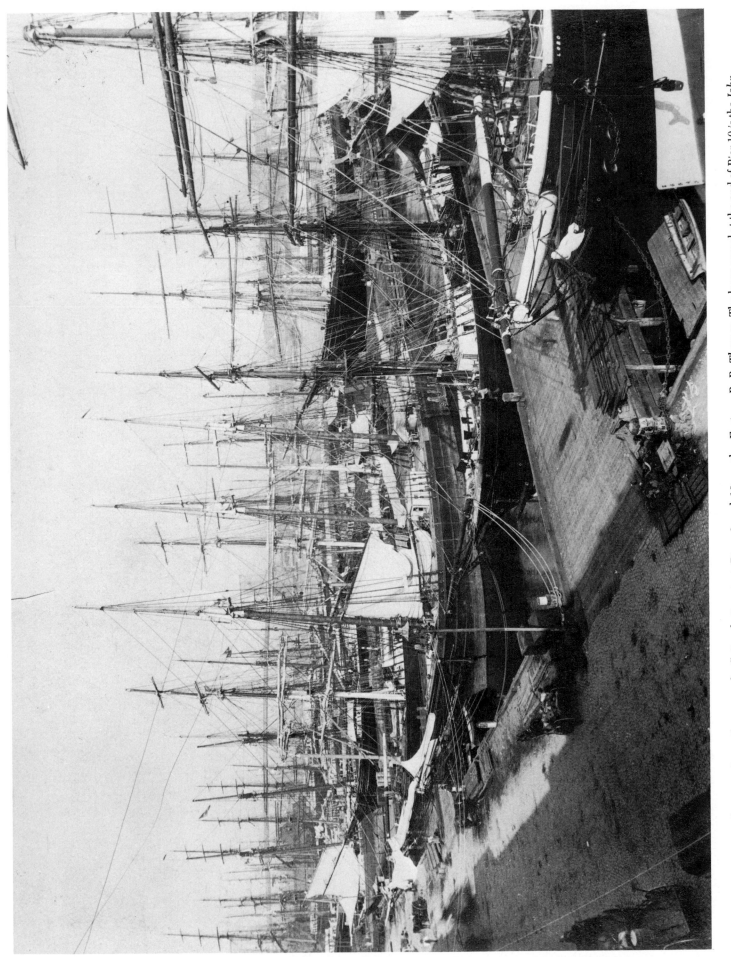

South Street, 1887

[PLATE 16] Ships stand off South Street at Piers 9 and 10 on the East River. Visible from front to back are the barks *Lobo* and *Henrietta*, the schooner *Florence Shay*, and the down-Easter *R. R. Thomas*. The large vessel at the end of Pier 10 is the *John R. Kelley*.

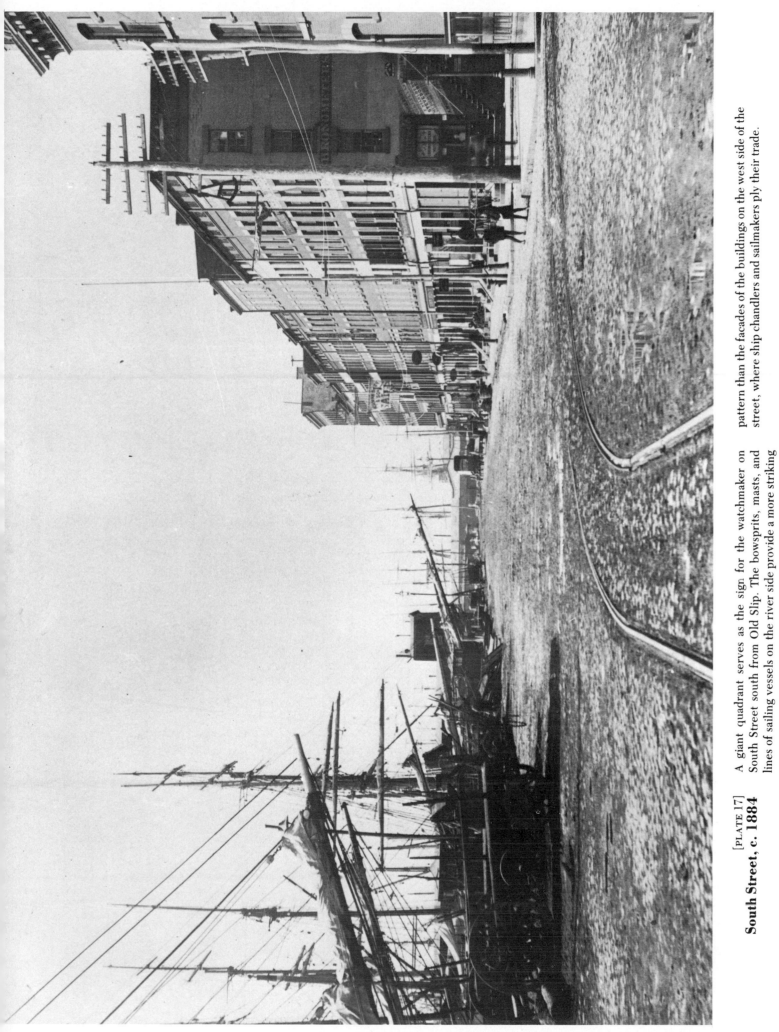

South Street, c. 1884 [PLATE 17]

A giant quadrant serves as the sign for the watchmaker on South Street south from Old Slip. The bowsprits, masts, and lines of sailing vessels on the river side provide a more striking pattern than the facades of the buildings on the west side of the street, where ship chandlers and sailmakers ply their trade.

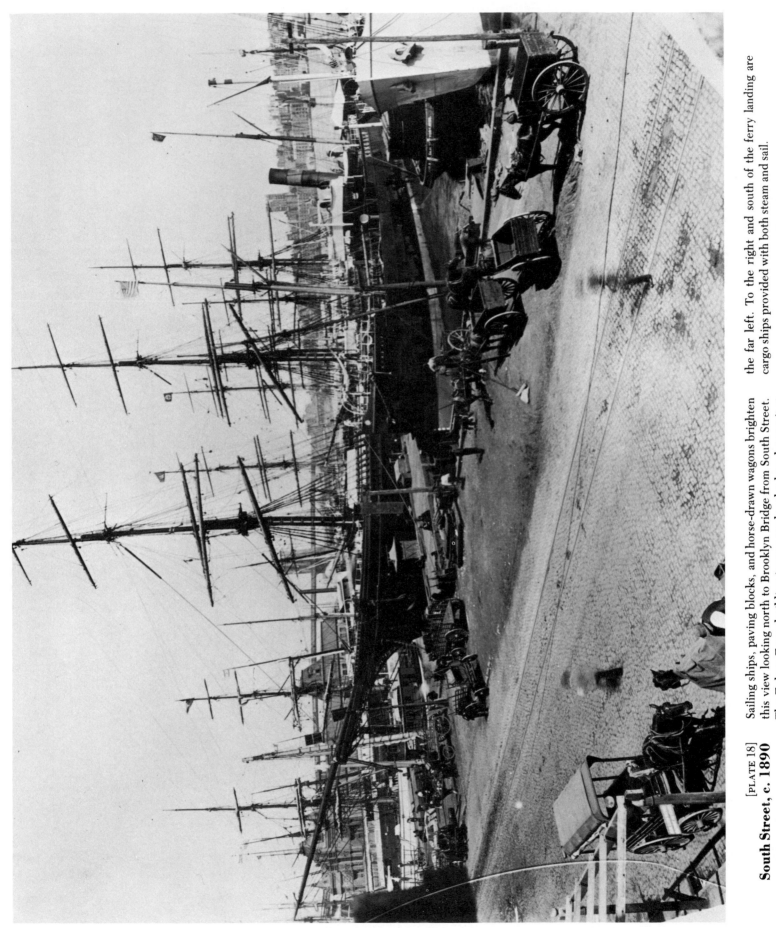

[PLATE 18]
South Street, c. 1890

Sailing ships, paving blocks, and horse-drawn wagons brighten this view looking north to Brooklyn Bridge from South Street. The Fulton Ferry building is seen under the long bowsprit at the far left. To the right and south of the ferry landing are cargo ships provided with both steam and sail.

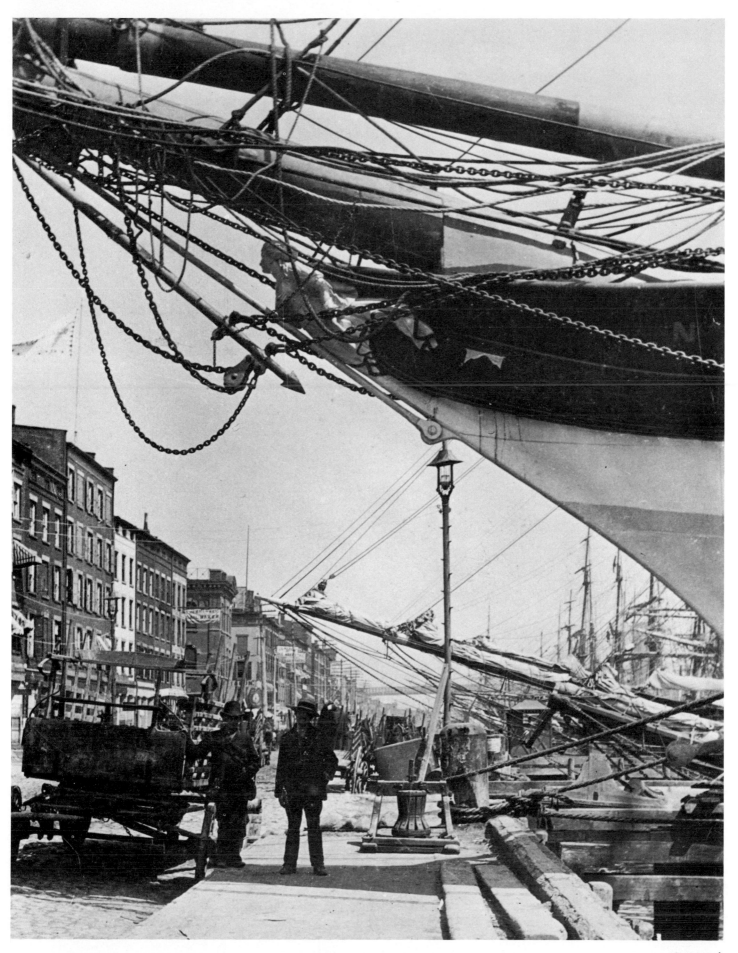

Stereograph

[PLATE 19]
South Street, c. 1897

This print shows the South Street piers crowded with sailing ships. The two men posing may be sailors from the boat at the right with its great nineteenth-century figurehead, but it is more likely that they are workers from one of the many sailmaking and woodcarving ships that lined the street.

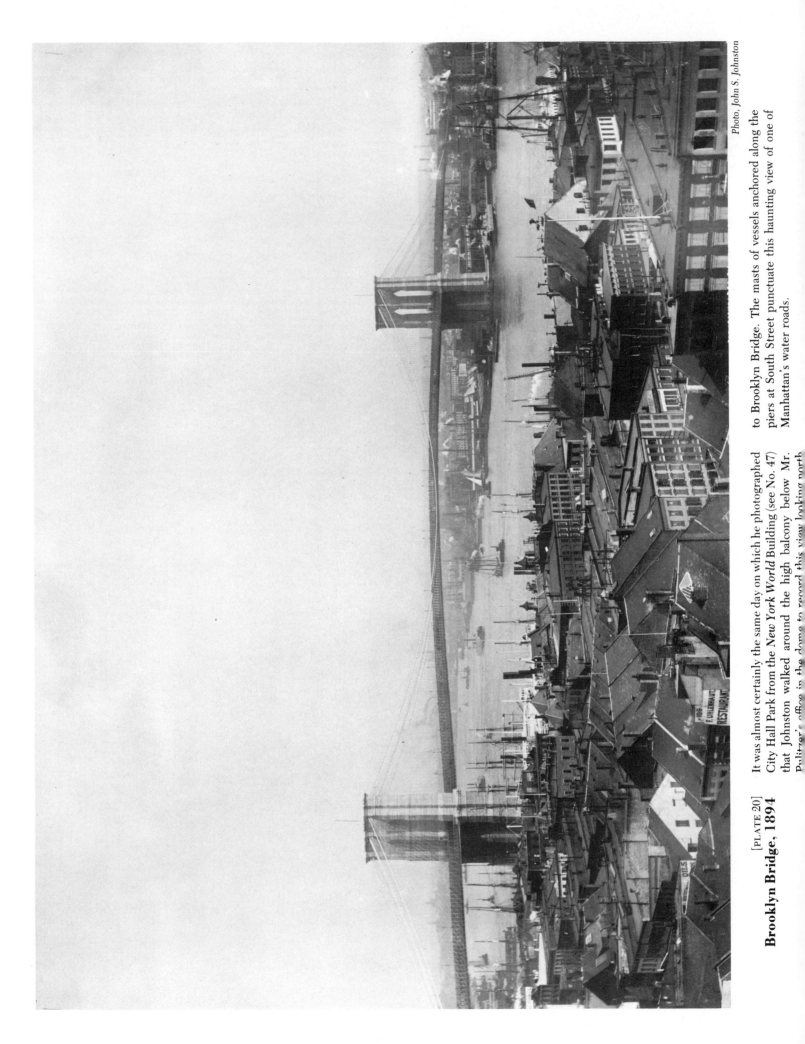

[PLATE 20]
Brooklyn Bridge, 1894

It was almost certainly the same day on which he photographed City Hall Park from the *New York World* Building (see No. 47) that Johnston walked around the high balcony below Mr. Pulitzer's office in the dome to record this view looking north to Brooklyn Bridge. The masts of vessels anchored along the piers at South Street punctuate this haunting view of one of Manhattan's water roads.

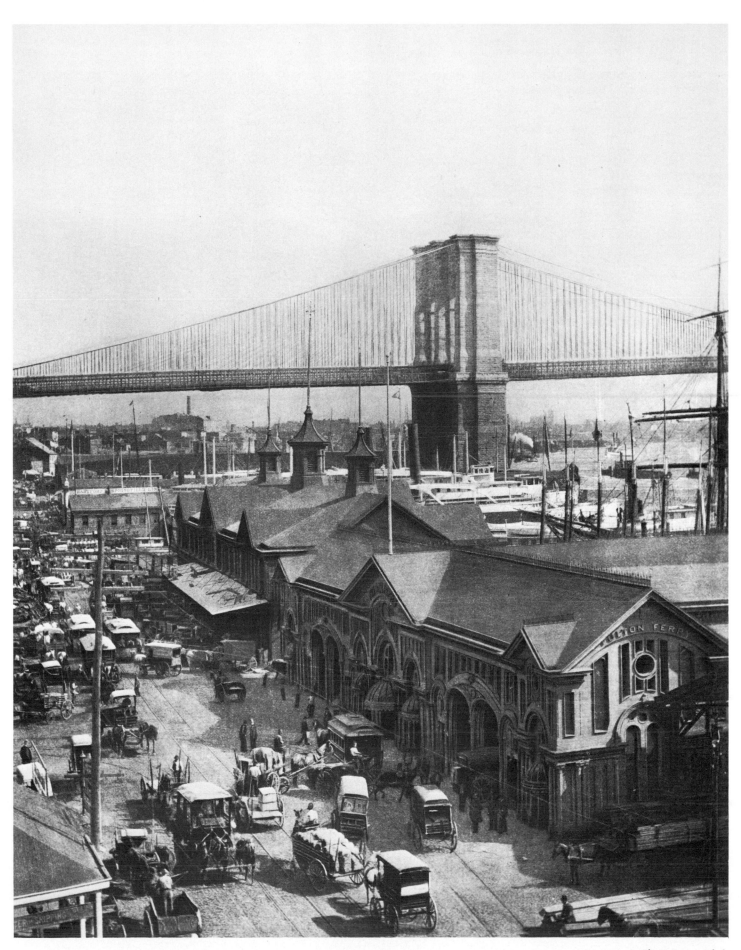

[PLATE 21]
Fulton Ferry and South Street, c. 1898

This grainy-textured photoengraving by George Schulz, in which the lines of bridge and background have been strengthened with fine-line retouching, was produced and sold in quantity. Brooklyn Bridge soars above the Fulton Ferry building and the cupolas of the Fulton Fish Market.

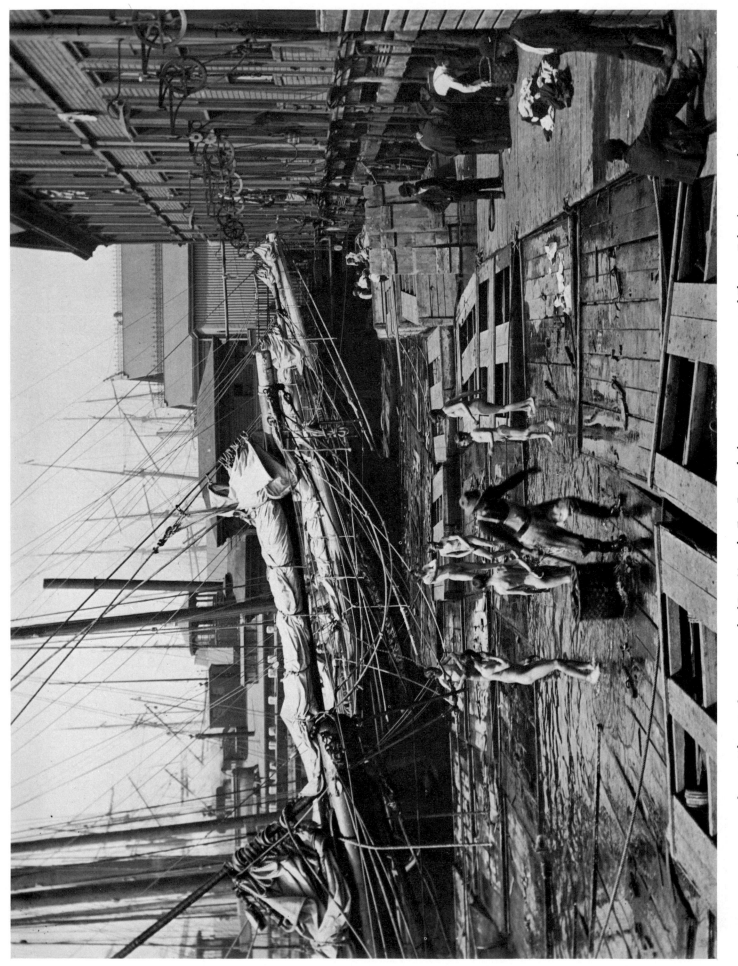

[PLATE 22]

Fulton Fish Market, 1892

In this scene, south of Pier 23 on the East River, the bowsprits of two cargo schooners almost touch the wooden warehouses on the pier while the nude boys are captured in poses reminiscent of Thomas Eakins' painting *The Swimming Hole*. In the background is the Fulton Fish Market, its roof decorated with ornamental iron crest rails.

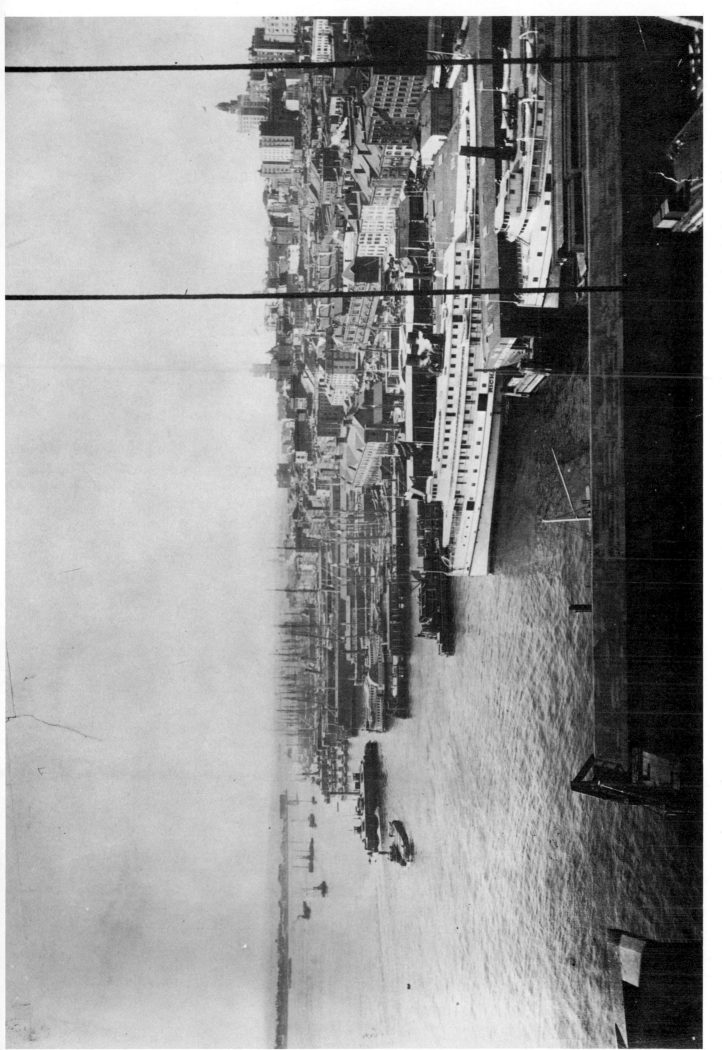

[PLATE 23]
From Brooklyn Bridge, 1894

Late in the nineteenth century the Brooklyn Bridge provided a panoramic new view. The ferry to Fulton Street entering its dock (in the river, left) marks the location of Schermerhorn Row at Fulton and South Streets. Its old pitched roof with high chimneys and the mansard roof, a later modification, are seen immediately right and left of the innermost strut of the bridge. Obscuring the facade of this row of attached buildings is the Fulton Market with two of its low corner towers visible.

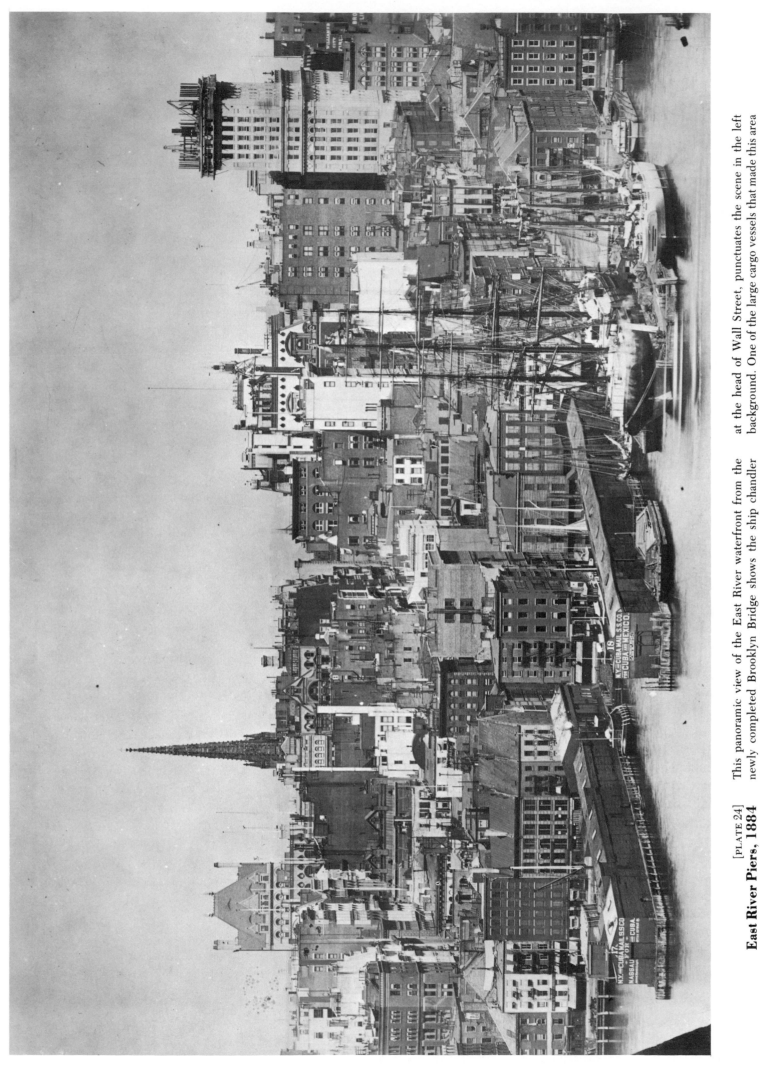

[PLATE 24]
East River Piers, 1884

This panoramic view of the East River waterfront from the newly completed Brooklyn Bridge shows the ship chandler shops and sail lofts along South Street between Wall Street (left) and Maiden Lane (right). Trinity's steeple, on Broadway at the head of Wall Street, punctuates the scene in the left background. One of the large cargo vessels that made this area the street of ships is seen to the right at Pier 19.

II

THE BROADWAY AREA

North from Bowling Green to Duane Street

and the Brooklyn Bridge

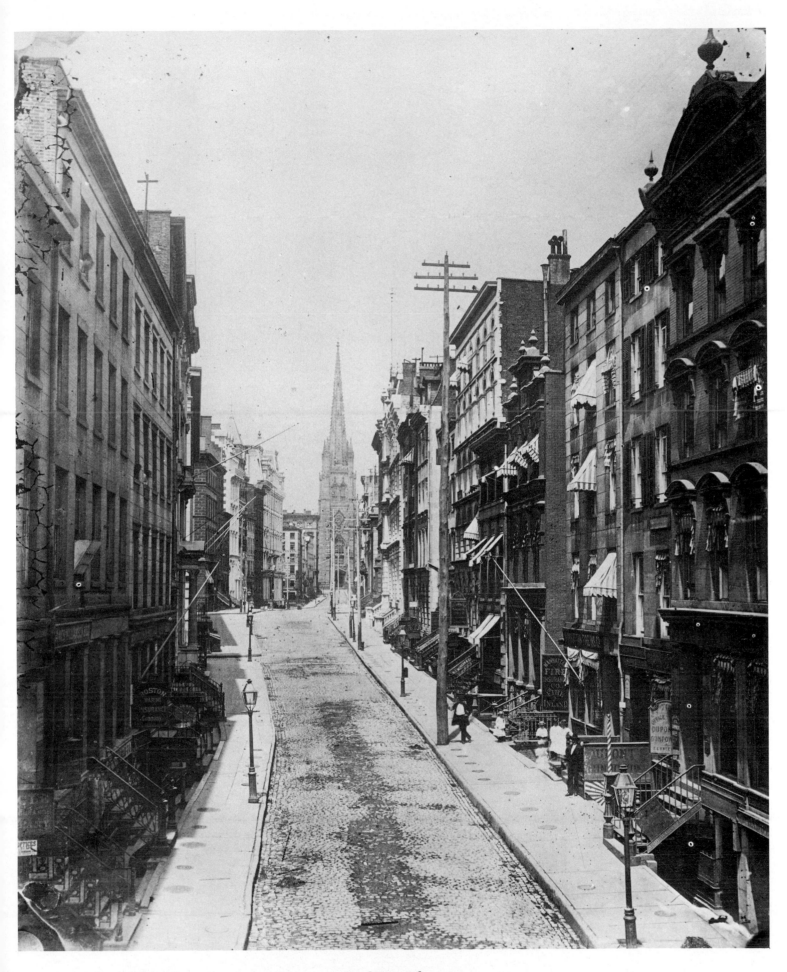

[PLATE 25]
Wall Street, c. 1880

Looking up Wall Street, the third Trinity Church on this site, completed in 1846, is seen here from a new aspect, for the photograph appears to have been shot from the new elevated station at Wall and Pearl Streets completed in 1878. The repeated circular forms along the sidewalks are, in all likelihood, covers for the coal chutes serving these buildings.

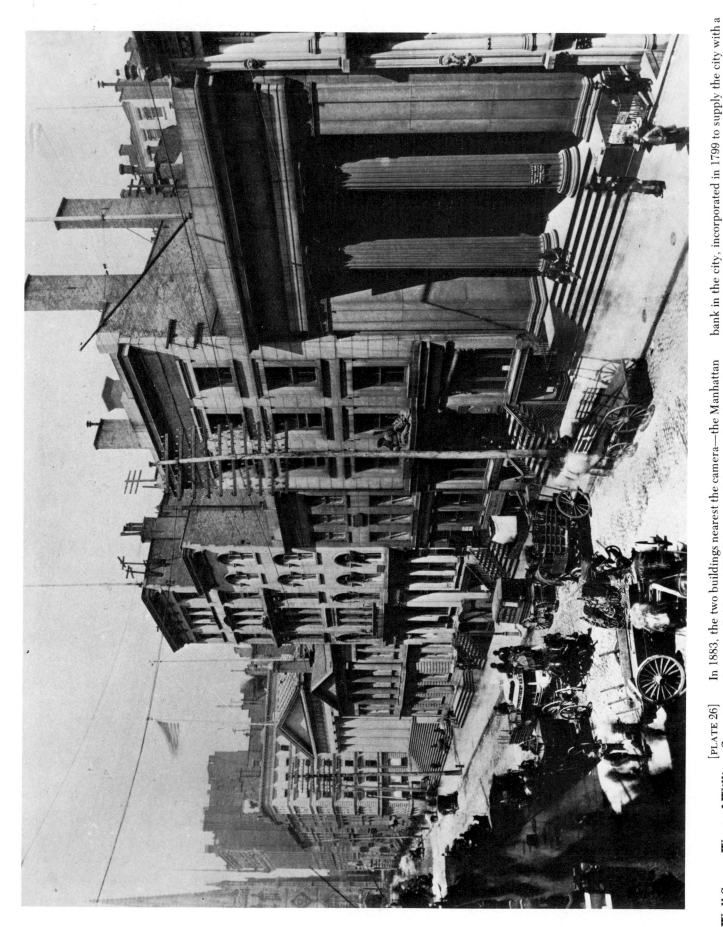

**Wall Street West of William Street,
c. 1882**

[PLATE 26]

In 1883, the two buildings nearest the camera—the Manhattan Company (left) at 40 Wall Street and the Merchant's Bank at No. 42—were replaced by one structure that joined the rival companies into one, the Manhattan and Merchants Bank. The figure of Neptune resting above the entrance to the Manhattan Company was an appropriate symbol for the second oldest bank in the city, incorporated in 1799 to supply the city with a pure water source.

Further west on Wall Street appears the oldest building on the street, the colonnaded Assay Office, and just beyond it the Subtreasury Building at the northeast corner of Broad Street.

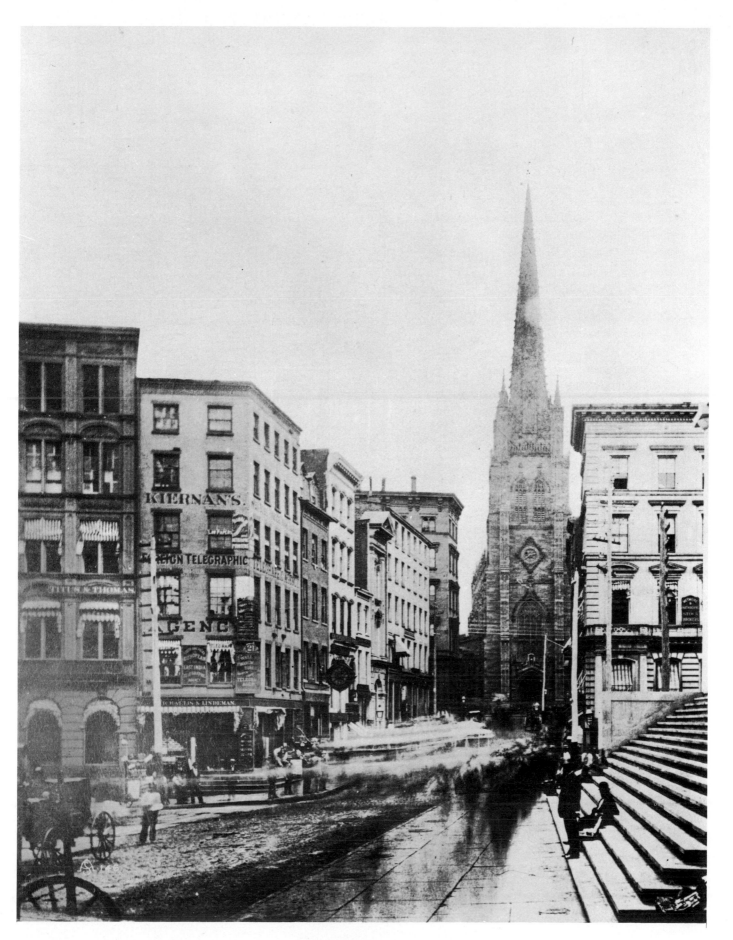

[PLATE 27]
Wall Street, 1870

In a time exposure taken on a busy weekday afternoon streetcars and throngs of people move along Wall Street at a point just east of Broadway. A street peddler relaxes and displays his wares on the steps of the Subtreasury Building. The highest elevation in the photograph, Trinity's imposing spire, is a reminder of the time when church steeples were the best guide to city locations.

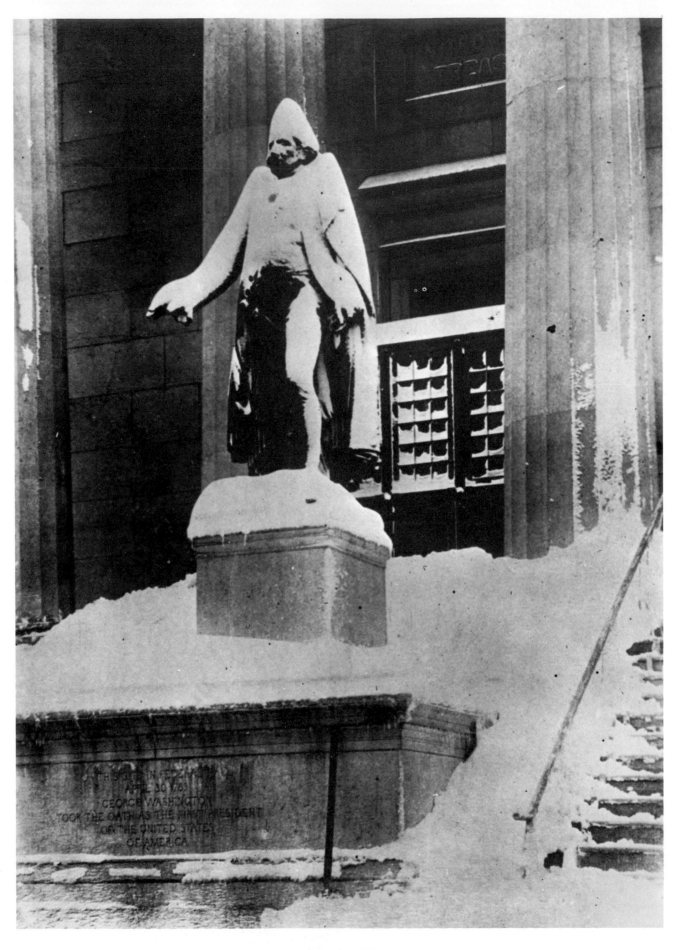

[PLATE 28]
Washington in the Snow, 1888

Looking more like a Hessian soldier than like himself, the figure of Washington by John Quincy Adams Ward stands beneath the drifting snows of the blizzard of 1888 on the steps of the Subtreasury Building on Wall Street at Nassau. The statue was then only five years old, but it is still located on almost the same spot where Washington took his oath as first president in 1789.

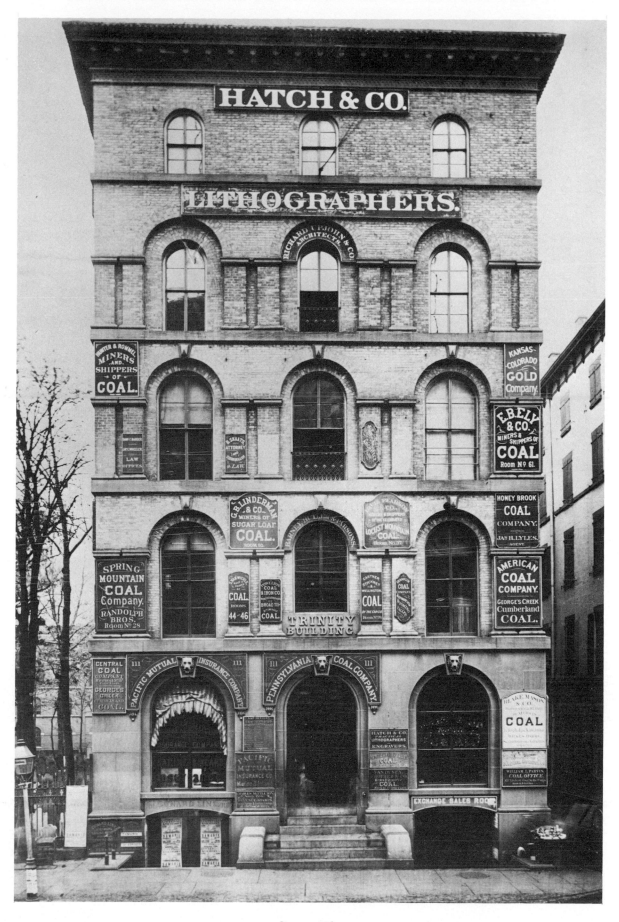

[PLATE 29]
Trinity Building, c. 1868

Since Hatch and Company moved from 111 Broadway to other locations in lower Manhattan after 1869, the date of this photograph is set at 1868, the only possible year in which the Cunard Line's steam and sail vessel *Samaria* sailed on Thursday, October 22nd. The five-story Trinity Building, completed in 1852, was replaced by a new building designed by Francis H. Kimball in 1906 that now stands between Trinity Church graveyard and Thames Street. When the picture was taken, the architect Richard Upjohn maintained offices in the building he had designed. The two figures seen spectrally in the doorway may be the owners of these oddments of street sculpture.

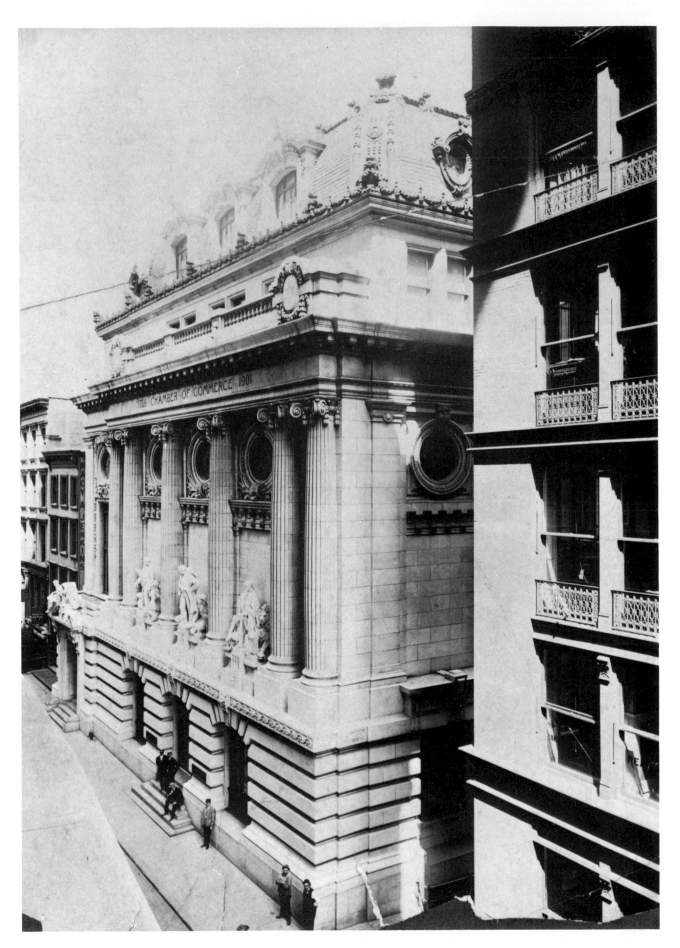

[PLATE 30]
Chamber of Commerce, c. 1901

James B. Baker's glorious structure for the Chamber of Commerce shines forth in new and pristine splendor at Liberty and Nassau Streets in this photograph taken soon after its completion. While the building still stands, the elaborate marble figures were removed in 1924 because of decomposition. Two of the figures, Alexander Hamilton, left, and John Jay, right, are by Philip Martiny. DeWitt Clinton, at the center, is by Daniel Chester French.

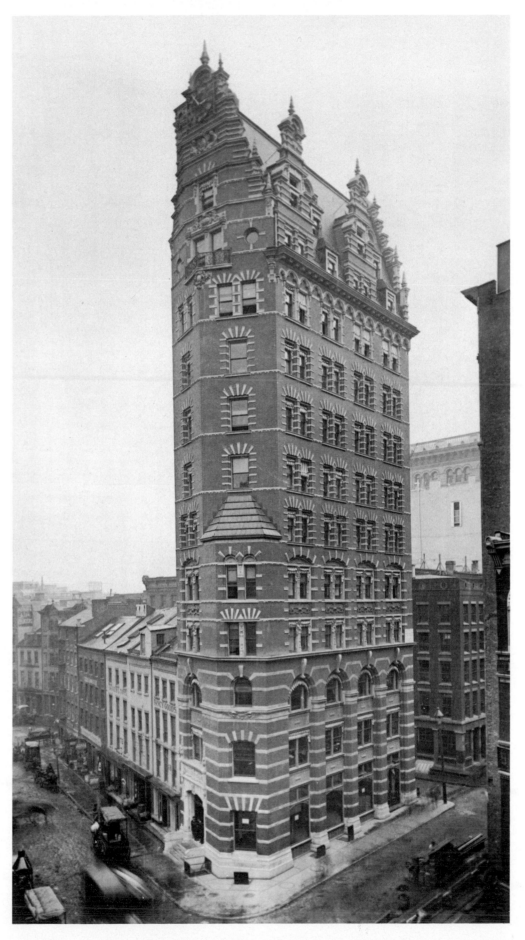

[PLATE 31]
Maiden Lane at William and Liberty Streets, c. 1897

This twelve-story building on the south side of Maiden Lane at William and Liberty Streets has been identified by the architect Andrew Alpern as the John Wolfe Building, designed in 1895 by Henry Janeway Hardenbergh. Hardenbergh was also the designer of the Dakota apartment building at 72nd Street and Central Park West (see No. 164) and the second Plaza Hotel.

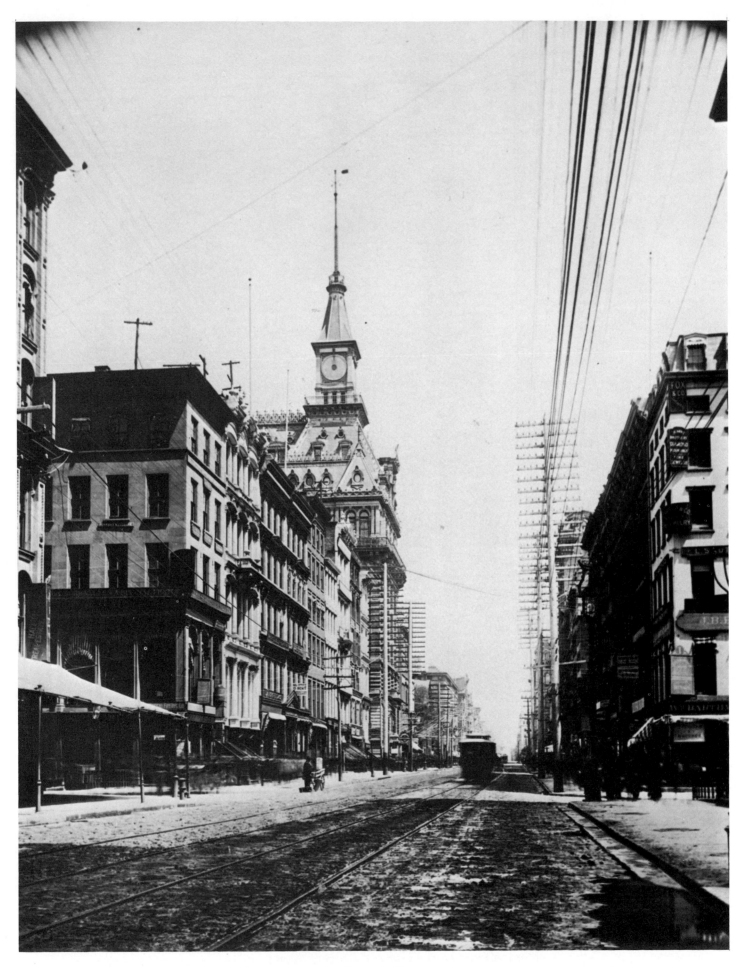

[PLATE 32]
Lower Broadway, c. 1890

Looking up Broadway from Cortlandt Street, the parade of telegraph poles and wires leads past George B. Post's turreted building for the Western Union Telegraph Company at Broadway and Dey.

[PLATE 33]
Nassau Street, c. 1890

The Bennett Building, in Victorian style, rises just right of center. The view is south on Nassau Street at its bend at Ann Street. The *Evening Post* building (far right) helps to locate and identify this view of lower Manhattan.

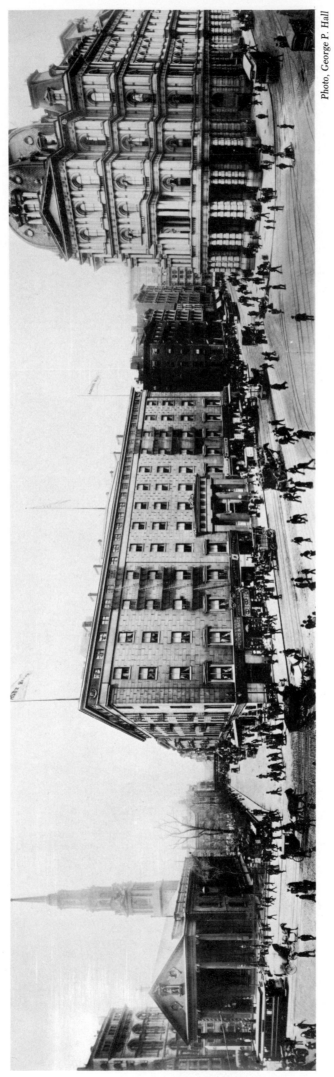

[PLATE 34]
Broadway, c. 1890

In this sweeping late nineteenth-century scene along lower Broadway is a review of more than a century of architecture. At the left is St. Paul's Chapel and churchyard of 1766 (the oldest Manhattan church extant), Isaiah Rogers' Astor House of 1834–1837, and the high Victorian style of the Old Post Office of 1875. Looking straight down Vesey Street one can barely see a patch of the Hudson River at the end. The photographer was from the firm of George P. Hall and Son. The photo is probably a composite of two or more shots carefully registered and rephotographed. The nineteenth-century photographer was skilled in retouching his prints to strengthen detail and architectural elements. This kind of work is visible in the retouching at the entrance and second floor window cornices of the Astor House and in the street directly in front of the old Post Office.

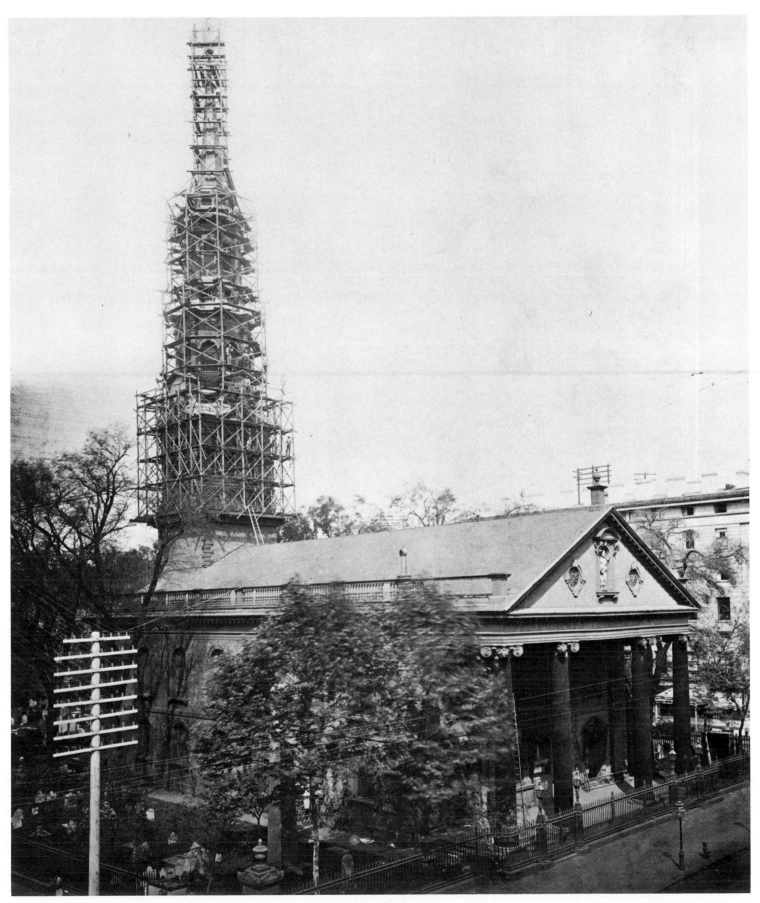

Photo, Joshua H. Beal

[PLATE 35]
St. Paul's Chapel, 1881

In the summer of 1881, J. H. Beal came from his nearby photographic studio at 16 Beekman Street to record the repairs made to James Crommelin Lawrence's steeple, which had been added to St. Paul's Chapel in 1796, thirty years after the chapel was built. The mourning cloths that drape the chapel door and are wrapped around its columns are probably for President Garfield, assassinated on July 2nd of that year.

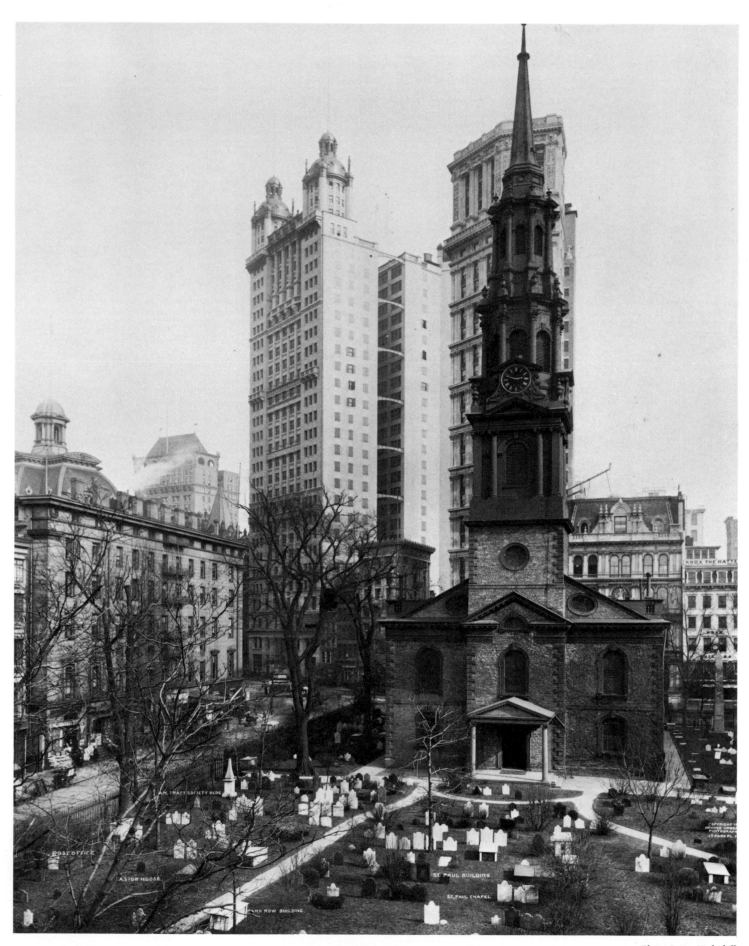

[PLATE 36]
St. Paul's Chapel, 1899

In 1899 Irving Underhill set up his camera on Church Street and recorded this nacreous afternoon view of St. Paul's Chapel and churchyard. Out on Broadway is the store of Knox the Hatter at the far right and St. Paul's Building behind the chapel steeple. Robert H. Robertson's brand new Park Row Building, completed this year, appears left of the church.

[PLATE 37]
Lower Broadway, c. 1895

When it was established in the 1880s, the National Park Bank was the largest in the United States. Its 125 employees worked on the main floor of the elegant building shown here. The bank, on the west side of Broadway across from St. Paul's Chapel, was cozily flanked by a wholesale men's clothier and Knox the Hatter. Park Row and the old Post Office are barely visible at left center.

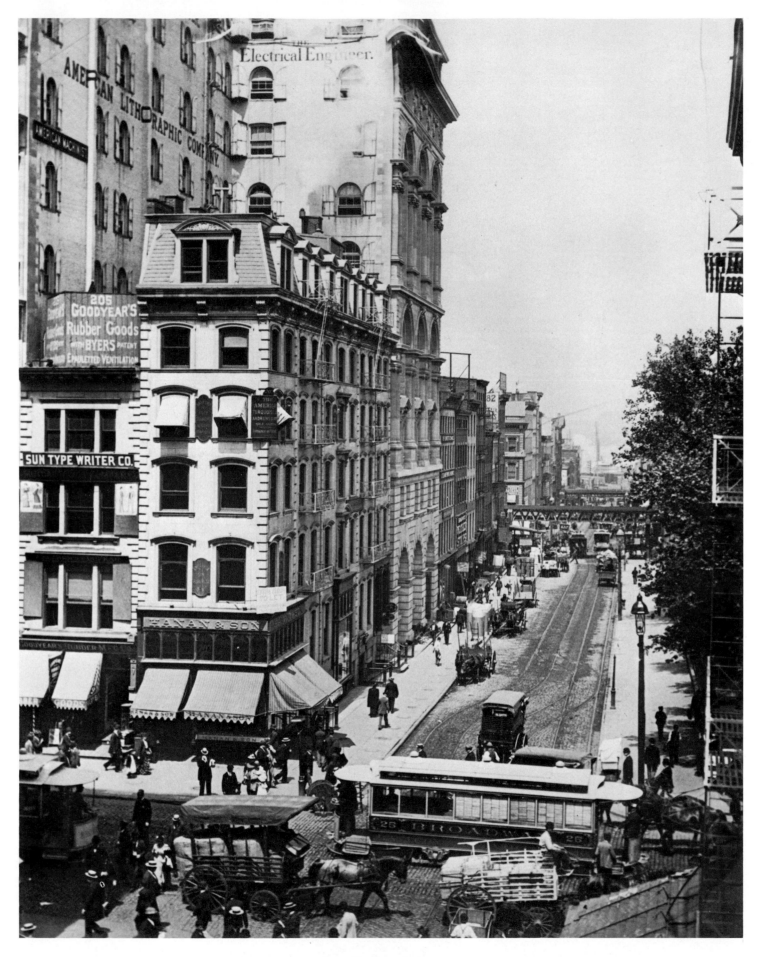

[PLATE 38]
Broadway Traffic, c. 1892

This view from the northeast corner of Broadway at Fulton Street was taken about 1892 according to city directory listings of the firms on Broadway. Trolleys, wagons, and people hasten across Broadway; Fulton Street stretches to the Hudson and is crossed by two elevated lines. The green trees at the far right are in the churchyard of St. Paul's Chapel.

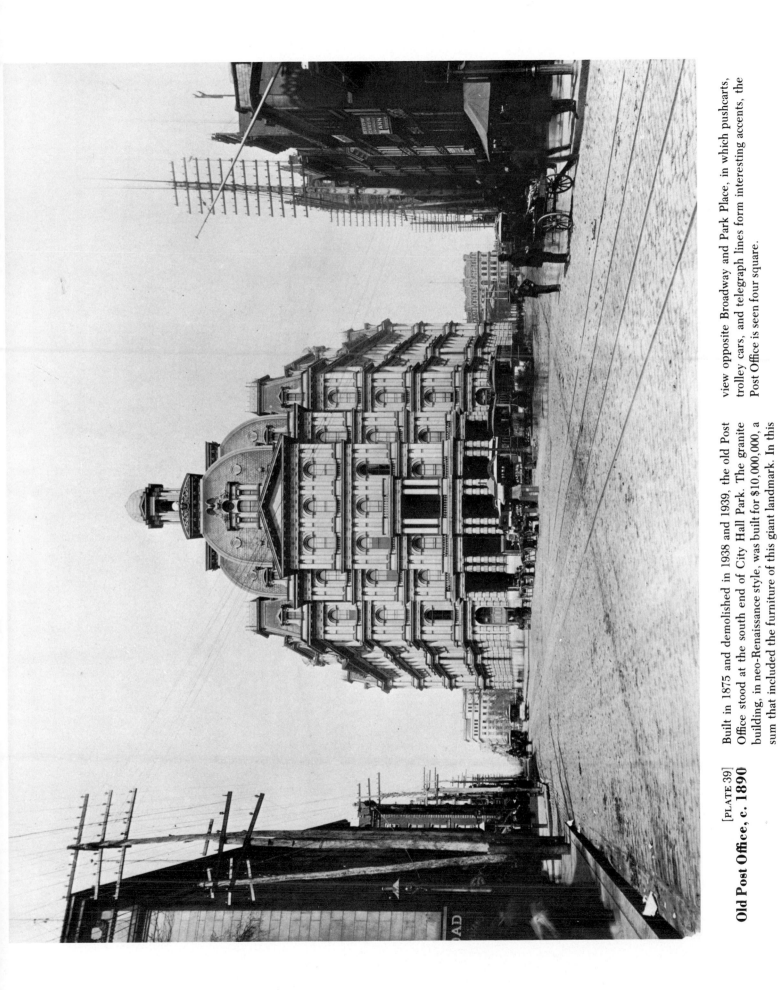

[PLATE 39]
Old Post Office, c. 1890

Built in 1875 and demolished in 1938 and 1939, the old Post Office stood at the south end of City Hall Park. The granite building, in neo-Renaissance style, was built for $10,000,000, a sum that included the furniture of this giant landmark. In this view opposite Broadway and Park Place, in which pushcarts, trolley cars, and telegraph lines form interesting accents, the Post Office is seen four square.

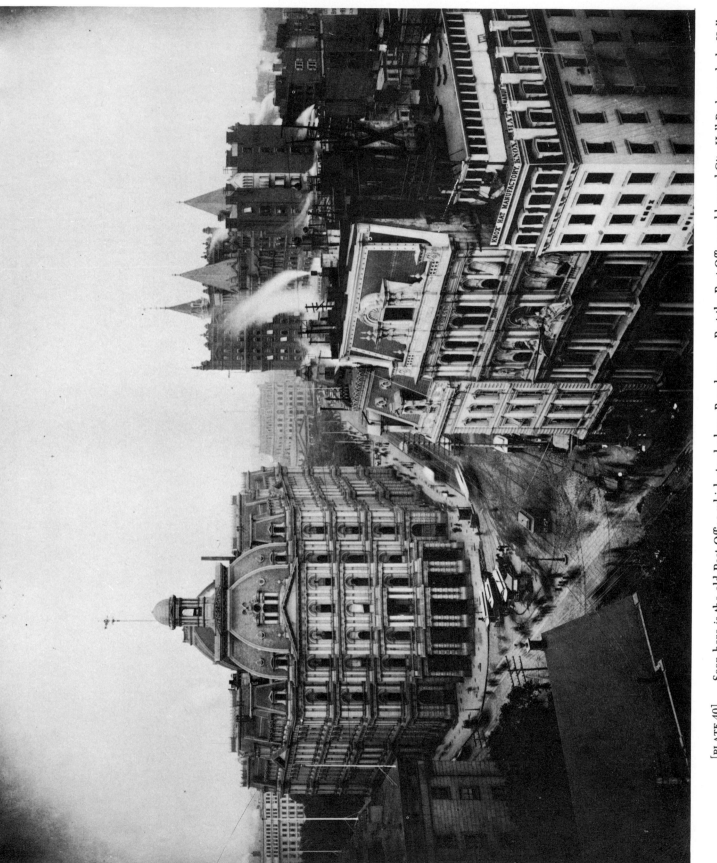

Old Post Office, c. 1890

[PLATE 40]

Seen here is the old Post Office which stood where Broadway (left) meets Park Row (right). At the lower left corner is the roof of St. Paul's Chapel. Across Broadway are the *New York Herald* Building, Park Bank, and the Knox Hat Manufactory.

Past the Post Office and beyond City Hall Park stands the Hall of Records with its classical pediment barely visible above the trees.

[PLATE 41]
Park Row and Center Street, 1876

The old Hall of Records (left center), which was the oldest civic building in New York, dated back to the late Colonial period. When the British held Revolutionary New York, 100 years before the date of this photograph, many Loyalists were imprisoned there. In contrast to its rigid classicism is the Victorian splendor of the *Staats Zeitung* Building on Printing House Square (right center), on the third-floor portico of which stand the figures of Gutenberg and Franklin by Ernst Plassman. This building is a reminder of the great importance of the foreign-language press in the life of the city at that time.

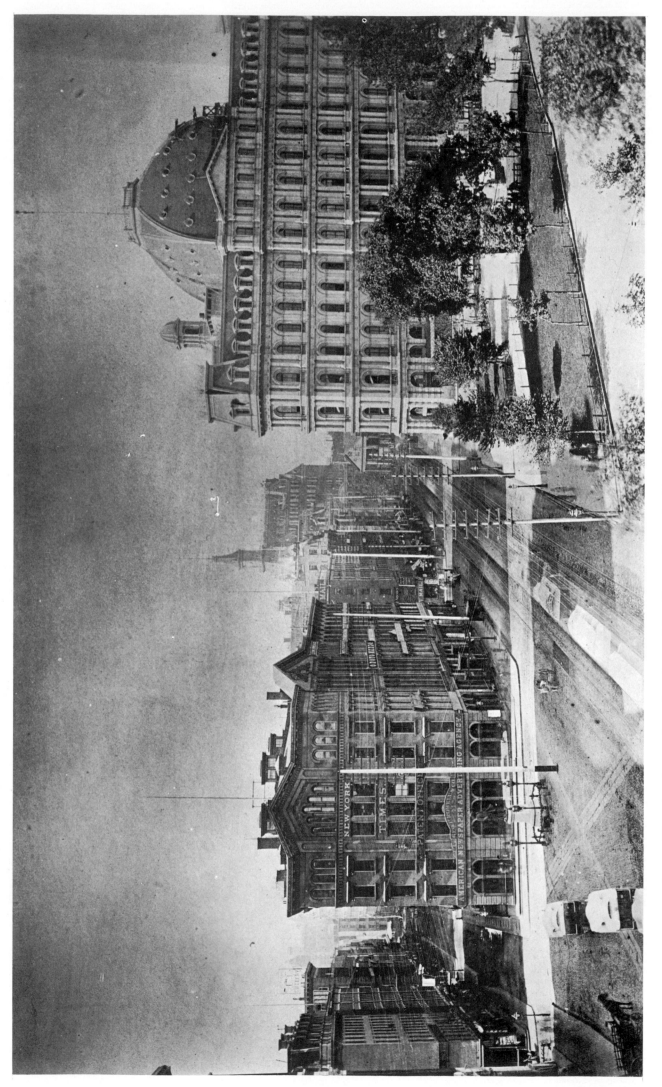

[PLATE 42]

Park Row, c. 1880

A wide view shows the relation of the old Post Office to the old *Times* Building (right and left center respectively). Ghosts of trolleys move down Park Row (at center). The *Times* Building on Spruce Street faced on Printing House Square. This photograph and several others in this book bear the monogram S. A. or A. S.—initials which may identify one of three photographers active in this period: Safford or Seth Adams at 260 The Bowery, or Alfred Stoffregen at 613 Third Avenue.

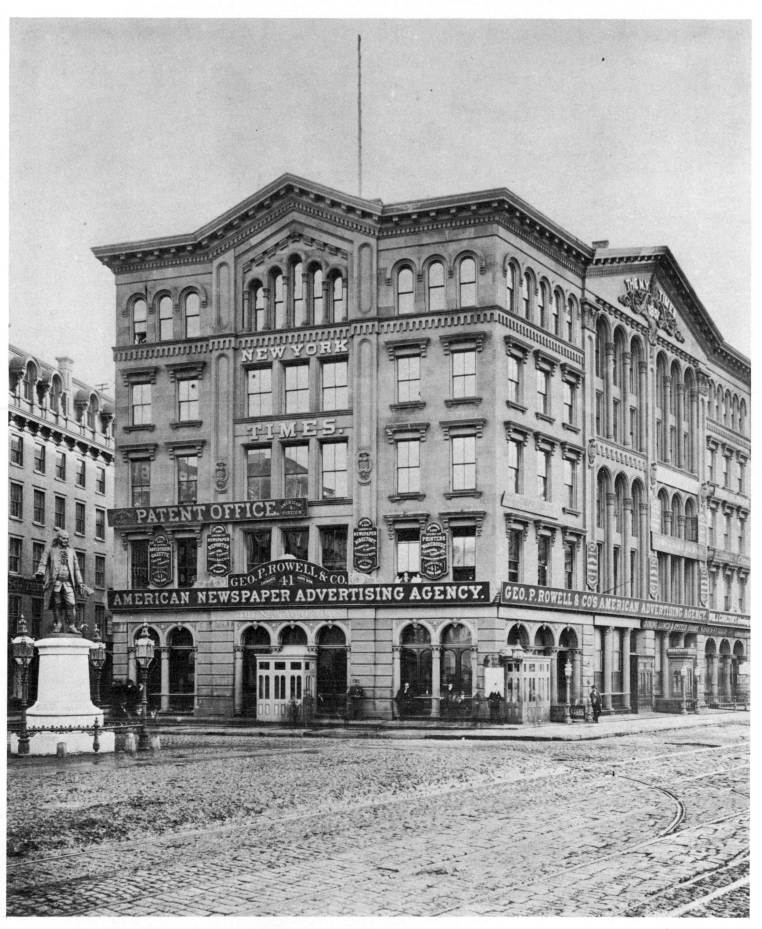

Photo, Charles K. Bill

[PLATE 43]
Times Building, c. 1874

Before the old *Times* Building on Printing House Square stands the bronze figure of Benjamin Franklin by Ernst Plassman. The statue was dedicated on January 17, 1872, and it is likely that the photograph was taken soon after. The building seen here occupied the site from 1857 to 1889, when a new building appeared there—"accomplished as by enchantment" according to *King's Handbook*. The *New York Business Directory* of 1873–1874 is the first to list Charles K. Bill at 1164 Broadway, the address stamped on the original print in the Society's collection.

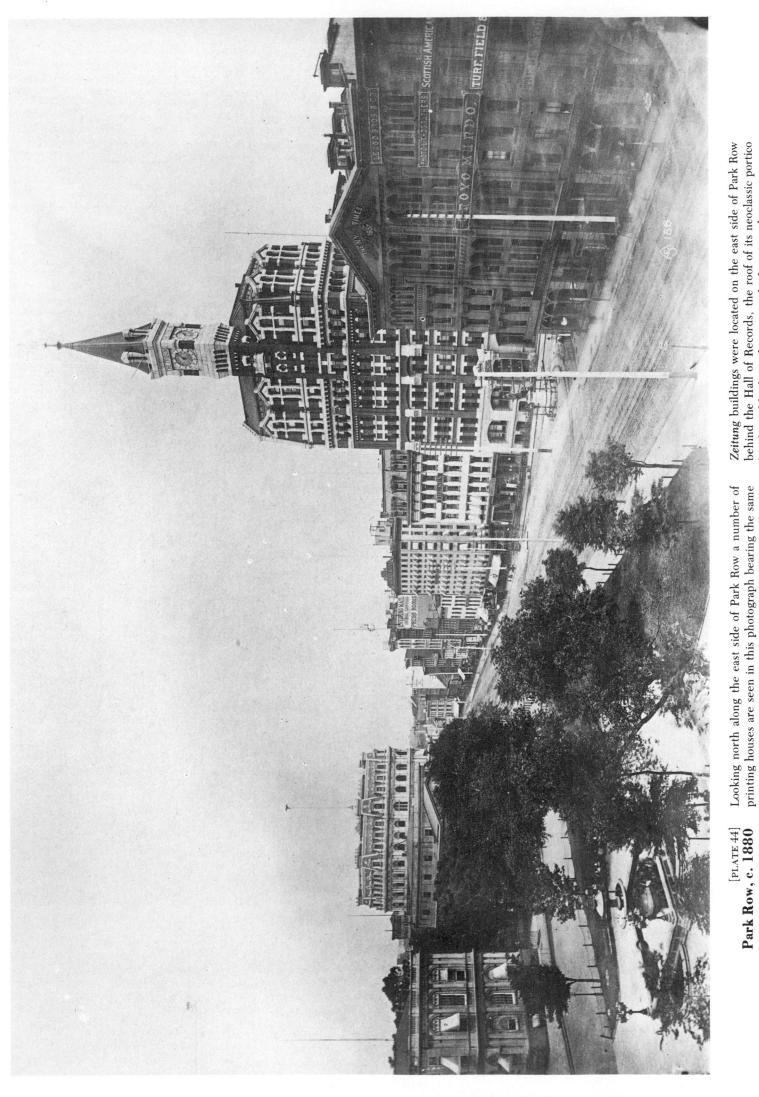

[PLATE 44]
Park Row, c. 1880

Looking north along the east side of Park Row a number of printing houses are seen in this photograph bearing the same monogram as No. 42. The *Times*, *Tribune*, *Sun*, and *Staats Zeitung* buildings were located on the east side of Park Row behind the Hall of Records, the roof of its neoclassic portico barely visible above the trees in the foreground.

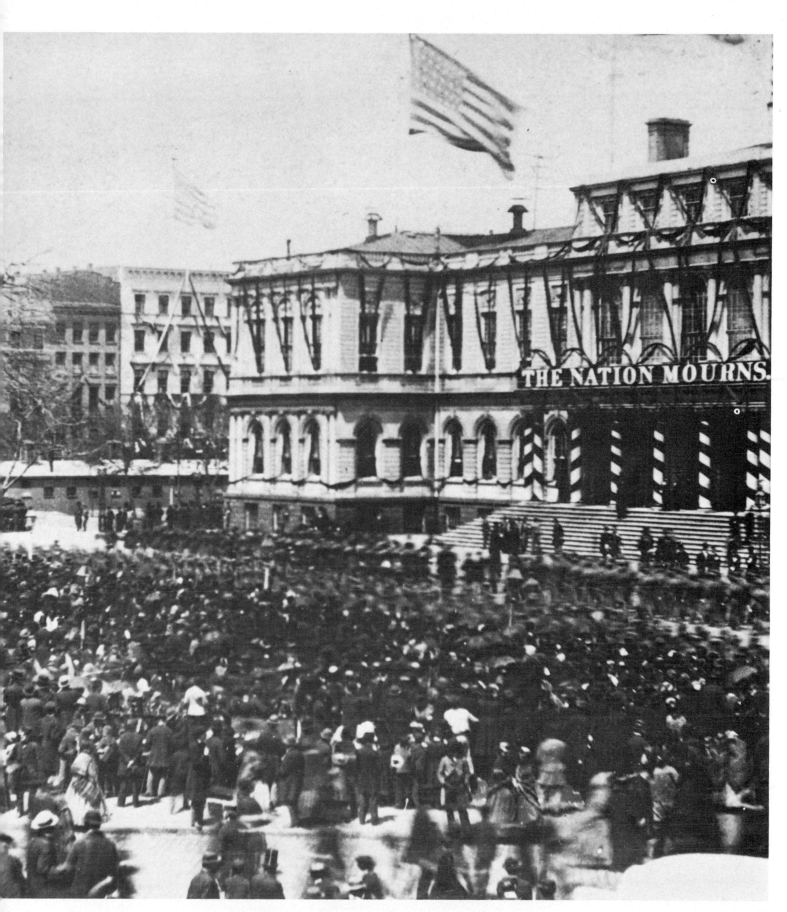

Stereograph

[PLATE 45]

Lincoln's Funeral Cortege at City Hall, 1865

In this rare early stereograph taken in April, 1865, City Hall appears draped in black and with a legend over its entrance honoring the memory of Abraham Lincoln. It is in interesting contrast to the mourning decorations used when Grant lay in state there (No. 46).

[PLATE 46]
Grant's Funeral Cortege at City Hall, 1885

Time stood still early on the morning of August 8, 1885 as the funeral procession for Grant formed at City Hall. Mangin and McComb's graceful architecture, which can still be admired today, is here almost obscured beneath black Victorian swags, pleats, and bunting in mourning for the dead president.

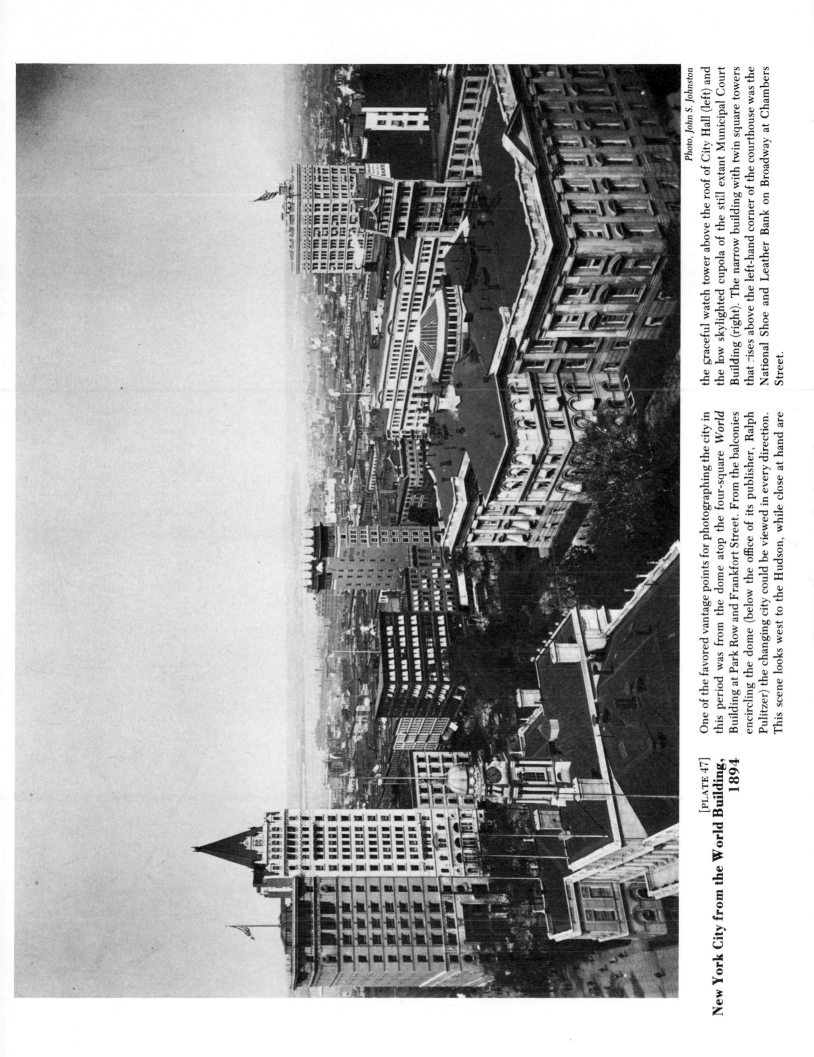

Photo, John S. Johnston

[PLATE 47]

New York City from the World Building, 1894

One of the favored vantage points for photographing the city in this period was from the dome atop the four-square *World* Building at Park Row and Frankfort Street. From the balconies encircling the dome (below the office of its publisher, Ralph Pulitzer) the changing city could be viewed in every direction. This scene looks west to the Hudson, while close at hand are the graceful watch tower above the roof of City Hall (left) and the low skylighted cupola of the still extant Municipal Court Building (right). The narrow building with twin square towers that rises above the left-hand corner of the courthouse was the National Shoe and Leather Bank on Broadway at Chambers Street.

51

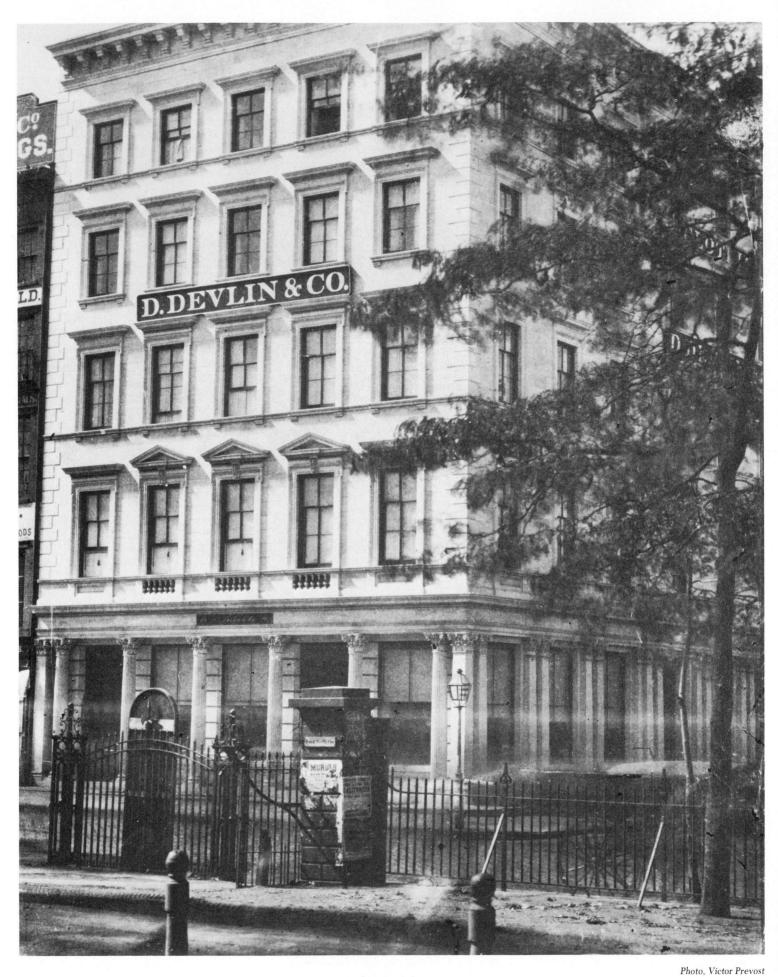

Photo, Victor Prevost

[PLATE 48]
Devlin's Tailoring Establishment, 1854

Facing the gates of City Hall Park at Broadway and Warren is this building which housed Devlin's Tailoring Establishment.

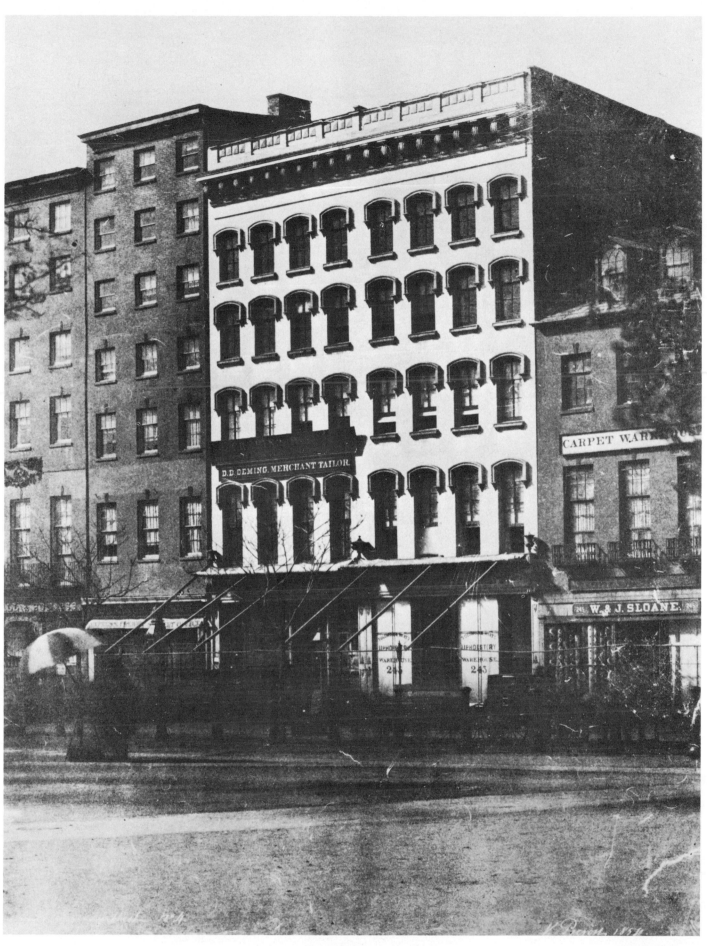

Photo, Victor Prevost

[PLATE 49]
Bixby's Hotel, 1854

Victor Prevost's view of the west side of Broadway (between Park Place and Murray Street) was taken in 1854. The entrance to Bixby's Hotel was located next to Solomon & Hart's Upholstery Warehouse at 243 Broadway. At 245 was the early store of W. & J. Sloane.

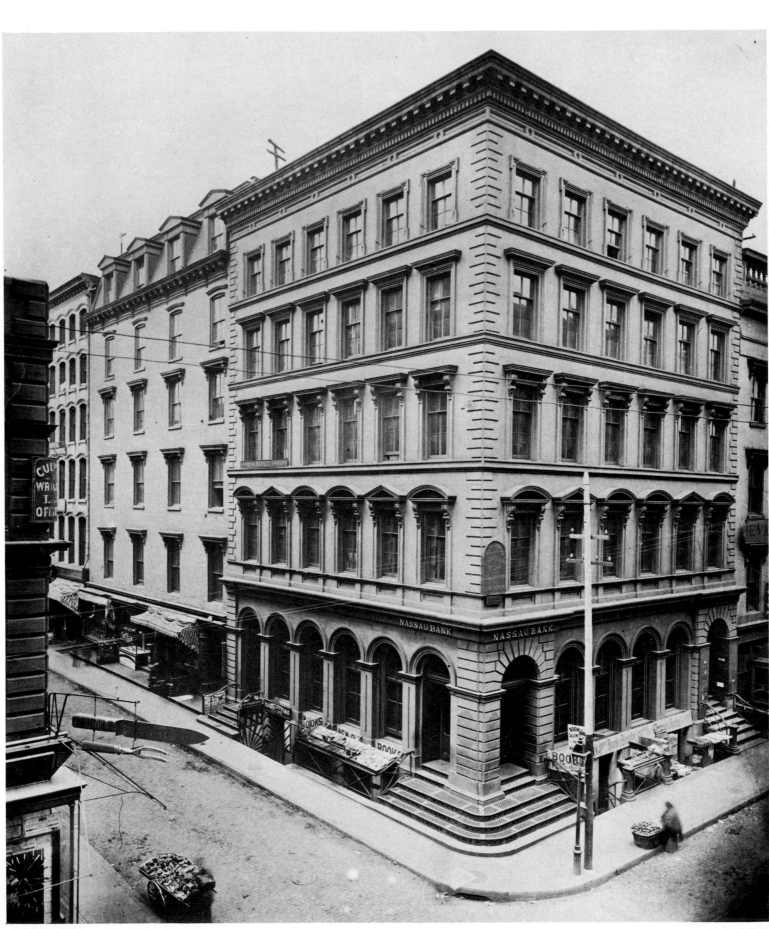

Photo, Joshua H. Beal

[PLATE 50]
Nassau Bank, c. 1890

The trade sign of knife and fork is on a cutlery store located in the neighboring Vanderbilt Building. The handsome Temple Court Building housing the Nassau Bank on its ground floor at 139 Nassau Street rises in splendor above surrounding street sales of books, bananas, and apples.

54

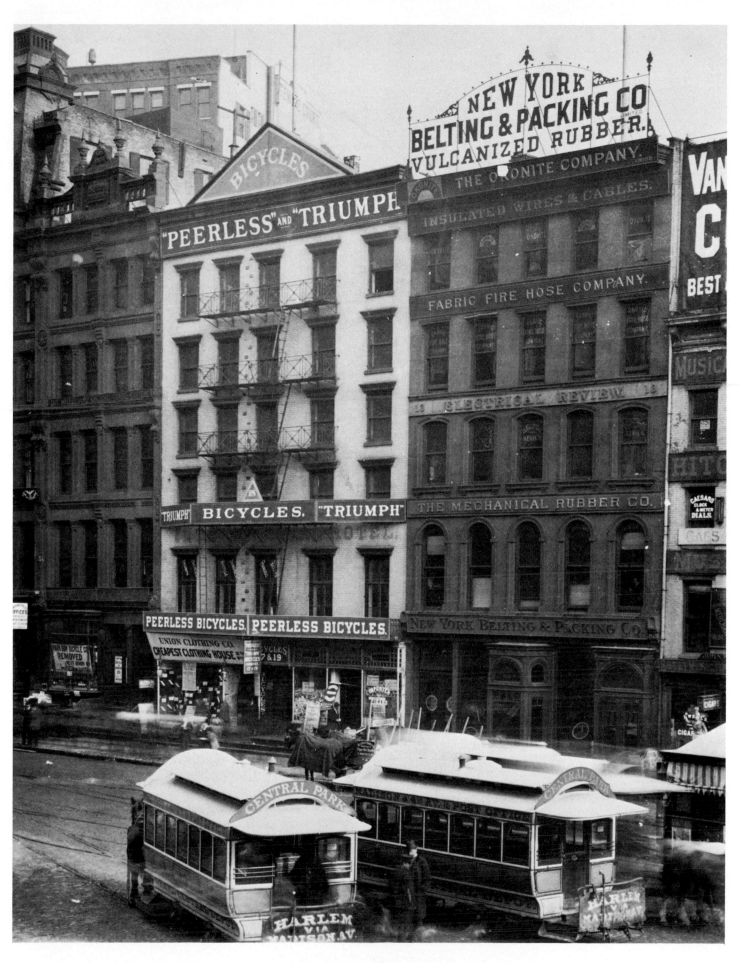

[PLATE 51]
Park Row, c. 1896

A sale of 500,000 cigars is advertised by the importer on the ground floor of the Peerless and Triumph Bicycle building; a wooden Indian graces the front of another cigar store at the far right. Horse-drawn trolleys move along Park Row in the block just opposite the old Post Office south of City Hall.

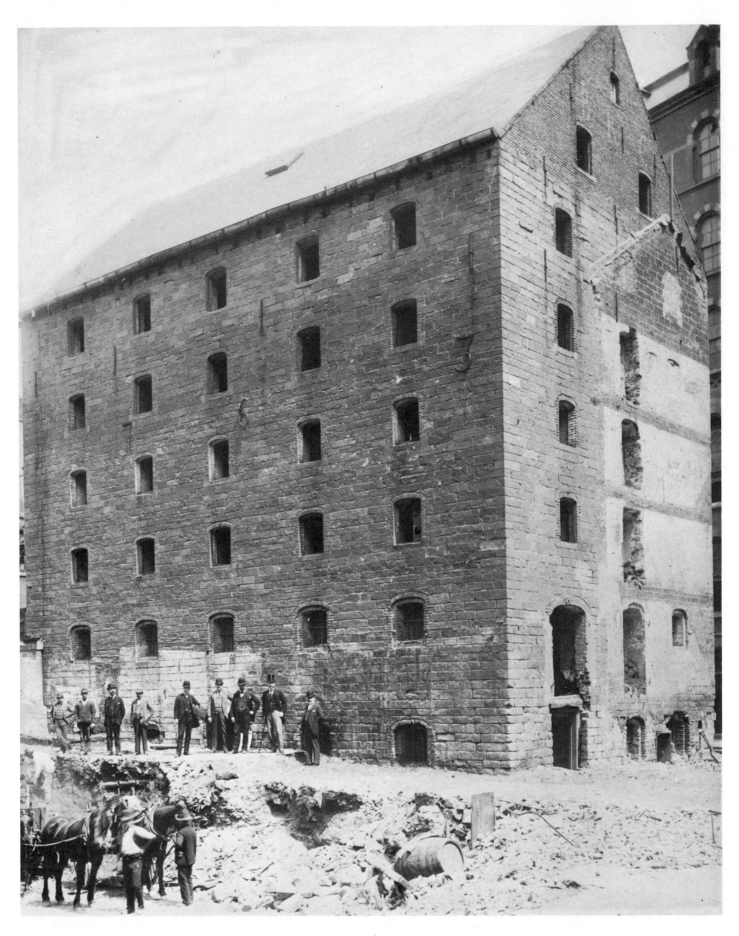

[PLATE 52]
Rhinelander Sugar House, c. 1892

This pre-Revolutionary warehouse, constructed in 1763, stood as a tall landmark for 129 years at Rose and Duane Streets. Why it came to be called a sugar house is uncertain—either raw sugar or molasses may have been stored here. During the Revolution the sugar house became a British prison when New York was headquarters for the British army. The group standing in the sun at the side of the sugar house includes William Rhinelander Stewart (top hat and cane), grandson of the building's first owner.

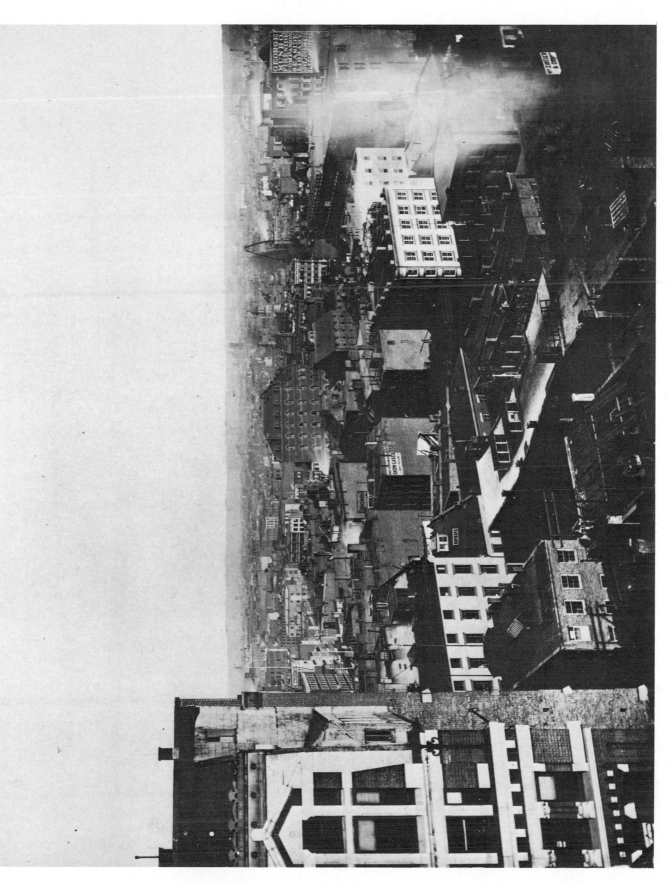

[PLATE 53]
Lower Manhattan, c. 1890

This panoramic view into the lower city was probably taken from the newly constructed Brooklyn Bridge looking northwest to William and Duane Streets. The Rhinelander Sugar House (see No. 52) is visible just right of center. The building immediately in back and to the left of it (with semicircular ornaments over the windows) is the Brace Memorial Newsboys' House, founded in 1853, which provided inexpensive room and board for homeless boys. On the left is Crook's Hotel on Park Row. The photograph was taken after 1883, when the bridge was dedicated, and before 1892, when the sugar house was razed.

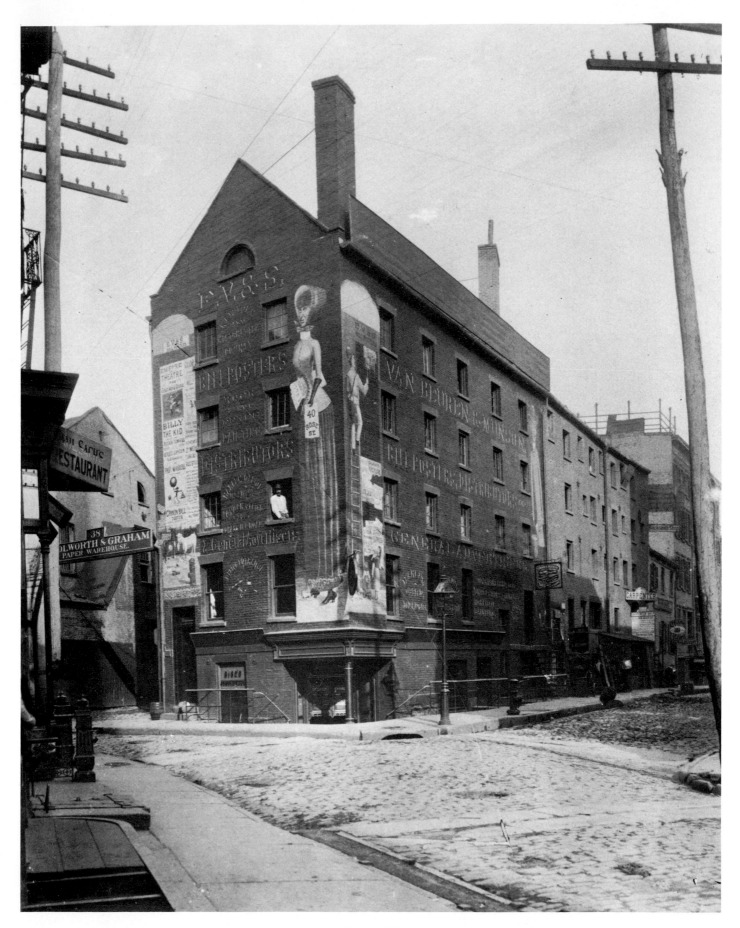

[PLATE 54]
Rose and Duane Streets, c. 1890

Fanciful signs decorate the facade of the handbill and poster shop at 40 Rose Street (corner of Duane) owned by Alfred Van Beuren and Henry Munson and his son. On the left, goats nibble away at a sign for "Billy the Kid" by "Rotan Tomatus." One of the sign painters is seen at the third-story Rose Street window. The alley at the left leads to the Rhinelander Sugar House in the center of the block—at this time in use as a warehouse for Woolworth and Graham, paper manufacturers and dealers (see Nos. 52 and 53).

III

THE WEST SIDE

Locations West of Trinity Place and North to Duane Street

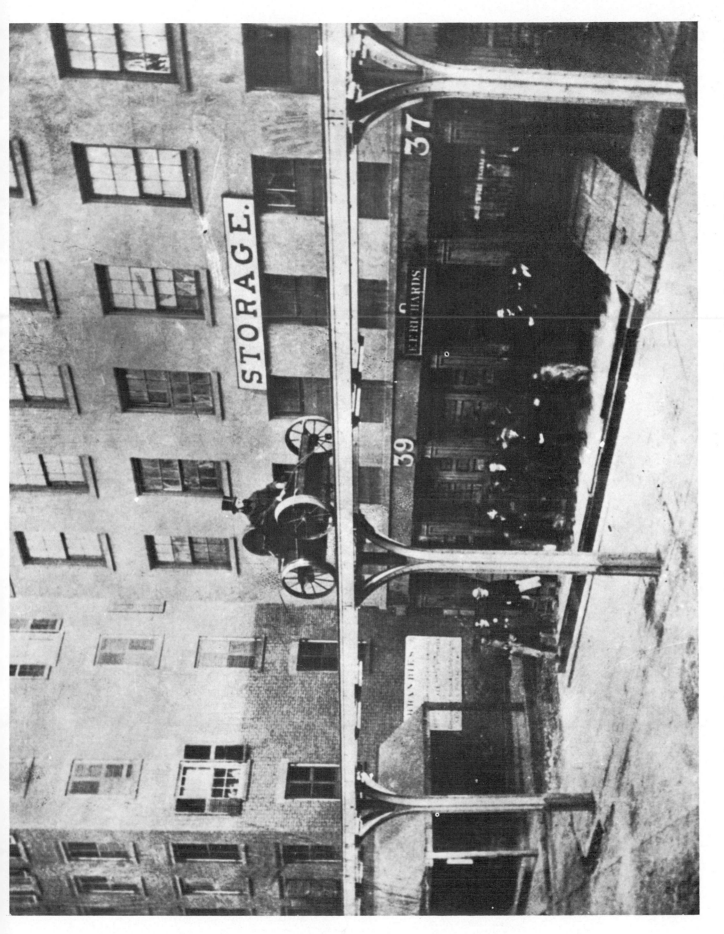

[PLATE 55]
Colonel Harvey Testing a Cable Car,
c. 1867

The inventor Charles T. Harvey is seen operating one of his experimental car trucks on a section of the elevated railroad on Greenwich Street as it crosses Morris Street. An interested group of observers watches from the safety of the ground in front of Edwin F. Richard's storage plant on Greenwich Street. One of the striking features of nineteenth-century New York life was the general interest in experimental means of transportation.

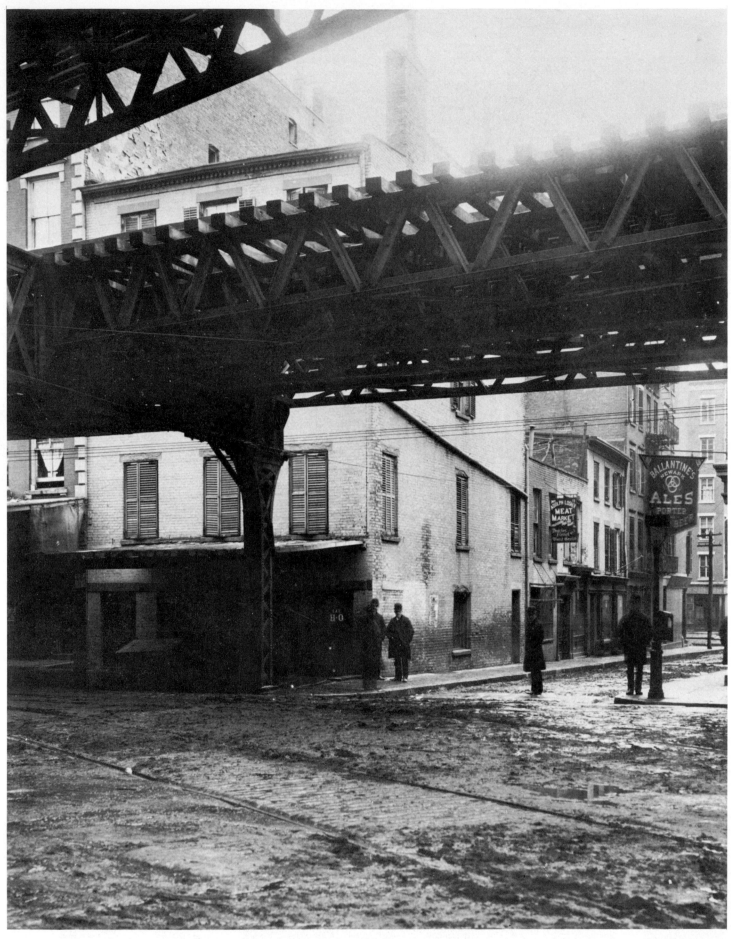

[PLATE 56]
Greenwich and Morris Streets, 1891

From the dark canyon under the el at Greenwich Street is seen the short block of Morris Street with Washington Street (parallel to Greenwich) in the distance. A solemn bowler-hatted group has emerged into the sunlight to be photographed near the puddles of a mid-winter thaw.

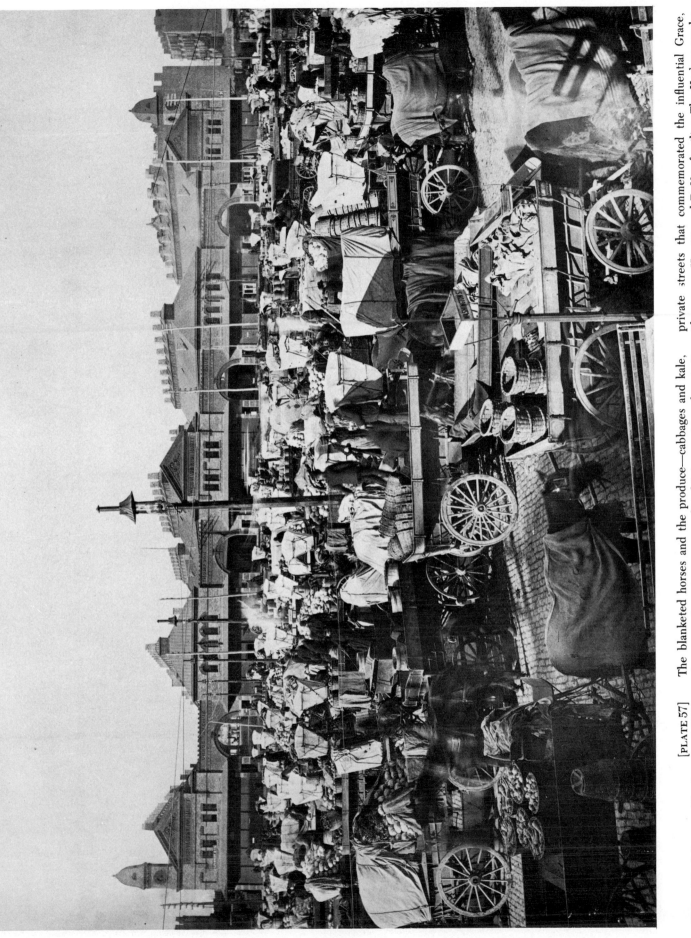

[PLATE 57]
West Washington Market, c. 1885

The blanketed horses and the produce—cabbages and kale, parsnips and turnips—suggest that this is an autumnal portrait of Washington Market west of West Street and north of Pier 19. The handsome market building that lay between the outdoor marketplace and the Hudson River incorporated private streets that commemorated the influential Grace, Thompson, Hewitt, and DeVoe families. The Hudson can be seen beyond the southernmost arch that identifies Grace Avenue.

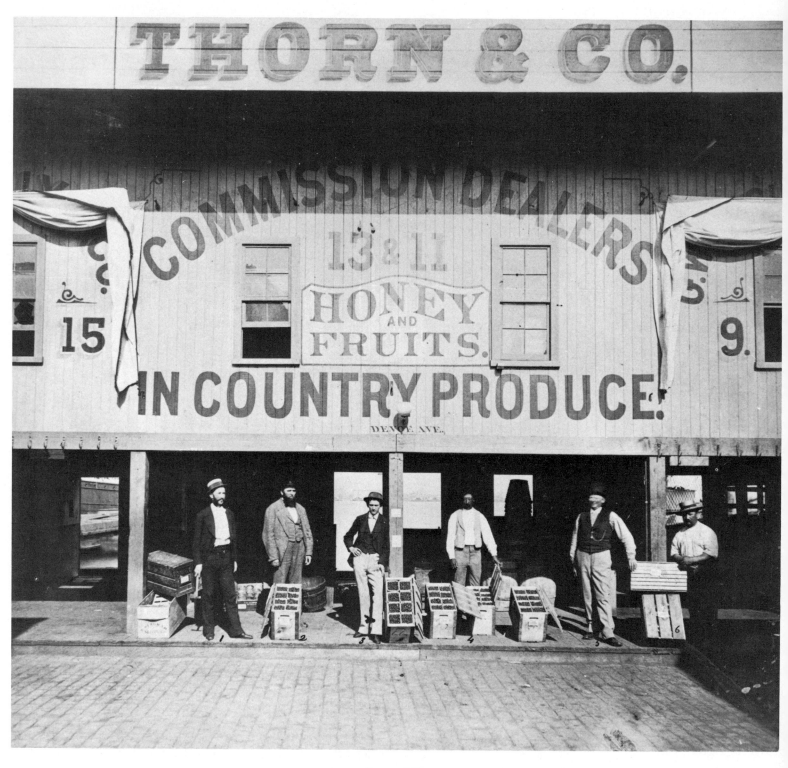

[PLATE 58]
Thorn & Co., 1874

Within the West Washington Market complex, the produce store of Richard H. Thorn was located at Nos. 11–13 DeVoe Avenue, the northernmost street in the preceding photograph. Here, Thorn stands at the left, next to a bearded man identified as Theodore R. Hanford, who may be a relation (a Hanford Thorn appears in the 1874 New York directory). The youngest of the other men proudly displaying crates of strawberries is Thorn's son.

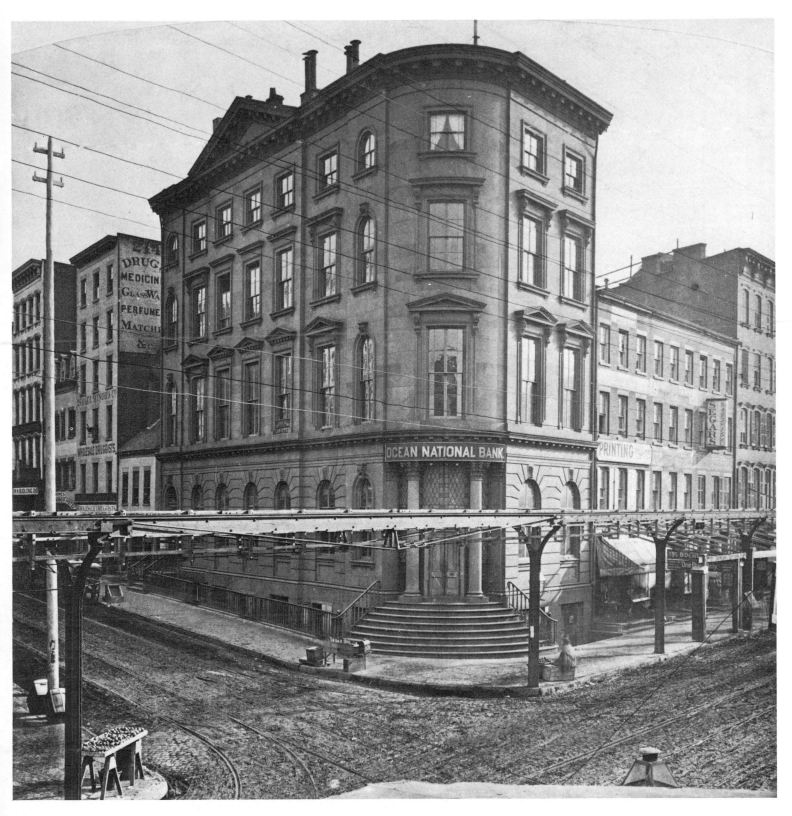

[PLATE 59]
First Elevated Railroad, 1869

The first cable-operated elevated railroad in New York City extended from Battery Place to 30th Street and Ninth Avenue. It had two stations: Dey and Greenwich Streets, and 29th Street at Ninth Avenue. The tracks seen here pass beside the Ocean National Bank on Greenwich Street at Fulton.

The furnishings along the street are fascinating: a mortar and pestle sign hangs at Israel Minor's wholesale drug company on Fulton (left center) and the lower half of a cigar store figure appears at the doorway to the wholesale cigar store on Greenwich (to the right).

I V

THE WEST SIDE

from Broadway West to the Hudson River and North

from Duane Street to Barrow and Bleecker Streets

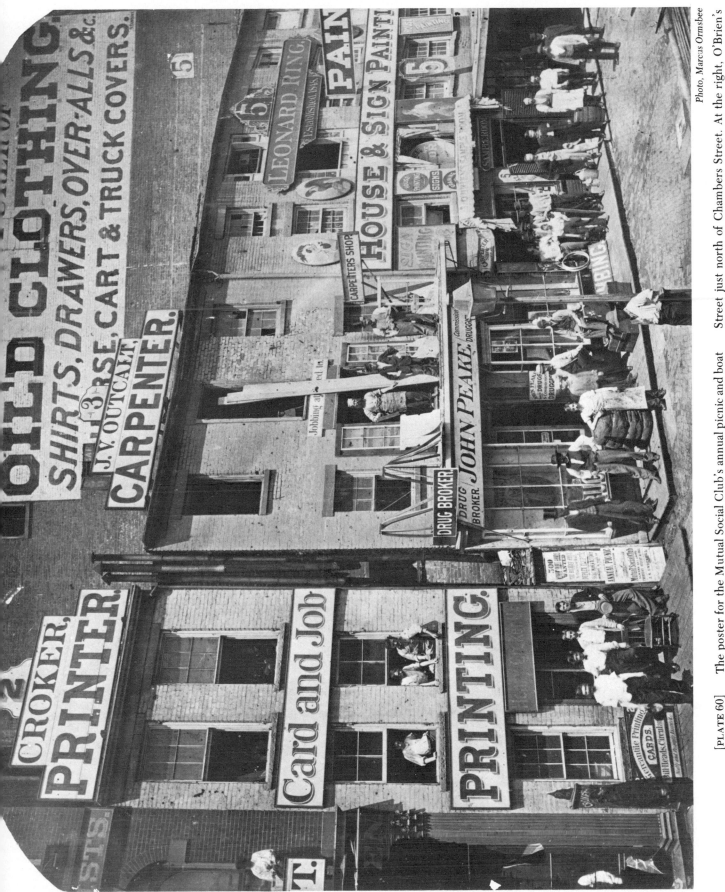

[PLATE 60]
Lower Hudson Street, c. 1865

The poster for the Mutual Social Club's annual picnic and boat excursion to Newark Bay Grove on Thursday, August 3, 1865 sets the date for this photograph of the printing, carpentry, painting, and oilskin merchants on the west side of Hudson Street just north of Chambers Street. At the right, O'Brien's Sample Room sets the trend for modern saloons, for behind the swinging door a sign hints at the samples within: ales, liquors, and segars.

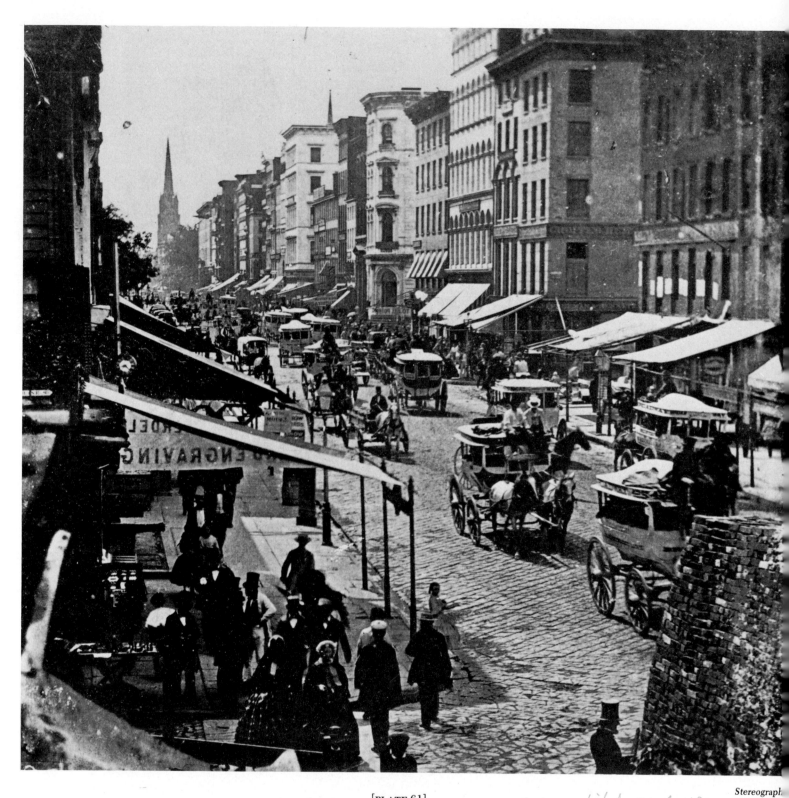

Stereograph

[PLATE 61]
Broadway and Duane Street, c. 1870 *? more likely early 1860s*

Looking south to St. Paul's Chapel in the far distance is this view along stone-paved Broadway from Duane Street. The location of Irving House, at the corner of Chambers Street, is marked by the steeple of St. Paul's Catholic Church that appears directly above the fashionable hotel. New York's small public stagecoaches crowd the busy street.

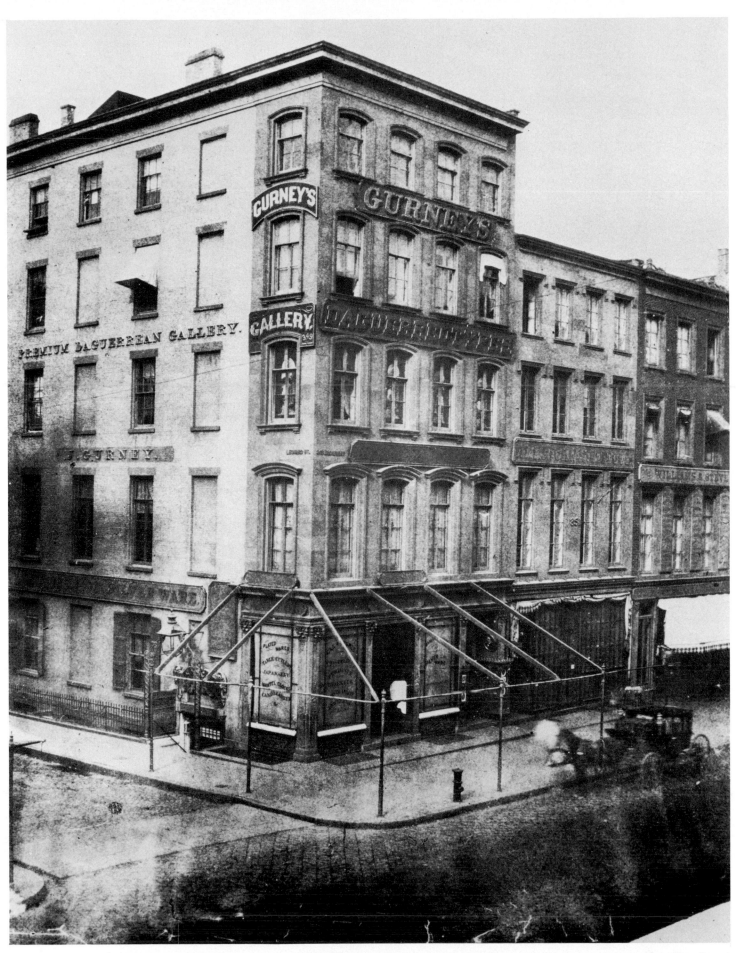

Photo, Victor Prevost

[PLATE 62]
Broadway at Leonard Street, c. 1855

An early view of New York shows Jeremiah Gurney's Premium Daguerrean Gallery occupying the good-sized five-story building at 349 Broadway. The small building next door was the home of the American Institute of the City of New York, sponsor of the annual fair to which many early Daguerrean artists and photographers sent samples of their work.

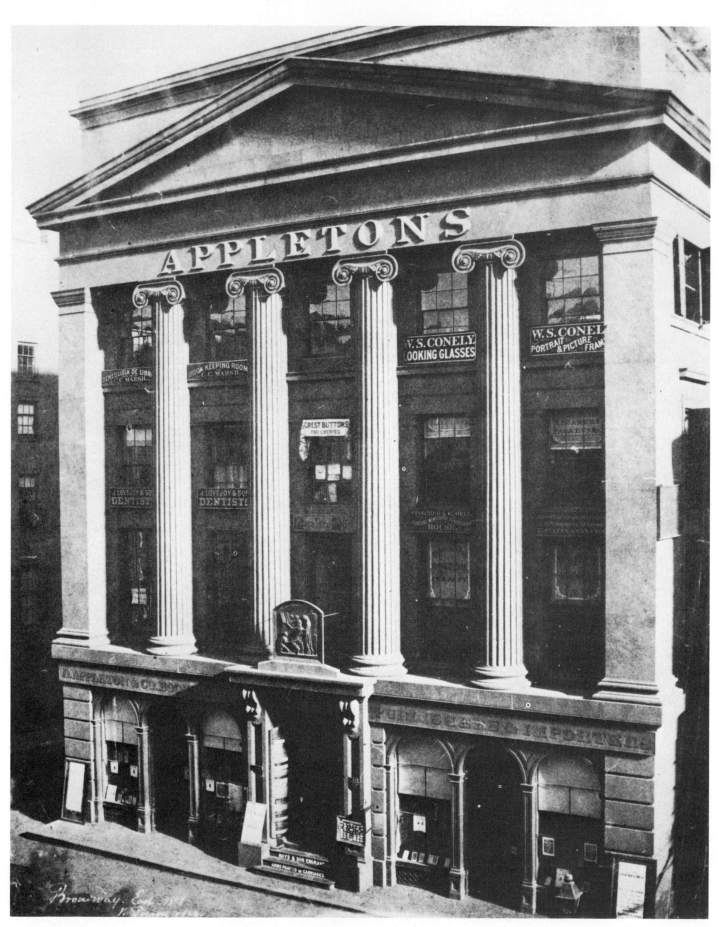

Photo, Victor Prevost

[PLATE 63]
Appletons, 1854

A convivial band of Appletons, relations of Daniel, the publisher who founded the company, continued on as publishers and book and print sellers in this graceful building at 346–348 Broadway that once housed the New-York Society Library. Daniel S., George S., John A., S. F., and William H. are all listed at this business address in the *New York City Directory* of 1854. Other offices were occupied by the accountant Christopher Marsh, by J. Lovejoy and his son, dentists, and by the gilder William S. Conely.

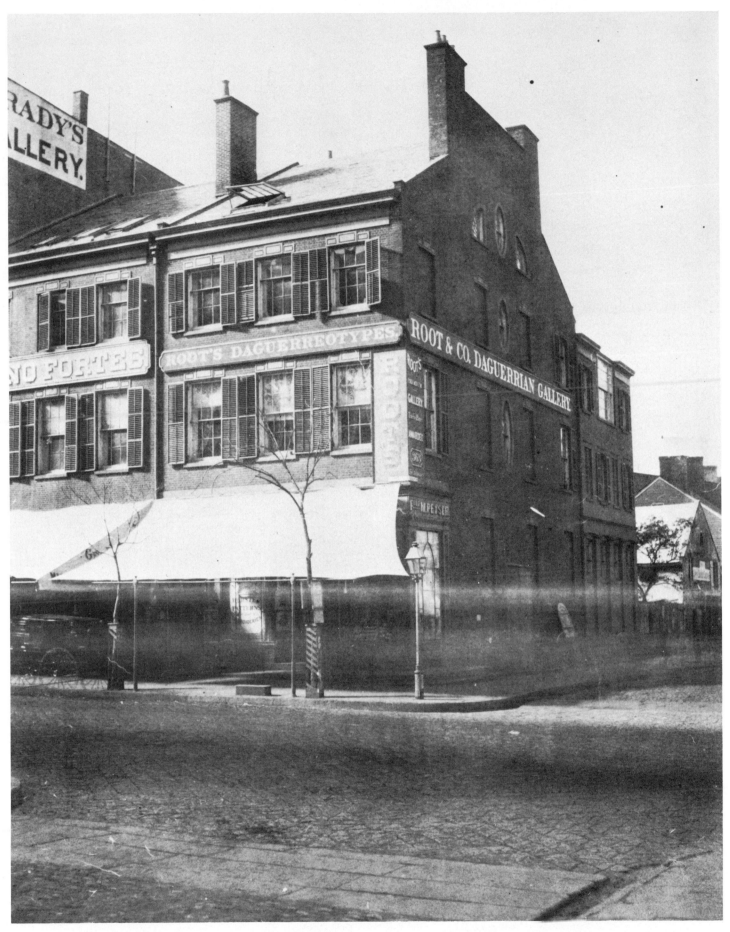

[PLATE 64]
Broadway at Franklin, c. 1855

On the west side of Broadway and in the same block as Gurney's Daguerrean Gallery and the American Institute (see No. 62) were Mathew Brady's gallery and Root's Daguerrian Gallery shown here. This early photo of the handsome twin townhouses at 363 and 361 Broadway (from the original wax paper negative by Prevost now in the collection of the Smithsonian Institution) records one of two coexistent spellings of the adjective derived from Daguerre's name.

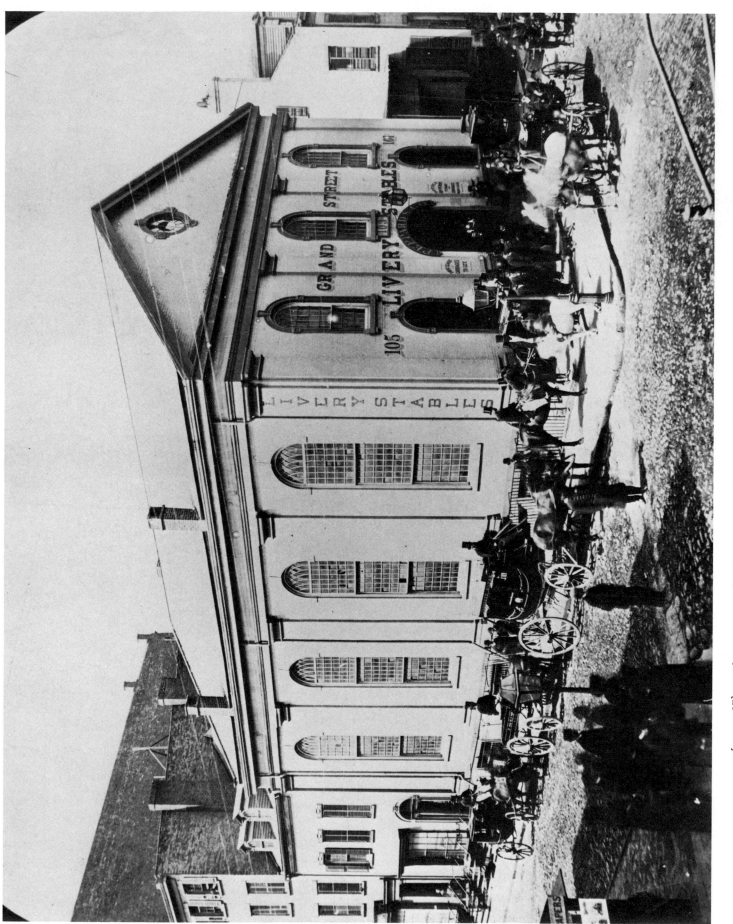

Grand Street Livery Stables, c. 1865 [PLATE 65]

This attractive building on Grand Street at the corner of Mercer began its existence in 1837 as the First Associated Presbyterian Church of Whitefield Nassau. In 1865 Michael Peppard's "first class carriages" entered the stable through the old church door.

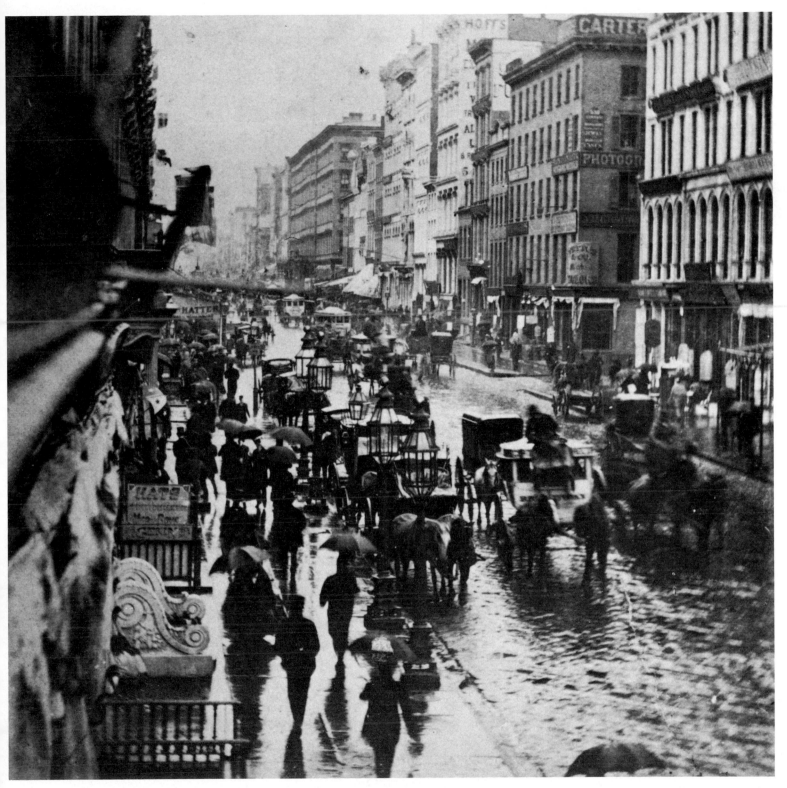

[PLATE 66]
Broadway at Spring Street, c. 1880

By the date of this photo, Robert Carter & Brothers, book dealers at the northeast corner of Broadway and Spring Street, had expanded their interests to include photography. Their building appears at the far right in this revealing rainy-day view of the busy street, with horse trolleys, walkers with umbrellas, and handsome street furniture.

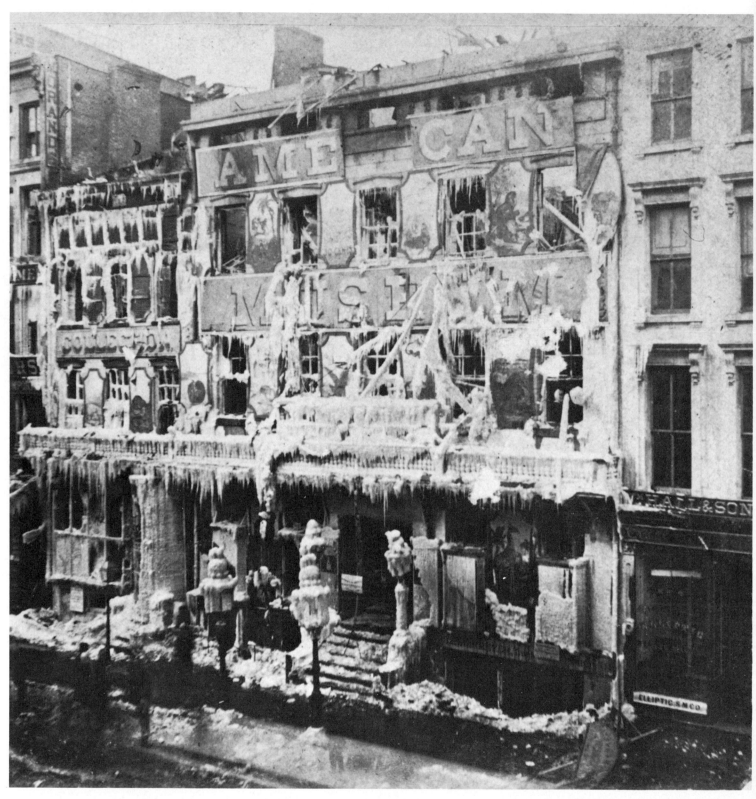

[PLATE 67]

Barnum's Museum after the Fire of 1868

On March 3, 1868 P. T. Barnum lost his second museum on this site at 539 Broadway opposite St. Paul's Chapel. The icicle-festooned building shown here replaced one that had burned down only three years before. In his museums Barnum gave space to live theatrical exhibitions as well as to cases of oddities.

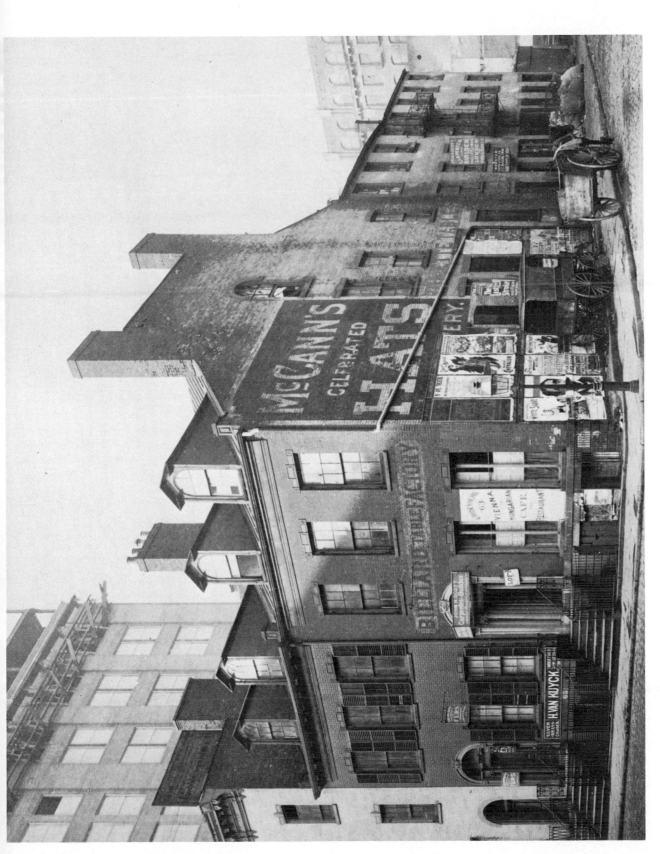

[PLATE 68]
Monroe House, 1896

Side by side at 63 and 65 Prince Street were the twin houses built by Samuel L. Gouverneur in 1825 and 1826. By marriage to his first cousin, Maria Hester Monroe, Gouverneur became the son-in-law as well as the nephew of James Monroe. Early in 1830 the ailing and impoverished ex-president came to live in the house at the corner of Prince and Marion Streets, where he died on the Fourth of July, 1831.

The additions made to the house on the Marion Street side

in the last half of the nineteenth century, as well as its vicissitudes in this same period, are visible in the fading sign for a billiard-table factory and its use as a builder's office and the home of G. Rosenberg's Vienna and Hungarian Café and Restaurant. The advertisement for the play *The Last Stroke* on the side wall becomes an ominous comment on the ultimate decline of this house in which a former president ended his days.

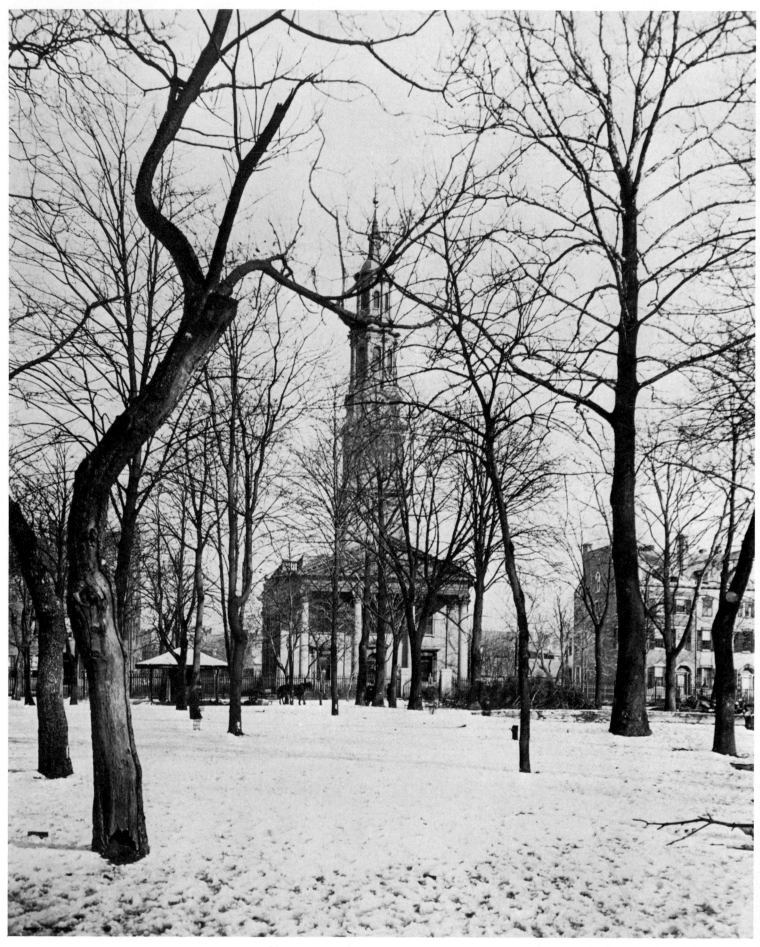

Photo, George G. Rockwood and Company

[PLATE 69]
St. John's Chapel, c. 1866

At the time of this photograph John McComb's St. John's Chapel, part of Trinity Parish, had stood on Varick Street at the east end of St. John's Park for some sixty years. This winter view was taken just before the park, laid out in 1803, was taken over as a railroad depot and the Episcopal chapel surrounded by factories and tenements.

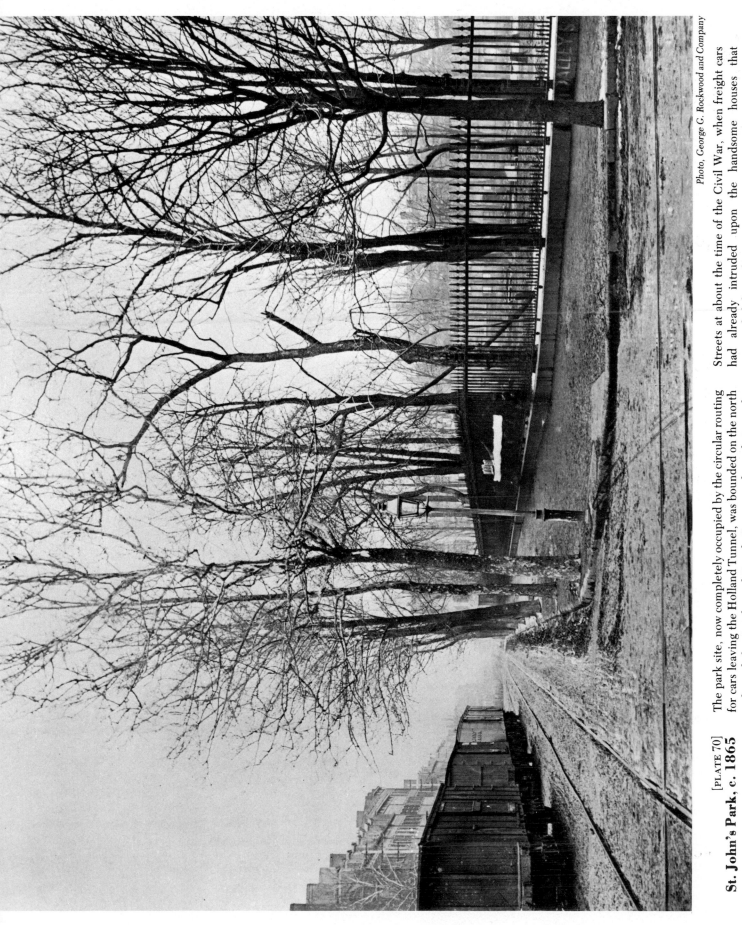

St. John's Park, c. 1865 [PLATE 70]

The park site, now completely occupied by the circular routing for cars leaving the Holland Tunnel, was bounded on the north and south by Laight and Beach Streets and on the west by Hudson Street. Shown here is the corner of Hudson and Beach

Streets at about the time of the Civil War, when freight cars had already intruded upon the handsome houses that surrounded the park.

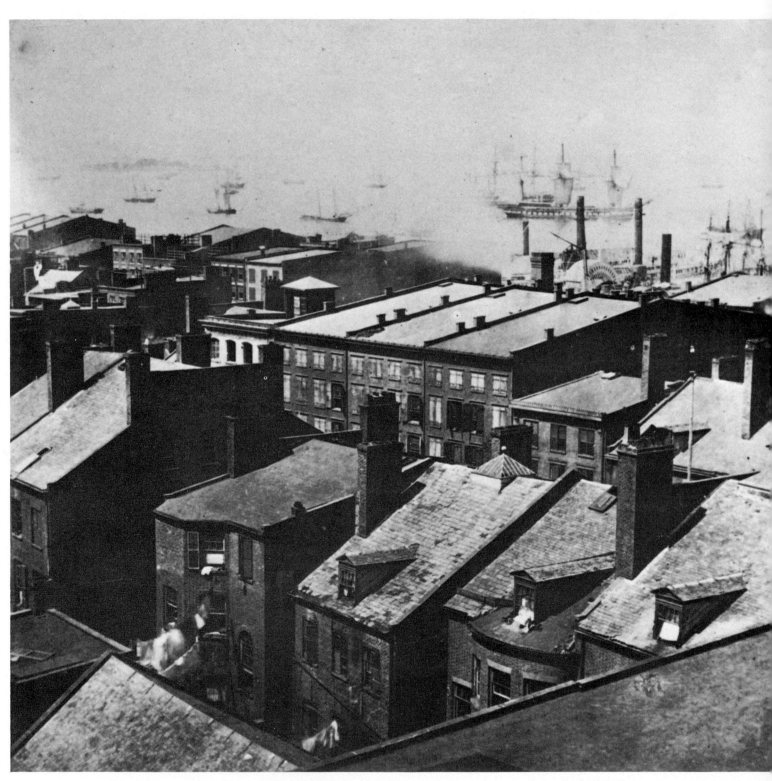

Stereograph, Edward and Henry T. Anthony

[PLATE 71]

New York Harbor, c. 1890

From a location overlooking the bowed and bayed rear windows of houses on Varick Street, Edward and Henry T. Anthony photographed the rooftops that bordered the Hudson, where sailing ships rode at anchor in the stream and a side-wheeler rested at pierside. The location is west of Edward Anthony's business address at 591 Broadway and the house at 17 University Place where both the Anthonys lived.

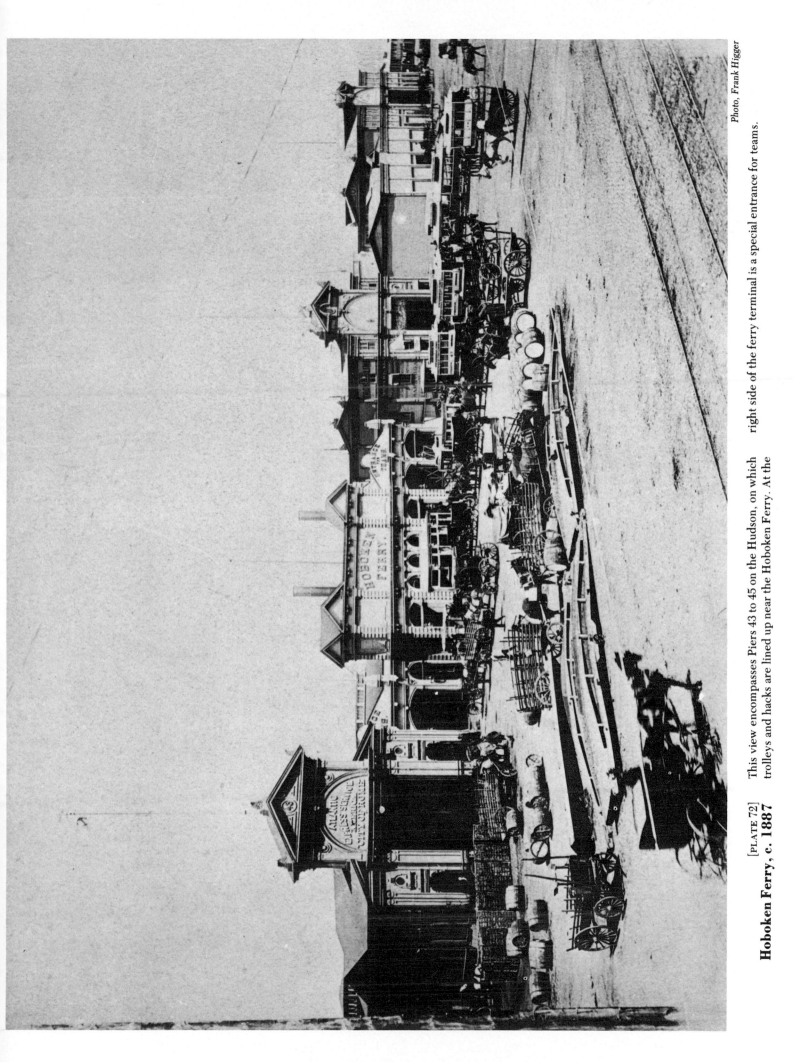

Hoboken Ferry, c. 1887 [PLATE 72] This view encompasses Piers 43 to 45 on the Hudson, on which trolleys and hacks are lined up near the Hoboken Ferry. At the right side of the ferry terminal is a special entrance for teams.

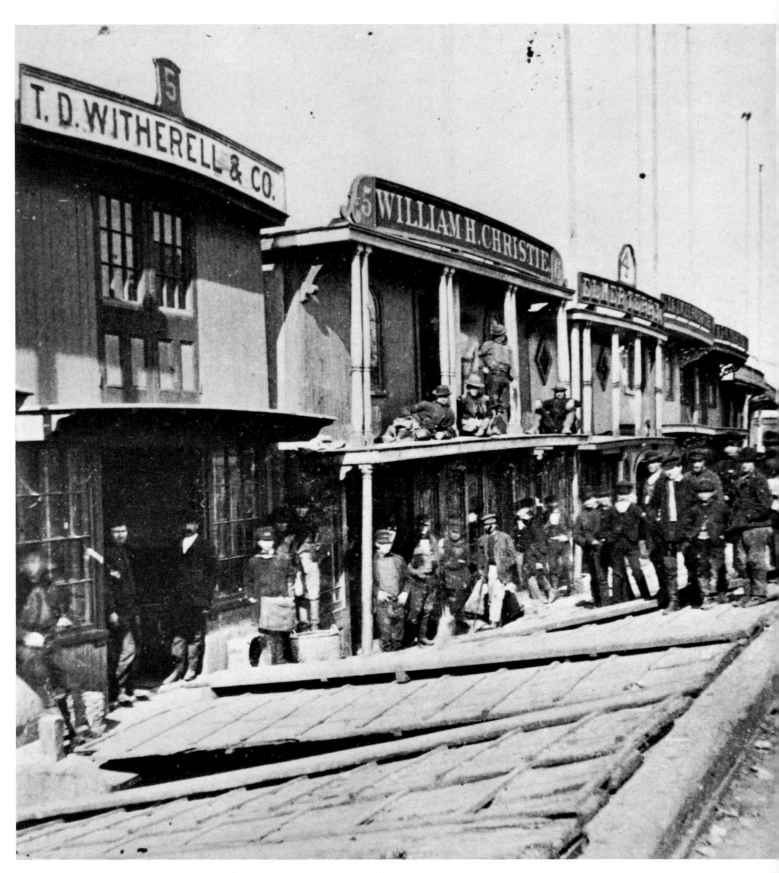

Stereograph

[PLATE 73]
Oyster Barges, c. 1870

Several oyster barges were once more or less permanent adornments along the Hudson at the foot of Christopher Street, just north of the Hoboken Ferry slip and the White Star pier. Two of the barge owners, Timothy D. Witherell and William H. Christie, are listed in the 1872 *New York City Directory* as dealers in oysters at this location.

V

THE EAST SIDE

from Broadway to the East River and North from Duane Street

to Spring and Delancey Streets

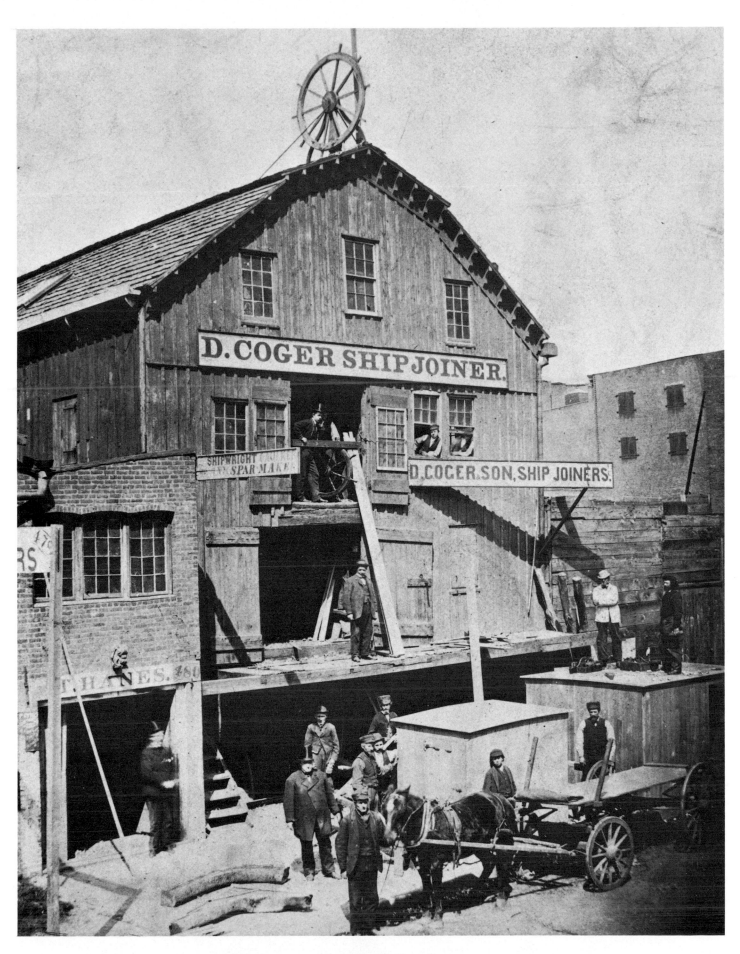

[PLATE 74]
Ship Joiner Shop of Daniel Coger and His Son, c. 1865

One block west of South Street was an area in which innumerable stables, breweries, foundries, coopers' establishments, and ship joiners' shops were located. Seen here is the shop of shipwrights Daniel Coger and his son John J. Coger on Water Street between Pike and Rutgers Streets.

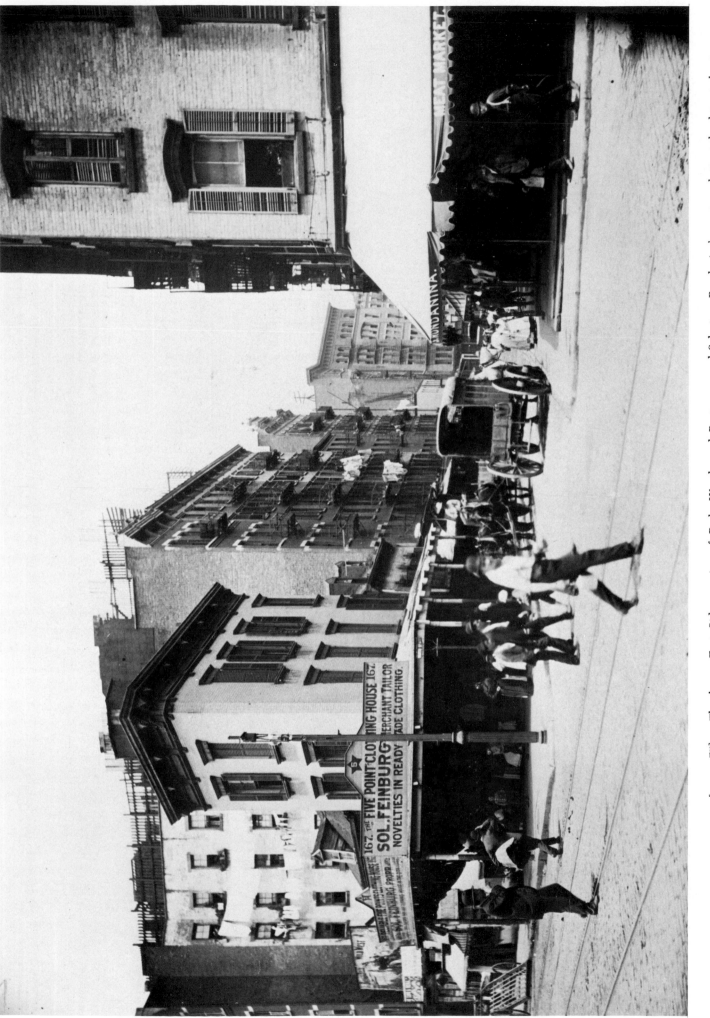

Worth and Baxter Streets, c. 1895

[PLATE 75] The lower East Side crossing of Park, Worth, and Baxter Streets was known as the Five Points. Two of the corners are shown here. A poster for Buffalo Bill's Wild West Show at the left, beyond Solomon Feinburg's Five Points Clothing House,

and Salvatore Rondanina's meat market set the date at about 1895, when various immigrant groups lived and worked in the area.

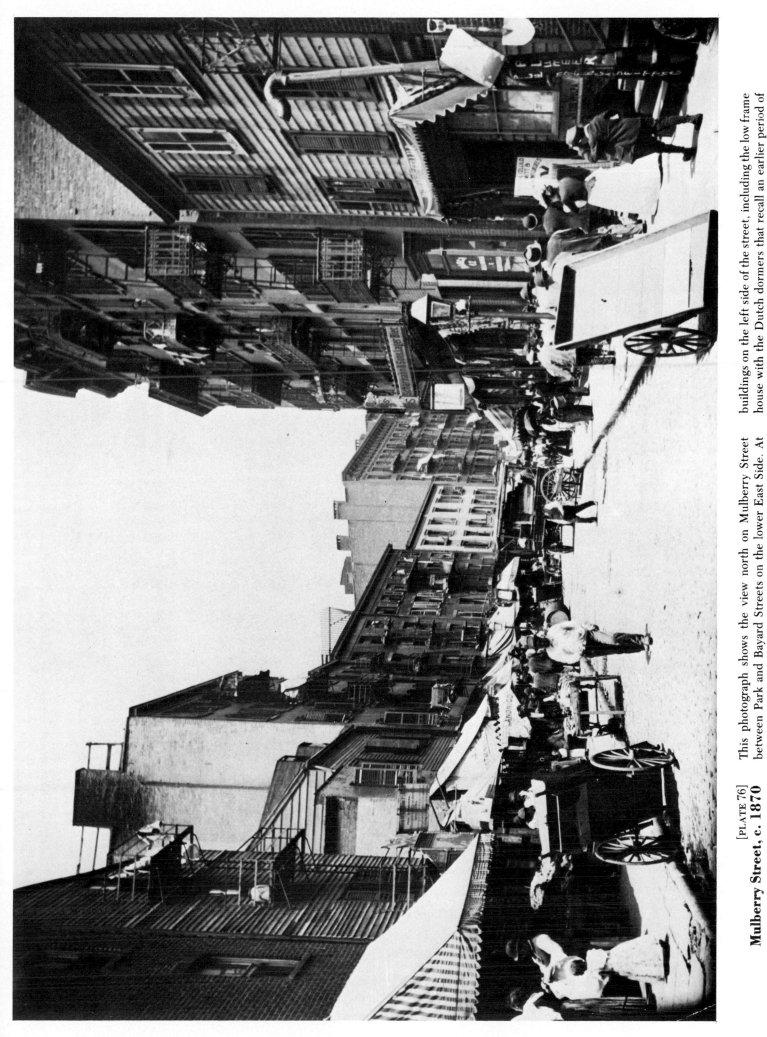

[PLATE 76]
Mulberry Street, c. 1870

This photograph shows the view north on Mulberry Street between Park and Bayard Streets on the lower East Side. At the end of the century, Mulberry Bend Park had replaced the buildings on the left side of the street, including the low frame house with the Dutch dormers that recall an earlier period of New York history.

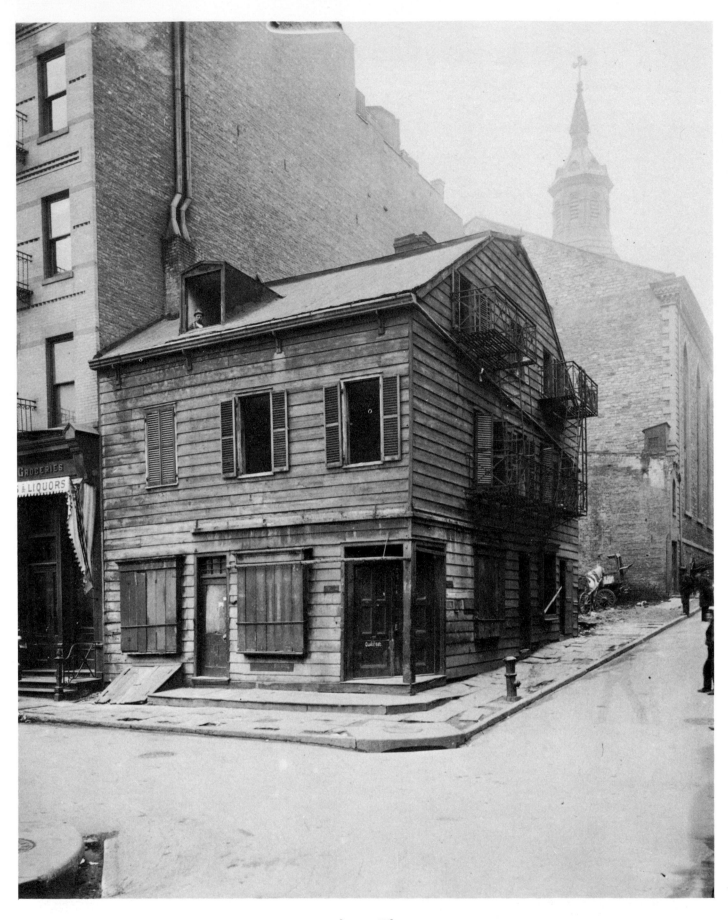

[PLATE 77]
Black Horse Tavern, c. 1895

In this late nineteenth-century view, the Black Horse Tavern stands as a derelict at the northeast corner of Mulberry Street at Park Street. The photograph was taken after 1895 and before 1899, the period when the west side of the street was wiped clean of the buildings and tenements in which many Italian families had lived and worked, and Mulberry Bend Park came into being. At some time in the same period the Black Horse Tavern vanished, and by 1899 had been replaced by a larger building that occupied its site and the vacant lot seen beyond it (just west of the Church of the Transfiguration, the building with the steeple at the far right).

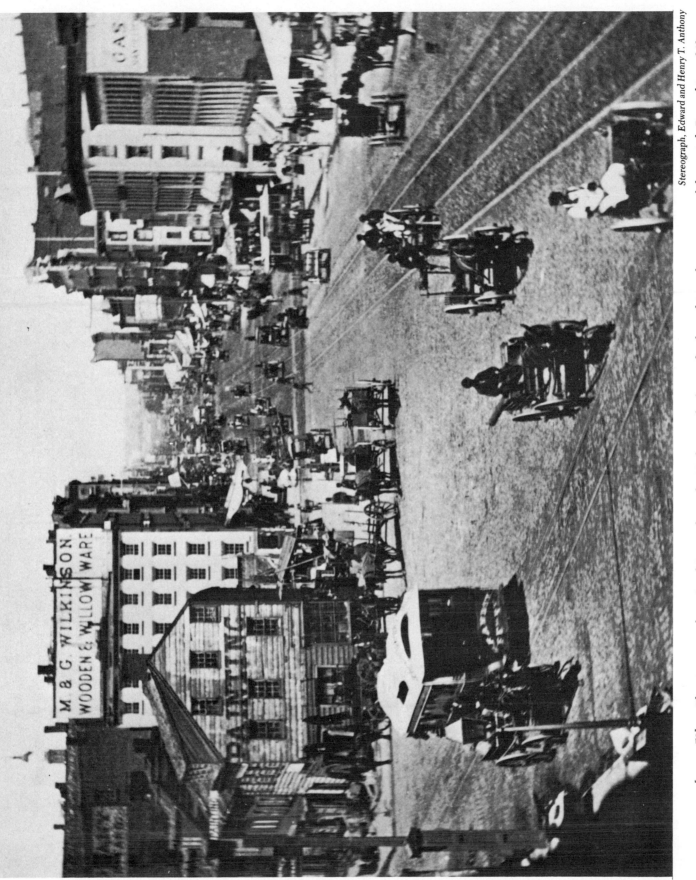

Stereograph, Edward and Henry T. Anthony

[PLATE 78]
Canal Street, 1870

The view west along Canal Street shows the Hudson in the far distance from Mulberry Street at the point where Walker and Canal Streets come together to form a triangular block. The three-story frame house marked "Painting" is identified as a fire hazard in real estate maps of the period. Beyond it, at 242 Canal Street, is the fireproof brick building of Maurice and George Wilkinson.

89

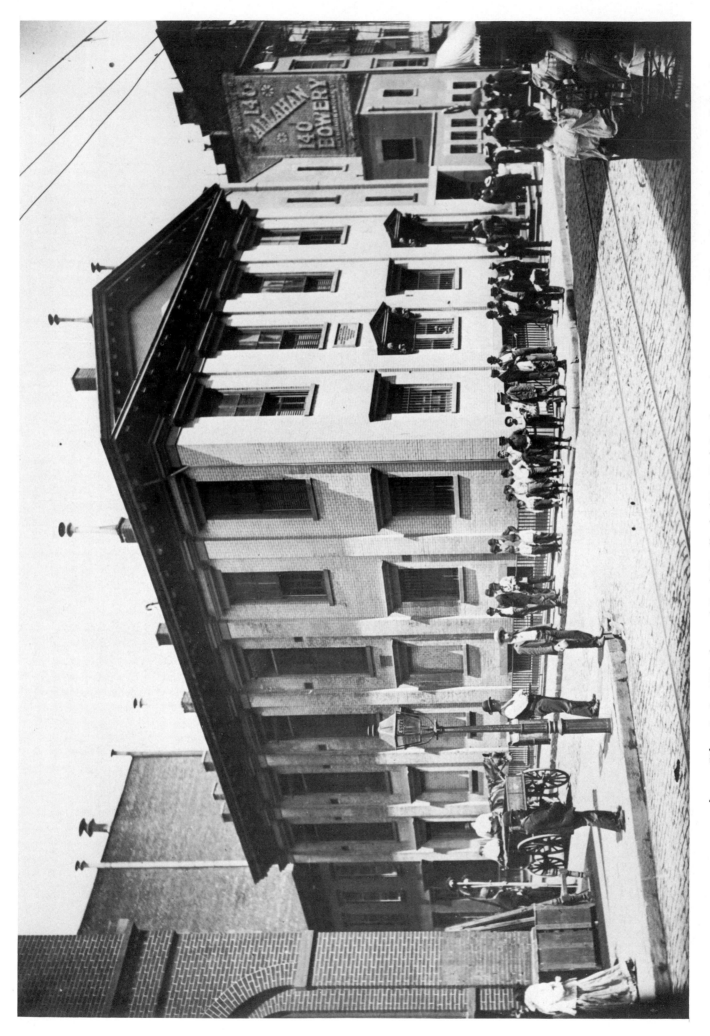

[PLATE 79]

Essex Market Police Court, c. 1892

In the 1893 edition of *King's Handbook of New York City* the justice dispensed in police courts like this one at Essex Market Place is characterized as follows: "They stand next to the common people and their province is not only to correct abuses but also to adjust family and neighborhood differences. . . . The justices are not often members of the legal fraternity . . . and have salaries of $8,000 a year." The high wall behind the police court belongs to the Ludlow Street Jail, built in 1868. At the left foreground is P.S. 137, which—along with the street market—helps to explain the bustle of activity in front of the police court.

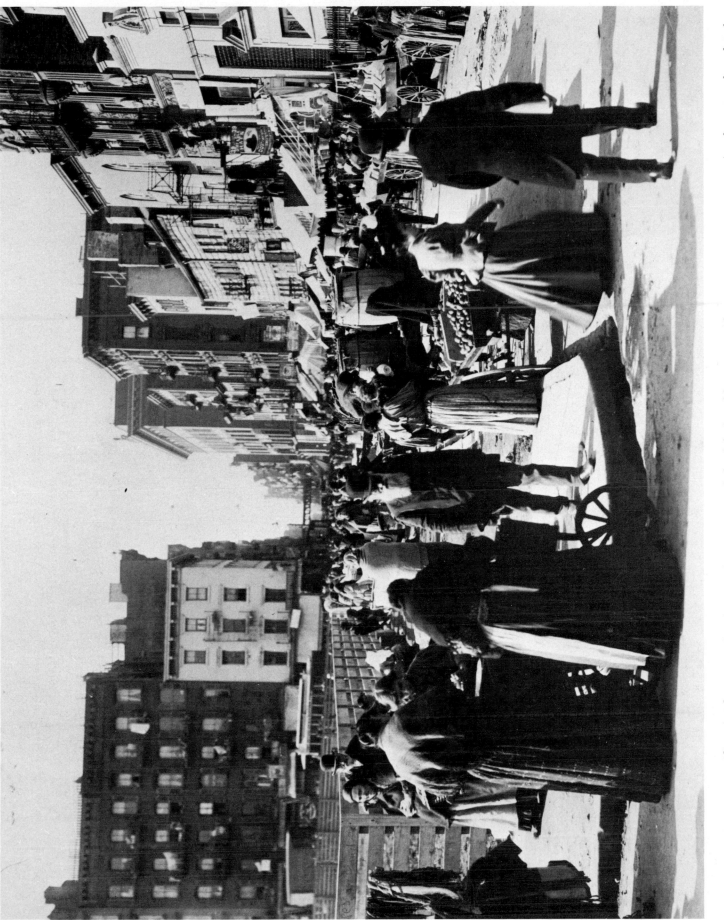

[PLATE 80]
Norfolk and Hester Streets, 1898

Seward Park was under construction behind the board fence at the left when this photograph was taken. Residents of the lower East Side filled Norfolk Street at its crossing with Hester (the street seen in perspective), where Jewish and Italian immigrants created an old-world atmosphere in this section of the city. Note the large number of wooden structures.

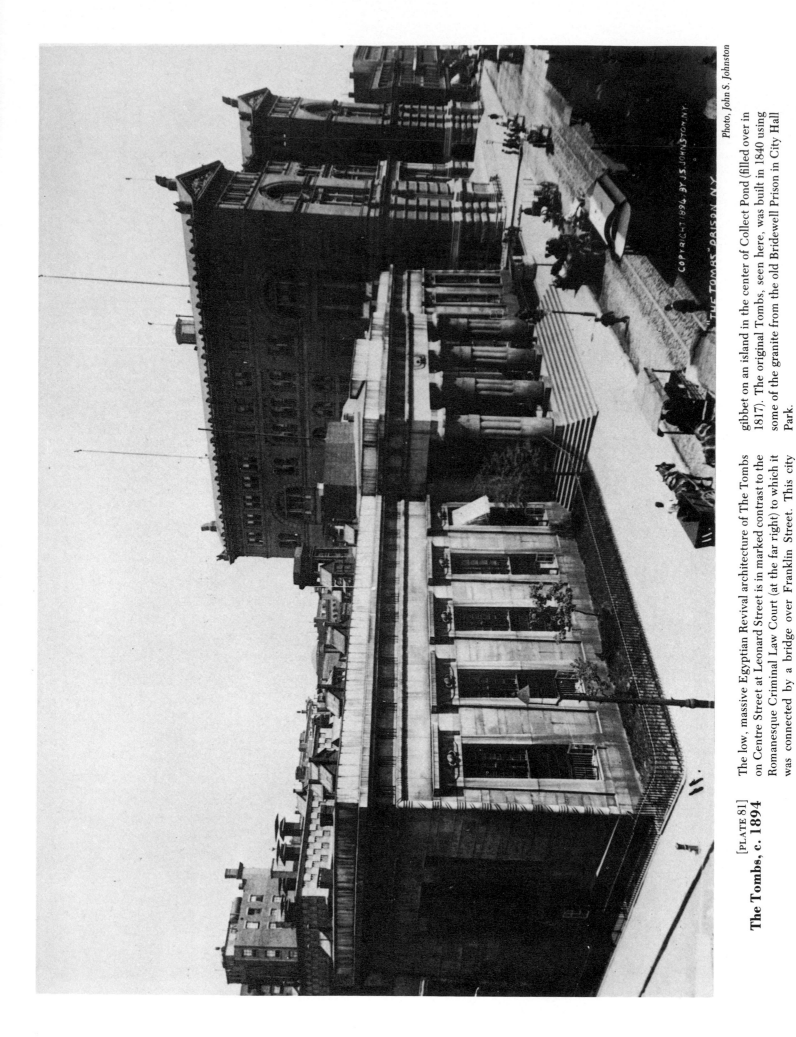

Photo, John S. Johnston

[PLATE 81]
The Tombs, c. 1894

The low, massive Egyptian Revival architecture of The Tombs on Centre Street at Leonard Street is in marked contrast to the Romanesque Criminal Law Court (at the far right) to which it was connected by a bridge over Franklin Street. This city prison was located on the site of the early eighteenth-century gibbet on an island in the center of Collect Pond (filled over in 1817). The original Tombs, seen here, was built in 1840 using some of the granite from the old Bridewell Prison in City Hall Park.

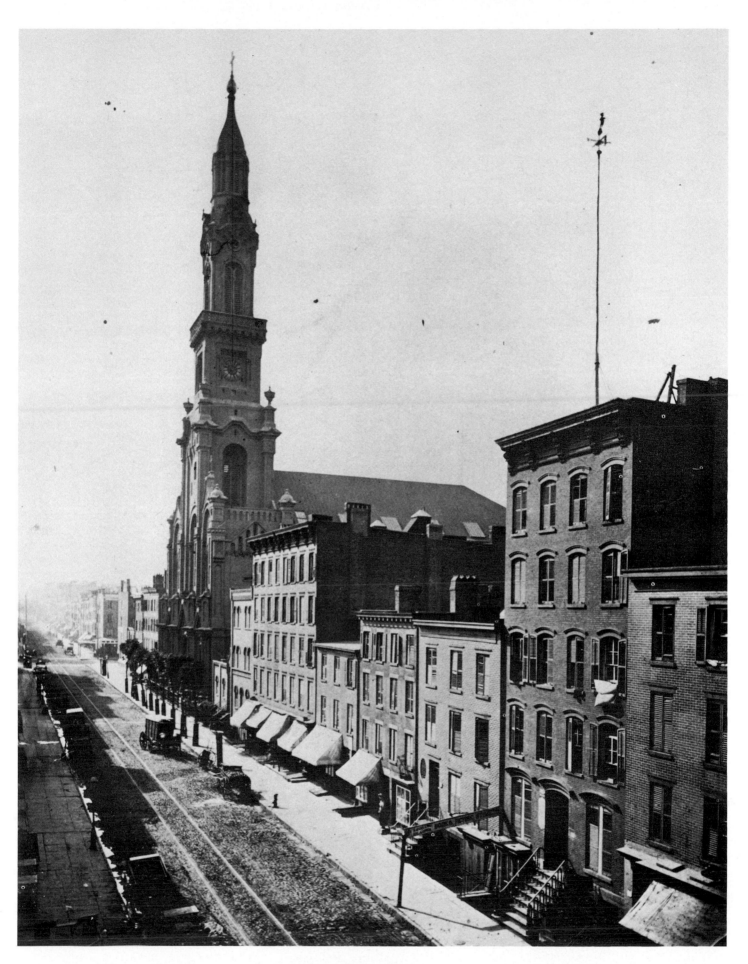

[PLATE 82]
East Third Street, c. 1875

The Roman Catholic Church of the Most Holy Redeemer dominates this morning view of the north side of East Third Street (between Avenue A and Avenue B). A fine cigar store figure of a Turk graces the sidewalk just beyond the unusual overhead sign for a book and picture store.

V I

THE EAST SIDE

from Broadway to the East River and North from Spring and Delancey Streets to 14th Street

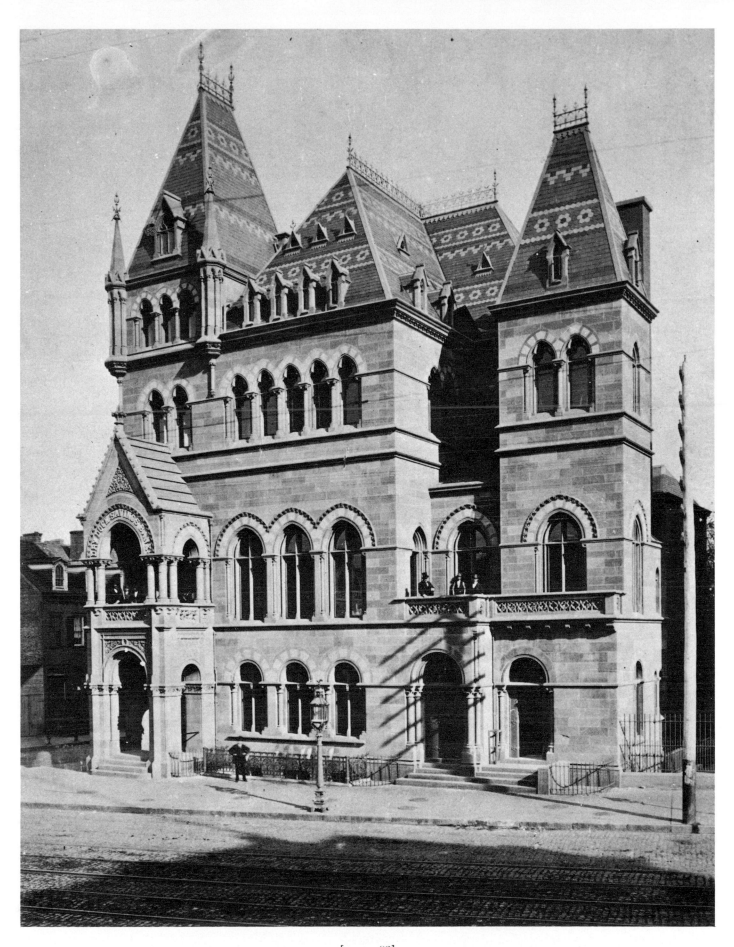

[PLATE 83]
Dry Dock Savings Institution, c. 1875

In 1848, when the old dry dock at the foot of 10th Street was the center of shipbuilding activity, "a group of gentlemen principally interested in that business established this institution to encourage thrift and prudence among their workmen," according to *King's Handbook* of 1893. In 1875 an unidentified photographer recorded the pristine splendor of the bank's second building located at The Bowery and Third Street, some distance from the old dry dock but still a far piece from present-day Dry Dock Country.

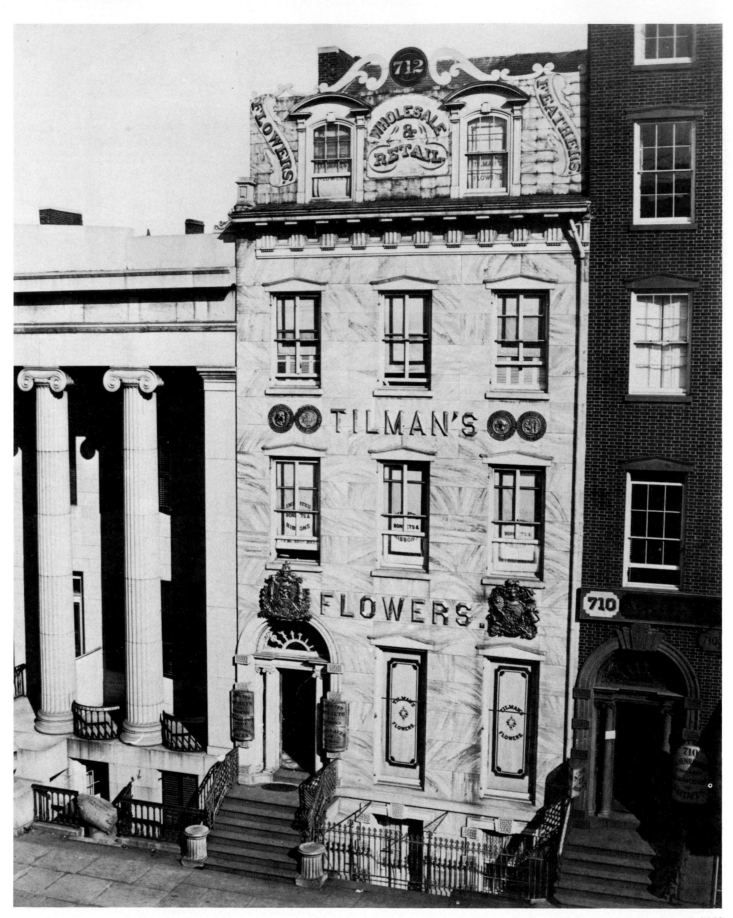

Photo, Maurice Stadtfeld

[PLATE 84]
Tilman's Flowers, c. 1866

Leopold Tilman's wholesale and retail artificial flower house is painted in imitation of its grander neighbors, the marble houses at 714 and 716 Broadway (one is partly visible at the left). The trompe l'oeil is carried from the main entrance to the mansard roof, which incorporates real dormer windows into its design. Decorative painted window shades are used over inside shutters to advertise the shop's specialities, and large replicas of medals awarded at the London Exposition of 1851 and the Paris Exposition of 1859 are further enhancements. Maurice Stadtfield shot this view from the window of his studio, across the street at 711 Broadway.

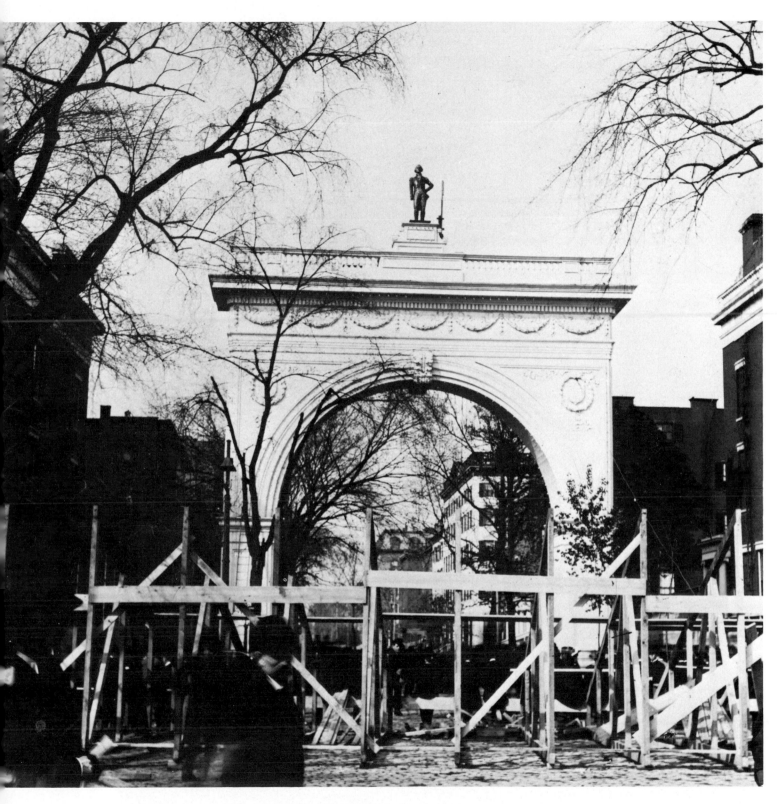

First Washington Arch, 1889

The wooden arch constructed for the centennial of Washington's inauguration, designed by Stanford White and financed by private subscription, stood at the foot of Fifth Avenue. Here scaffolding for reviewing stands is under construction for the celebration. The primitive wooden figure of Washington—eleven feet high—is now in the collection of the Historical Society of Delaware.

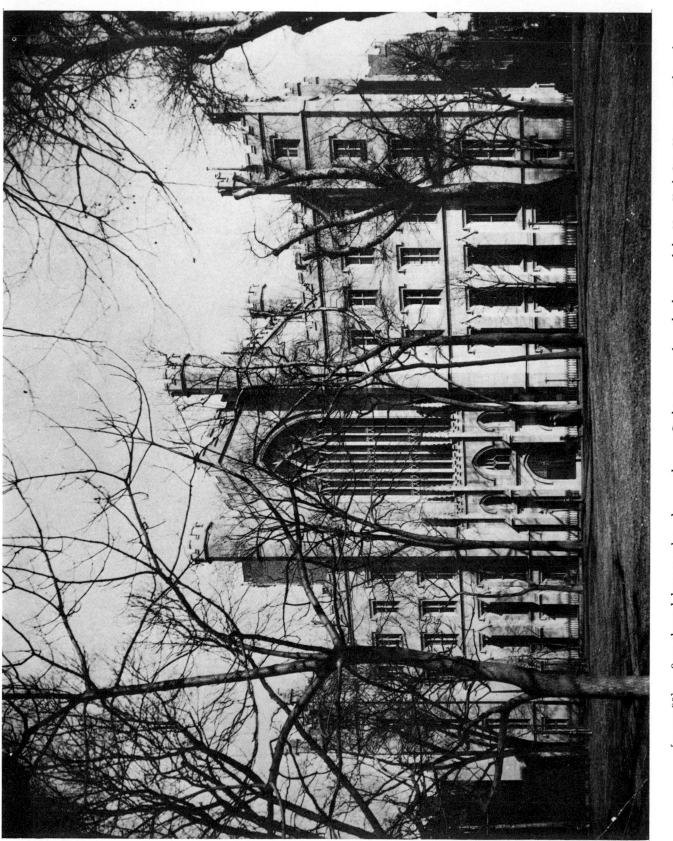

[PLATE 86]

University of the City of New York (Washington Square), c. 1880

Seen through bare tree branches are the neo-Gothic towers of New York University, completed in 1837. It was from the third story in this building that Samuel F. B. Morse, often called the "Father of American Photography," took his first successful photograph. Of this event he writes in his journal: "The first experiment crowned with any success was a view of the Unitarian Church from the window on the staircase from the third story of the New York City University. This, of course, was before the building of the New York Hotel. It was in September, 1839. The time, if I recollect, in which the plate was exposed to the action of light in the camera was about fifteen minutes. The instruments, chemicals, etc., were strictly in accordance with directions in Daguerre's first book."

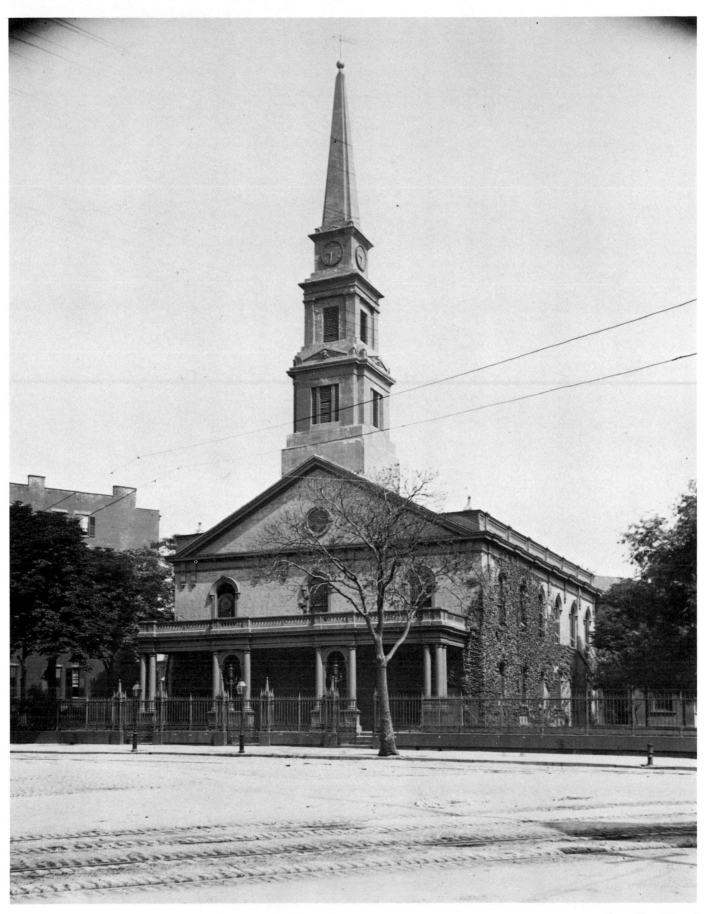

Photo, Edward Wenzel

[PLATE 87]
St. Mark's Church In-the-Bowery, 1895

In 1660 this historic church was established as a Dutch chapel on the farm of Gov. Peter Stuyvesant. In 1799 the building shown here rose at the same location, the northwest corner of Second Avenue at 10th Street, where it still stands. The steeple and portico were added in 1828 and 1854, respectively.

St. Mark's graveyard, famous for the tombs of Stuyvesant and Commodore Perry, was the scene of a celebrated body-snatching in 1878, when the remains of A. T. Stewart, merchant and store owner, were removed and held for $20,000 ransom.

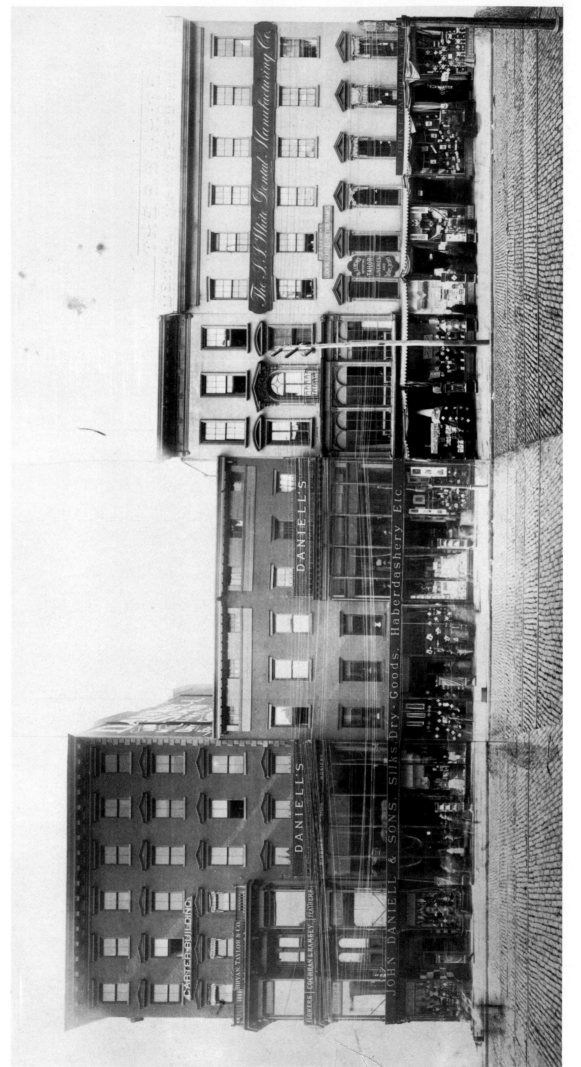

[PLATE 88]

West Side of Broadway between 8th and 9th Streets, c. 1890

This composite view is made up of three carefully registered photographs. Trolley lines, paving blocks, and artfully lettered signs evoke another era. Time exposure captures the ghosts of nineteenth-century ladies and gentlemen as they saunter or stride to John Daniell & Sons, Haberdashers, and to R. J. Lyons, tailors of liveries and ladies' jackets. Mr. Daniell has

taken over the Carter Building (formerly the American Hotel) along with the two less important buildings next to it. Spring seems to be in the air: the elegant Victorian store at right center advertises a special sale of "scarlet underwear" and wide open windows abound.

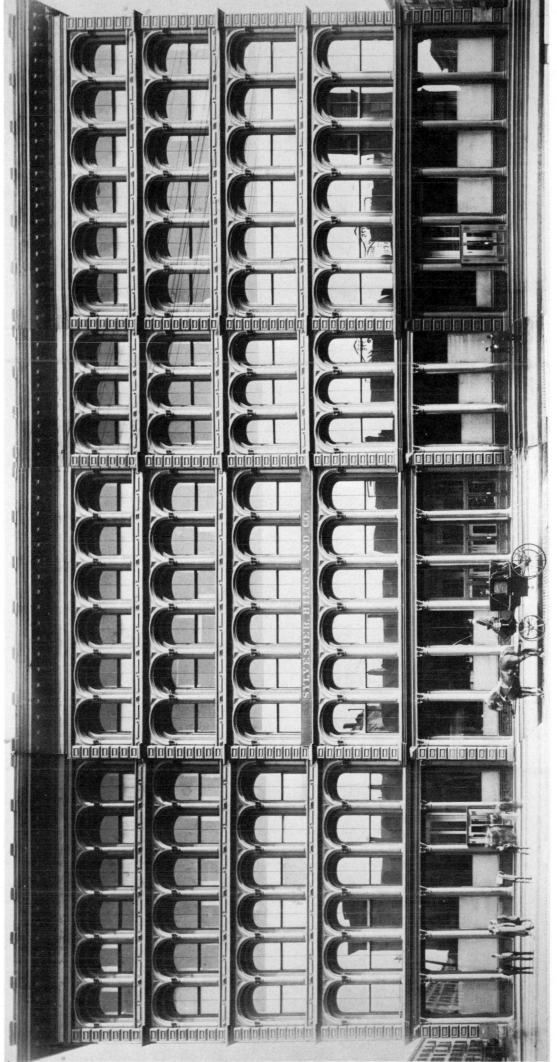

[PLATE 89]
East Side of Broadway between 9th and 10th Streets, c. 1885

A composite view made up of three photographs records the neo-Venetian elegance of this cast-iron building. In the 1880s E. J. Denning and Company operated a retail store in part of the building while Sylvester, Hilton and Company engaged in wholesale trade there. Earlier, the store was A. T. Stewart's; later it became John Wanamaker's. Of the three composite studies shown here, this is the only one with a number of recognizable human figures. The bright afternoon sunlight suggests that the exposure was a shorter one than in the two views of the west side of Broadway.

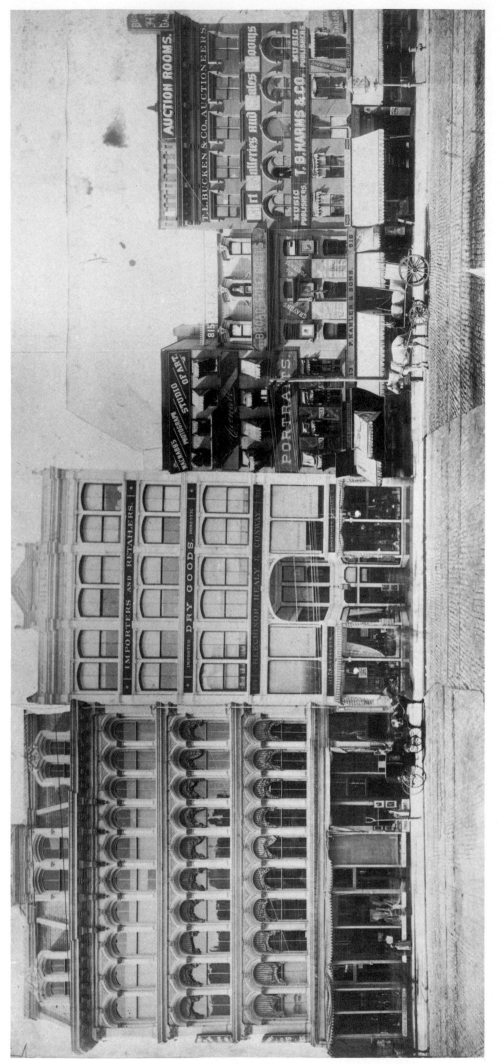

[PLATE 90]

West Side of Broadway between 11th and 12th Streets, c. 1889

The photographer of this view of the block north of the two preceding ones is unknown, although it is pleasant to think that he might have been Francis P. Macnabb of the "Studio of Art" at right center. McCreery's beautiful store, with its third and fourth-floor windows swathed in awnings, is easily the most distinguished building on this block, although Sylvester, Hilton and Company (see No. 89) was the architectural gem of the neighborhood. The street furniture—lamps and a hydrant —are as worthy of note as the patient horses left and right and the stationary coachman who moves only his whip.

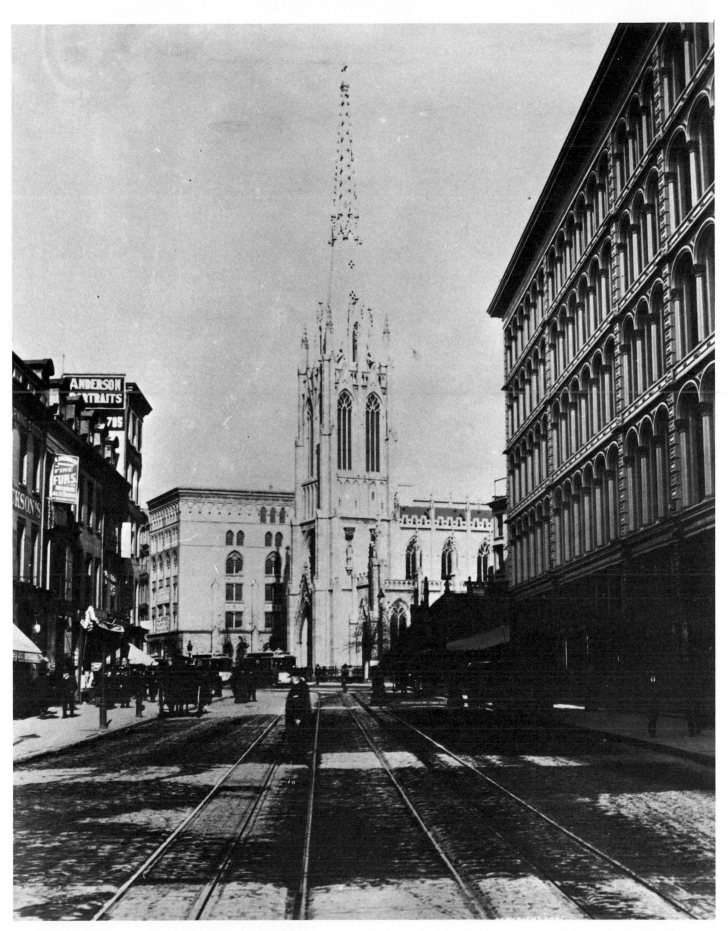

Photo, John S. Johnston

[PLATE 91]
Grace Church, 1895

Working on his record of Broadway in 1895, J. S. Johnston appears to have set up his camera in the center of the street to record James Renwick's still-extant Grace Church. A later building, also by Renwick's firm, and also still standing, is the Gothic Revival structure seen almost as a backdrop to the church. On the right, with the pleasing repeat of arched windows, is the beautiful cast-iron facade of the Stewart Building, operating in 1895 as Hilton, Hughes and Company's drygoods store.

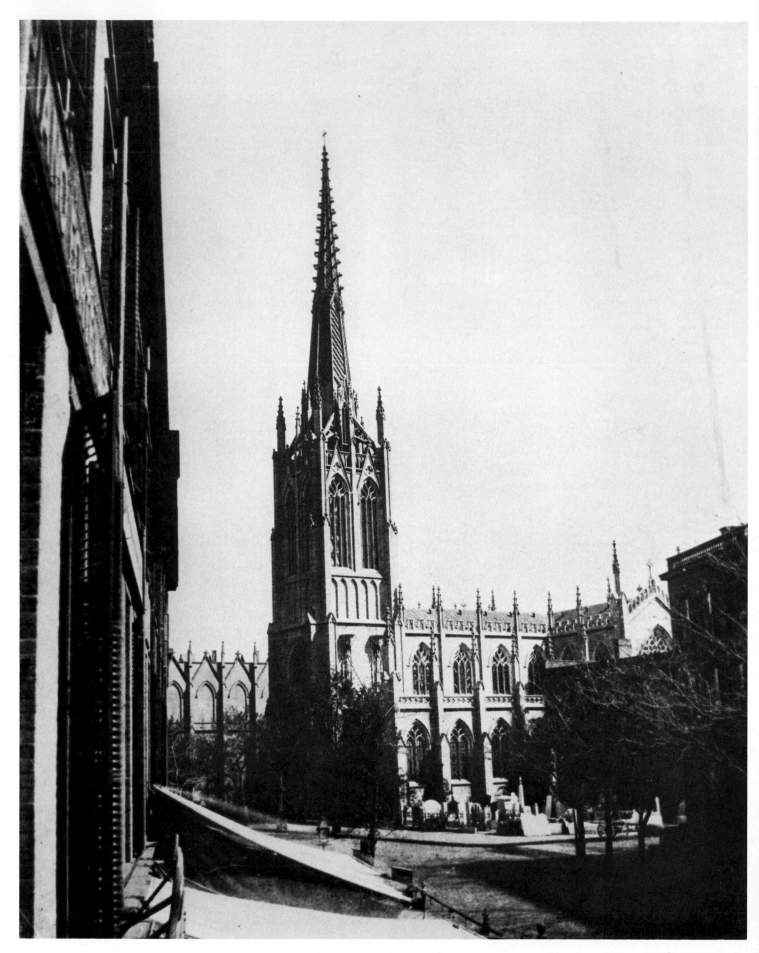

Photo, Victor Prevost

[PLATE 92]
Grace Church, c. 1855

The delicacy of Grace Church's Gothic spires at Broadway and 10th Street and the cross-hatched blinds on Michael J. Flannely's tailoring establishment show the early cameraman's ability to record detail. The wax paper negative for this and other early Prevost photographs are in the Society's collection.

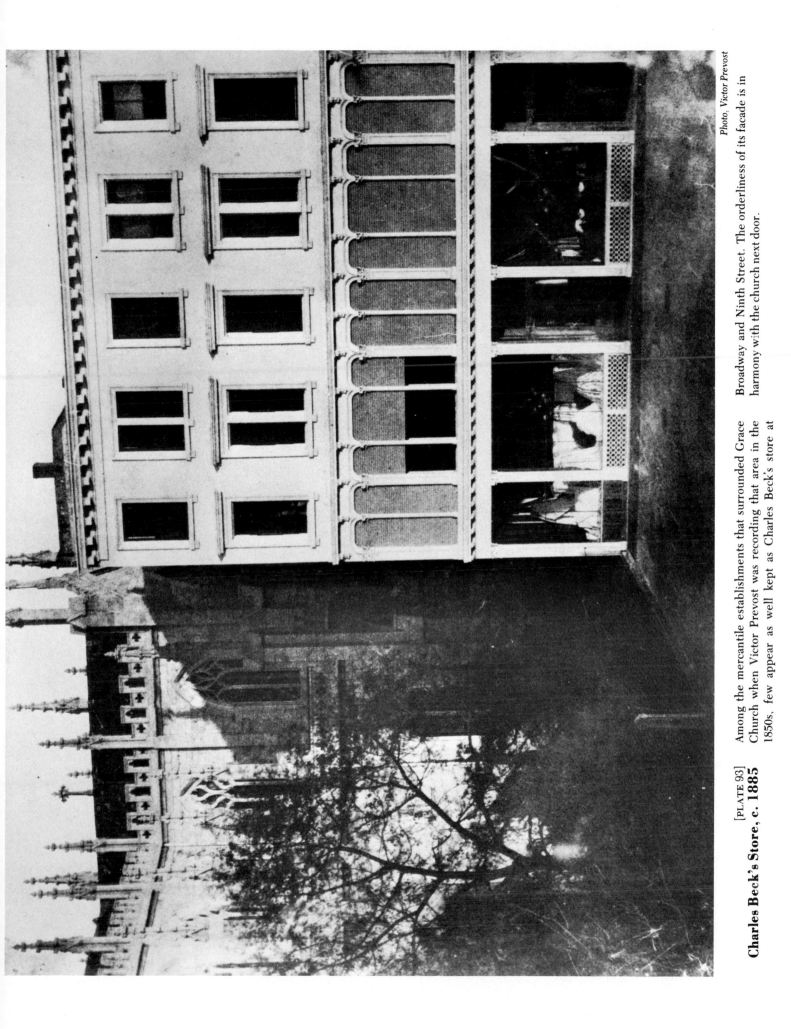

Photo, Victor Prevost

[PLATE 93]
Charles Beck's Store, c. 1885

Among the mercantile establishments that surrounded Grace Church when Victor Prevost was recording that area in the 1850s, few appear as well kept as Charles Beck's store at Broadway and Ninth Street. The orderliness of its facade is in harmony with the church next door.

VII

THE WEST SIDE

from the Washington Square Area West to the Hudson River

and North from Barrow and Bleecker Streets to 23rd Street

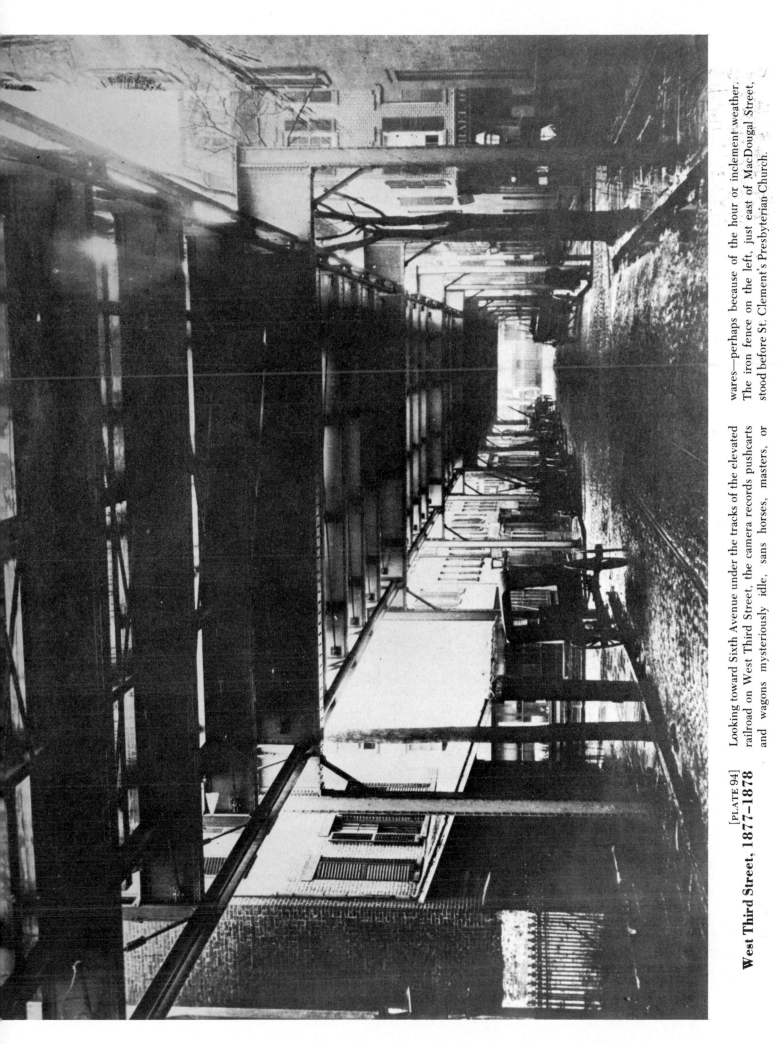

[PLATE 94]
West Third Street, 1877–1878

Looking toward Sixth Avenue under the tracks of the elevated railroad on West Third Street, the camera records pushcarts and wagons mysteriously idle, sans horses, masters, or wares—perhaps because of the hour or inclement weather. The iron fence on the left, just east of MacDougal Street, stood before St. Clement's Presbyterian Church.

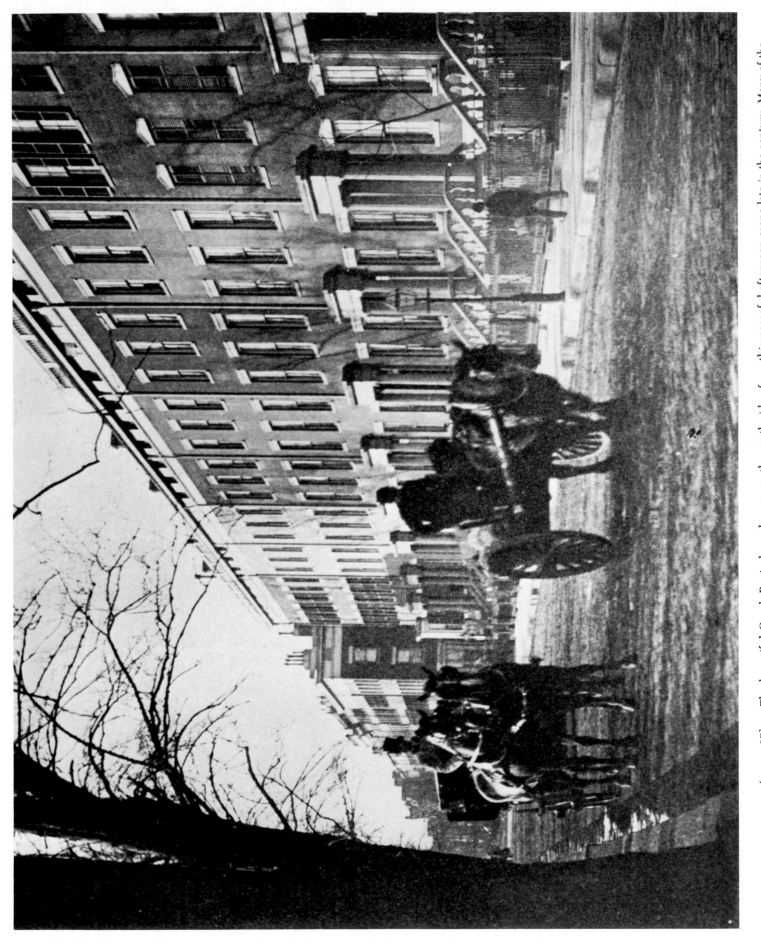

[PLATE 95]
Washington Square. 1894

The beautiful Greek Revival row houses on the north side of Washington Square, built about 1831, appear to advantage in this peaceful afternoon scene late in the century. Many of the facades remain virtually unaltered.

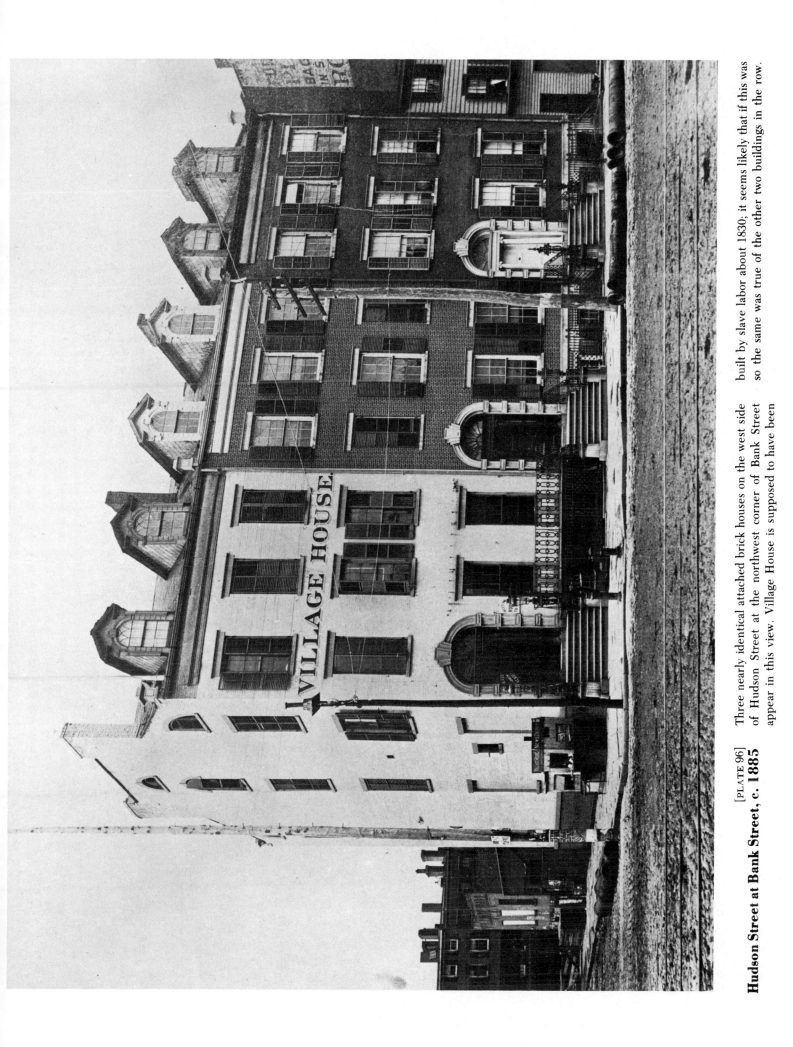

[PLATE 96]
Hudson Street at Bank Street, c. 1885

Three nearly identical attached brick houses on the west side of Hudson Street at the northwest corner of Bank Street appear in this view. Village House is supposed to have been built by slave labor about 1830; it seems likely that if this was so the same was true of the other two buildings in the row.

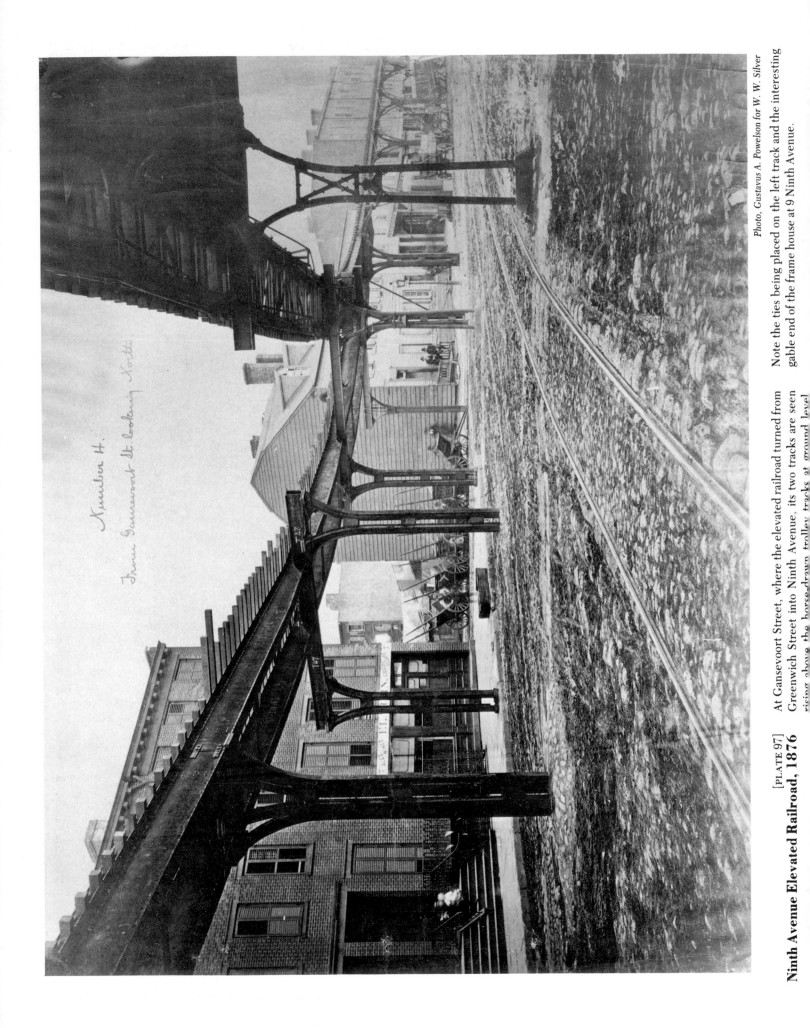

Number 4.

From Gansevoort St. looking North

Photo, Gustavus A. Powelson for W. W. Silver

[PLATE 97]

Ninth Avenue Elevated Railroad, 1876

At Gansevoort Street, where the elevated railroad turned from Greenwich Street into Ninth Avenue, its two tracks are seen rising above the horsedrawn trolley tracks at ground level.

Note the ties being placed on the left track and the interesting gable end of the frame house at 9 Ninth Avenue.

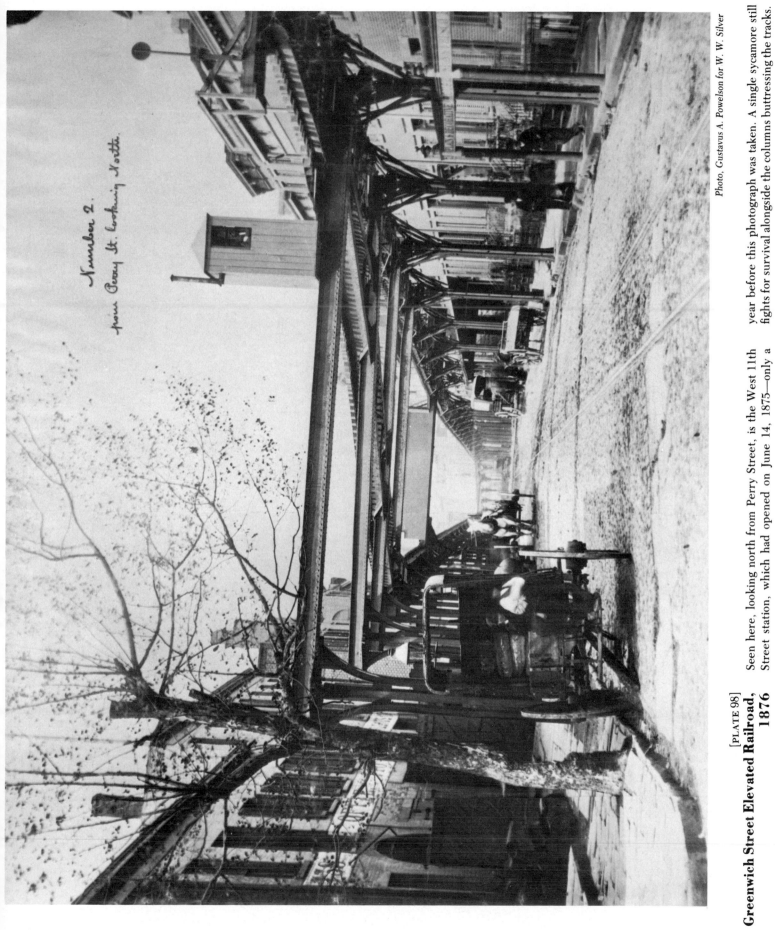

Number 2.
from Perry St. looking North.

Photo, Gustavus A. Powelson for W. W. Silver

[PLATE 98]
**Greenwich Street Elevated Railroad,
1876**

Seen here, looking north from Perry Street, is the West 11th Street station, which had opened on June 14, 1875—only a year before this photograph was taken. A single sycamore still fights for survival alongside the columns buttressing the tracks.

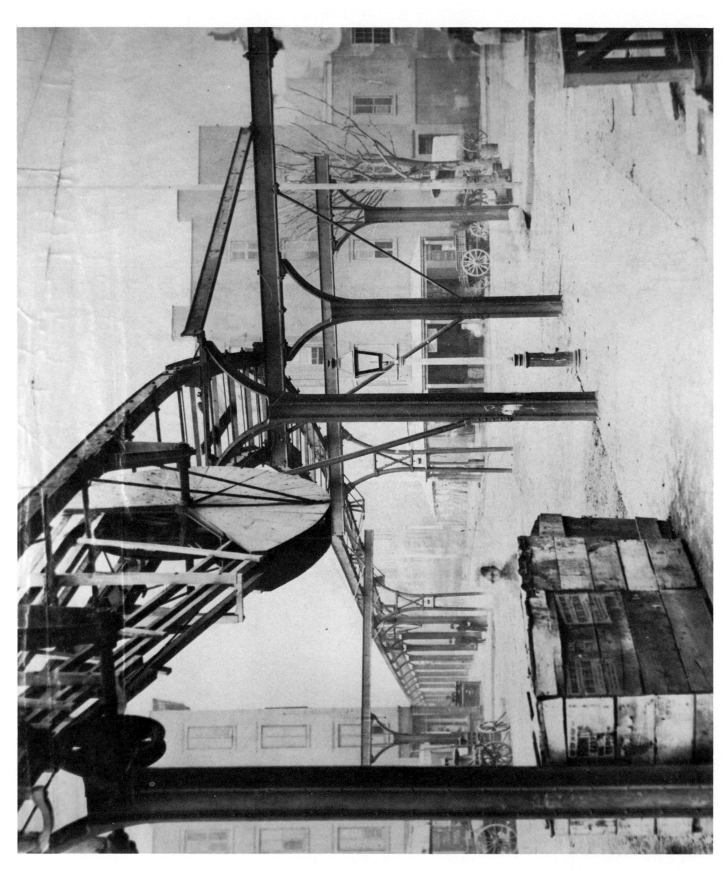

[PLATE 99]
Little West 12th Street, 1869

The carts along Little West 12th Street (left and right) show the contrast between older modes of transportation and the then new Greenwich Street–Ninth Avenue el. The single-column rail supports repeat the form of a tree so faithfully that the sycamore at the right appears almost as a continuation of them. In the center of this reprint from an old and damaged photograph is the box enclosing the cable which towed the first cars along this single track line.

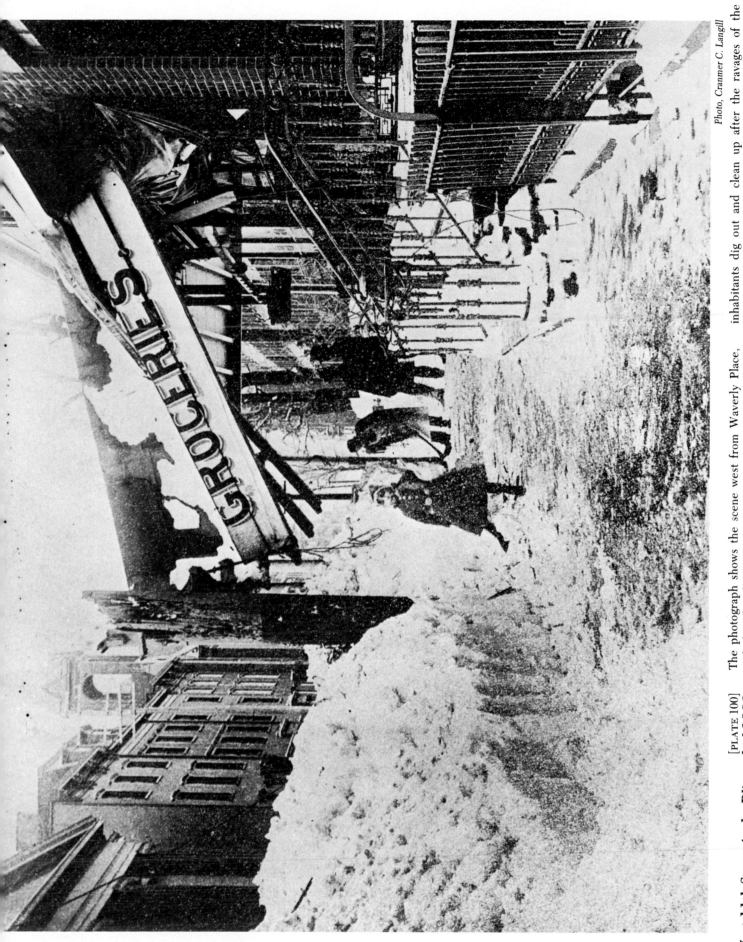

Photo, Cranmer C. Langill

West 11th Street in the Blizzard of 1888 [PLATE 100]

The photograph shows the scene west from Waverly Place, with the Church of St. John the Evangelist at the left; further on in this same direction is the North Baptist Church. Here the inhabitants dig out and clean up after the ravages of the blizzard of '88.

[PLATE 101]
West 14th Street, c. 1880

New York's low nineteenth-century profile is reflected in the windows of the lofts to let at 14–16 West 14th Street west of Union Square. The buds on the branches portend the coming of spring, although the furrier's slightly moth-eaten grizzly and the sleds alongside the stacked carts indicate a winter date for the photograph.

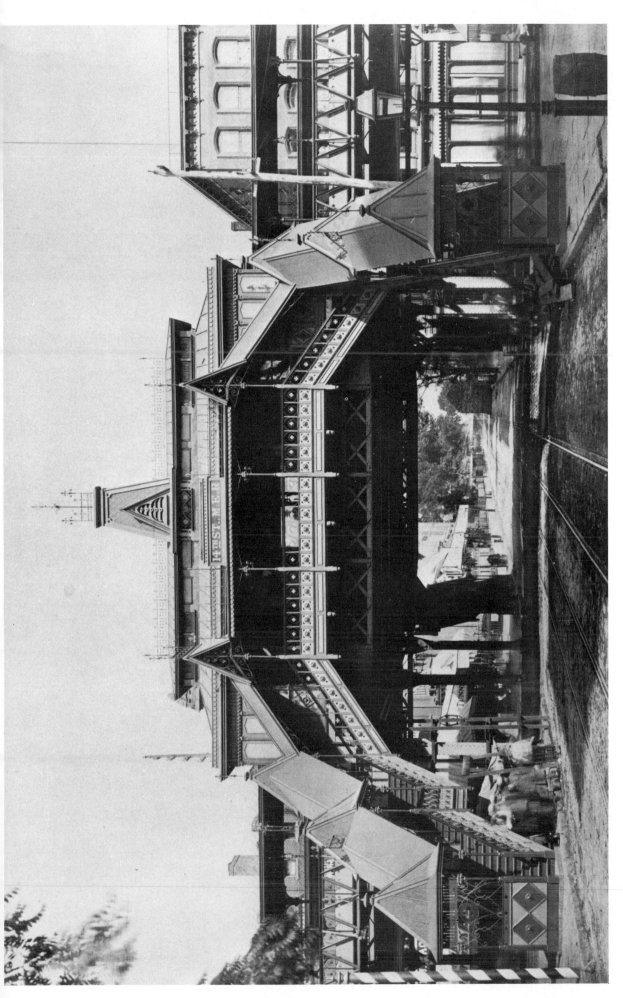

[PLATE 102]

Metropolitan Elevated Railroad Station at 14th Street, c. 1879

At the right, beyond the delicate Victorian tracery of the 14th Street station of the Metropolitan Elevated Railroad (after a design by the painter Jasper Cropsey suggesting Swiss chalet architecture), is the R. H. Macy store in its early location at the southeast corner of Sixth Avenue. The shadows indicate that it is almost noon; drawn shades on the Macy store and the deserted street (save for the "ghosts" at the street level entrances to the el) suggest that this is a Sunday view. Far along 14th Street, at the left, trees mark the location of the Scotch Presbyterian Church.

The elevated railroad, which plunged the first floors of old buildings into shadow, was not always viewed as an assault to eyes and ears. In the 1893 edition of *King's Handbook* the elevated is praised as "the crowning achievement in solving the problems of rapid transit. By its aid the New-Yorkers fly through the air from end to end of their teeming island at railway speed and in comfortable and well-appointed cars . . . high above the streets . . . in a fresh and wholesome atmosphere."

VIII

THE BROADWAY AREA

from 14th Street to 23rd Street

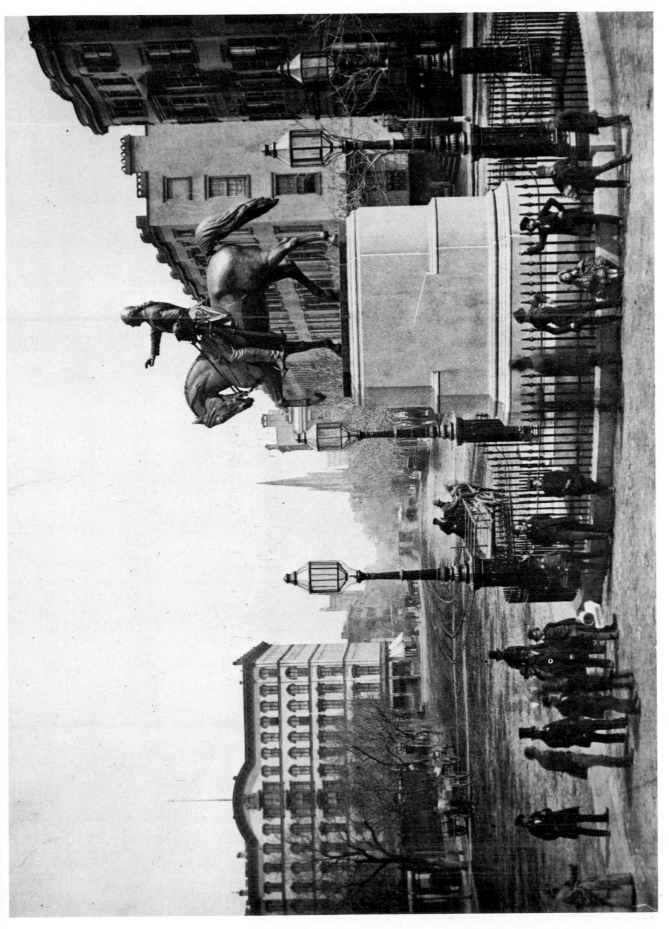

[PLATE 103]
Union Square, c. 1870

This view of the east side of Union Square at Fourth Avenue shows the elegant iron fence and lamps surrounding Henry K. Brown's bronze equestrian figure of Washington, on which his apprentice, J. Q. A. Ward, also worked. Erected in 1856, it is one of the most successful of New York's outdoor sculptures and the oldest figure in New York still in its original location (although it has been moved from the triangle east of the square to its center). The group surrounding the figure forecasts the popularity of Union Square as a favorite gathering place for street orators. At the left is Union Square's three-acre park, at this date still surrounded by an iron fence. At left background is Everett House at the northeast corner of the park.

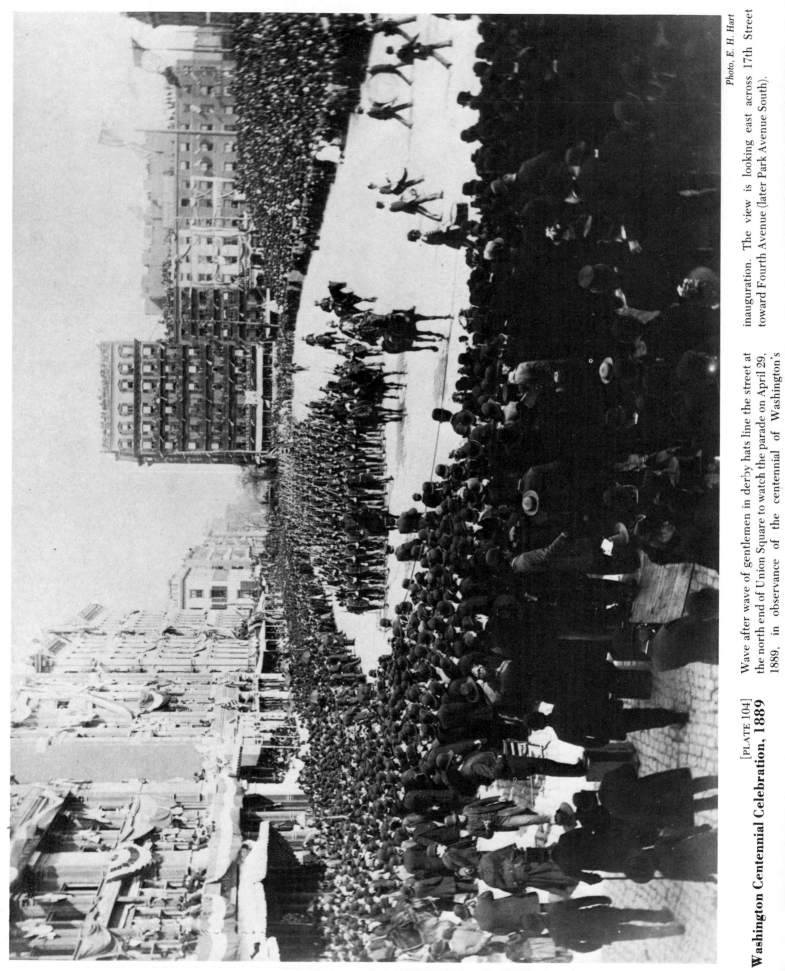

[PLATE 104]

Washington Centennial Celebration, 1889

Photo, E. H. Hart

Wave after wave of gentlemen in derby hats line the street at the north end of Union Square to watch the parade on April 29, 1889, in observance of the centennial of Washington's inauguration. The view is looking east across 17th Street toward Fourth Avenue (later Park Avenue South).

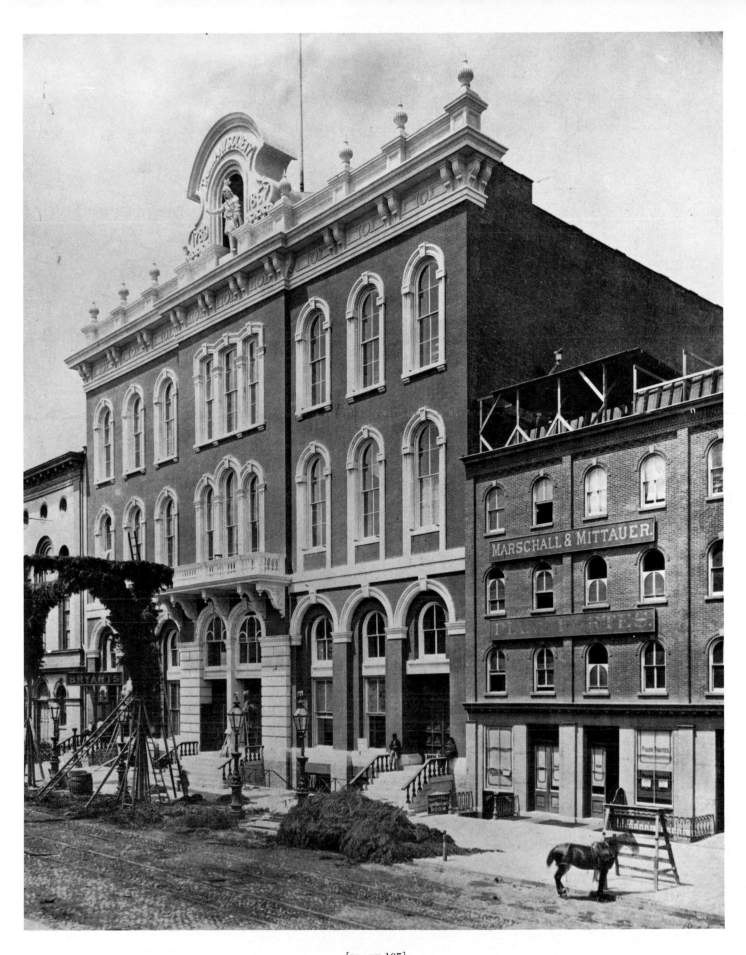

[PLATE 105]
Tammany Hall, c. 1890

From 1869 on the Tammany Society occupied this Victorian building topped with an improbable housing for the heroic-sized figure of the legendary Indian chief whose name the Society adopted at its founding in 1789. Tammany Hall was located next to the Academy of Music (left) on the north side of 15th Street between Irving Place and Third Avenue. By the late nineteenth century, when this photograph was taken, the Tammany Hall General Committee held power over the Democratic Party and was firmly in control of the city's political machine.

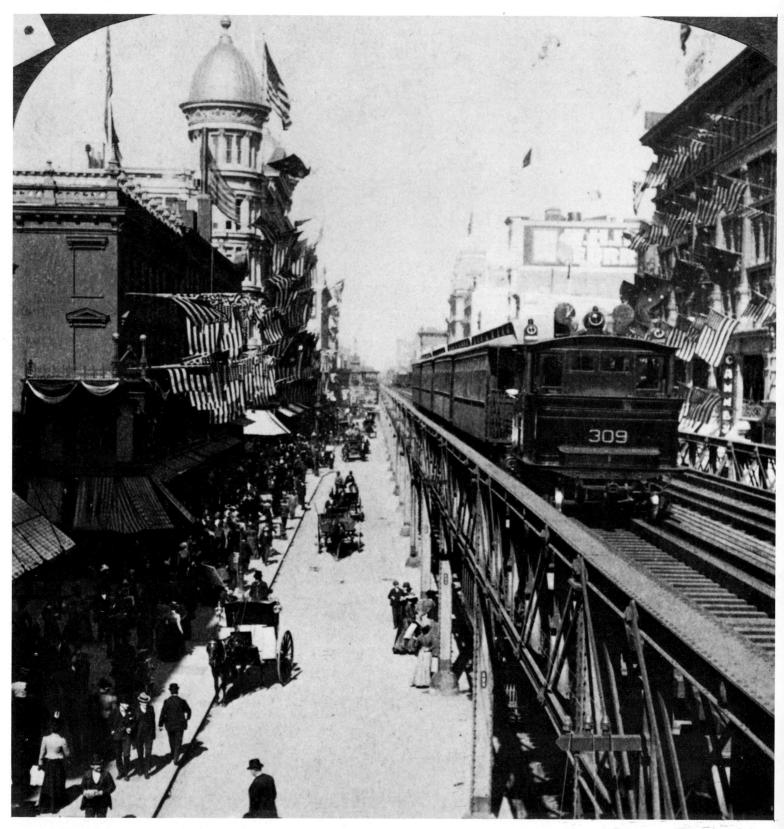

Stereograph, Underwood and Underwood

[PLATE 106]

Sixth Avenue, 1899

A holiday spirit fills the air in this late nineteenth-century view up Sixth Avenue from 18th Street looking toward the area that was then a popular shopping district. Flags wave from the windows of B. Altman, left, and Siegel, Cooper and Co., right. Though the occupants have changed, the buildings on this stretch of Sixth Avenue are still essentially the same.

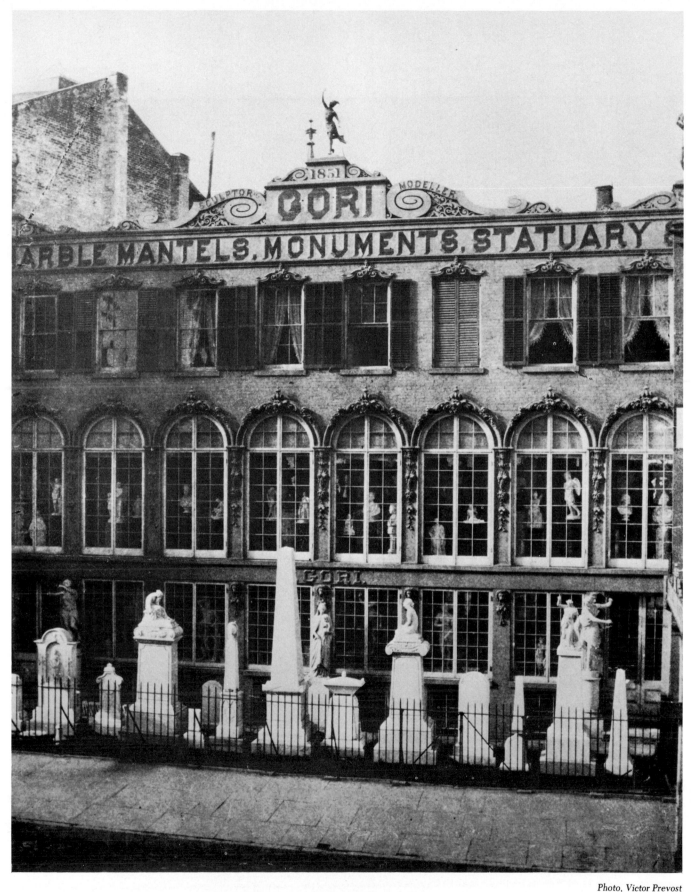

Photo, Victor Prevost

[PLATE 107]
Gori's Marble Cutting Establishment, c. 1853

This fascinating early view is from one of the wax paper negatives by the French photographer Victor Prevost, whose record of the city dates to the early 1850s. Unlike its neighbors on the west side of Broadway between 19th and 20th Streets, the building housing Ottaviano Gori's residence and workshop is set back from the street to provide display space for his wares in marble and alabaster.

In 1853 Gori's house is listed at 895 Broadway with his business adjoining at 897. Here, it appears that the third floor, where swagged curtains are seen behind the windows with beautifully designed applied decorations, is his living space. A miscellany of neoclassic figures and portrait busts in the lower windows record part of Signor Gori's New York production from 1841 to 1859.

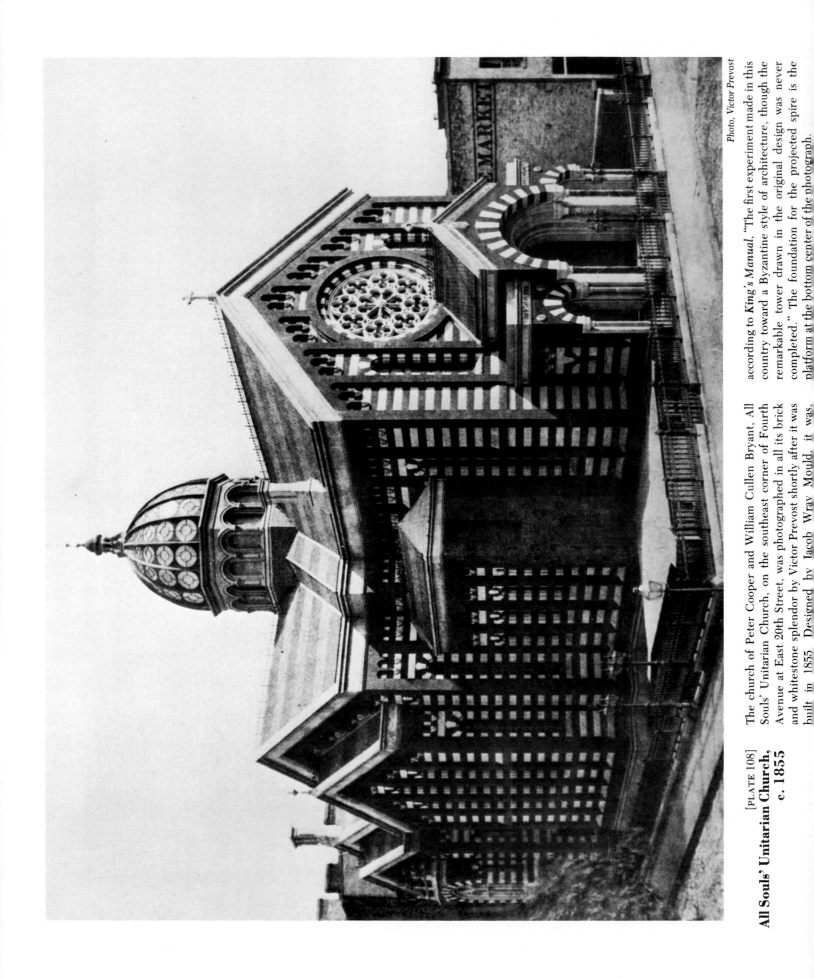

Photo, Victor Prevost

[PLATE 108]
**All Souls' Unitarian Church,
c. 1855**

The church of Peter Cooper and William Cullen Bryant, All Souls' Unitarian Church, on the southeast corner of Fourth Avenue at East 20th Street, was photographed in all its brick and whitestone splendor by Victor Prevost shortly after it was built in 1855. Designed by Jacob Wray Mould, it was, according to *King's Manual*, "The first experiment made in this country toward a Byzantine style of architecture, though the remarkable tower drawn in the original design was never completed." The foundation for the projected spire is the platform at the bottom center of the photograph.

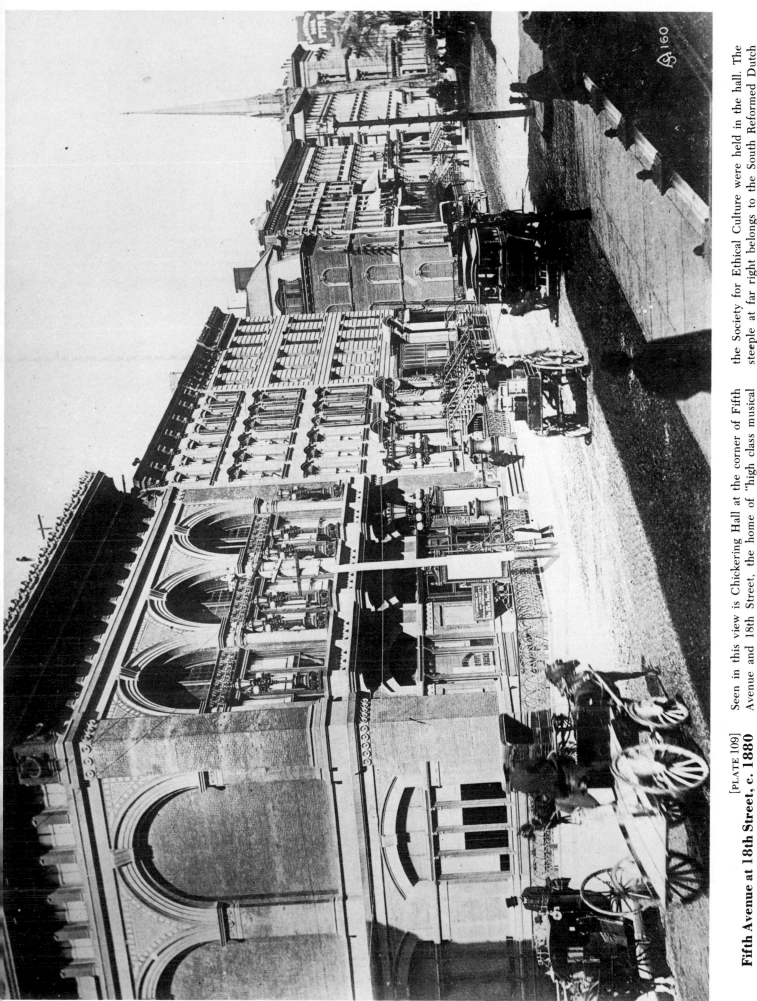

[PLATE 109]
Fifth Avenue at 18th Street, c. 1880

Seen in this view is Chickering Hall at the corner of Fifth Avenue and 18th Street, the home of "high class musical entertainments." On Sundays religious services sponsored by the Society for Ethical Culture were held in the hall. The steeple at far right belongs to the South Reformed Dutch Church on the southwest corner of 21st Street.

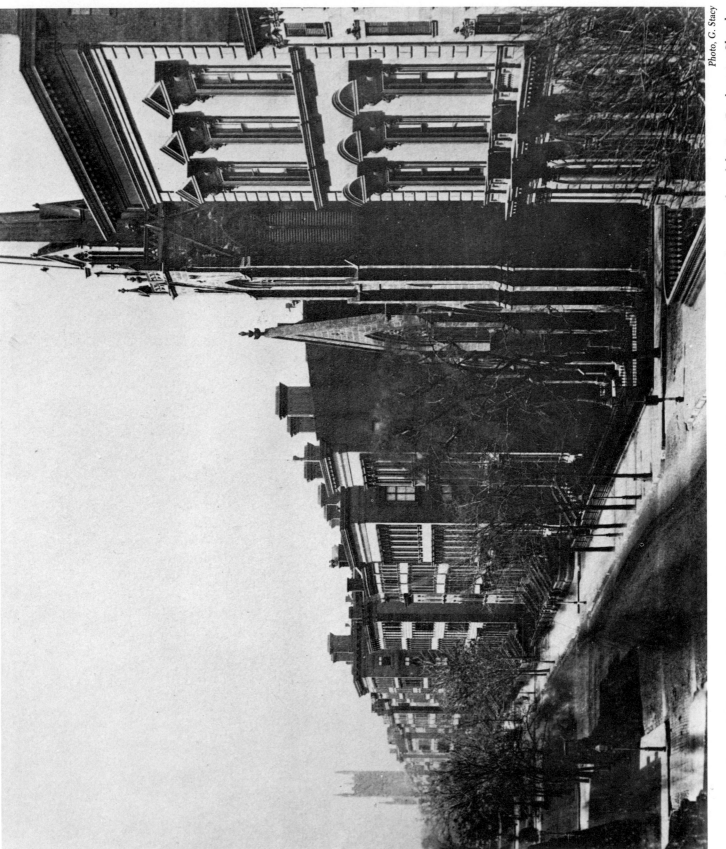

[PLATE 110]
**South on Fifth Avenue,
c. 1865**

Leading off the parade of houses downtown from the west side
of Fifth Avenue above 21st Street, were the Union Club and
Dutch Reform Church, the buildings seen at the right. The

steeple in the distance is that of the First Presbyterian Church
at 12th Street.

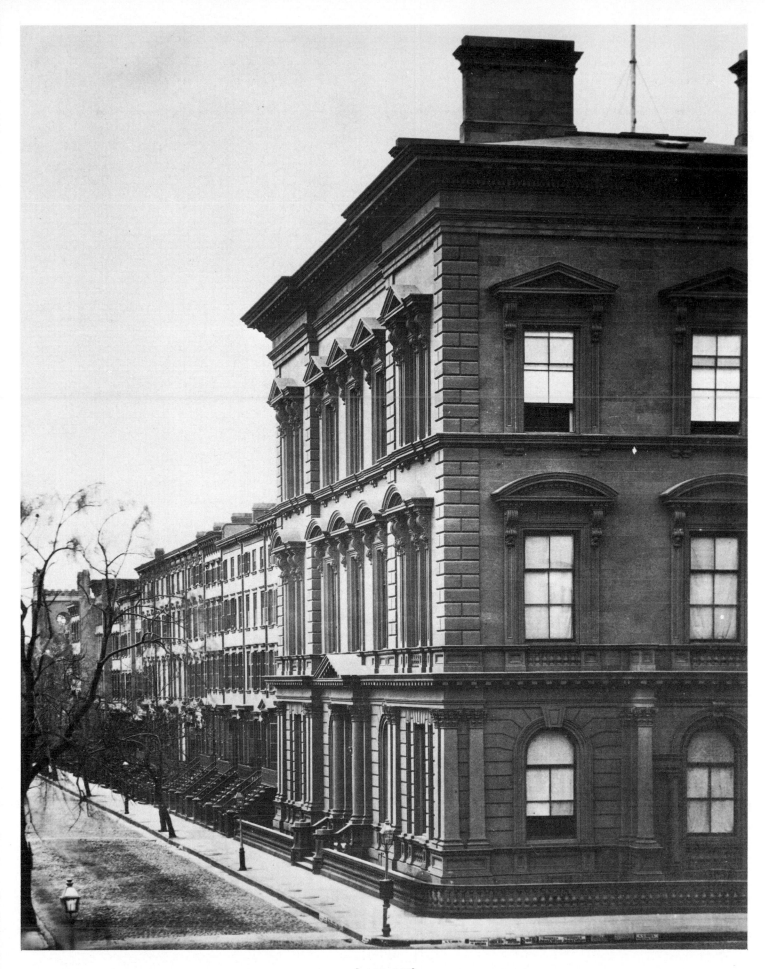

[PLATE 111]
Union Club, c. 1893

The ordered affluence of the row houses on 21st Street at Fifth Avenue is seen in this study in which the fourth home of the Union Club is the most impressive building of the lot. In 1893, the approximate date of this view, it had 1500 members, each of whom paid an entrance fee of $300 and yearly dues of $75—handsome sums in the economy of the 1890s.

131

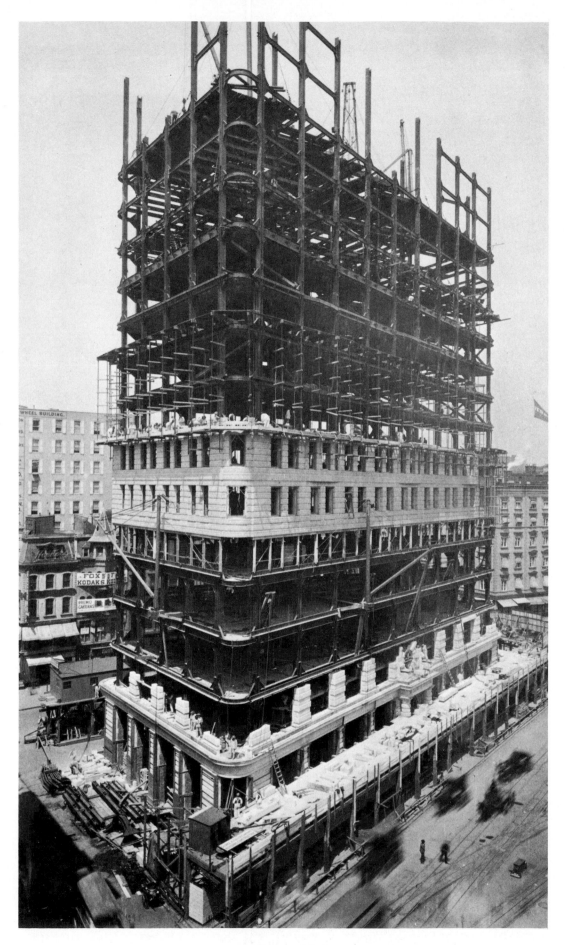

[PLATE 112]
Flatiron Building, 1901

In 1901 George Fuller's Flatiron Building, designed by D. H. Burnham, rose in steel and was clad in gleaming rusticated limestone. For well over half a century it has served as a high landmark on the triangular plot where Broadway and Fifth Avenue meet at 23rd Street. The view here, from 22nd Street, shows very clearly the true nature of the nonbearing curtain walls.

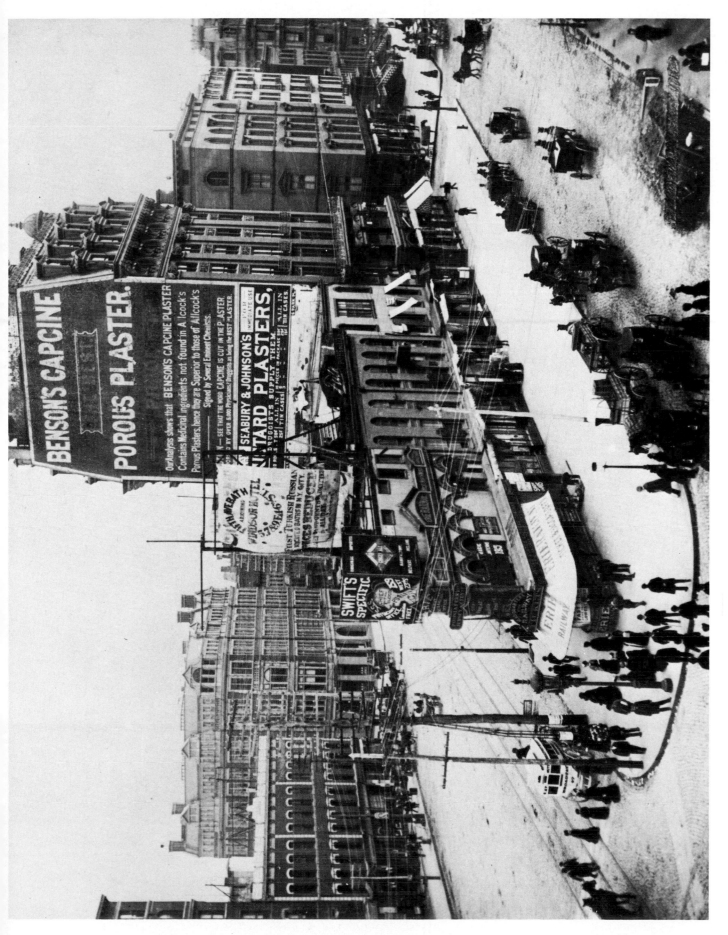

[PLATE 113]
**Fifth Avenue and Broadway at
23rd Street, 1884**

Turning back in time to 1884, the site of the Flatiron Building is like a giant billboard. The photo was taken from a point just west of Madison Square Park where Broadway crosses Fifth Avenue at 23rd Street. The building with the painted side is the Cumberland Hotel. The "Finest Turkish Russian Heated Baths" in the city are advertised on the huge sail of a banner atop the Erie Railroad office, the one steady occupant in this row of low office buildings.

[PLATE 114]
Broadway and 23rd Street, 1890s

At five minutes to twelve on a lost day in the nineties time stood still for the unidentified photographer shooting this view from the east side of Broadway across to the future site of the Flatiron Building. Vignettes of people, carriages, and trolleys are clearcut in this compressed view of four blocks of city streets. The major structure at the left with the classical portico is the Fifth Avenue Hotel. Only the Worth Monument (at the right) and the tall, dark-colored building across the street from the hotel are still standing. Note the "Painless Dentistry" sign—a common advertisement in the days before novocaine.

[PLATE 115]
Broadway and 23rd Street, 1899

This September afternoon view was taken from almost the same place as the preceding photograph, but the site is transformed by the dazzling pillars and the plaster and lathe arch honoring Admiral Dewey, the triumphal arch that lined up with the earlier one on lower Fifth Avenue dedicated to Washington's memory (see Nos. 116 and 117). The vicissitudes of the tenants on the Flatiron Building site are emphasized by changes in business names—while painless dentists have operated there for years their identities change as only the Erie Railroad sign remains the same.

IX

B R O A D W A Y

to the East River from 23rd Street to 40th Street

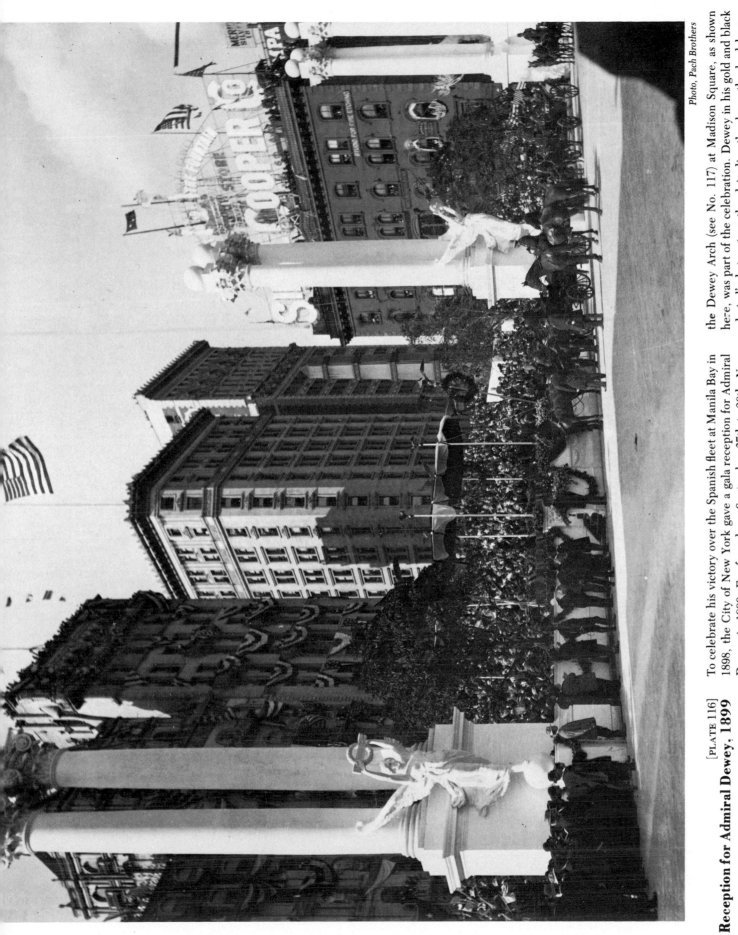

Photo, Pach Brothers

[PLATE 116]
Reception for Admiral Dewey, 1899

To celebrate his victory over the Spanish fleet at Manila Bay in 1898, the City of New York gave a gala reception for Admiral Dewey in 1899. For four days, September 27th to 30th, New York City was filled with troop parades and maneuvers, and naval maneuvers were carried out in both rivers. Dedication of the Dewey Arch (see No. 117) at Madison Square, as shown here, was part of the celebration. Dewey in his gold and black admiral's hat enters the dais directly above the lead horse. Note the famous advertising slogan "Meet Me at the Fountain" on the Siegel-Cooper department store.

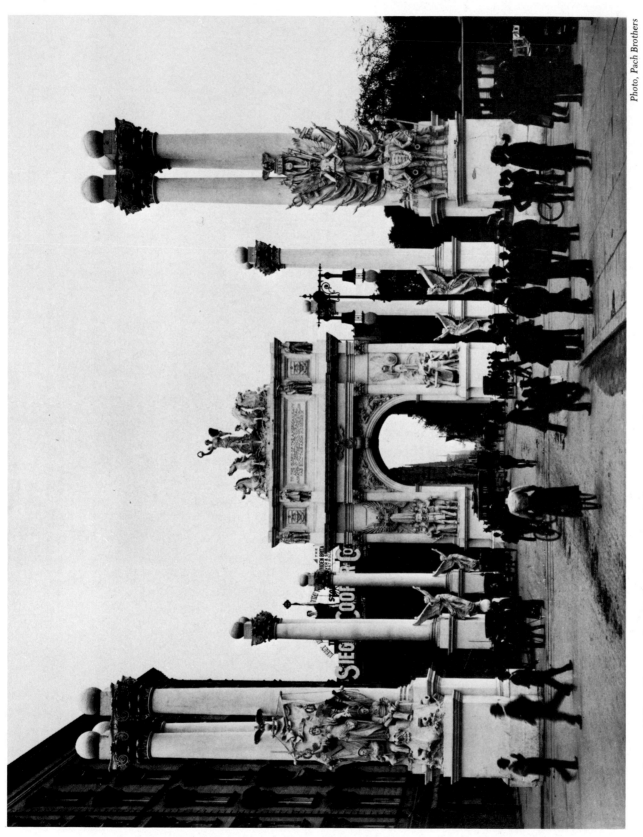

Photo, Pach Brothers

[PLATE 117]
Dewey Arch, 1899

Here we have a head-on view of the Dewey Arch, looking north on Fifth Avenue with the Fifth Avenue Hotel at the left. The Arch was built at an actual cost of $35,000 for materials and artisan labor. Works by leading American sculptors were included in the ornate design, which was suggested by the general outline of the Roman arch of Titus and Vespasian, according to the program, *The Dewey Reception and Committee of New York City, an Album of One Thousand Portraits, Scenes, etc.,* published by Moses King. The twenty-foot quadriga crowning the arch was designed by John Quincy Adams Ward, president of the National Sculpture Society. The four colossal groups at the base of the arch were by Philip Martiny, Karl Bitter, Charles H. Niehaus, and Daniel Chester French. The Dewey Arch was aligned with the Washington Arch, thus converting the lower stretch of Fifth Avenue into a "triumphal" thoroughfare of a type frequently found in Europe.

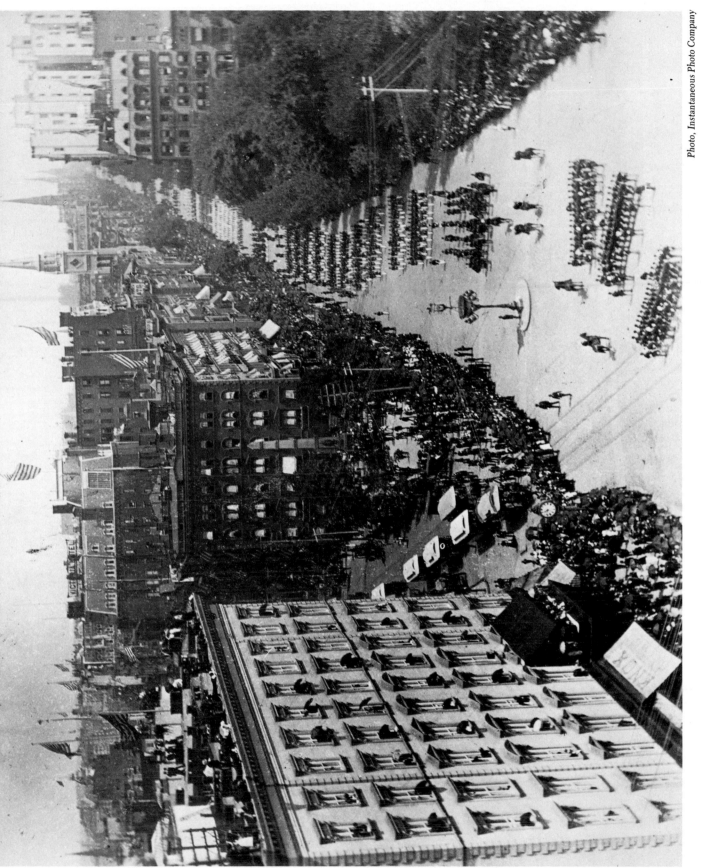

[PLATE 118]
Troop Parade in Madison Square, 1886

As the parade makes its way down Fifth Avenue, observers at windows in the Fifth Avenue Hotel (left) watch in comfort beneath a host of black shade umbrellas. The handsome lamp in the square and, further north, the obelisk to General Worth show to advantage. A tangle of people, carts, and streetcars on Broadway wait and watch in the morning sun as the parade passes by.

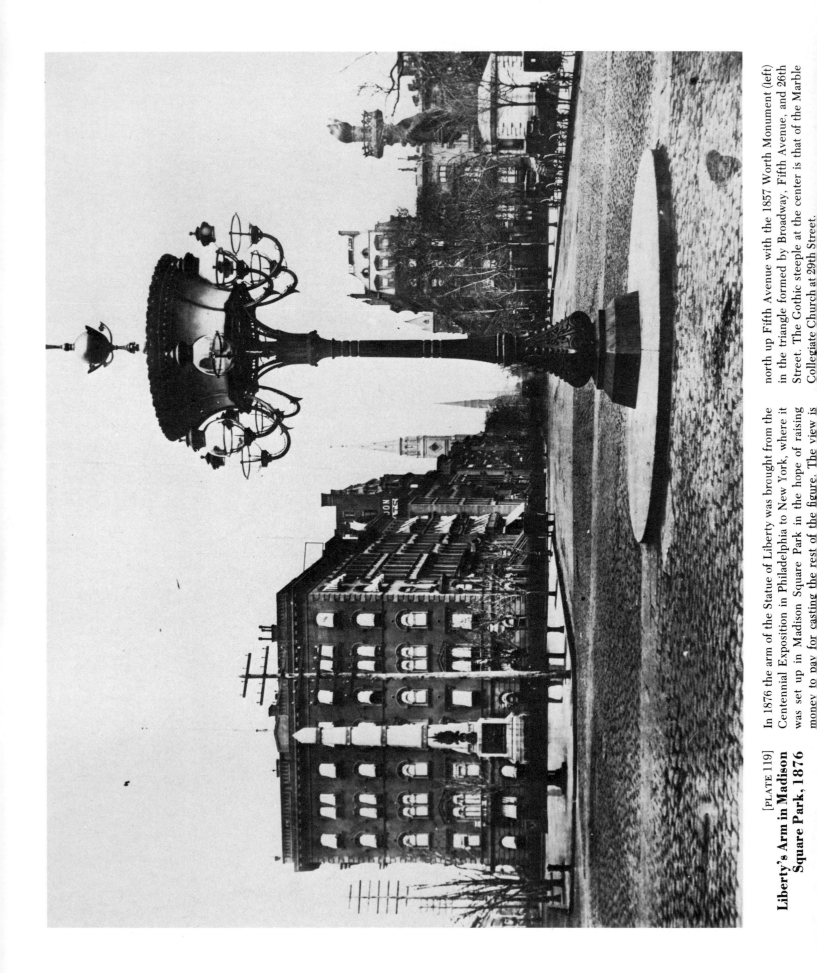

[PLATE 119]

Liberty's Arm in Madison Square Park, 1876

In 1876 the arm of the Statue of Liberty was brought from the Centennial Exposition in Philadelphia to New York, where it was set up in Madison Square Park in the hope of raising money to pay for casting the rest of the figure. The view is north up Fifth Avenue with the 1857 Worth Monument (left) in the triangle formed by Broadway, Fifth Avenue, and 26th Street. The Gothic steeple at the center is that of the Marble Collegiate Church at 29th Street.

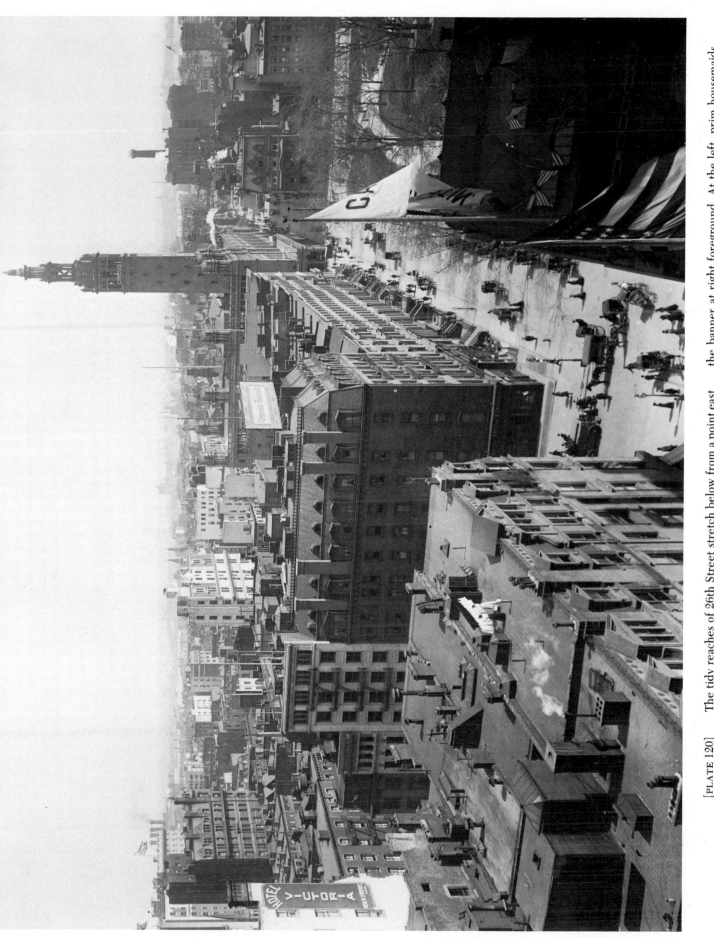

[PLATE 120]

East 26th Street, c. 1900

The tidy reaches of 26th Street stretch below from a point east of Madison Square (right) with Madison Square Garden on the north side of the street just beyond it. The Jerome Mansion (see No. 123) facing on the park is above and to the right of the banner at right foreground. At the left, prim housemaids hang a glistening wash on an unsullied rooftop above Fifth Avenue.

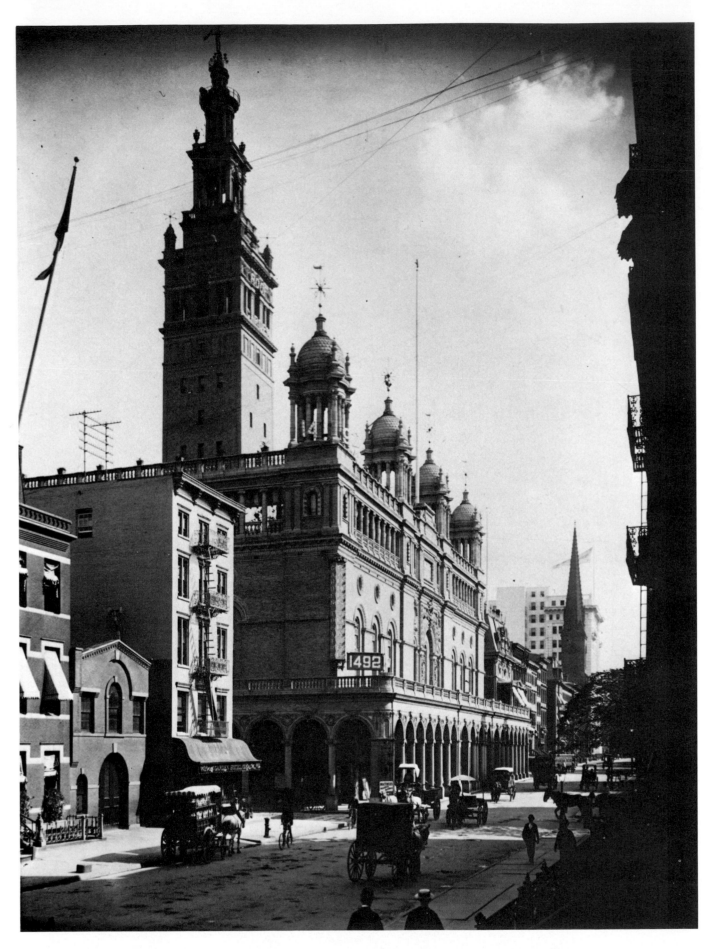

Madison Square Garden, 1892

At a cost of $3,000,000 the Madison Square Garden Company built its second structure at Madison Avenue and 26th Street. At the time of this photograph it was the largest building in America devoted entirely to amusements. Within its walls there were circuses, social and fund-raising activities, horse and dog shows, cultural and sports events. The exterior, finished in buff brick and terra-cotta tile, was distinguished by a roof colonnade, open cupolas, and an arcade at street level.

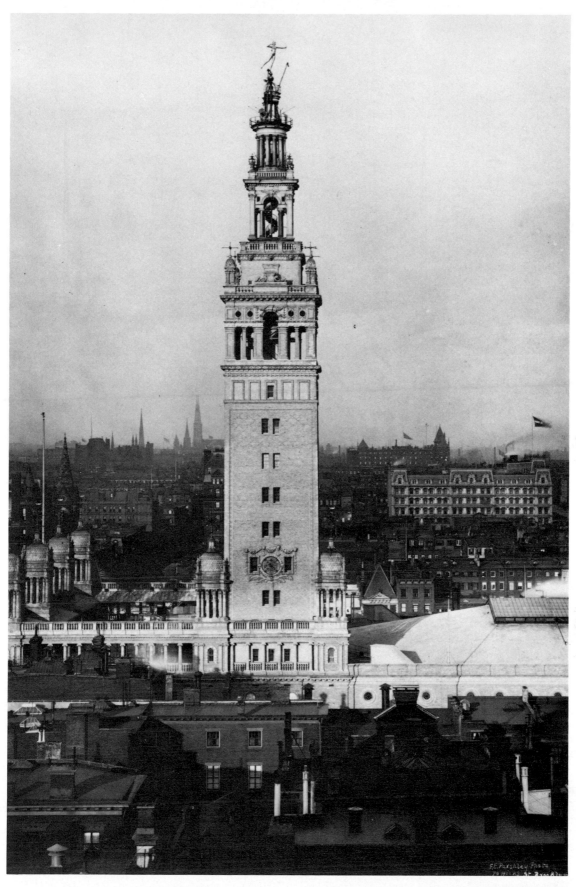

Photo, E. E. Parshley

[PLATE 122]
Madison Square Garden, c. 1895

Photographed in late afternoon (probably from the roof of a building south of 24th Street) this view of the second Madison Square Garden shows the building in a light reminiscent of Seville where its inspiration, the Moorish Giralda Tower, still stands.

Saint-Gaudens' figure of Diana atop the tower is seen without her original drapery—stripped away in a thunder-storm. Dwarfed by the tower in this view, the statue's heroic size is now apparent as she stands in ten-foot splendor on the stair landing at the Philadelphia Museum of Art. In the gallery to the left of the tower, Harry Thaw shot and killed Stanford White in 1906. In addition to a vast amphitheater, a café, concert hall, an assembly or dining hall, and a huge kitchen were located within its walls.

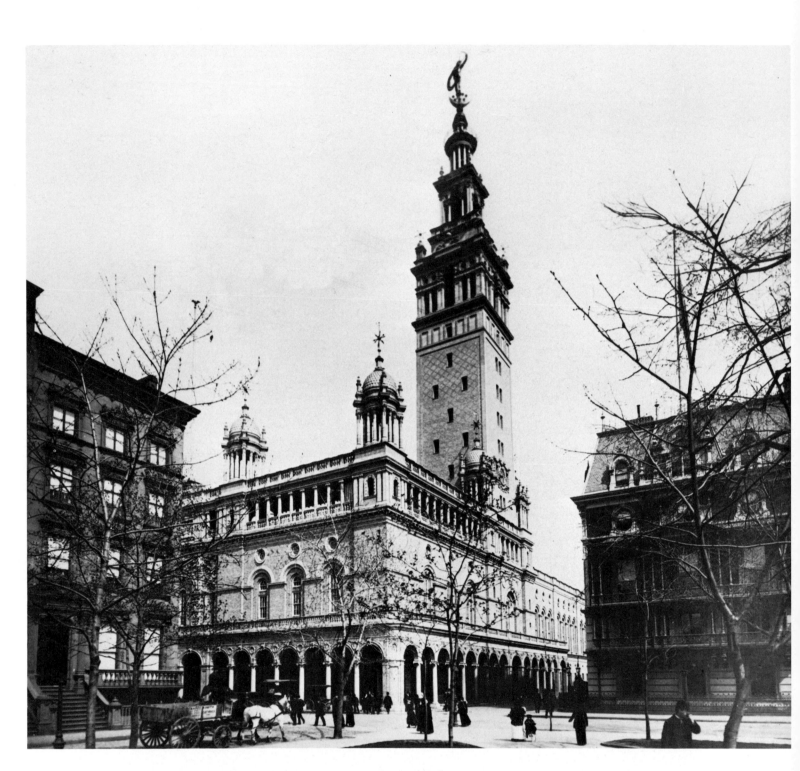

[PLATE 123]
Madison Square Garden, c. 1895

The second Madison Square Garden—McKim, Mead and White's stunning design—is seen at the center. To the right is the recently demolished Jerome Mansion, the house where Winston Churchill's mother lived as a girl. The date is set by the years in which the firm of Candee and Smith, whose horse-drawn delivery wagon is seen in the foreground, had its main office on the East River at the foot of 26th Street.

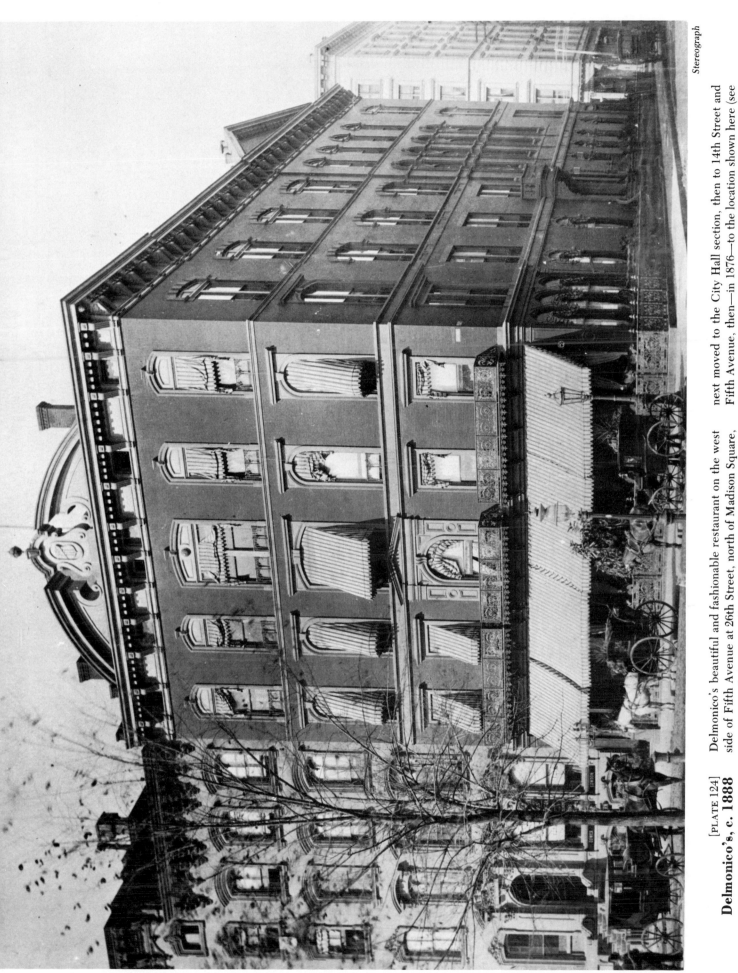

[PLATE 124]

Delmonico's, c. 1888

Delmonico's beautiful and fashionable restaurant on the west side of Fifth Avenue at 26th Street, north of Madison Square, appears to advantage in this late nineteenth-century stereograph. The original Delmonico's was near Bowling Green; it next moved to the City Hall section, then to 14th Street and Fifth Avenue, then—in 1876—to the location shown here (see also No. 138).

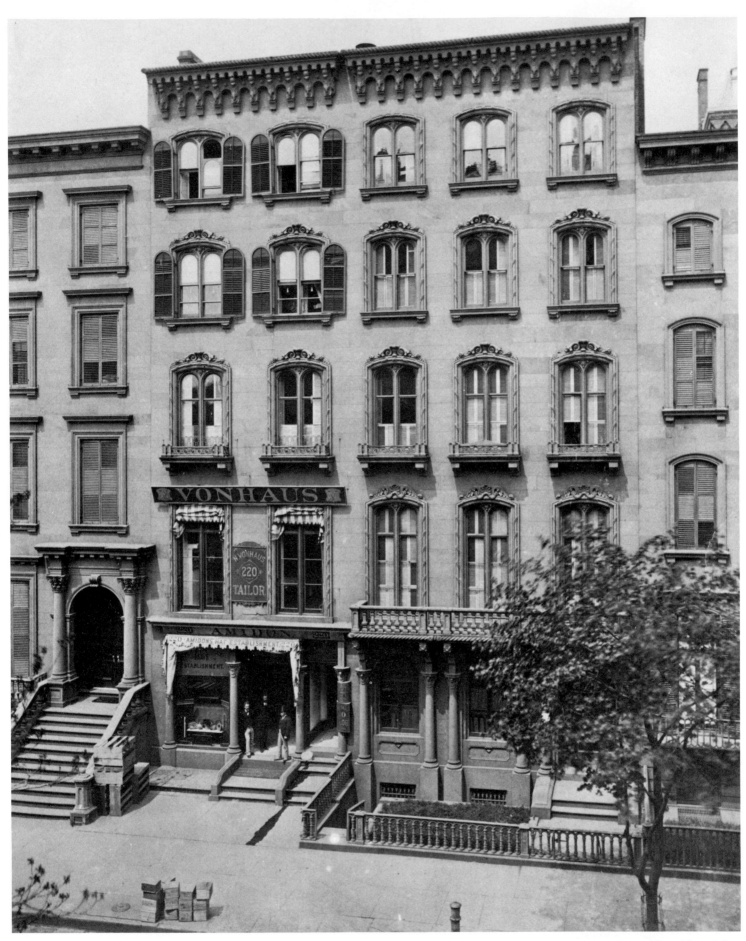

Photo, Silas A. Holmes

[PLATE 125]

Fifth Avenue between 26th and 27th Streets, 1876

On the west side of Fifth Avenue just north of Madison Square and across from the Hotel Brunswick stood this graceful five-story double house. At 220 Fifth, Nicholas Vonhaus had a tailoring shop on the second floor; on the ground floor, Francis H. Amidon and his son James Rufus made hats. The senior Amidon lived in the uptown side of the double house at the right, behind the neatly shuttered windows seen here.

[PLATE 126]
**Fifth Avenue North of
27th Street, c. 1865**

This view of Fifth Avenue, with its narrow paving-block street, wide sidewalks, and handsome lamps, fences, and stair rails, shows the steeple of Samuel A. Warner's Marble Collegiate Reformed Church, built in 1854. The Collegiate Reformed Protestant Dutch Church was established in 1628 as the first ecclesiastical organization in the city; the Marble Church was one of several member churches active in the parish two centuries later. The residential quality of the street in this period is noteworthy.

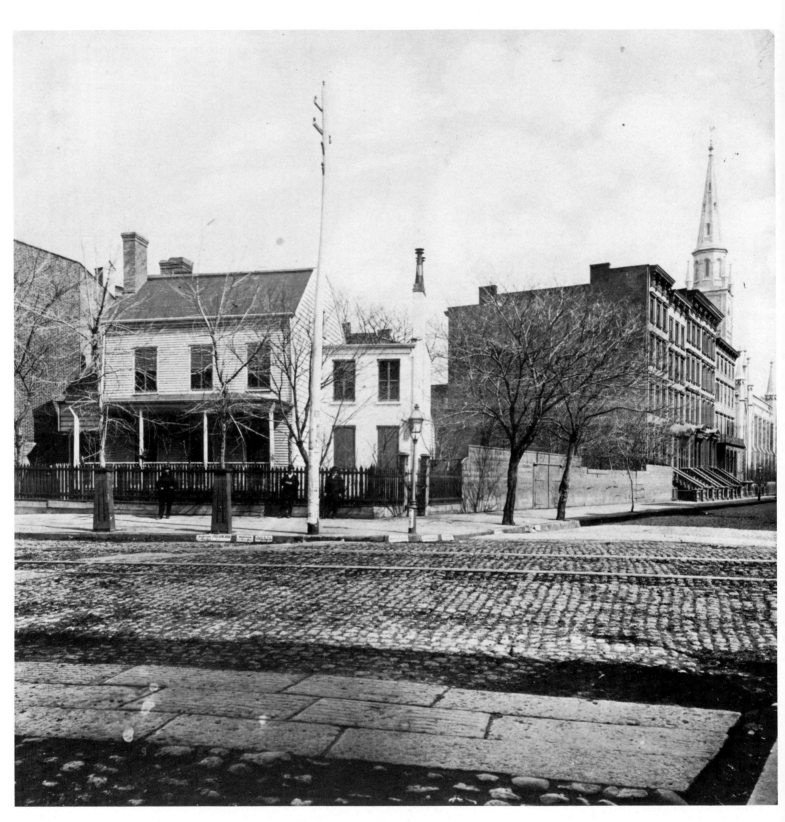

[PLATE 127]
Caspar Samler's Farmhouse, c. 1865

Here, looking across Broadway to the northeast corner of 29th Street, is seen the neat farmhouse of Caspar Samler, with paint, chimneys, and fences intact although the closed shutters suggest that the house is vacant. The church steeple with the weathercock (at far right) is Marble Collegiate Reformed Church on Fifth Avenue.

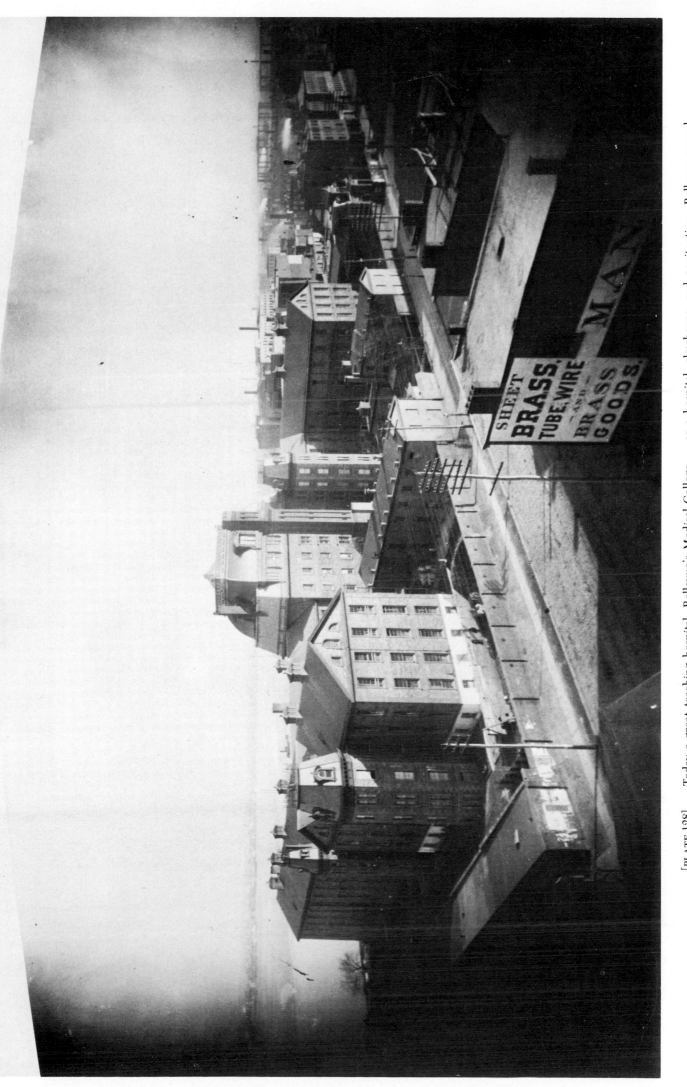

[PLATE 128]
Bellevue Hospital, c. 1885

Today a great teaching hospital, Bellevue's Medical College was founded in 1861. This late afternoon shot shows the central building and wings of the Bellevue Hospital complex outlined against the East River. The photograph was taken from the First Avenue side looking south at 28th Street. Opened in 1816 as a hospital, almshouse, and penitentiary, Bellevue served this triple function until 1848, when the paupers and prisoners were moved to quarters on Blackwell's (now Roosevelt) Island.

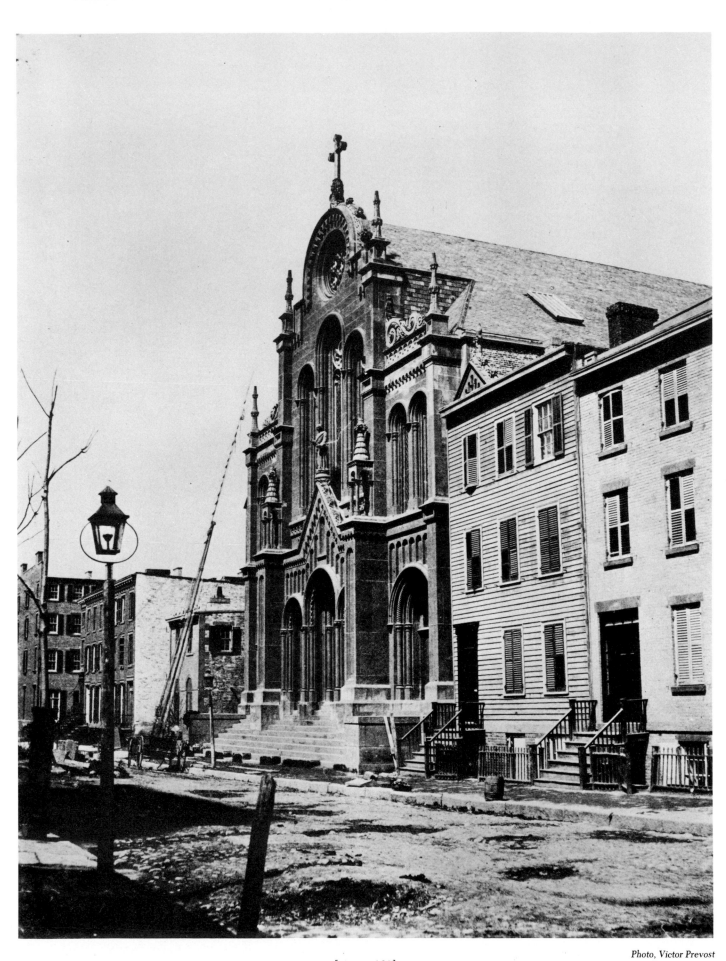

[PLATE 129]
St. Stephen's Roman Catholic Church, c. 1853

When Victor Prevost, "artist," recorded this view in 1853, St. Stephen's, on East 28th Street near Third Avenue, was newly built and an evanescent extension ladder beside it suggests that work was still in progress. The church was located just a few blocks east of Prevost's dwelling at 28 East 28th Street. The street lamp, the shuttered houses, and the ungraded street all capture another era in the city's history.

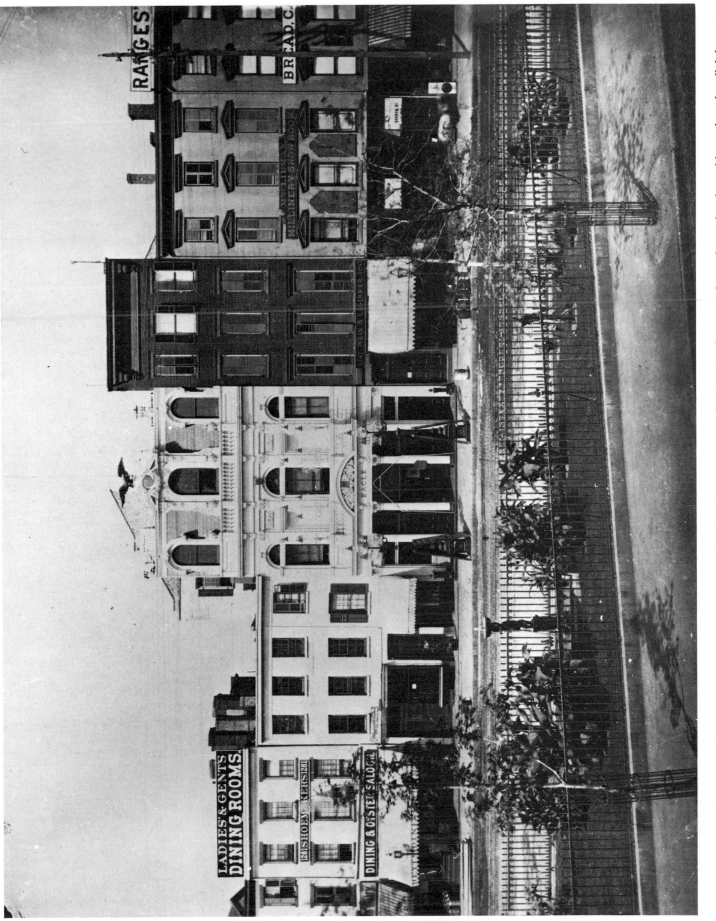

[PLATE 130]
Eagle Theatre, 1877

On Sixth Avenue between 32nd and 33rd Streets just south of the point where Broadway crossed (its sidewalk is in the foreground) stood the 1875 Eagle Theatre with ornate lights and street lamps, and an eagle with full wingspread cresting its facade. A wooden Indian is barely visible on the sidewalk left of the theater. The site is now the location of Gimbel's Department Store.

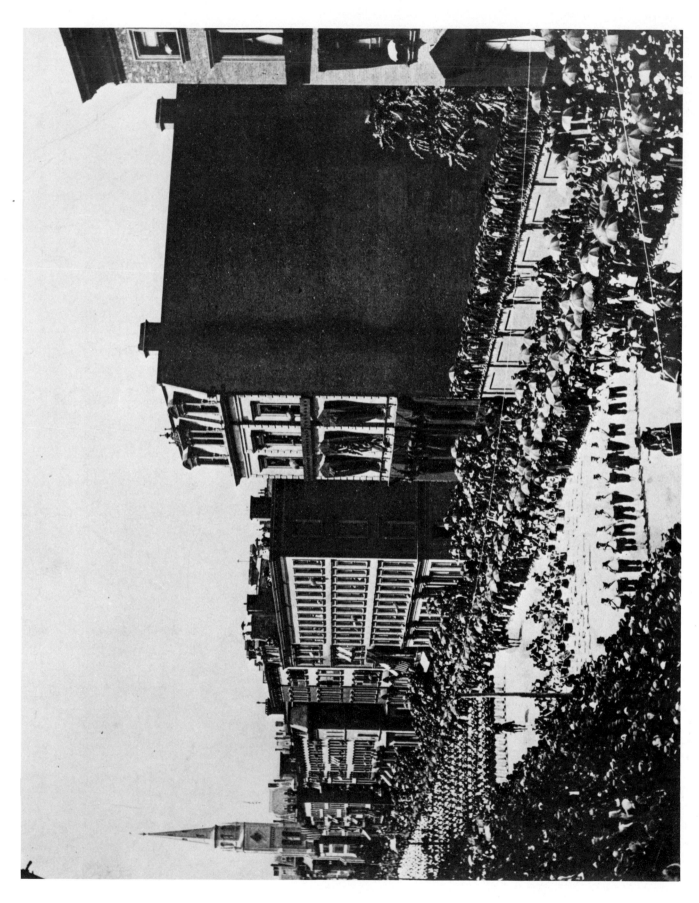

[PLATE 131]
**In Mourning for President
Grant, 1885**

Shaded from the morning sun by a canopy of umbrellas, New Yorkers line the street as the Naval Brigade Pioneer Corps and band in the funeral procession for Grant moves north along Fifth Avenue on August 8, 1885. The mansions of William Astor (far right) at 350 Fifth Avenue and John Jacob Astor at number 338 (right center, at the northwest corner of 33rd Street) are swathed in mourning cloth. Young men and boys have scaled the wall dividing the street from the empty lots between the two houses. Down Fifth Avenue at 29th Street rises the steeple of Marble Collegiate Church, a familiar landmark and locator in old photographs of the city.

154

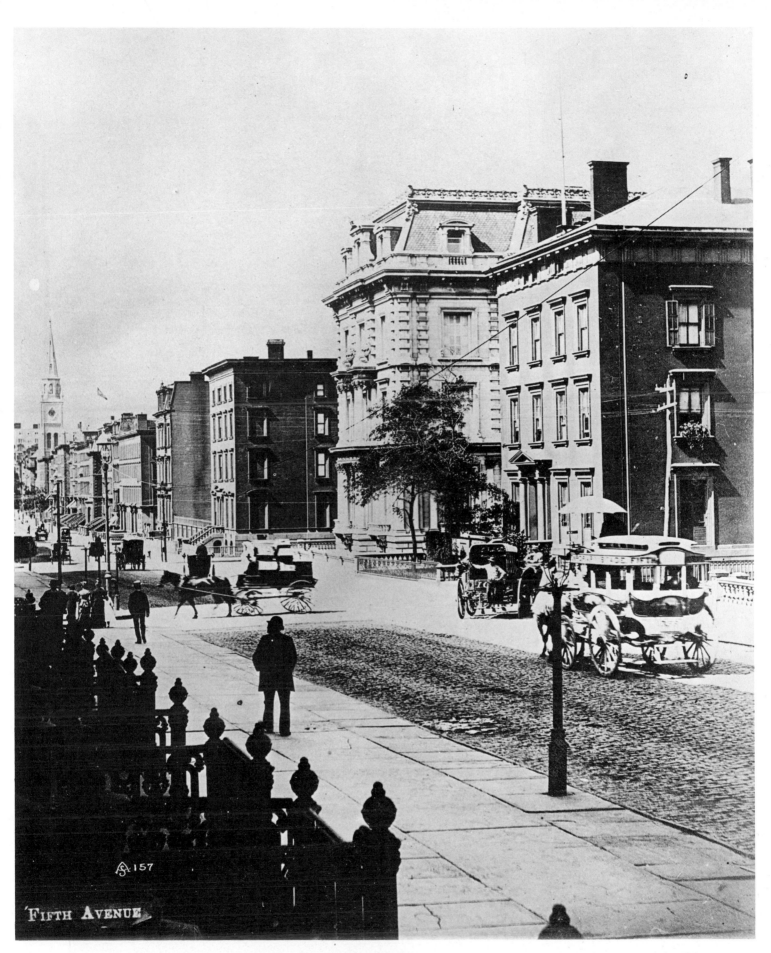

FIFTH AVENUE

[PLATE 132]
Fifth Avenue from 33rd Street, c. 1880

Looking south on Fifth Avenue from 35th Street, the Stewart mansion (the four-story structure with a mansard roof) appears at center. The steeple of Marble Collegiate Church at 29th and Fifth is seen at the far left. Fifth Avenue, with its wide sidewalks and narrow cobbled roadway, shows to advantage in this view. The order and cleanliness of this much-used thoroughfare is remarkable.

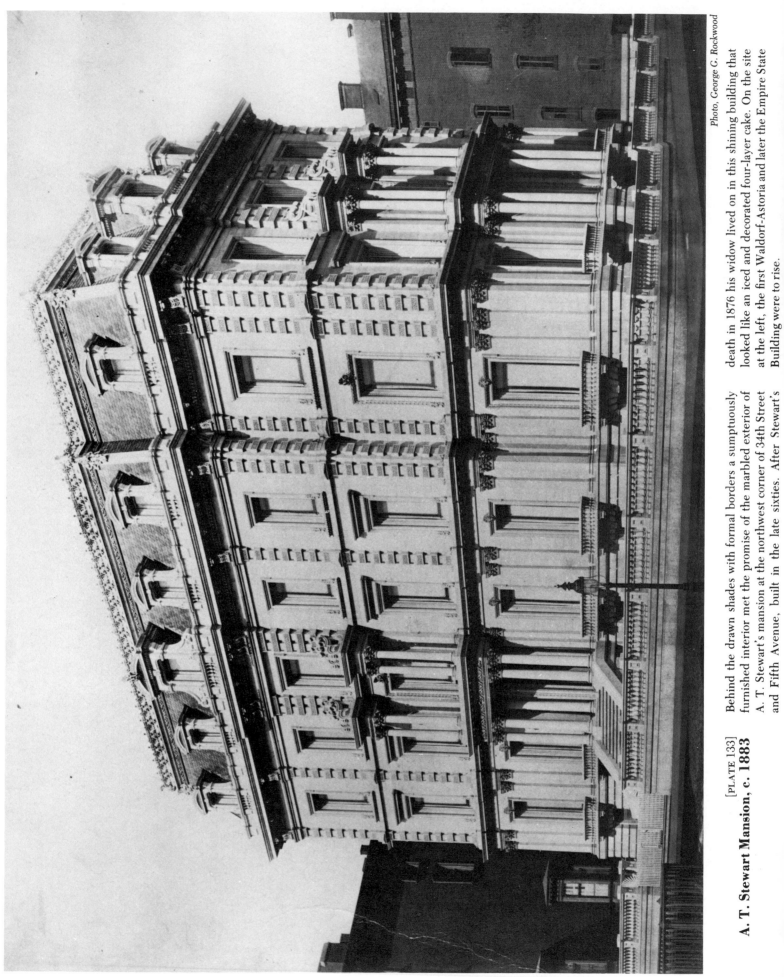

[PLATE 133]

A. T. Stewart Mansion, c. 1883

Behind the drawn shades with formal borders a sumptuously furnished interior met the promise of the marbled exterior of A. T. Stewart's mansion at the northwest corner of 34th Street and Fifth Avenue, built in the late sixties. After Stewart's death in 1876 his widow lived on in this shining building that looked like an iced and decorated four-layer cake. On the site at the left, the first Waldorf-Astoria and later the Empire State Building were to rise.

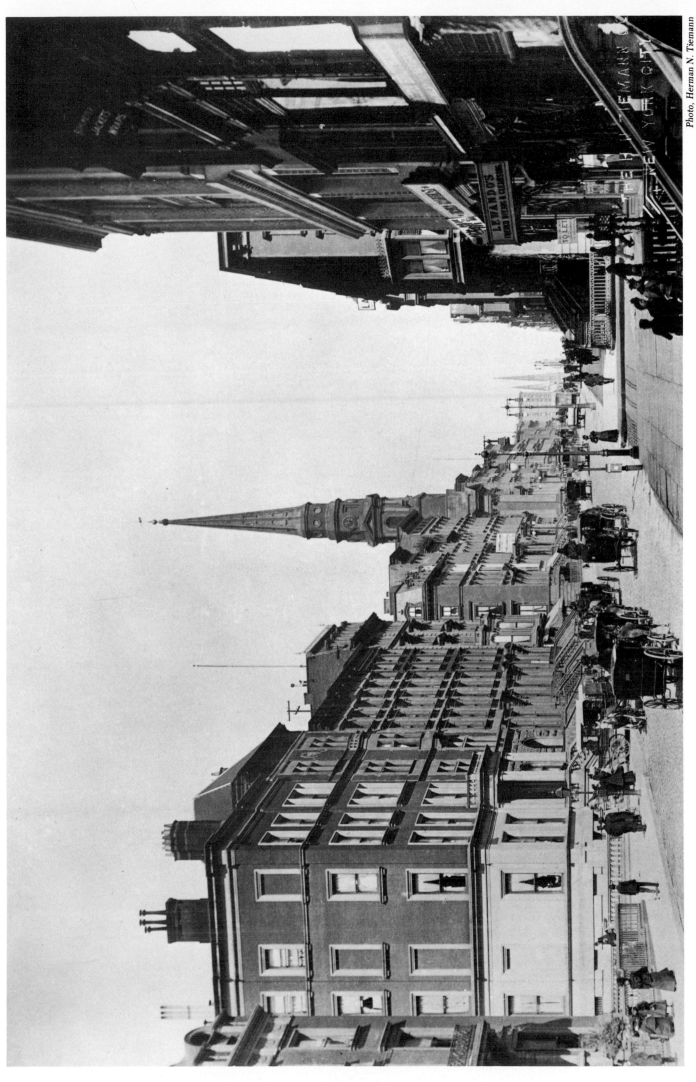

Photo, Herman N. Tiemann

[PLATE 134]
**Fifth Avenue North of 35th Street,
c. 1895**

The low profile of Fifth Avenue late in the nineteenth century is punctuated on the west side by three church steeples that identify the extent of the view. Each of the three—Brick Presbyterian at 37th Street, Reform Dutch at 48th Street, and St. Thomas at 53rd Street—is located on a northwest corner.

X

THE EAST SIDE

from Fifth Avenue to the East River between

40th Street and 59th Street

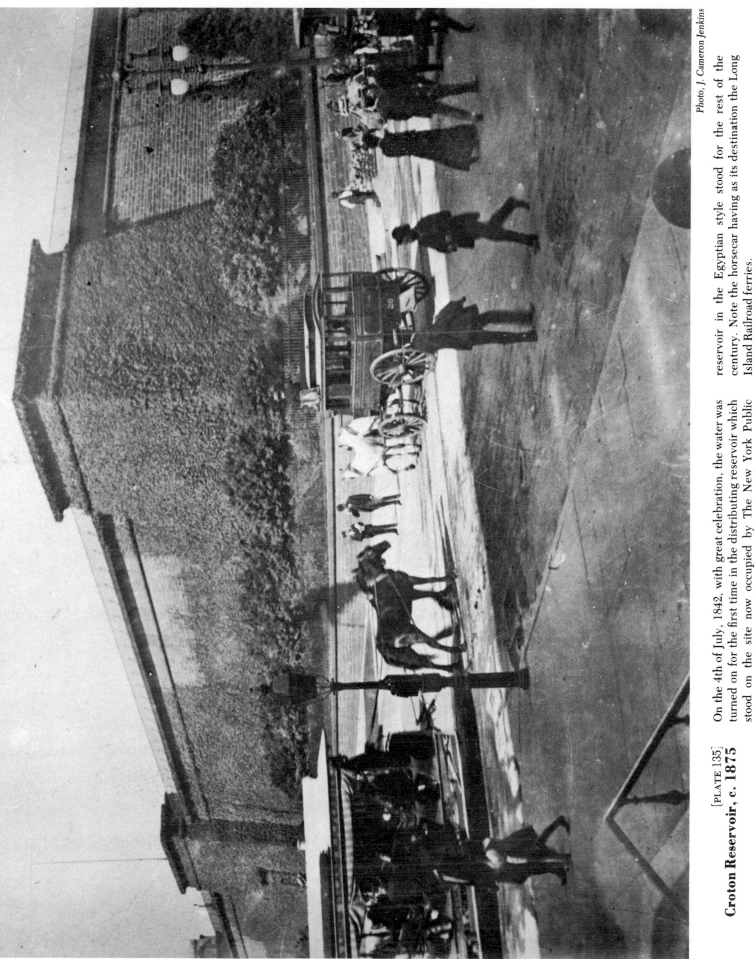

[PLATE 135]

Croton Reservoir, c. 1875

On the 4th of July, 1842, with great celebration, the water was turned on for the first time in the distributing reservoir which stood on the site now occupied by The New York Public Library at Fifth Avenue between 40th and 42nd Streets. The reservoir in the Egyptian style stood for the rest of the century. Note the horsecar having as its destination the Long Island Railroad ferries.

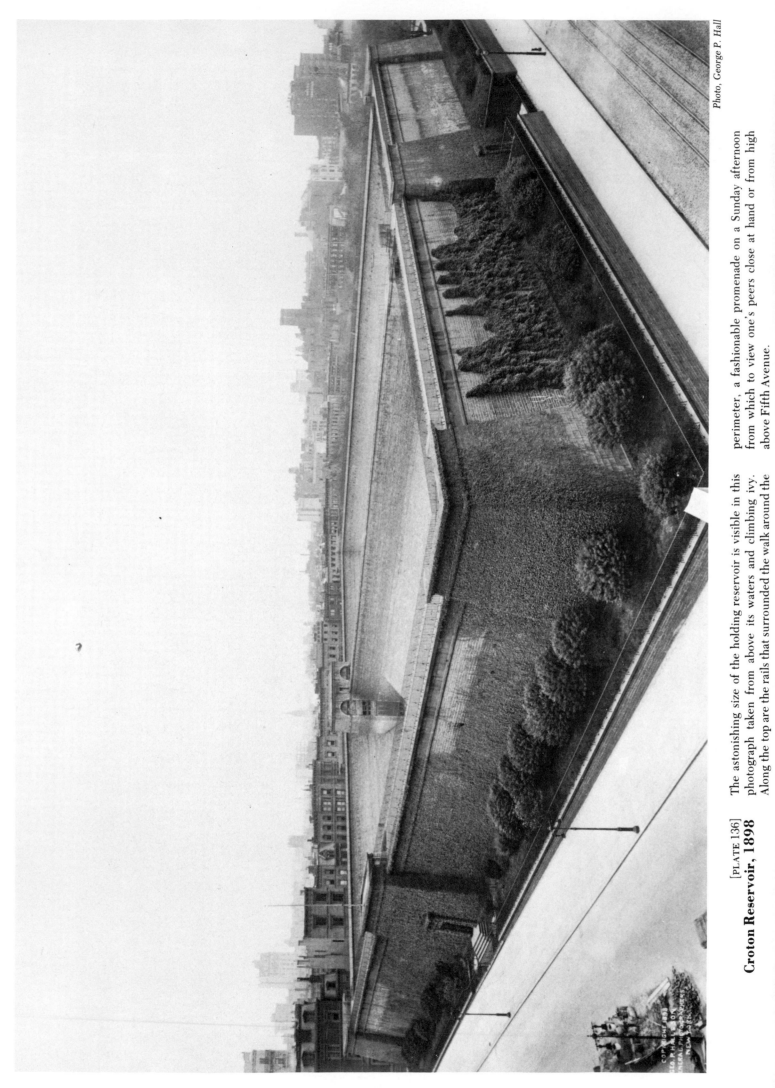

[PLATE 136]
Croton Reservoir, 1898

The astonishing size of the holding reservoir is visible in this photograph taken from above its waters and climbing ivy. Along the top are the rails that surrounded the walk around the perimeter, a fashionable promenade on a Sunday afternoon from which to view one's peers close at hand or from high above Fifth Avenue.

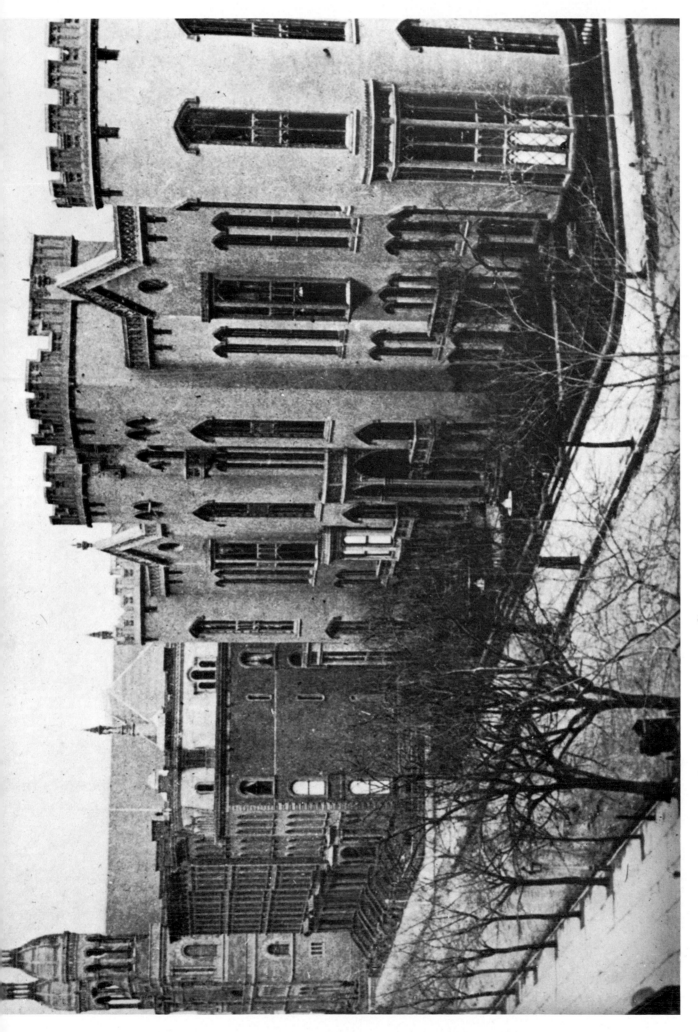

[PLATE 137]
House of Mansions, c. 1875

Filling the block opposite the Croton Reservoir on the east side of Fifth Avenue between 41st and 42nd Streets was the House of Mansions, eleven attached houses forming one overall complex, designed by Alexander Davis and erected about 1856. Rutgers Female College owned the north half of the building and occupied space there from 1860 to 1883. At the far left are the towers of the first Temple Emanu-El at Fifth Avenue and 43rd Street. The synagogue, designed by Leopold Eidlitz and completed in 1868, was in the grandiose and popular "Moorish" style.

163

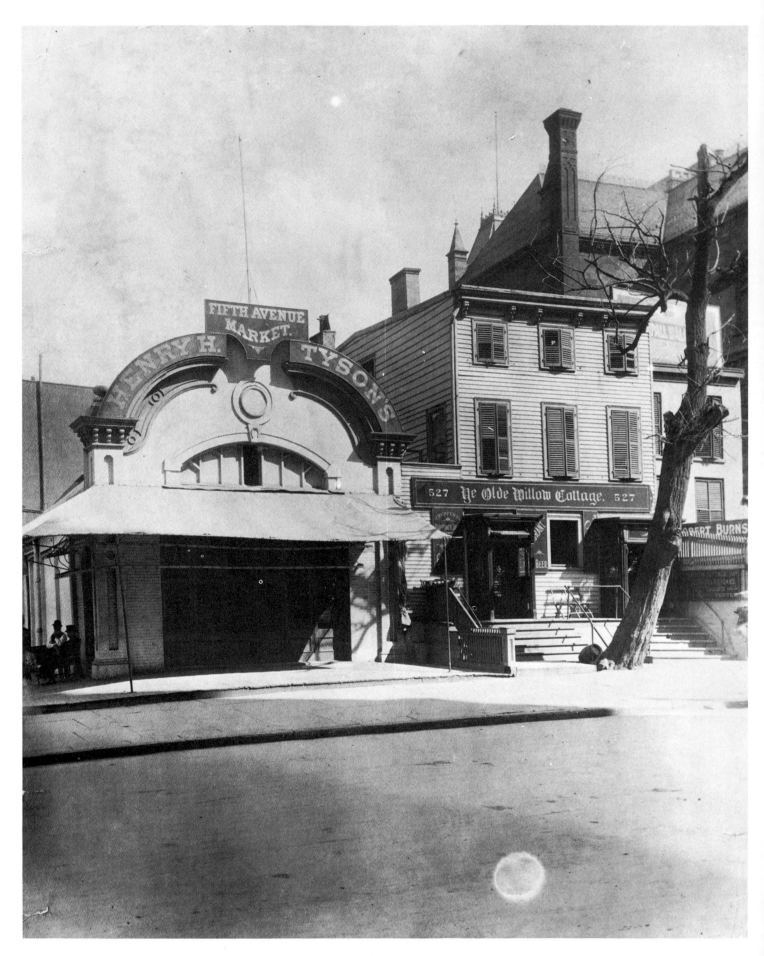

[PLATE 138]
Fifth Avenue, c. 1898

In the same block as Temple Emanu-El and just south of Delmonico's (by this time on 44th Street; see No. 124) is the meat market of Henry H. Tyson. Next door—shuttered behind an aged and sickly tree—is Ye Olde Willow Cottage purveying ye olde demon rum.

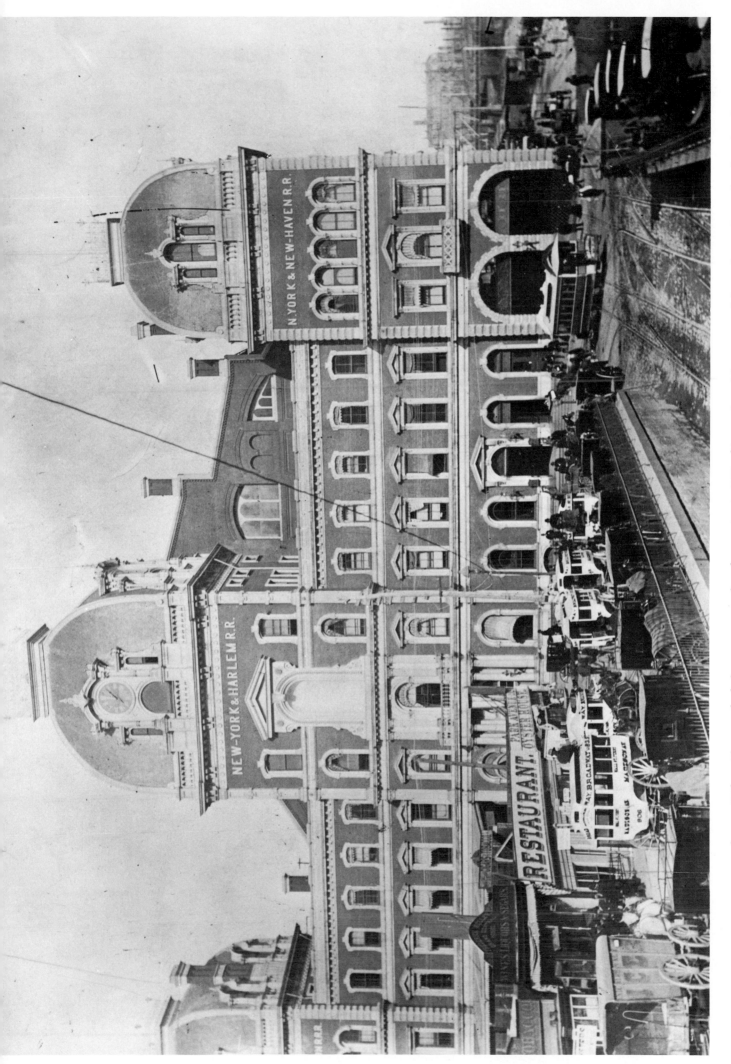

[PLATE 139]
Grand Central Depot, c. 1880

Photographed about ten years after the opening in 1871, this view of the southern facade of Grand Central shows the northern entrance of the Murray Hill Tunnel at the right and a glut of hansoms and horse-drawn jitneys lined up beside a raffish row of shops. Note the genteel group collected at the door of the one purveying wines, liquors, and "segars."

165

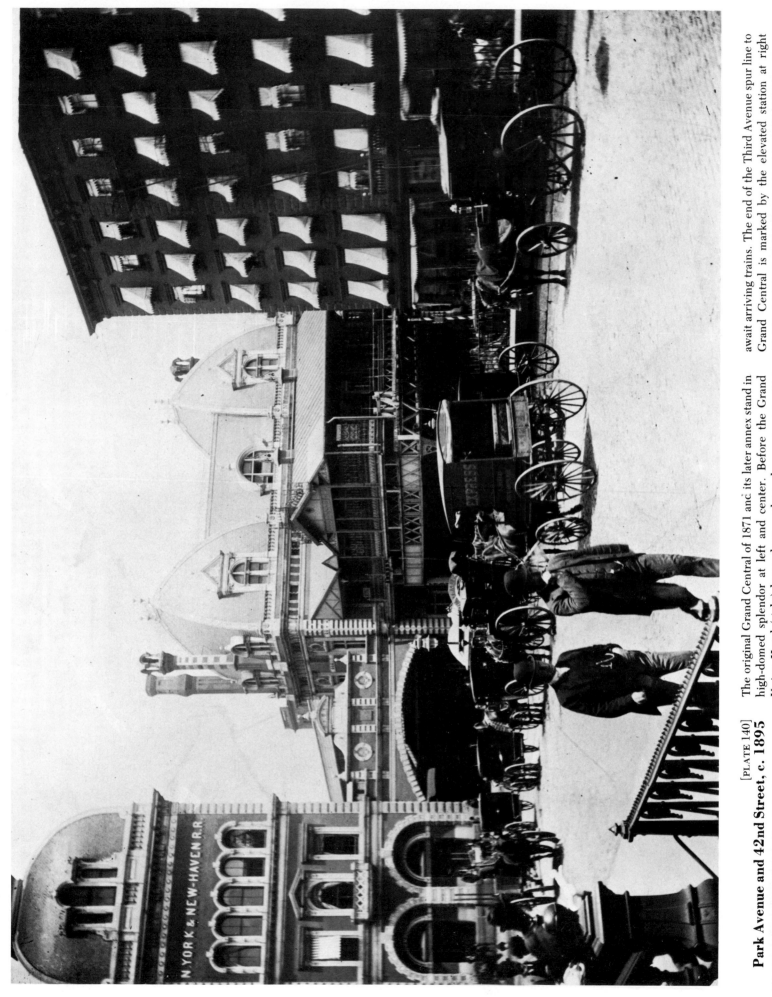

[PLATE 140]

Park Avenue and 42nd Street, c. 1895

The original Grand Central of 1871 and its later annex stand in high-domed splendor at left and center. Before the Grand Union Hotel (right) horse drawn cabs stand in serried ranks to await arriving trains. The end of the Third Avenue spur line to Grand Central is marked by the elevated station at right

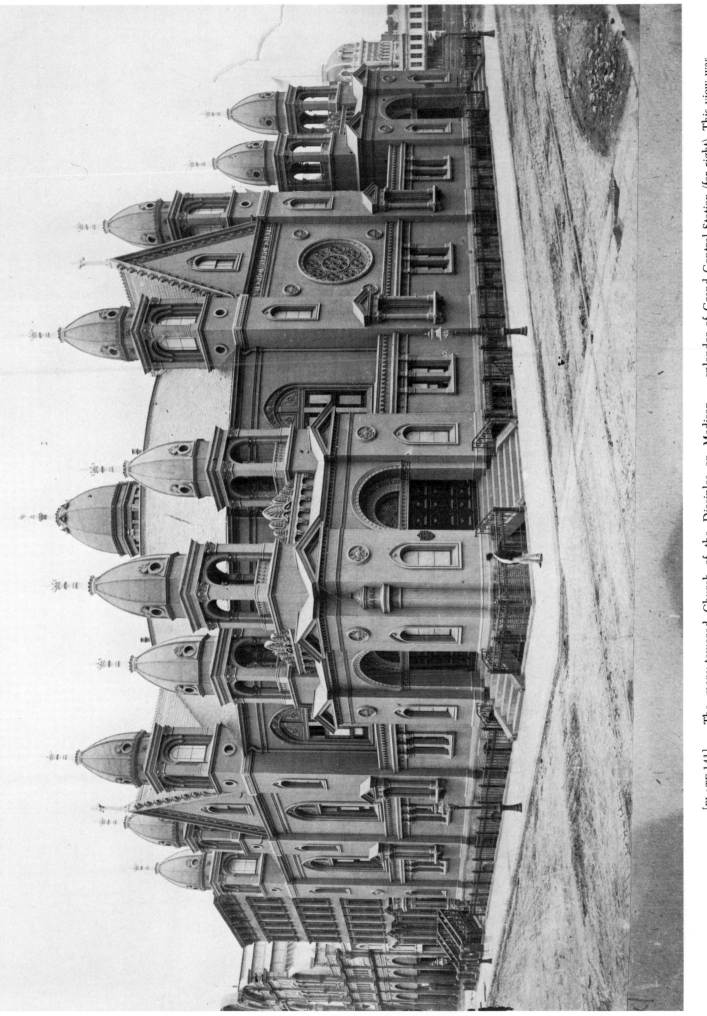

[PLATE 141]

Church of the Disciples, c. 1875

The many-towered Church of the Disciples on Madison Avenue at the southeast corner of 45th Street was a heavenly respite from the train shed of Grand Central (far left) and the splendor of Grand Central Station (far right). This view was taken by an unidentified photographer while the church, dedicated in 1873, was still new.

167

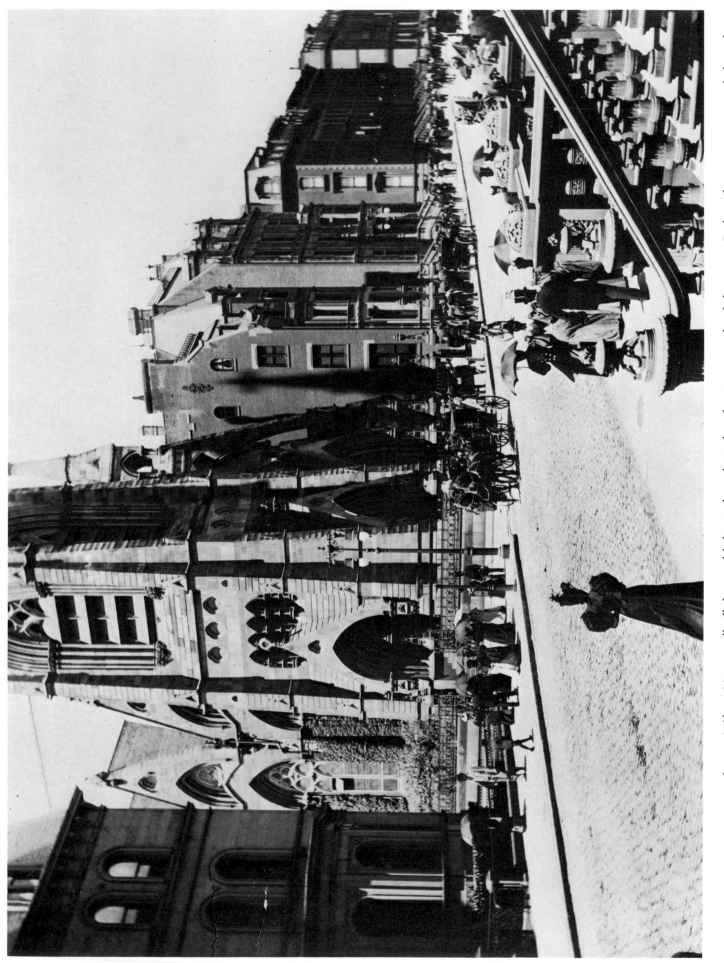

[PLATE 142]
Fifth Avenue and 48th Street, 1894

Men in tall silk hats and ladies in long skirts, leg-of-mutton sleeves, and fashionably plumed bonnets promenade along the sidewalk before the stone balustrades and steps of Fifth Avenue and the Fifth Avenue Collegiate Church on the west side of the street. Dedicated some twenty years before, the exterior of the church was faced with Newark sandstone. A graceful stone and iron fence, incorporating street lamps into its design, surrounded the church.

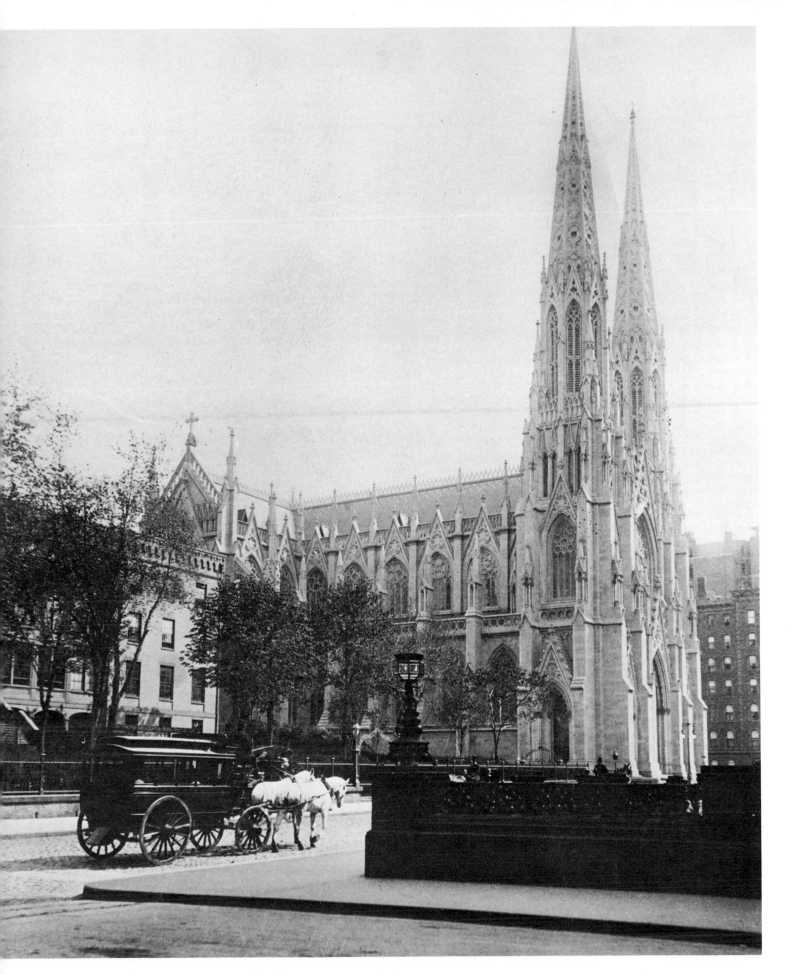

[PLATE 143]
St. Patrick's Cathedral, c. 1894

From 50th to 52nd Street the land between Madison and Fifth Avenues was occupied at the century's end by Roman Catholic structures—the boy's quarters of the Catholic Orphan Society (seen here behind the horse-drawn trolley) and, south of it, St. Patrick's Cathedral, constructed between 1858 and 1879 in neo-Gothic style after James Renwick's design.

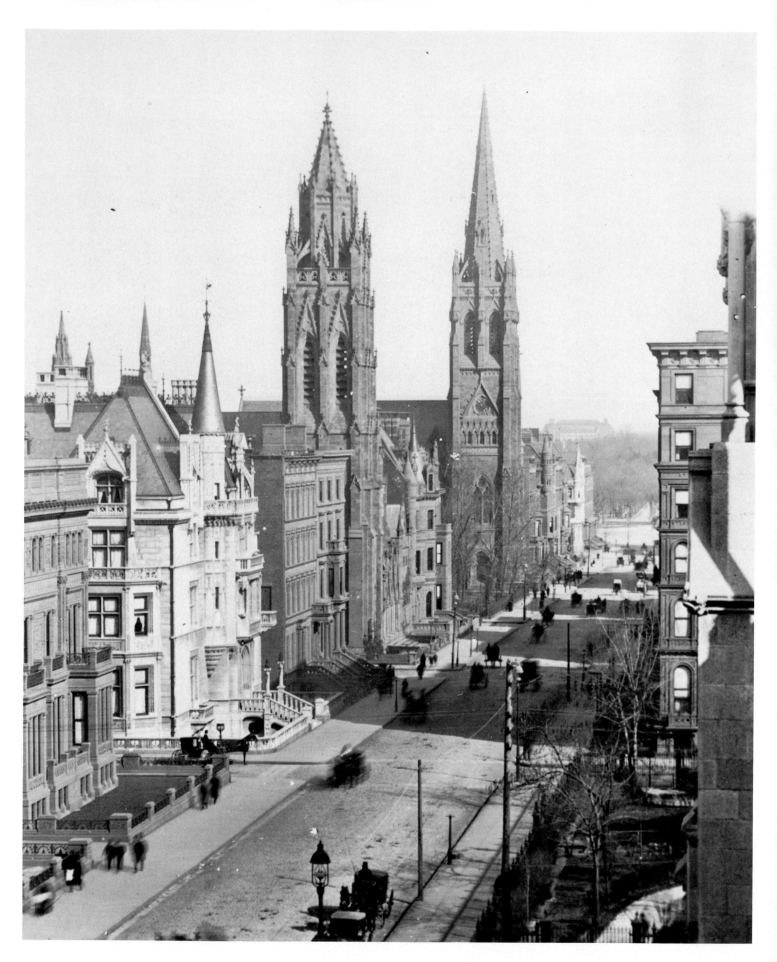

[PLATE 144]
Fifth Avenue in the Fifties, 1883–1884

This view of Fifth Avenue north from 51st Street was taken from the roof of St. Patrick's Cathedral. The wall of the Catholic orphan boys' home is at the extreme right. The two steeples (from left to right) are those of St. Thomas Episcopal Church and Fifth Avenue Presbyterian. The trees in the far distance mark the southern boundary of Central Park with the south side of the Metropolitan Museum seen above the trees.

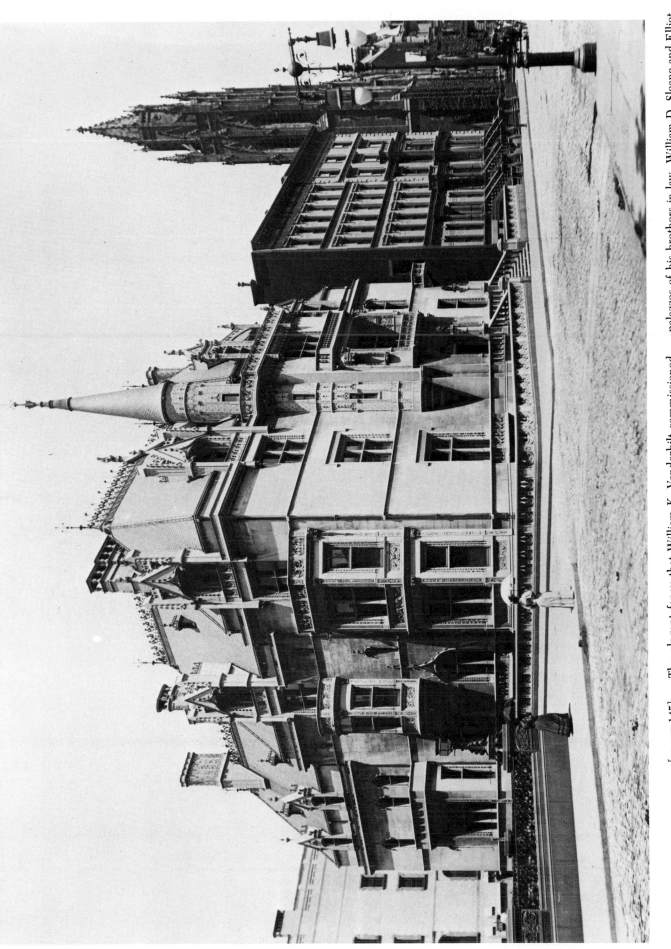

[PLATE 145]
Fifth Avenue from 52nd Street, c. 1895

The elegant fancy that William K. Vanderbilt commissioned from Richard M. Hunt, in the race among Vanderbilt relations to outdo each other in the magnificence of their housing, is seen in this view of the west side of Fifth Avenue north of 52nd Street. The fence at the far left surrounds the twin Italianate palazzos of his brothers-in-law, William D. Sloane and Elliot F. Shepard, which separated this house from that of his father William H. Vanderbilt. At far right rises the steeple of St. Thomas Episcopal Church, opened in 1870.

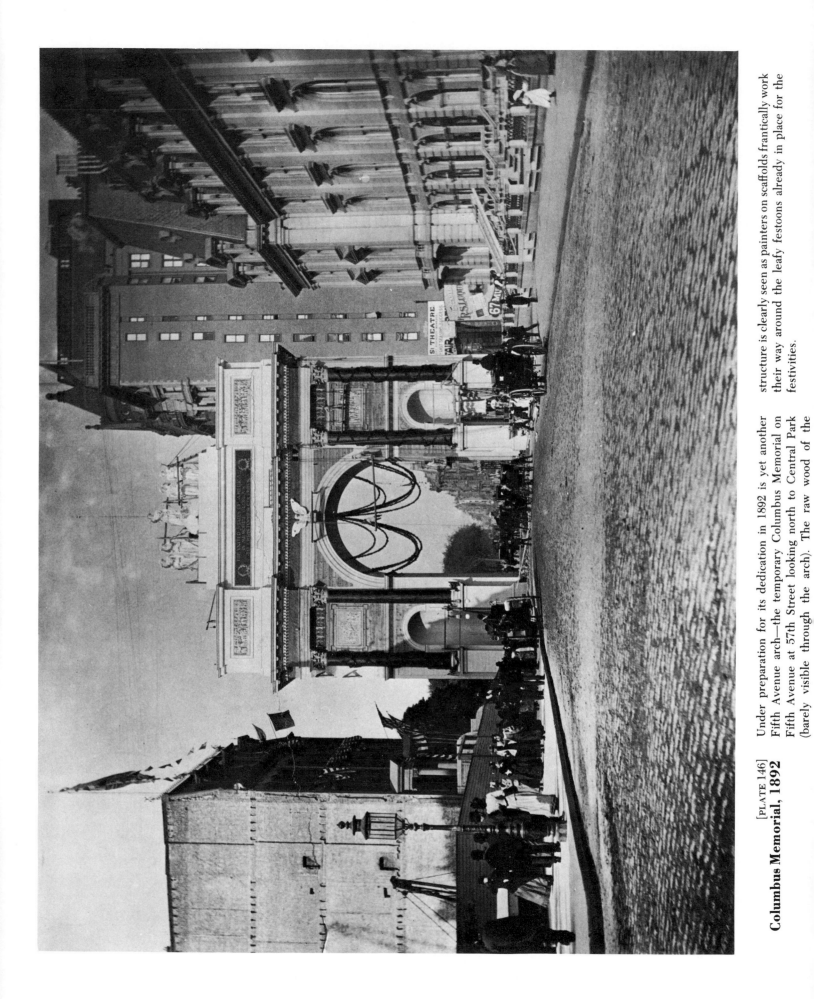

[PLATE 146]
Columbus Memorial, 1892

Under preparation for its dedication in 1892 is yet another Fifth Avenue arch—the temporary Columbus Memorial on Fifth Avenue at 57th Street looking north to Central Park (barely visible through the arch). The raw wood of the structure is clearly seen as painters on scaffolds frantically work their way around the leafy festoons already in place for the festivities.

X I

THE WEST SIDE

from Fifth Avenue to the Hudson River between

40th Street and 59th Street

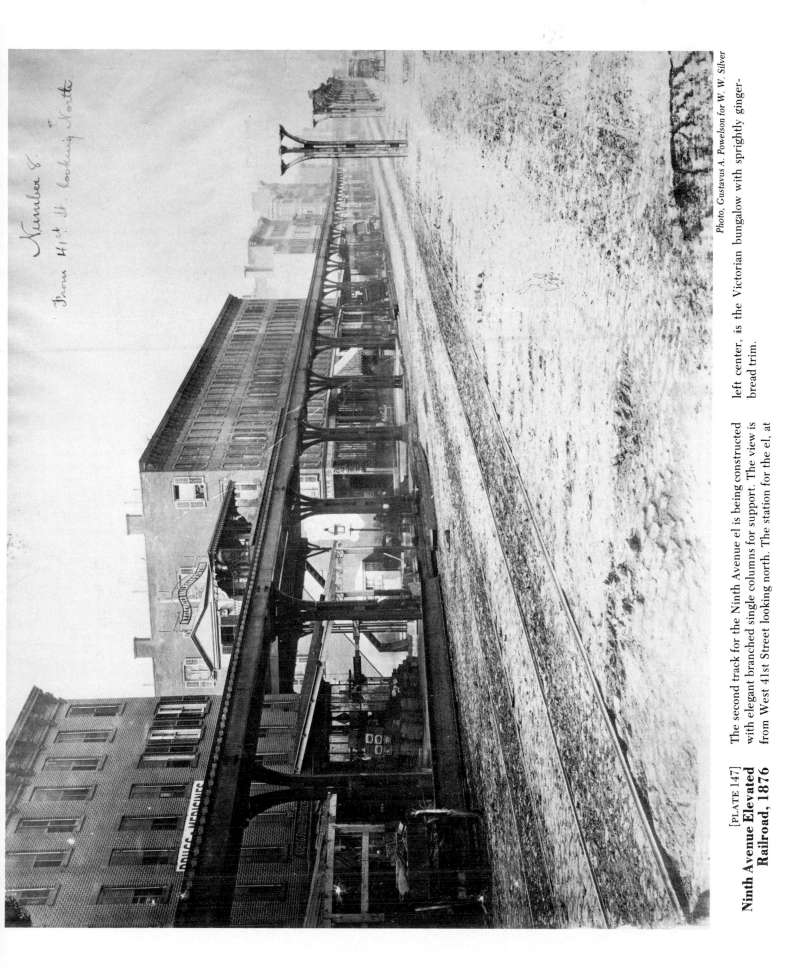

Number 8.
From 41st St. looking North.

Photo, Gustavus A. Powelson for W. W. Silver

[PLATE 147]
Ninth Avenue Elevated Railroad, 1876

The second track for the Ninth Avenue el is being constructed with elegant branched single columns for support. The view is from West 41st Street looking north. The station for the el, at left center, is the Victorian bungalow with sprightly ginger-bread trim.

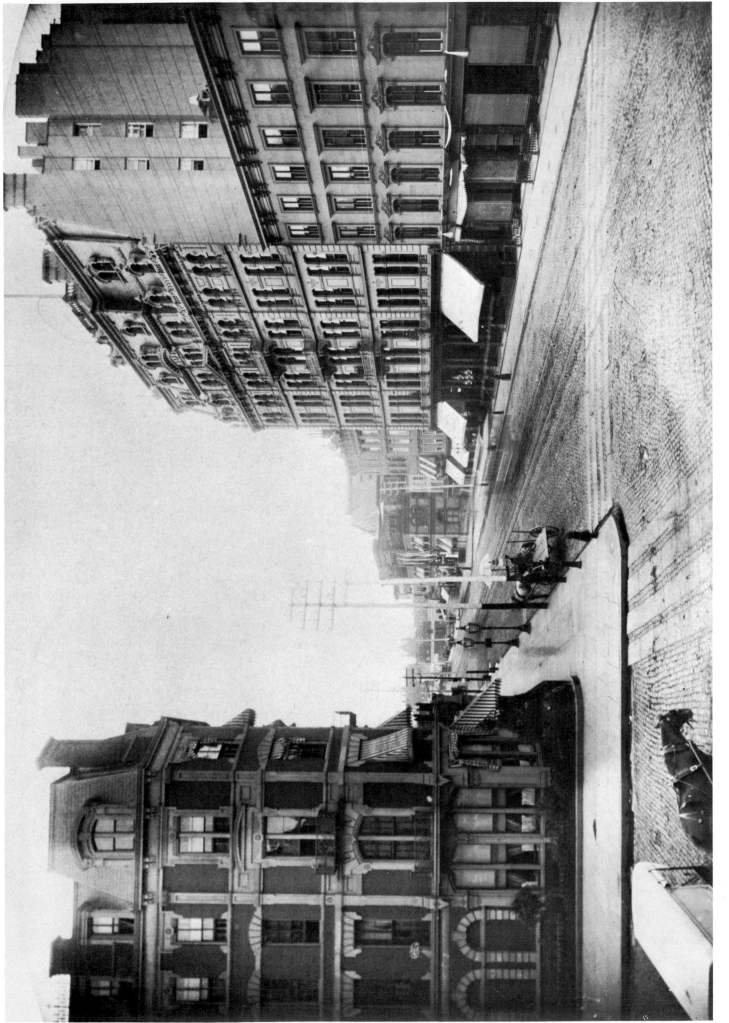

[PLATE 148]

Broadway at 42nd Street, c. 1894

Today's bustle at Broadway and 42nd Street is missing in this view of about 1894. South of 42nd a ghostly trolley moves along the street between the Hotel Metropole (on the right) and the St. Cloud Hotel (on the left). The Broadway Theatre is located farther south at the northwest corner of 41st Street.

Sixth Avenue between 42nd Street and 43rd Street, c. 1888

[PLATE 149]

Basking in the sunlight shining through the track and platform of the Sixth Avenue line of the Manhattan Elevated Railroad is a splendid wooden warrior figure at the entrance to the El

Mosquito Cigar Store (just right of the steps to the station). Note the man (above) having his shoes shined.

177

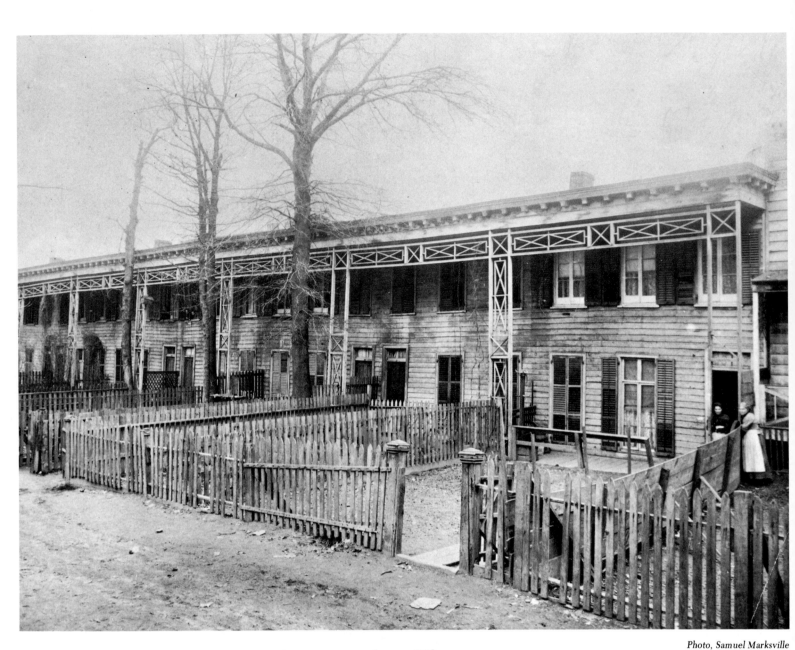

Photo, Samuel Marksville

[PLATE 150]
Striker's Cottages, c. 1887

When they were new this row of cottages on 52nd Street between 10th and 11th Avenues was glowingly advertised in the *New York Sun* for August 19, 1850.

Photographed by Samuel Marksville only a few years before they were demolished, the piazzas, verandas, and even the "elegant forest trees" look decayed, but as frequently happens in early photographs of run-down buildings, children lean from the upper windows (center), eager to be included in the record.

> TO LET—EIGHT ENTIRE NEW Two story Cottages, piazzas and Verandah fronts, court-yards 35 feet deep, filled with elegant forest trees; two lots of ground attached. Each house containing 4 bedrooms, two parlors and kitchen, and hard finished walls with cornice and centre piece. The cottages are on 52d street, near the Hudson River Rail Road; three Lines of Stages run near the premises throughout the day. Terms very moderate; possession given immediately. Inquire of General STRIKER, near the premises, or SANFORDS, PORTER & STRIKER, Counsellors at Law, 78 Broadway. al4 6*65

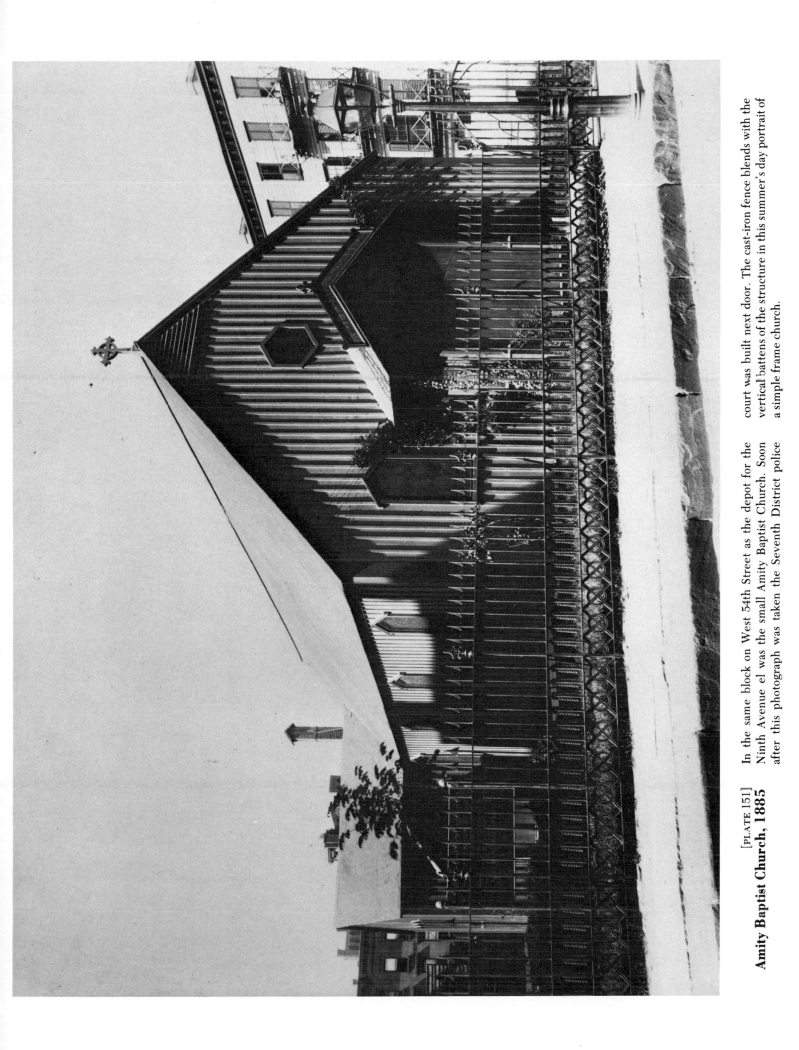

[PLATE 151]
Amity Baptist Church, 1885

In the same block on West 54th Street as the depot for the Ninth Avenue el was the small Amity Baptist Church. Soon after this photograph was taken the Seventh District police court was built next door. The cast-iron fence blends with the vertical battens of the structure in this summer's day portrait of a simple frame church.

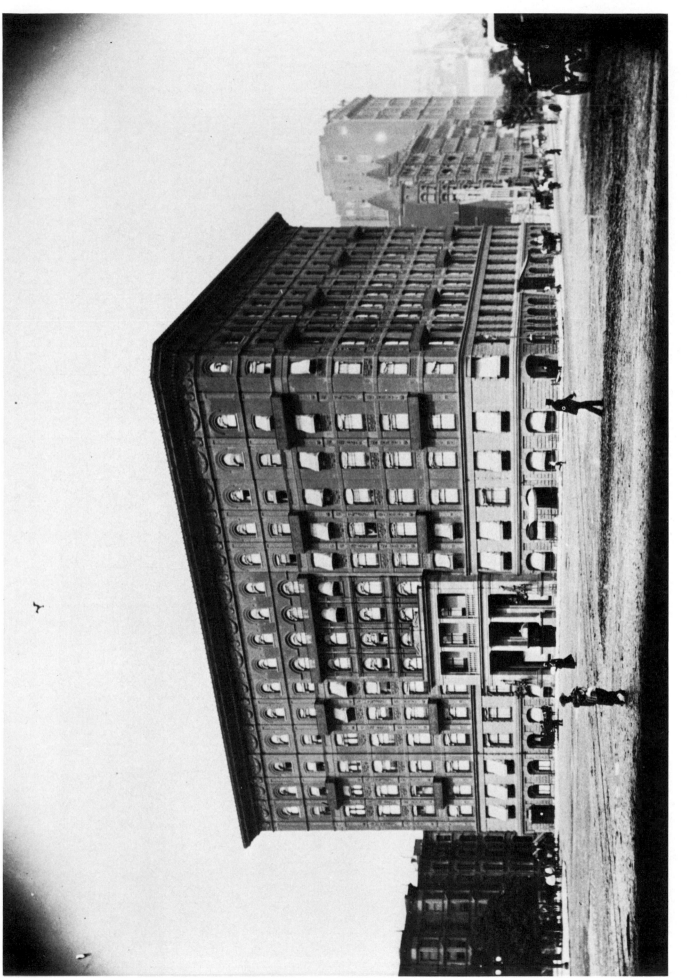

First Plaza Hotel, c. 1894 [PLATE 152]

Located on Central Park South, the original Plaza Hotel was, like its successor, one of the elite gathering places of the rich. It was begun in 1881 by the firm of Fife and Campbell but because of litigation over the land was not completed until 1889—at a cost of some $3,000,000. In its advertising it was claimed to be "the Model Hotel of the World" with the additional assurance that it was "absolutely fire proof." Although the old Plaza was furnished in great splendor, it was in use less than twenty years and was replaced by Henry Hardenbergh's even more splendid—and much larger—building in 1907.

[PLATE 153]
Spanish Flats, c. 1886

The location is today's Central Park South east of Seventh Avenue; the buildings include the Madrid, Cordoba, Grenada, and Valencia units of what were then known as the Navarro Flats. *King's Handbook* describes the Spanish Flats as several independent houses constructed as a single building with Moorish arches, numerous balconies, grand entrances, and ornamental facades in the Spanish style and including "interior appointments not surpassed in the world, constructed at a cost of $7,000,000." The Hispanic effect, expense notwithstanding, is lost to the modern eye. At the right appears one of the few street cleaners seen in these early photographs (see also No. 114), although his presence is everywhere apparent.

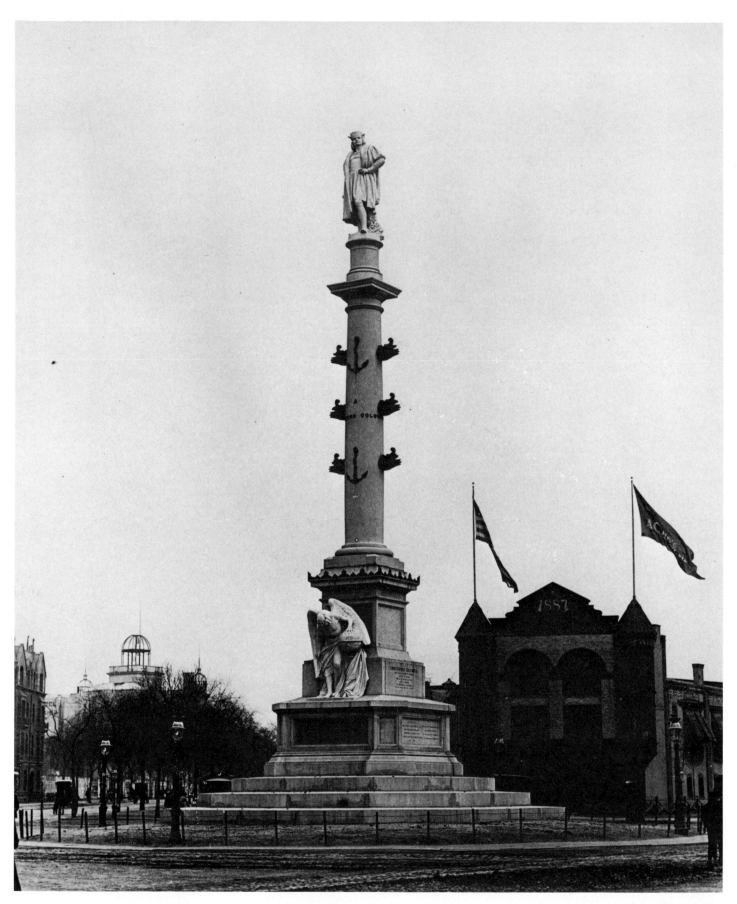

Photo, John S. Johnston

[PLATE 154]
Columbus Monument, 1893

The monument to Columbus, still standing, was begun in 1892, the quadricentennial of the discovery of America. Marking the center of Columbus Circle, its 77-foot granite shaft embellished with bronze rostra (ship's beaks or prows like those of captured vessels used to decorate speakers' platforms at the Roman forum), the column is surmounted by Gaetano Russo's statue of the great navigator while his angel of discovery examines a globe at the column's foot. The street to the left is Broadway; Central Park West is at the right. The curious 1887 structure is the riding academy that occupied the plot of land on which the Gulf and Western Building now stands.

XII

NORTH IN "THE TERRITORY"
from 59th Street to Spuyten Duyvil

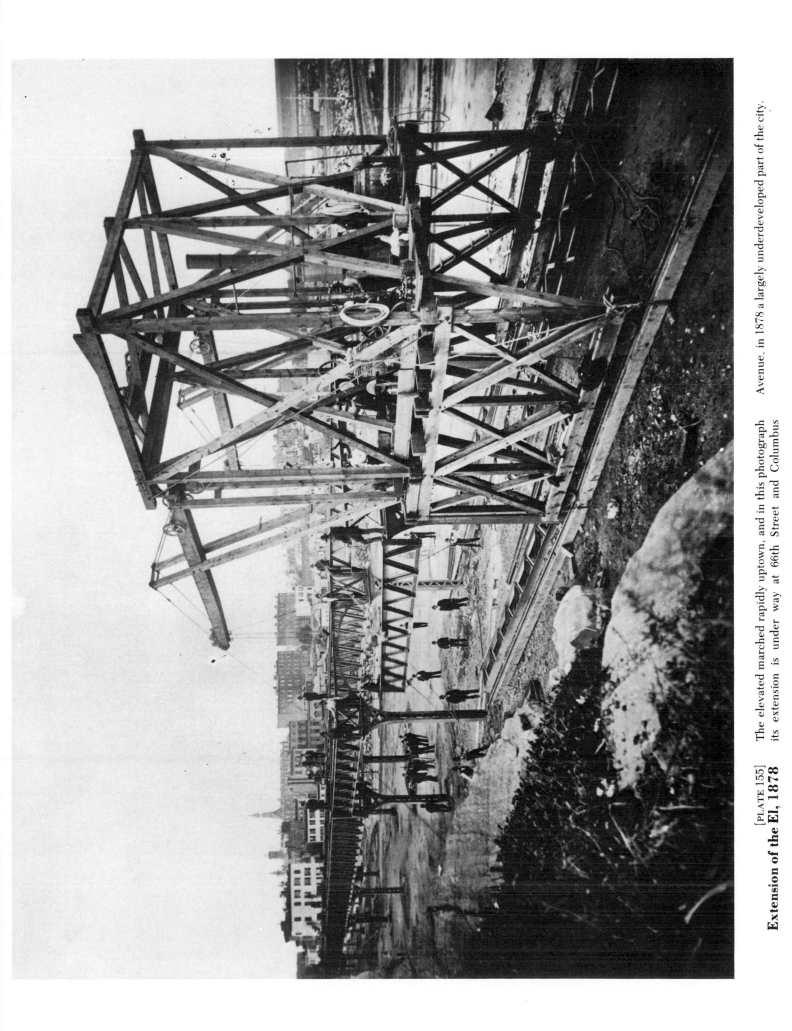

Extension of the El, 1878

[PLATE 155] The elevated marched rapidly uptown, and in this photograph its extension is under way at 66th Street and Columbus Avenue, in 1878 a largely underdeveloped part of the city.

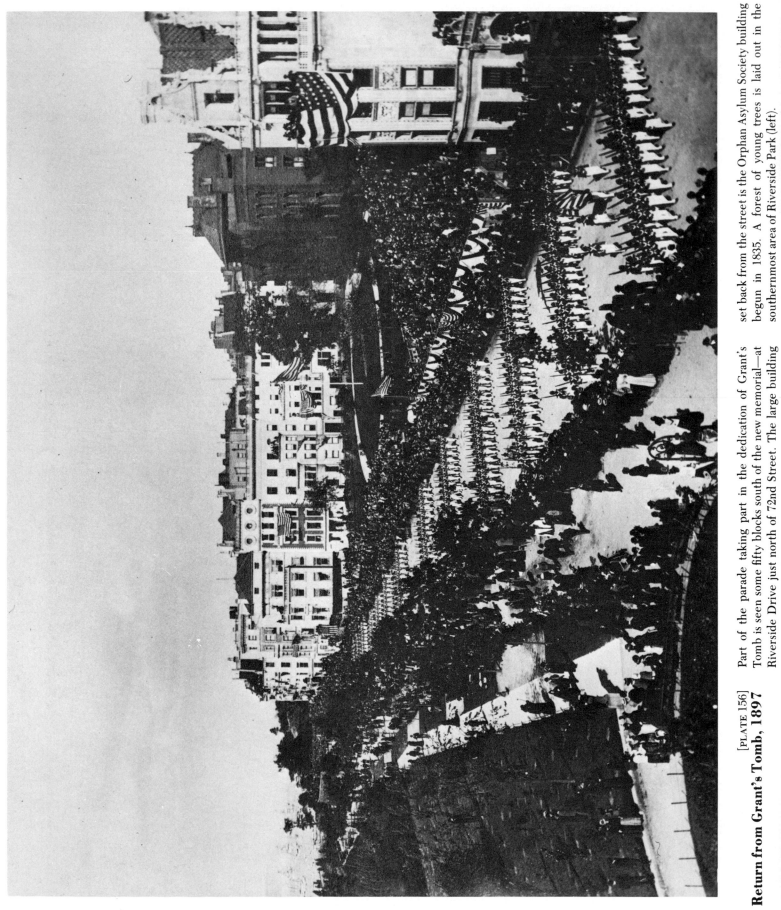

[PLATE 156]
Return from Grant's Tomb, 1897

Part of the parade taking part in the dedication of Grant's Tomb is seen some fifty blocks south of the new memorial—at Riverside Drive just north of 72nd Street. The large building set back from the street is the Orphan Asylum Society building begun in 1835. A forest of young trees is laid out in the southernmost area of Riverside Park (left).

[PLATE 157]

Backyard of the Harsen Homestead, c. 1888

Facing on 70th Street at the point where Broadway (then called Boulevard) flowed into and crossed Tenth Avenue was the Jacob Harsen Homestead. By the late 1880s, when this photograph was taken, Harsen no longer lived in the picturesque old stone and frame house. In 1893, five or six years after this charming record was made, the house was torn down.

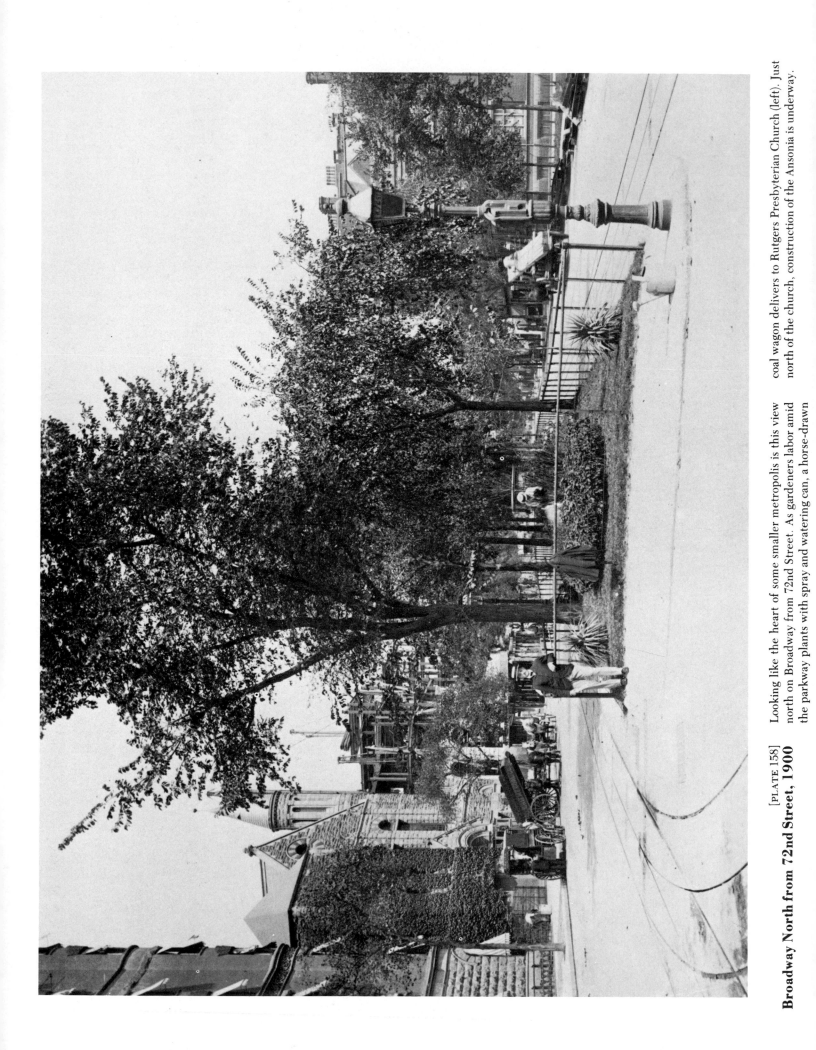

[PLATE 158]
Broadway North from 72nd Street, 1900

Looking like the heart of some smaller metropolis is this view north on Broadway from 72nd Street. As gardeners labor amid the parkway plants with spray and watering can, a horse-drawn coal wagon delivers to Rutgers Presbyterian Church (left). Just north of the church, construction of the Ansonia is underway.

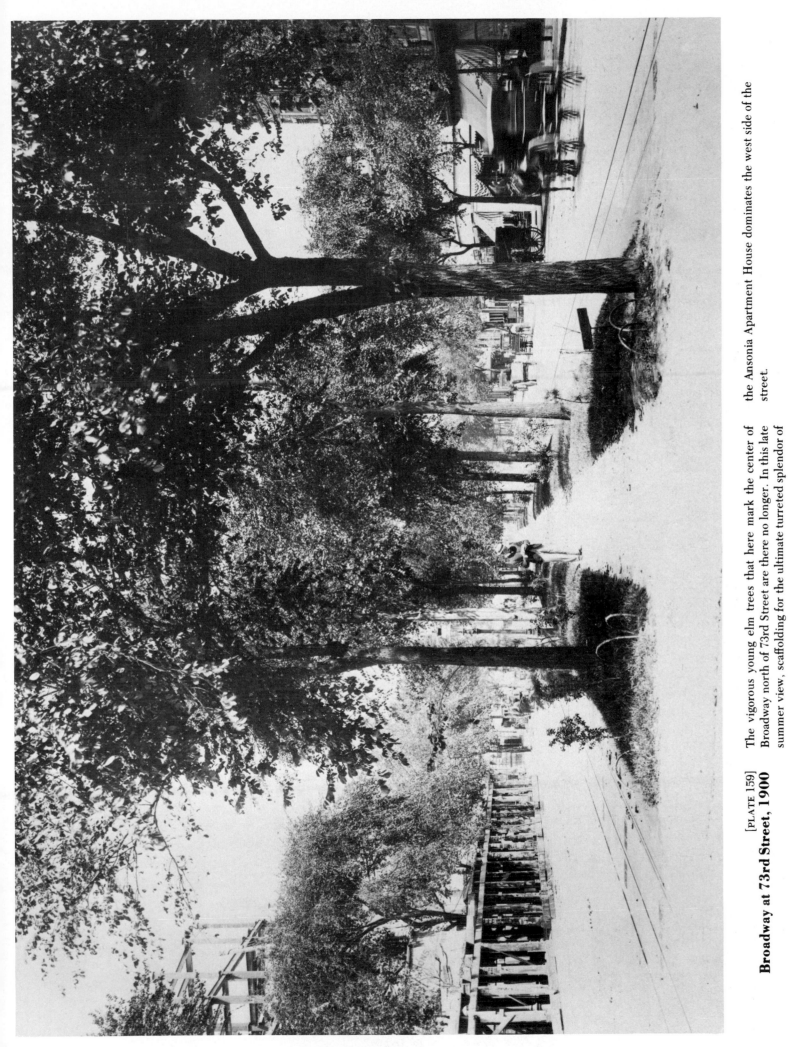

[PLATE 159]
Broadway at 73rd Street, 1900

The vigorous young elm trees that here mark the center of Broadway north of 73rd Street are there no longer. In this late summer view, scaffolding for the ultimate turreted splendor of the Ansonia Apartment House dominates the west side of the street.

189

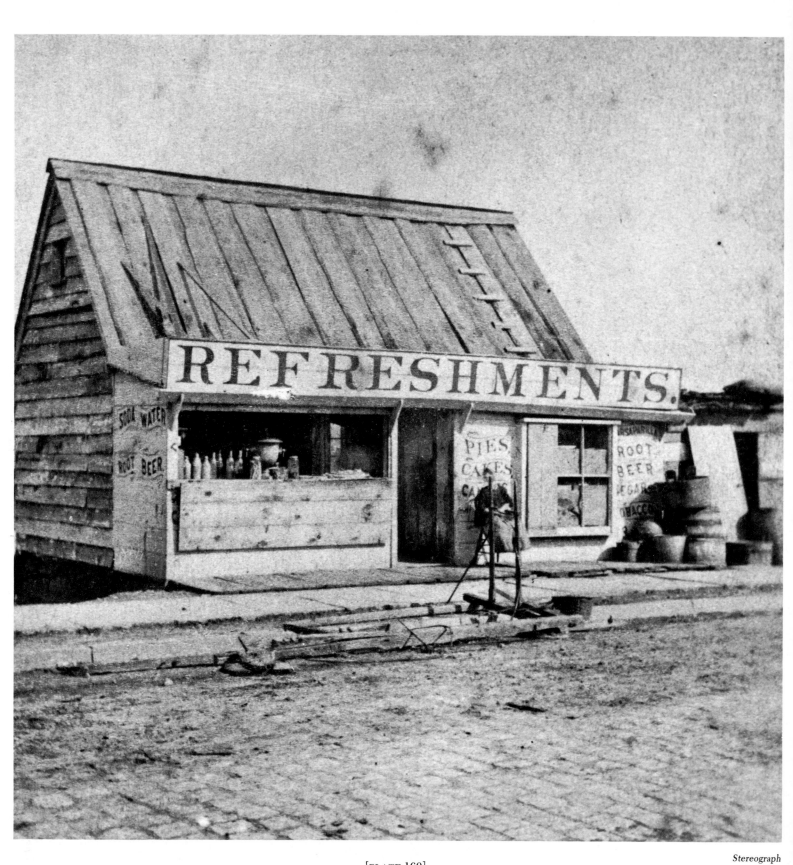

[PLATE 160]
Refreshment Stand, c. 1870

As late as 1870 frame shacks stood alongside the entrance to Central Park at Fifth Avenue just above 59th Street. Although a sidewalk had been laid for pedestrians and paving blocks were in place in the avenue's roadbed, a muddy gutter divided the two.

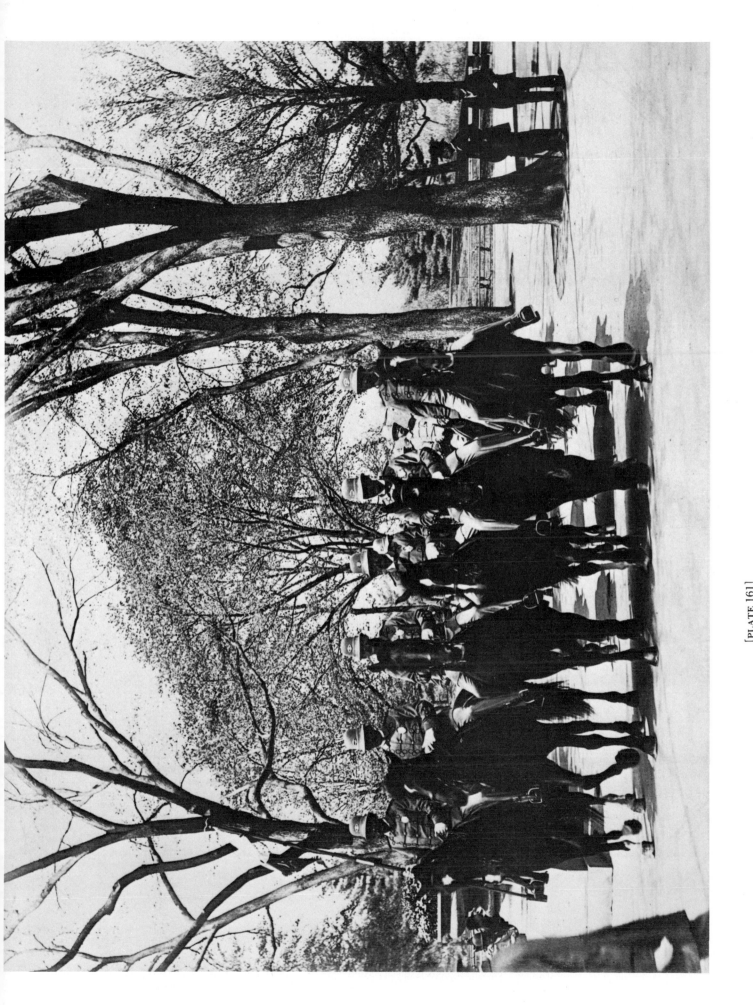

[PLATE 161]

Changing the Guard in Central Park, c. 1895 Then as now, New York's finest trotted through the park at regular intervals.

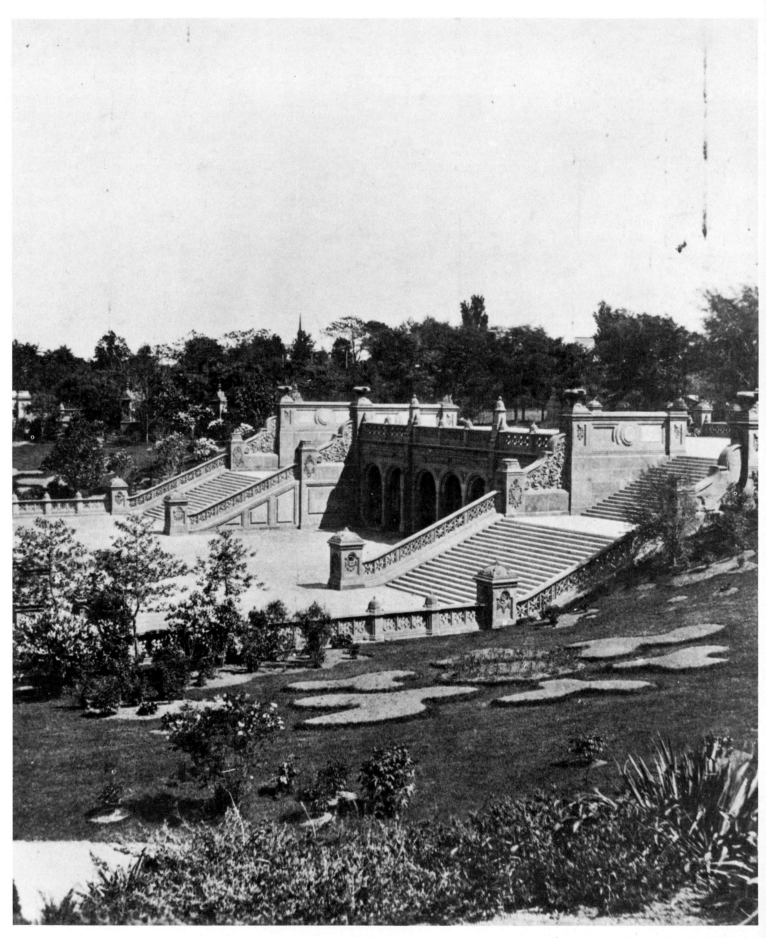

[PLATE 162]
Esplanade in Central Park, c. 1890

The organic forms that were a feature of the foundation planting and flower beds in Central Park are visible before this view of the Terrace and Esplanade. The Calvert Vaux design for the steps stands out clearly, and Jacob Wray Mould's naturalistic birds and branches in high relief along the sides of the terrace steps still kept their heads in this late-nineteenth-century view of one of the most popular parts of Central Park.

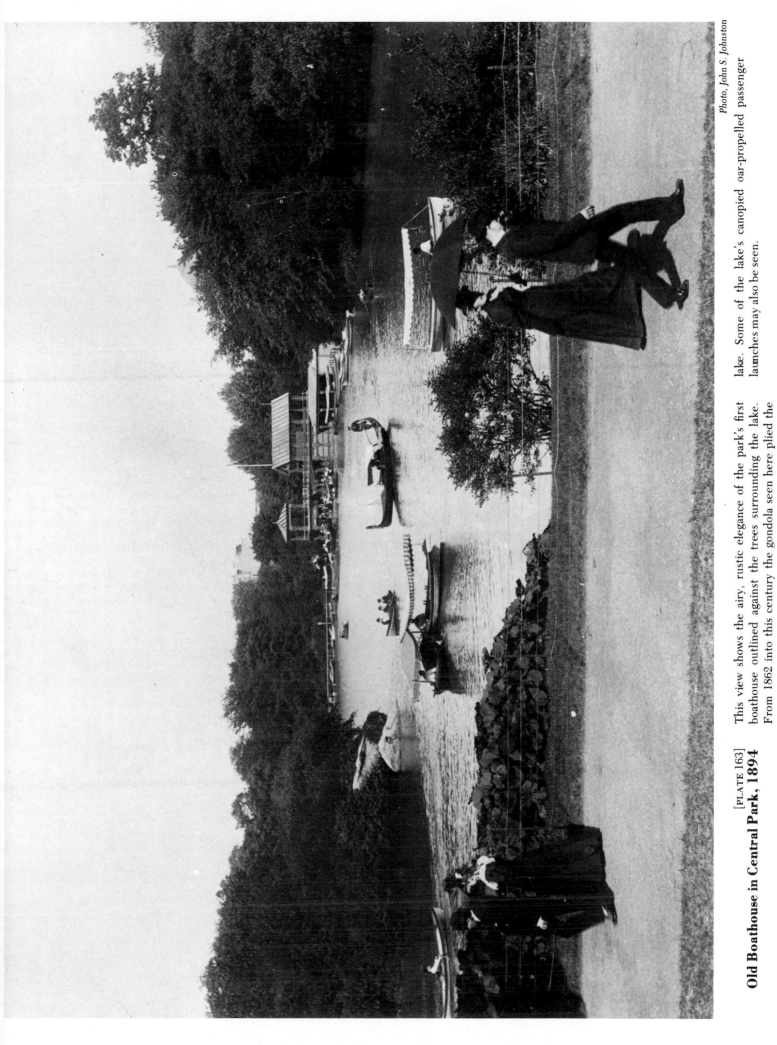

Photo, John S. Johnston

[PLATE 163]
Old Boathouse in Central Park, 1894

This view shows the airy, rustic elegance of the park's first boathouse outlined against the trees surrounding the lake. From 1862 into this century the gondola seen here plied the lake. Some of the lake's canopied oar-propelled passenger launches may also be seen.

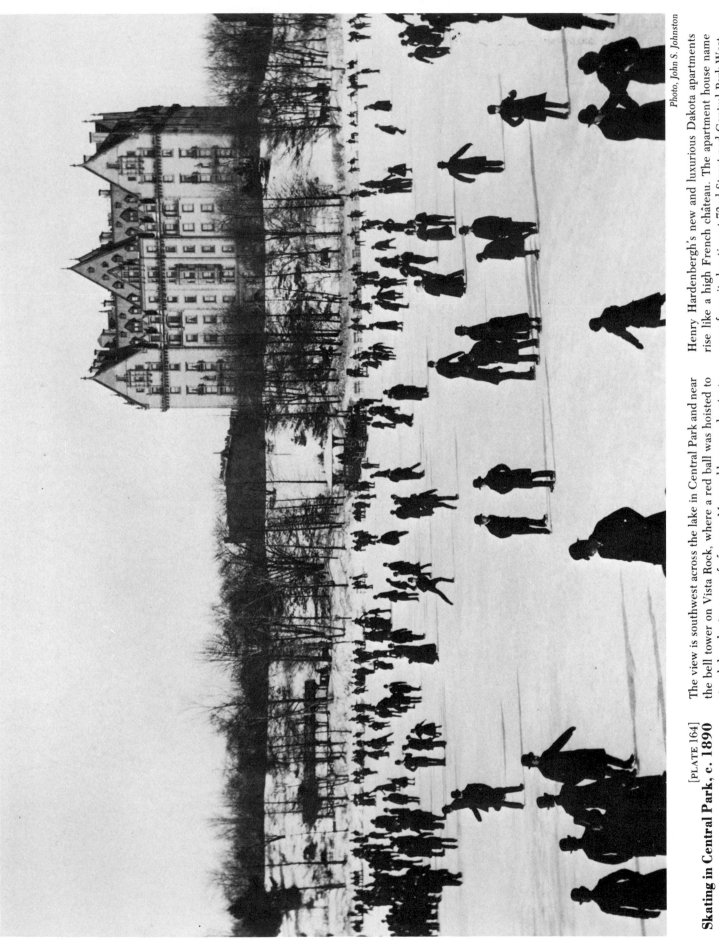

Photo, John S. Johnston

[PLATE 164]

Skating in Central Park, c. 1890

The view is southwest across the lake in Central Park and near the bell tower on Vista Rock, where a red ball was hoisted to signal that the ice was safe for use. Men and boys predominate among the skaters on this winter's day although more ladies might have gathered at the north end of the lake, where a place was reserved especially for them. In the right background

Henry Hardenbergh's new and luxurious Dakota apartments rise like a high French château. The apartment house name came from its location at 72nd Street and Central Park West, then considered to be as far from the center of the city as the Dakota Territory was from the settled parts of the country.

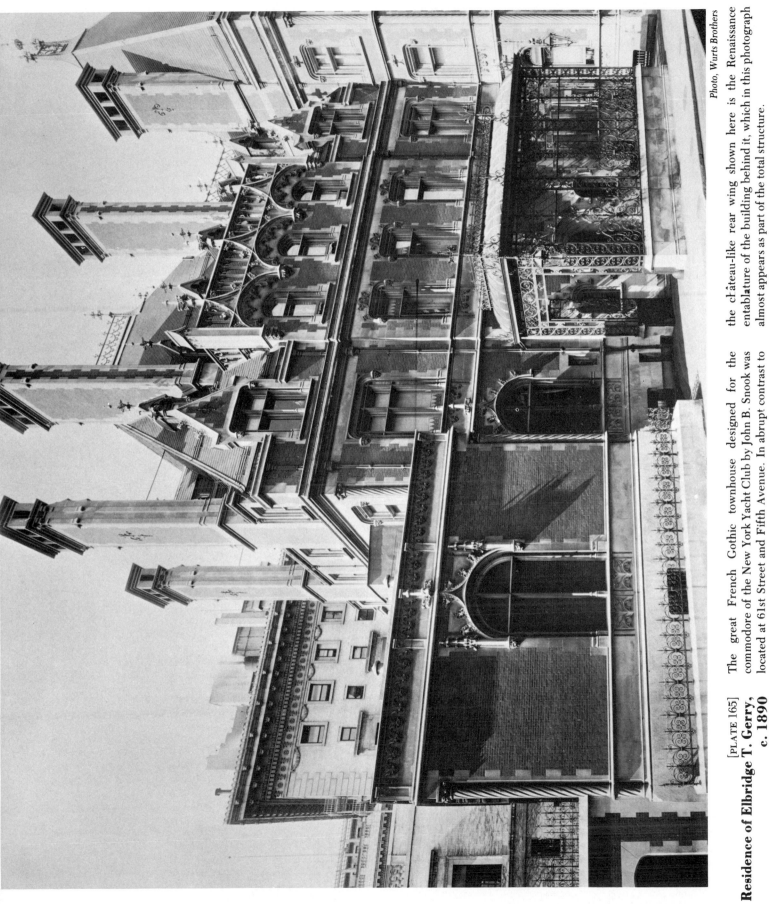

[PLATE 165]
**Residence of Elbridge T. Gerry,
c. 1890**

The great French Gothic townhouse designed for the commodore of the New York Yacht Club by John B. Snook was located at 61st Street and Fifth Avenue. In abrupt contrast to the château-like rear wing shown here is the Renaissance entablature of the building behind it, which in this photograph almost appears as part of the total structure.

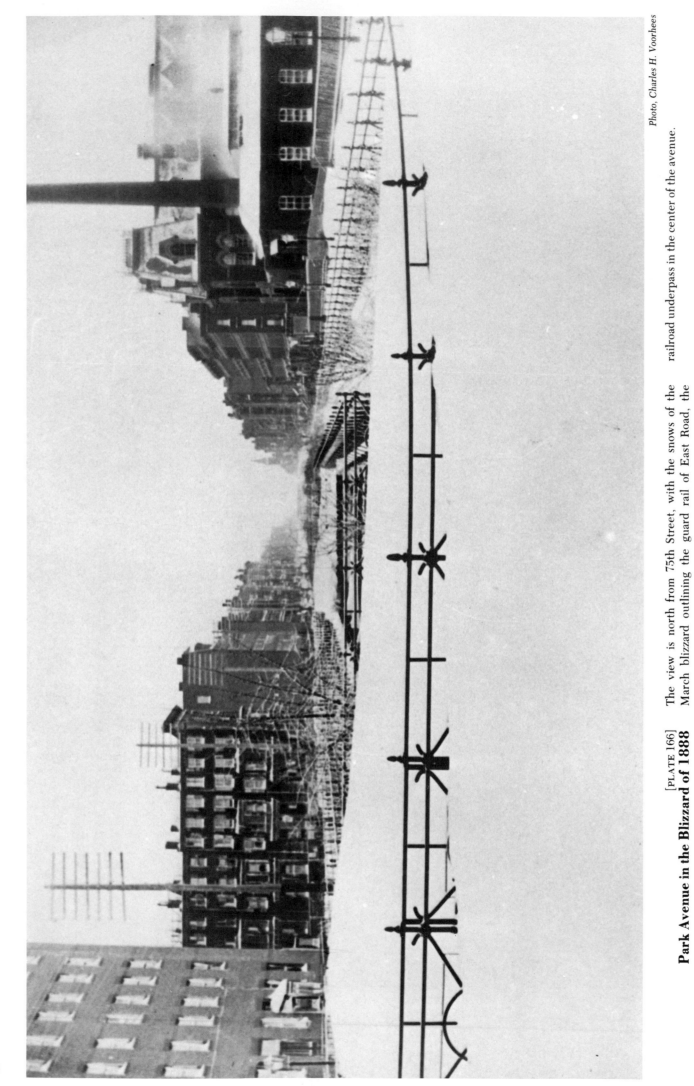

Photo, Charles H. Voorhees

[PLATE 166]

Park Avenue in the Blizzard of 1888

The view is north from 75th Street, with the snows of the March blizzard outlining the guard rail of East Road, the railroad underpass in the center of the avenue.

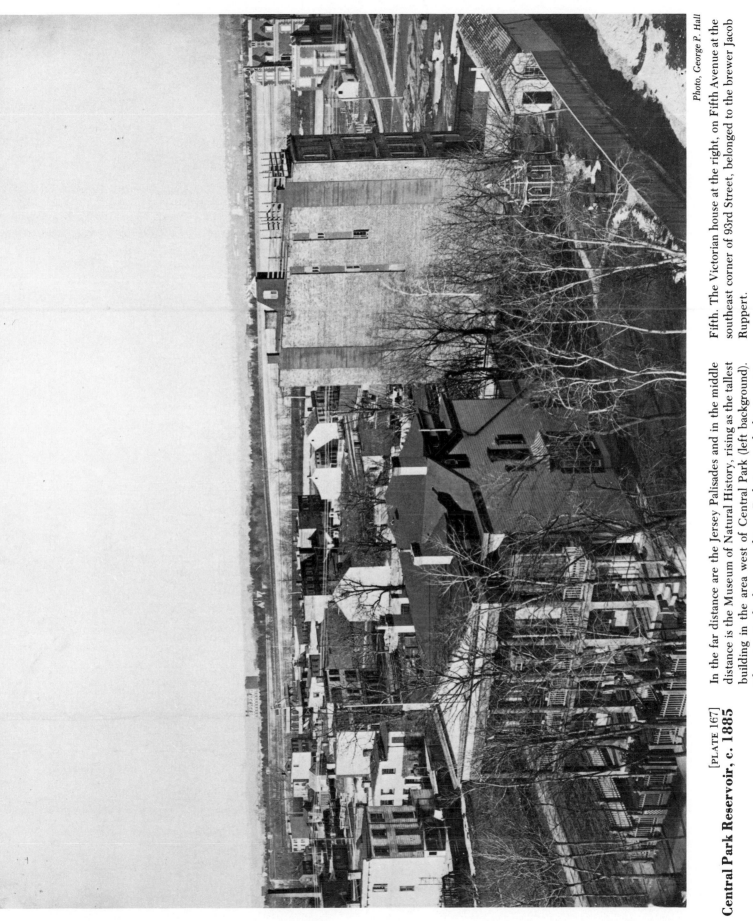

[PLATE 167]
Central Park Reservoir, c. 1885

In the far distance are the Jersey Palisades and in the middle distance is the Museum of Natural History, rising as the tallest building in the area west of Central Park (left background). The view in the foreground is on Park Avenue looking west to

Fifth. The Victorian house at the right, on Fifth Avenue at the southeast corner of 93rd Street, belonged to the brewer Jacob Ruppert.

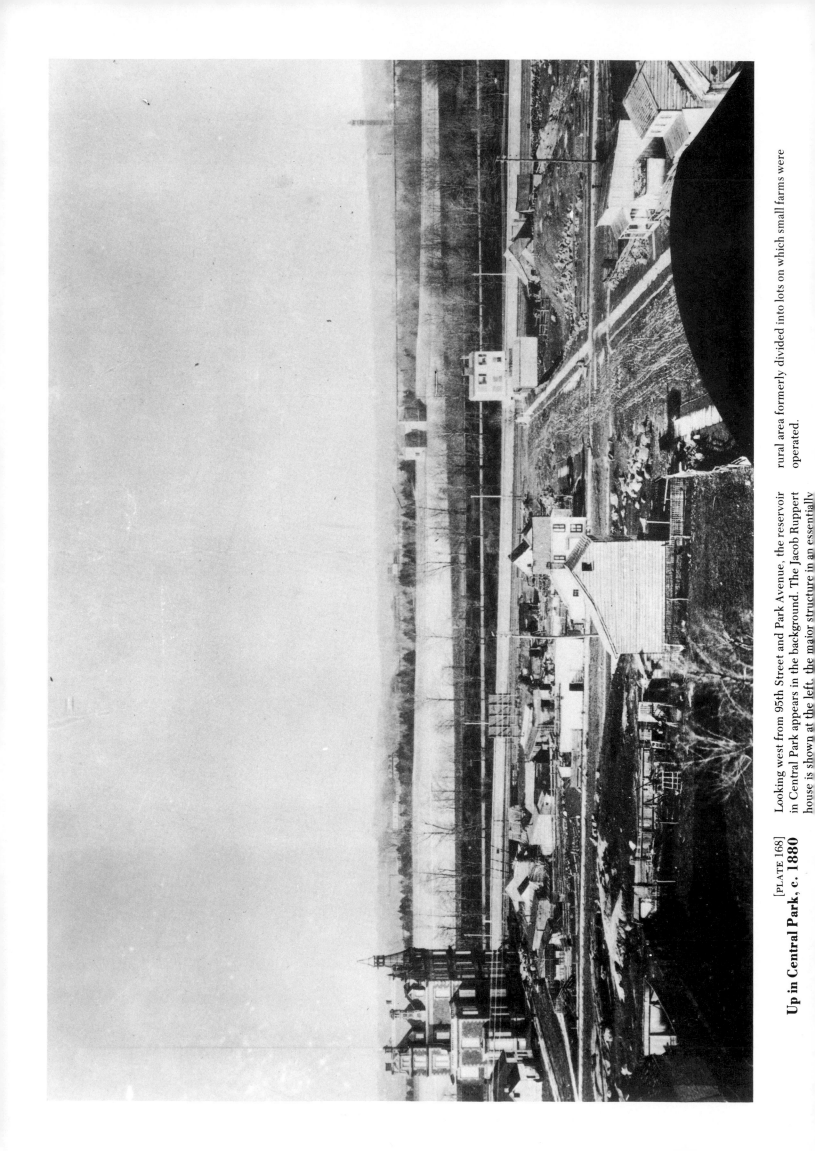

[PLATE 168]

Up in Central Park, c. 1880

Looking west from 95th Street and Park Avenue, the reservoir in Central Park appears in the background. The Jacob Ruppert house is shown at the left, the major structure in an essentially rural area formerly divided into lots on which small farms were operated.

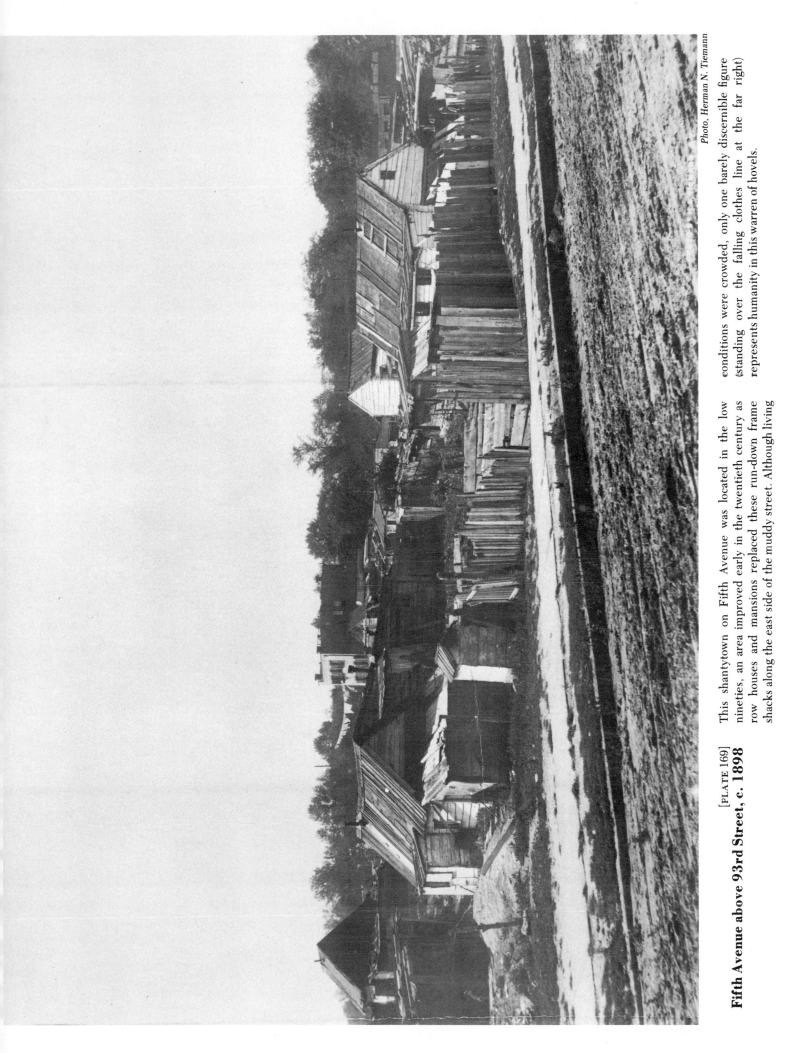

[PLATE 169]
Fifth Avenue above 93rd Street, c. 1898

This shantytown on Fifth Avenue was located in the low nineties, an area improved early in the twentieth century as row houses and mansions replaced these run-down frame shacks along the east side of the muddy street. Although living conditions were crowded, only one barely discernible figure (standing over the falling clothes line at the far right) represents humanity in this warren of hovels.

199

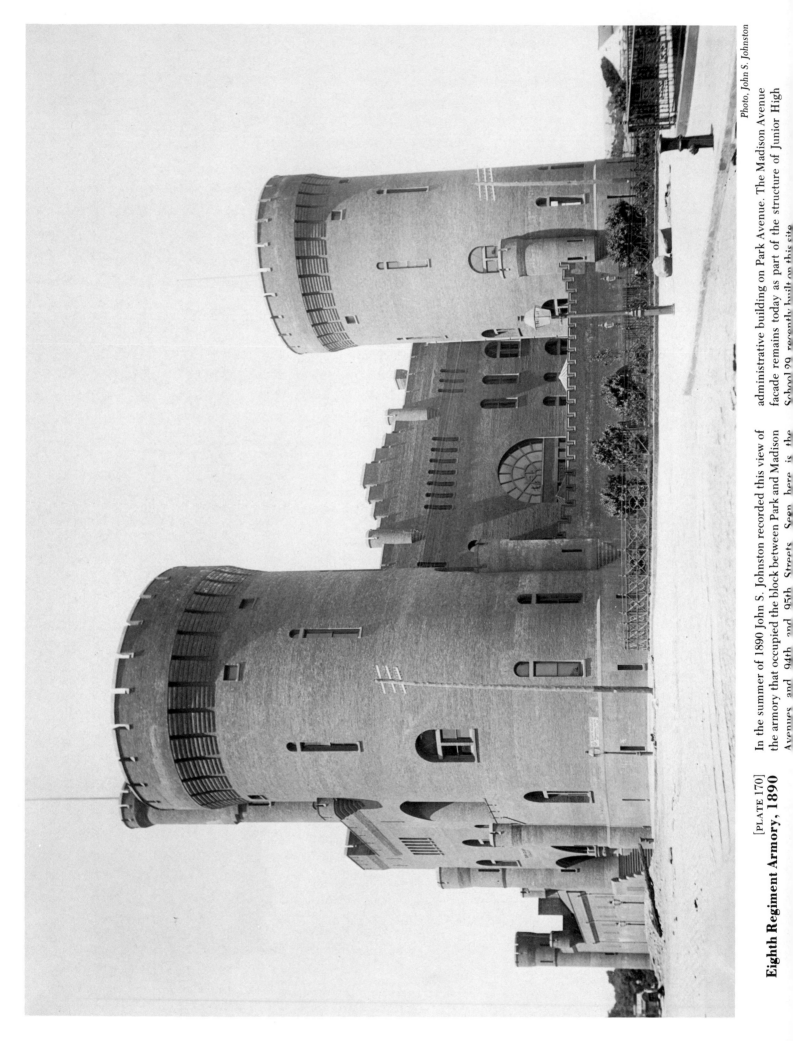

Photo, John S. Johnston

[PLATE 170]
Eighth Regiment Armory, 1890

In the summer of 1890 John S. Johnston recorded this view of the armory that occupied the block between Park and Madison Avenues, and 94th and 95th Streets. Seen here is the administrative building on Park Avenue. The Madison Avenue facade remains today as part of the structure of Junior High School 99, recently built on this site.

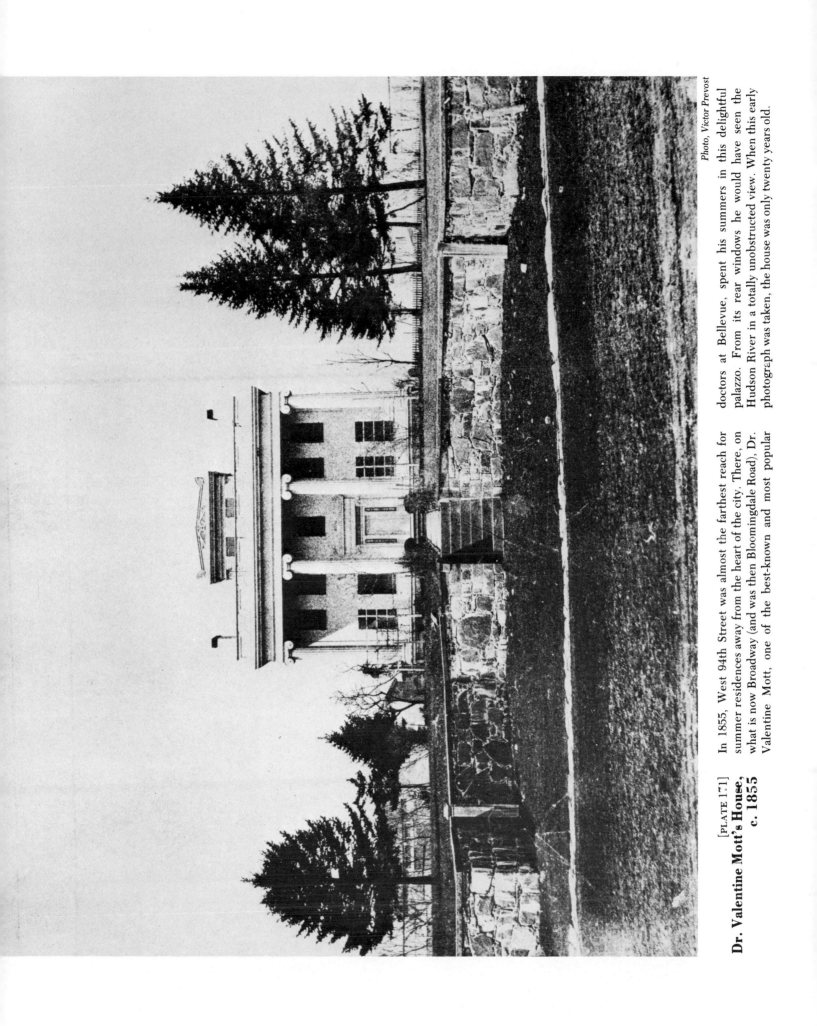

Photo, *Victor Prevost*

[PLATE 171]

Dr. Valentine Mott's House, c. 1855

In 1855, West 94th Street was almost the farthest reach for summer residences away from the heart of the city. There, on what is now Broadway (and was then Bloomingdale Road), Dr. Valentine Mott, one of the best-known and most popular doctors at Bellevue, spent his summers in this delightful palazzo. From its rear windows he would have seen the Hudson River in a totally unobstructed view. When this early photograph was taken, the house was only twenty years old.

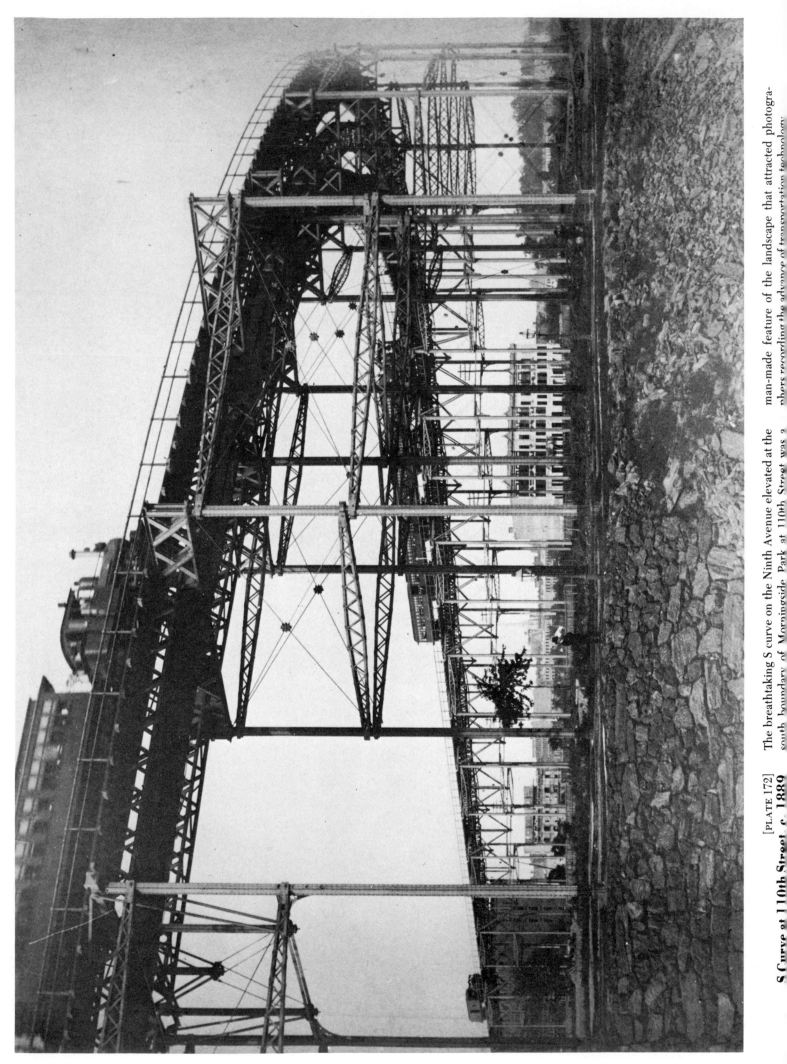

[PLATE 172]

S Curve at 110th Street, c. 1889

The breathtaking S curve on the Ninth Avenue elevated at the south boundary of Morningside Park, at 110th Street, was a man-made feature of the landscape that attracted photographers recording the advance of transportation technology.

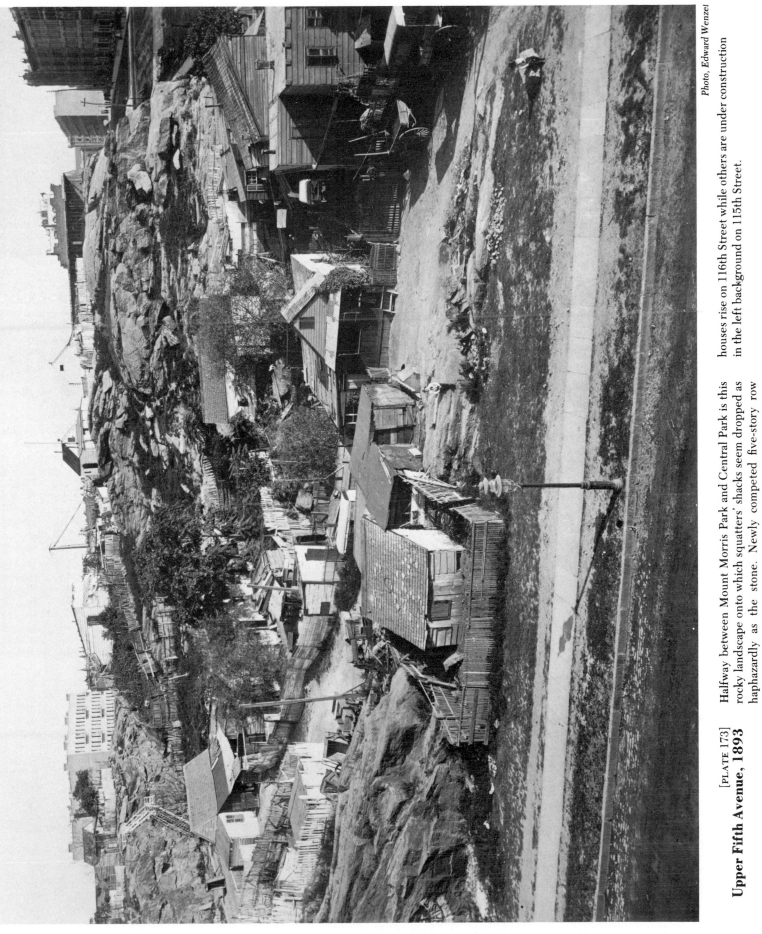

[PLATE 173]
Upper Fifth Avenue, 1893

Halfway between Mount Morris Park and Central Park is this rocky landscape onto which squatters' shacks seem dropped as haphazardly as the stone. Newly competed five-story row houses rise on 116th Street while others are under construction in the left background on 115th Street.

203

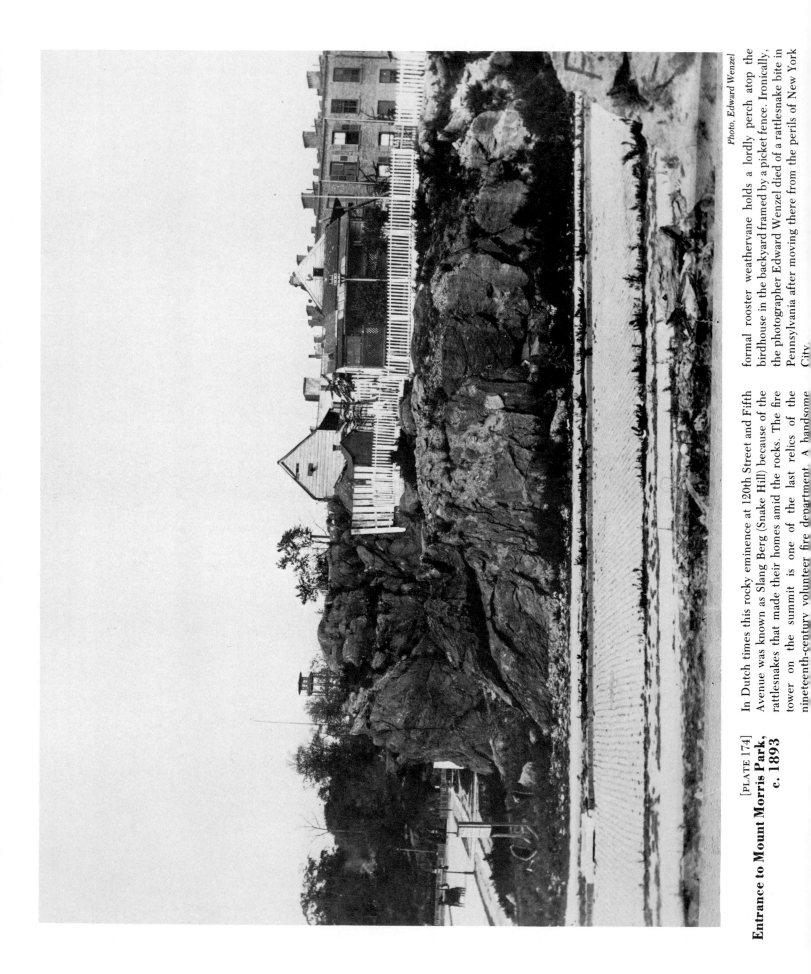

Photo, Edward Wenzel

[PLATE 174]

Entrance to Mount Morris Park, c. 1893

In Dutch times this rocky eminence at 120th Street and Fifth Avenue was known as Slang Berg (Snake Hill) because of the rattlesnakes that made their homes amid the rocks. The fire tower on the summit is one of the last relics of the nineteenth-century volunteer fire department. A handsome formal rooster weathervane holds a lordly perch atop the birdhouse in the backyard framed by a picket fence. Ironically, the photographer Edward Wenzel died of a rattlesnake bite in Pennsylvania after moving there from the perils of New York City.

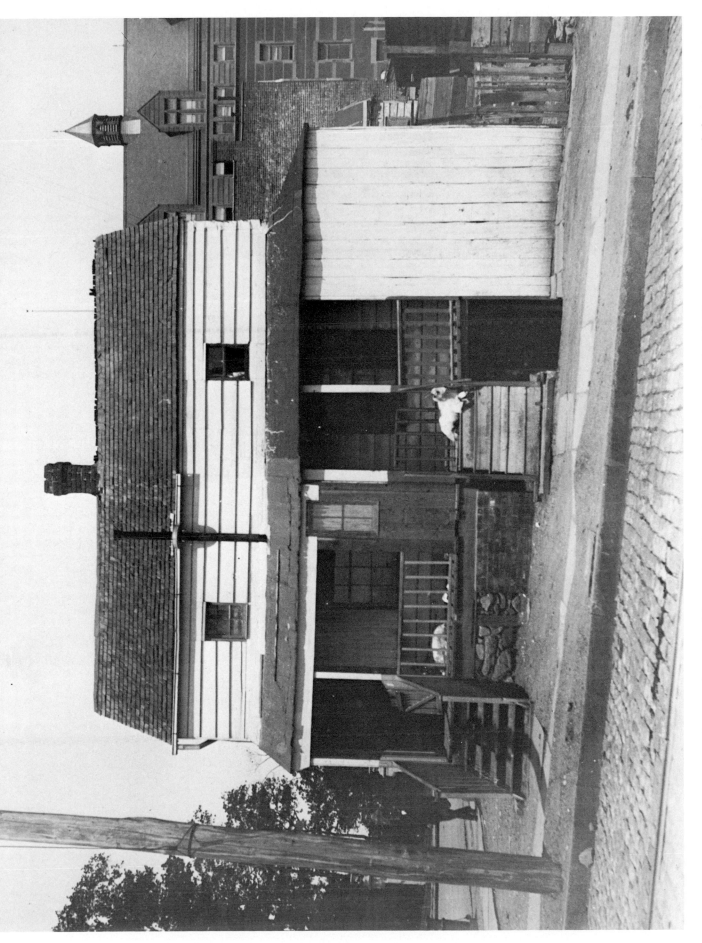

[PLATE 175]

Little House at 120th Street, 1897–1898

On the porch of the run-down frame house on the northwest corner of 120th Street and Amsterdam Avenue two goats rest in the sun. The Horace Mann School is the brick building in the background; gates guard one entrance to Columbia at the far left. The contrast of rural elements with the growing city is dramatically revealed in this photograph and its companion, No. 176.

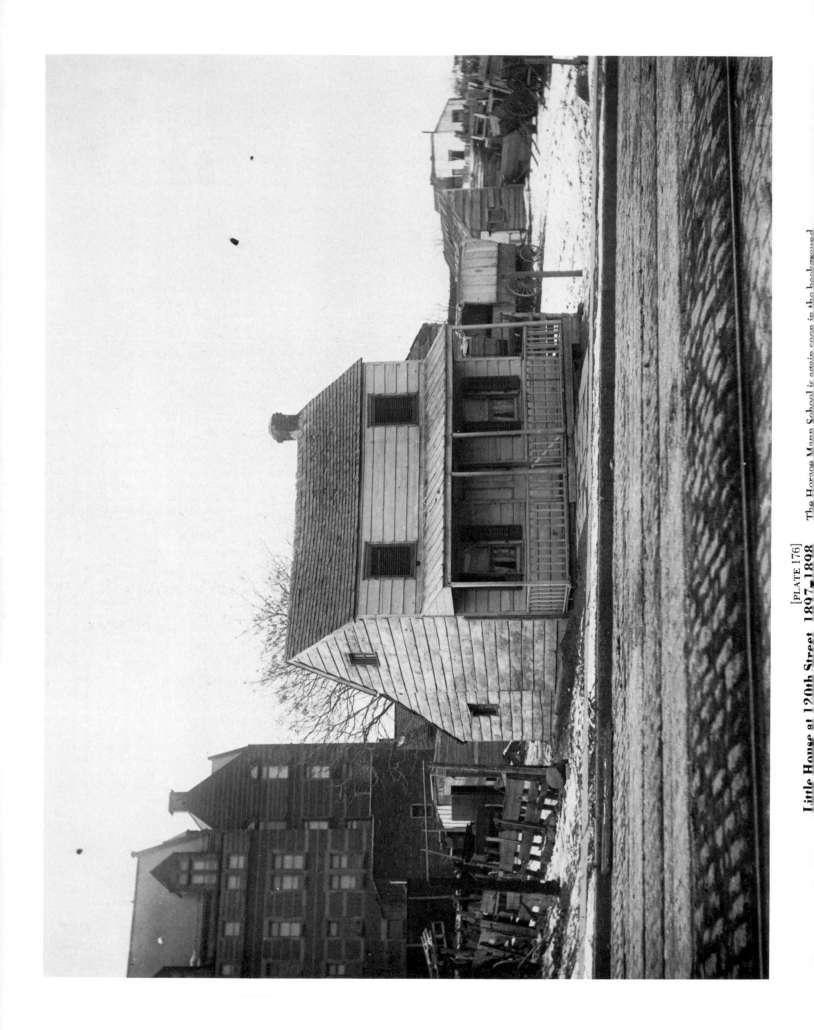

[PLATE 176]

Little House at 120th Street, 1897–1898

The Horace Mann School is again seen in the background.

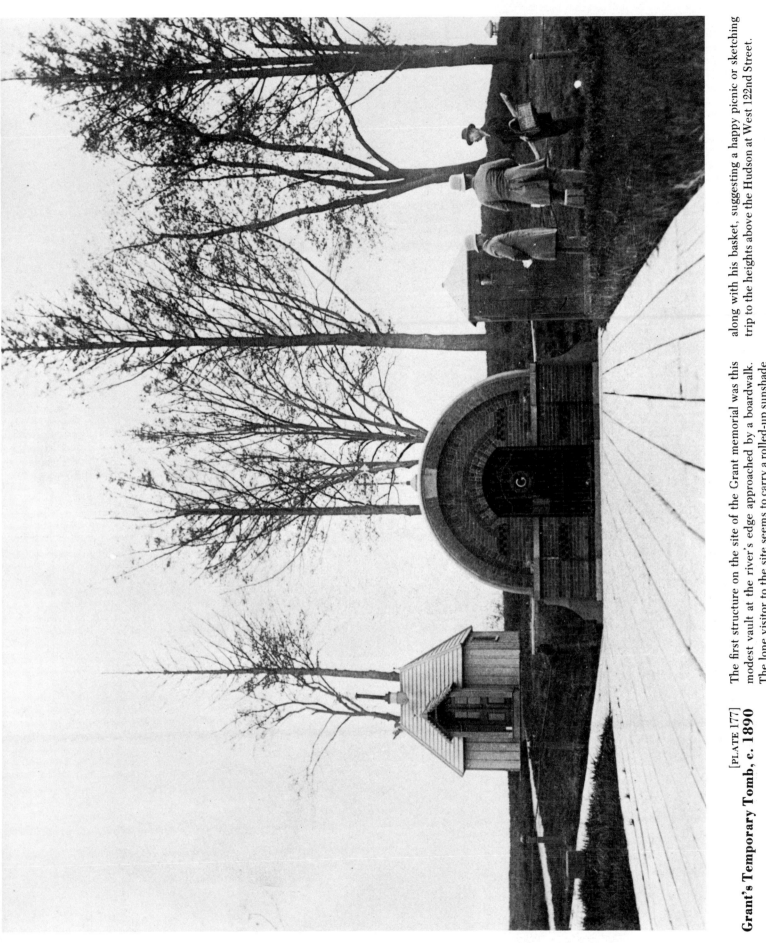

[PLATE 177]

Grant's Temporary Tomb, c. 1890

The first structure on the site of the Grant memorial was this modest vault at the river's edge approached by a boardwalk. The lone visitor to the site seems to carry a rolled-up sunshade along with his basket, suggesting a happy picnic or sketching trip to the heights above the Hudson at West 122nd Street.

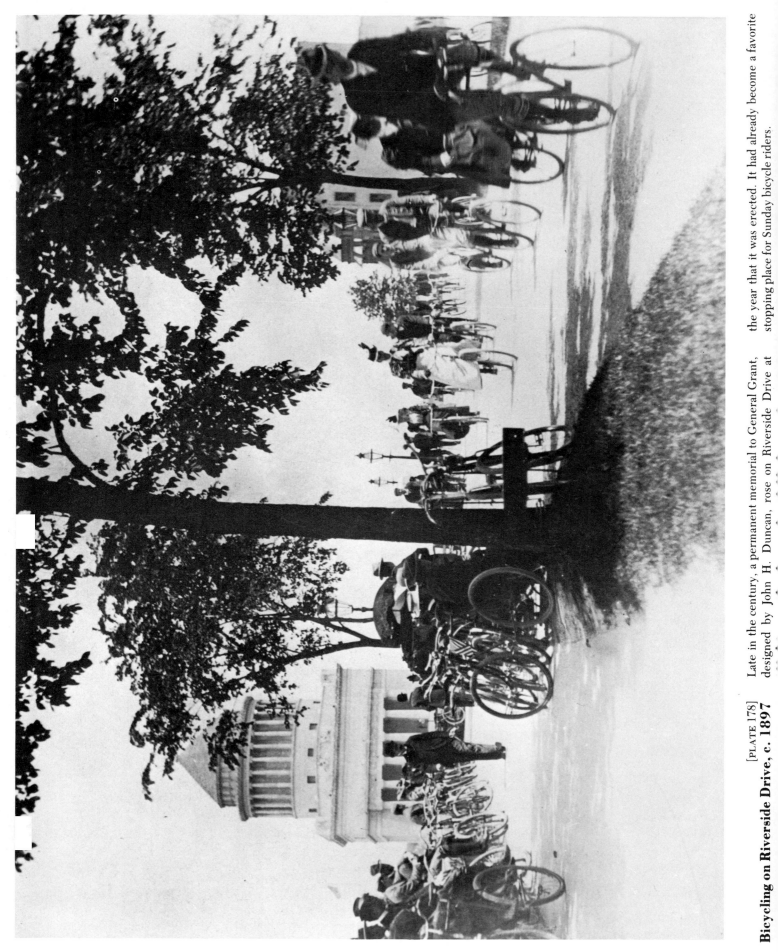

Bicycling on Riverside Drive, c. 1897

[PLATE 178] Late in the century, a permanent memorial to General Grant, designed by John H. Duncan, rose on Riverside Drive at the year that it was erected. It had already become a favorite stopping place for Sunday bicycle riders.

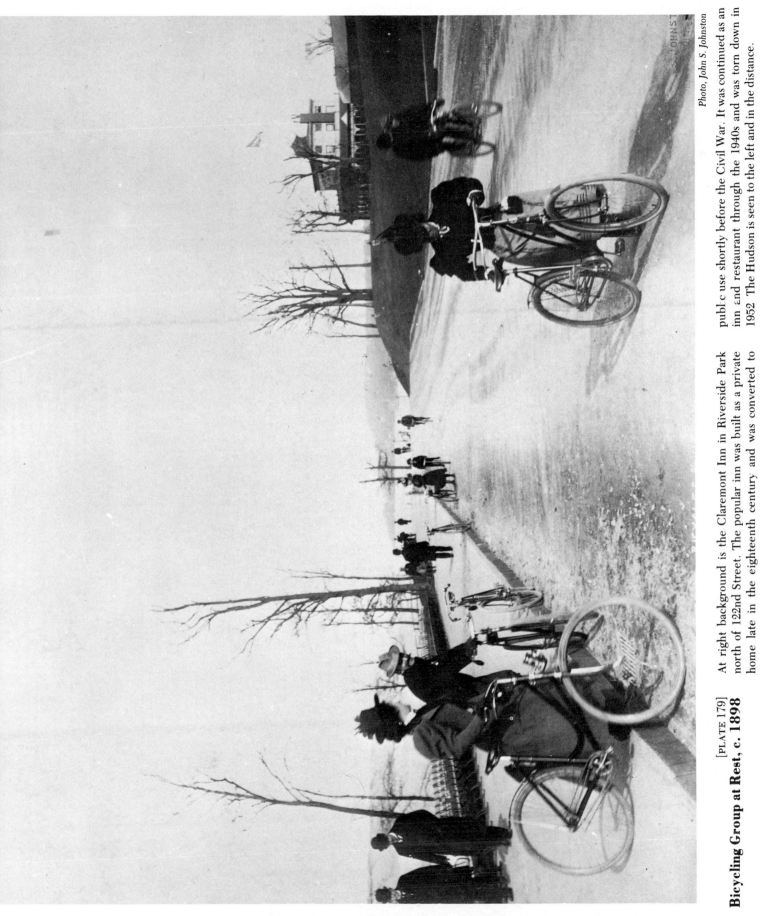

Photo, John S. Johnston

[PLATE 179]
Bicycling Group at Rest, c. 1898

At right background is the Claremont Inn in Riverside Park north of 122nd Street. The popular inn was built as a private home late in the eighteenth century and was converted to public use shortly before the Civil War. It was continued as an inn and restaurant through the 1940s and was torn down in 1952. The Hudson is seen to the left and in the distance.

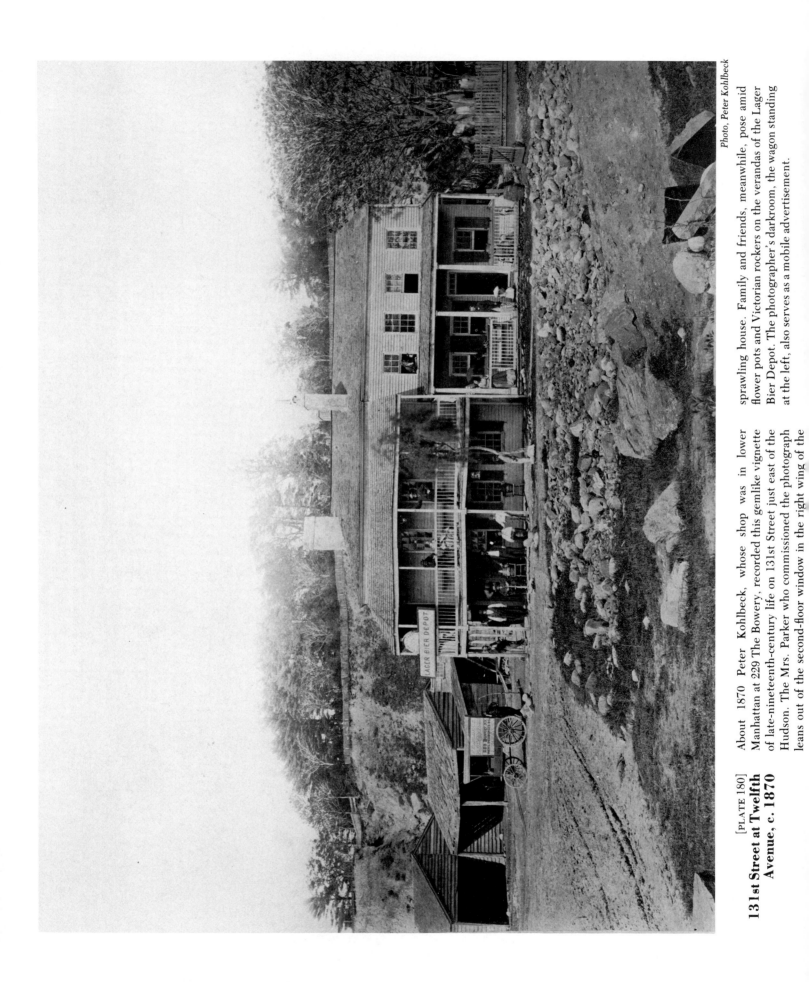

Photo, Peter Kohlbeck

[PLATE 180]
131st Street at Twelfth Avenue, c. 1870

About 1870 Peter Kohlbeck, whose shop was in lower Manhattan at 229 The Bowery, recorded this gemlike vignette of late-nineteenth-century life on 131st Street just east of the Hudson. The Mrs. Parker who commissioned the photograph leans out of the second-floor window in the right wing of the sprawling house. Family and friends, meanwhile, pose amid flower pots and Victorian rockers on the verandas of the Lager Bier Depot. The photographer's darkroom, the wagon standing at the left, also serves as a mobile advertisement.

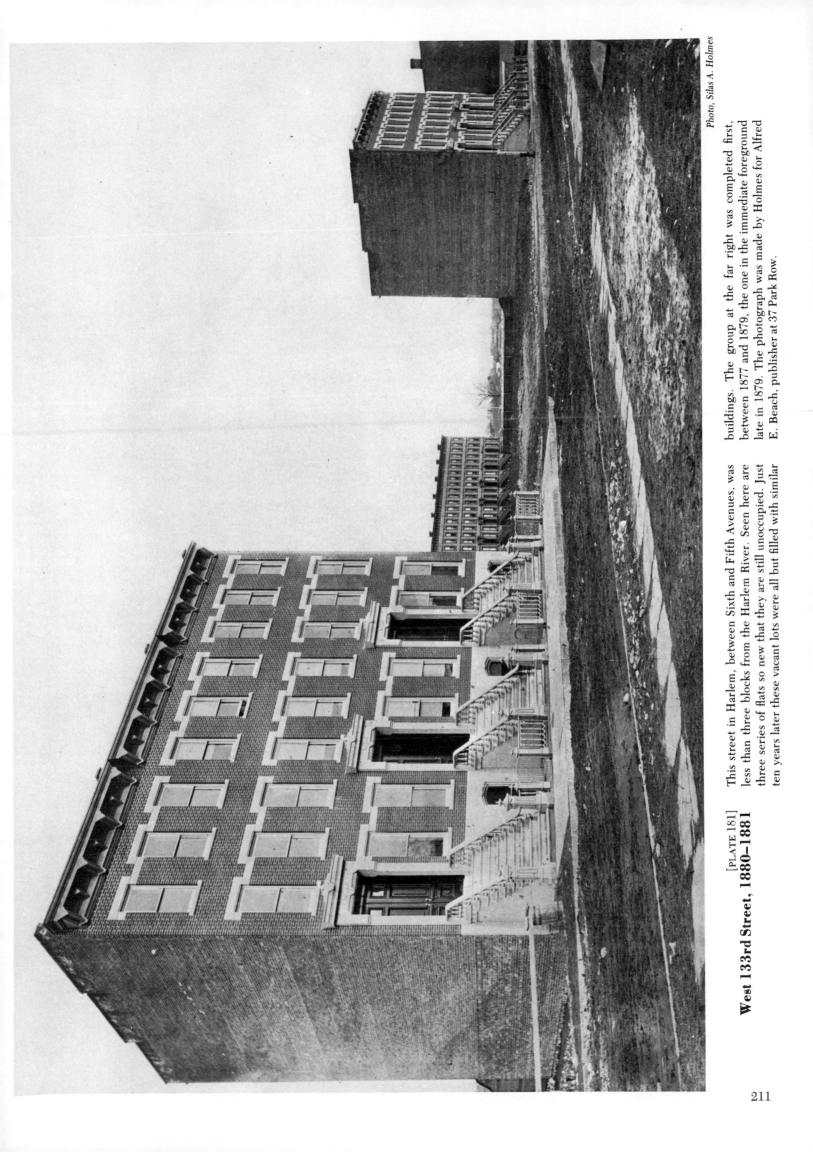

[PLATE 181]

West 133rd Street, 1880–1881

This street in Harlem, between Sixth and Fifth Avenues, was less than three blocks from the Harlem River. Seen here are three series of flats so new that they are still unoccupied. Just ten years later these vacant lots were all but filled with similar buildings. The group at the far right was completed first, between 1877 and 1879, the one in the immediate foreground late in 1879. The photograph was made by Holmes for Alfred E. Beach, publisher at 37 Park Row.

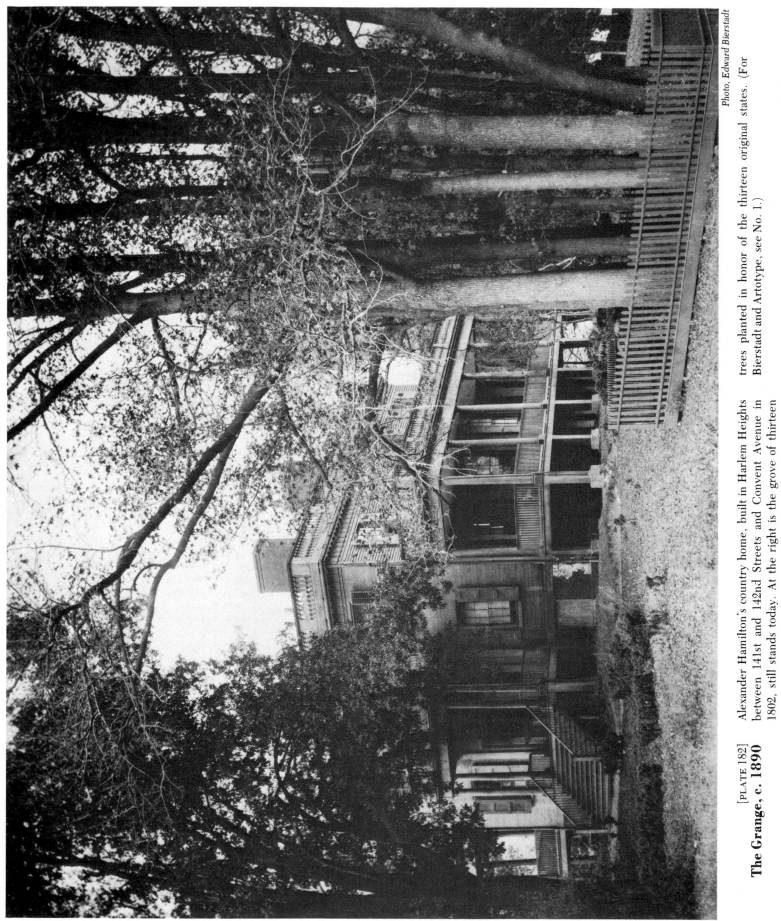

Photo, Edward Bierstadt

[PLATE 182]

The Grange, c. 1890

Alexander Hamilton's country home, built in Harlem Heights between 141st and 142nd Streets and Convent Avenue in 1802, still stands today. At the right is the grove of thirteen trees planted in honor of the thirteen original states. (For Bierstadt and Artotype, see No. 1.)

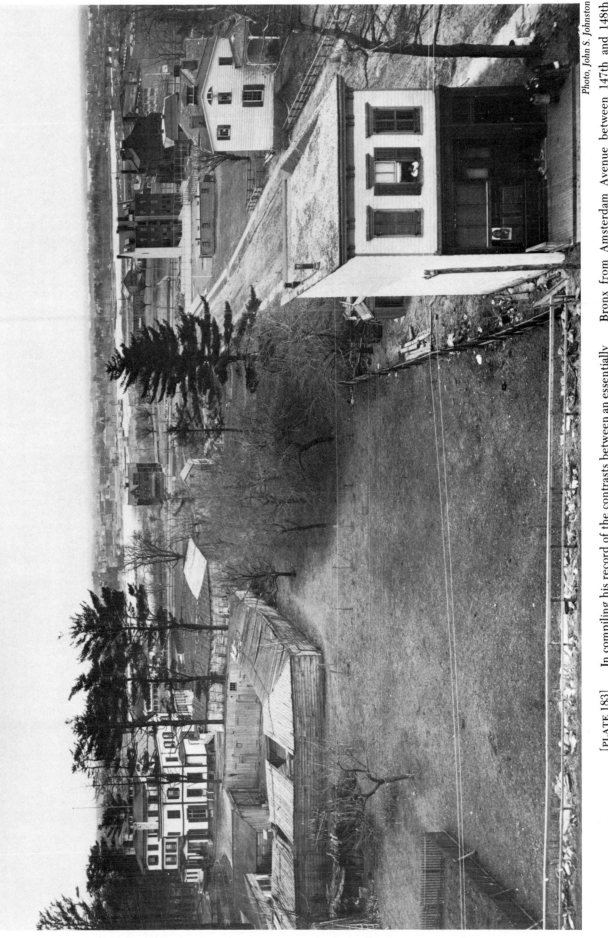

Photo, John S. Johnston

[PLATE 183]

View from Amsterdam Avenue, 1887

In compiling his record of the contrasts between an essentially rural area and the expanding city, John S. Johnston photographed this view east to the Harlem River and the Bronx from Amsterdam Avenue between 147th and 148th Streets. On the left is the new Mount Saint Vincent Hotel.

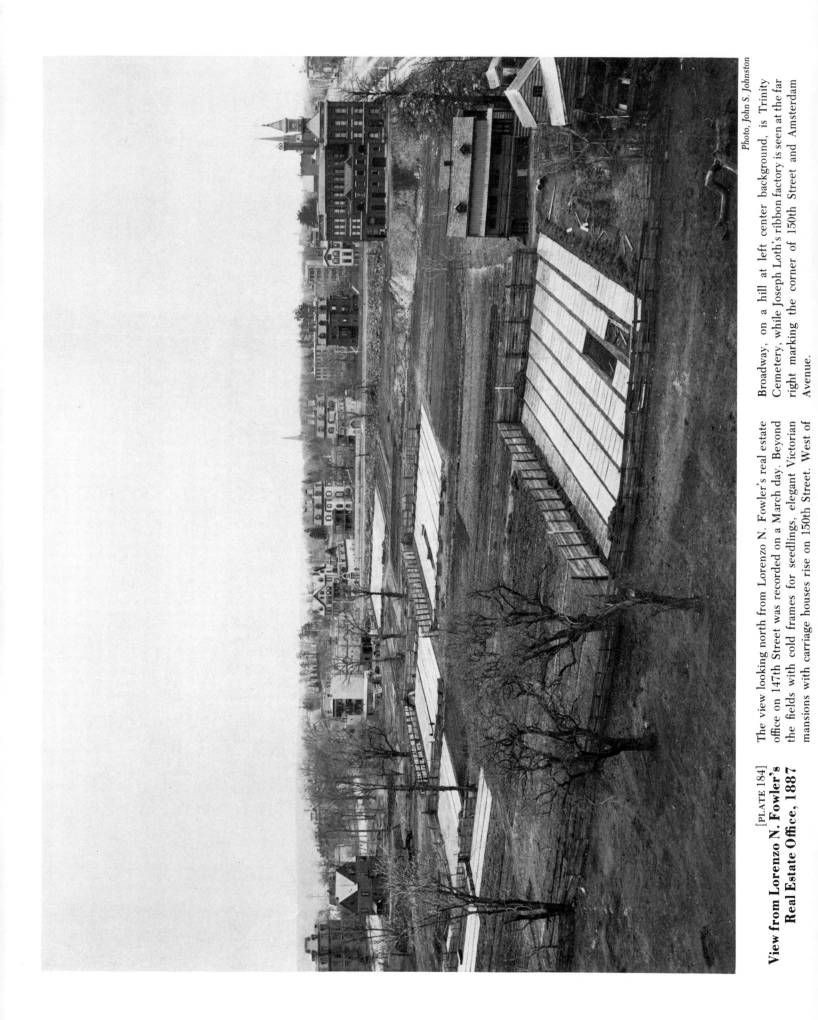

[PLATE 184]
View from Lorenzo N. Fowler's
Real Estate Office, 1887

The view looking north from Lorenzo N. Fowler's real estate office on 147th Street was recorded on a March day. Beyond the fields with cold frames for seedlings, elegant Victorian mansions with carriage houses rise on 150th Street. West of

Broadway, on a hill at left center background, is Trinity Cemetery, while Joseph Loth's ribbon factory is seen at the far right marking the corner of 150th Street and Amsterdam Avenue.

[PLATE 185]
Polo Grounds, c. 1900

By rail and carriage New Yorkers thronged to the second Polo Grounds at 157th Street and Eighth Avenue to observe the baseball games that were already a fashionable national pastime. Barely visible to the right, above Coogan's Bluff, is the Jumel Mansion (see No. 186). The first Polo Grounds in Manhattan, leased in 1883, were bounded by Fifth and Sixth Avenues between 110th and 112th Streets. While polo playing was the initial reason for leasing this large area of ground, baseball, football, lacrosse, and lawn tennis were also played here. In the early 1890s the grounds were relocated along the Harlem River as the streets of the growing city encompassed the old playing field.

215

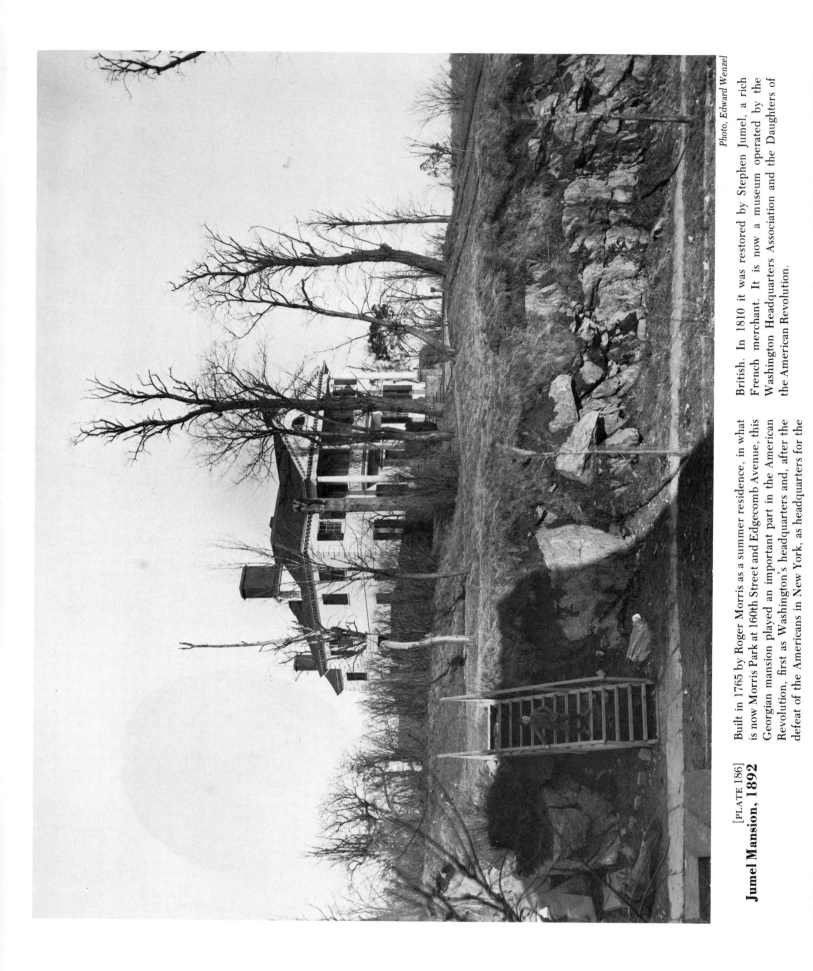

[PLATE 186]
Jumel Mansion, 1892

Built in 1765 by Roger Morris as a summer residence, in what is now Morris Park at 160th Street and Edgecomb Avenue, this Georgian mansion played an important part in the American Revolution, first as Washington's headquarters and, after the defeat of the Americans in New York, as headquarters for the

British. In 1810 it was restored by Stephen Jumel, a rich French merchant. It is now a museum operated by the Washington Headquarters Association and the Daughters of the American Revolution.

216

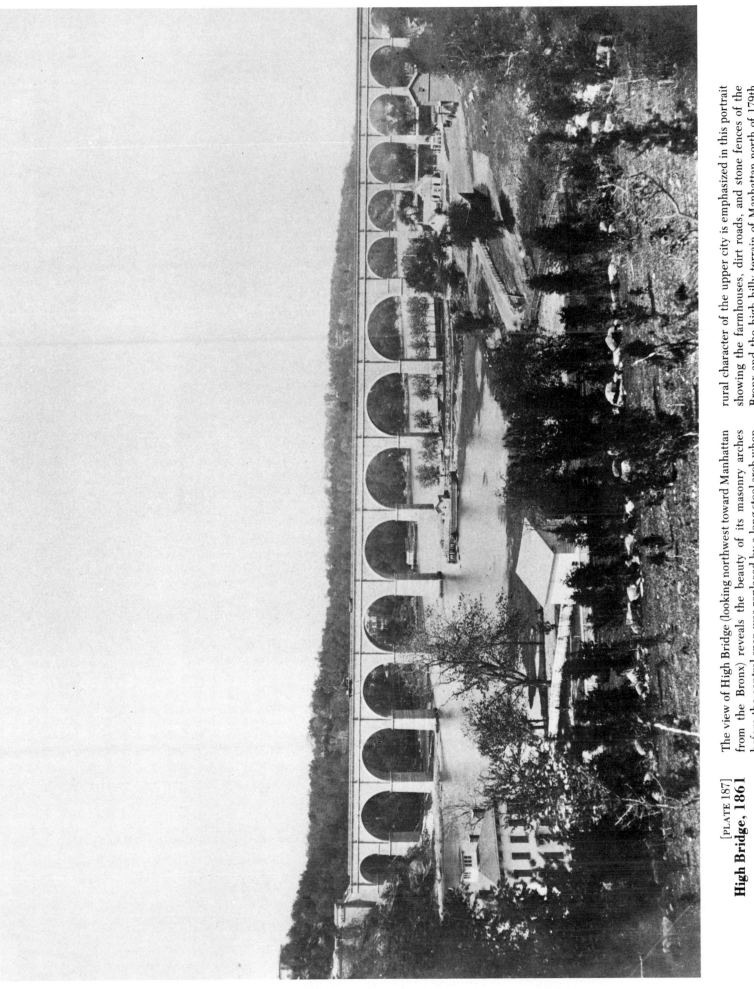

[PLATE 187]
High Bridge, 1861

The view of High Bridge (looking northwest toward Manhattan from the Bronx) reveals the beauty of its masonry arches before the central span was replaced by a long steel arch when the Harlem River Ship Canal was built late in the century. The rural character of the upper city is emphasized in this portrait showing the farmhouses, dirt roads, and stone fences of the Bronx and the high hilly terrain of Manhattan north of 179th Street. (See also Nos. 188 and 189.)

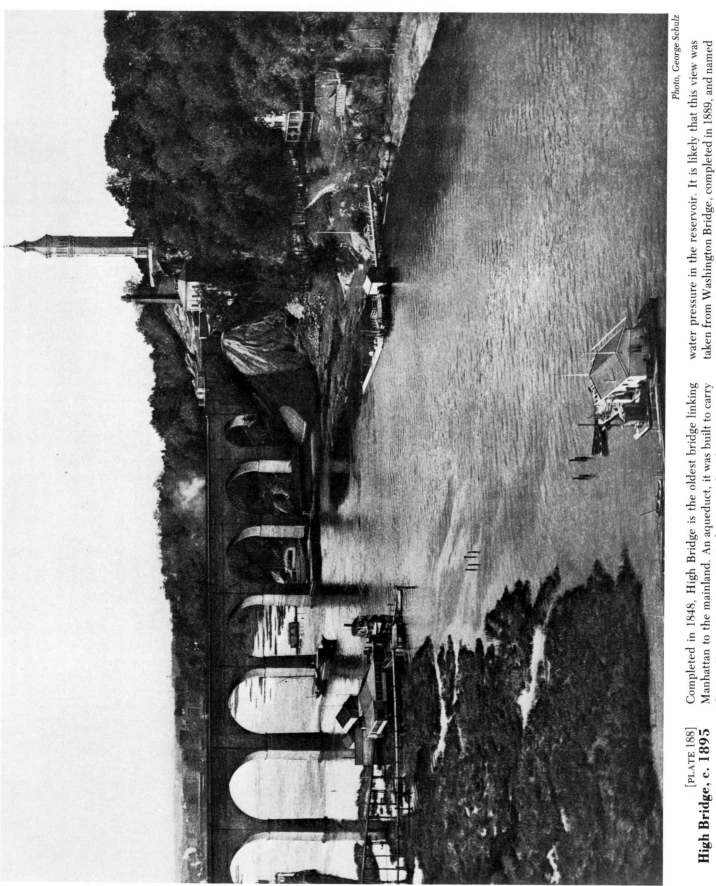

[PLATE 188]

High Bridge, c. 1895

Completed in 1848, High Bridge is the oldest bridge linking Manhattan to the mainland. An aqueduct, it was built to carry Croton Reservoir water to Manhattan, and underwent major reconstruction between 1885 and 1891 when the pipes were enlarged. High-bridge Tower, seen here at the right of the bridge on the Manhattan side of the river, was built to equalize water pressure in the reservoir. It is likely that this view was taken from Washington Bridge, completed in 1889, and named in honor of the first president and the centennial of his inauguration in New York. This photoengraving produced by George Schulz in a high quality, grainy print resembling an etching, was widely sold.

218

[PLATE 189]
High Bridge, c. 1890

This view was taken from the west gate house while new construction was under way, and the new large main is seen as it was placed over two smaller ones. The work crew and three young lady visitors took time out to pose for the unknown photographer. In the background is the Harlem River countryside at about 174th Street in the Bronx.

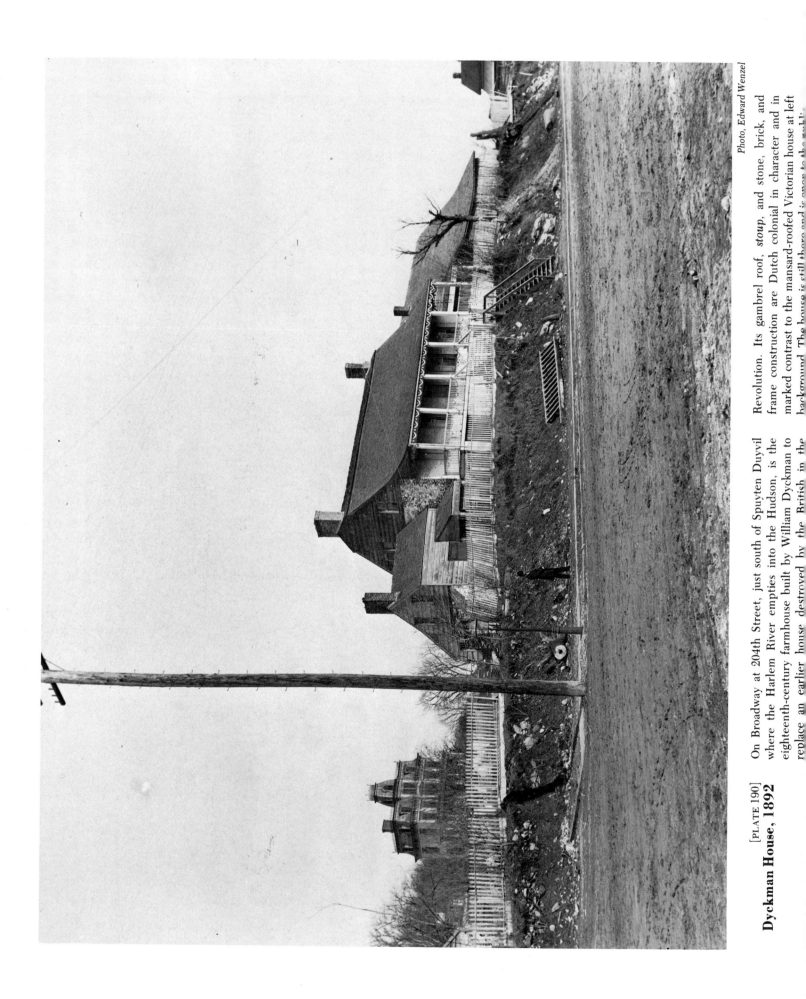

[PLATE 190]

Dyckman House, 1892

On Broadway at 204th Street, just south of Spuyten Duyvil where the Harlem River empties into the Hudson, is the eighteenth-century farmhouse built by William Dyckman to replace an earlier house destroyed by the British in the Revolution. Its gambrel roof, *stoup*, and stone, brick, and frame construction are Dutch colonial in character and in marked contrast to the mansard-roofed Victorian house at left background. The house is still there and is open to the public.

Photo, Edward Wenzel

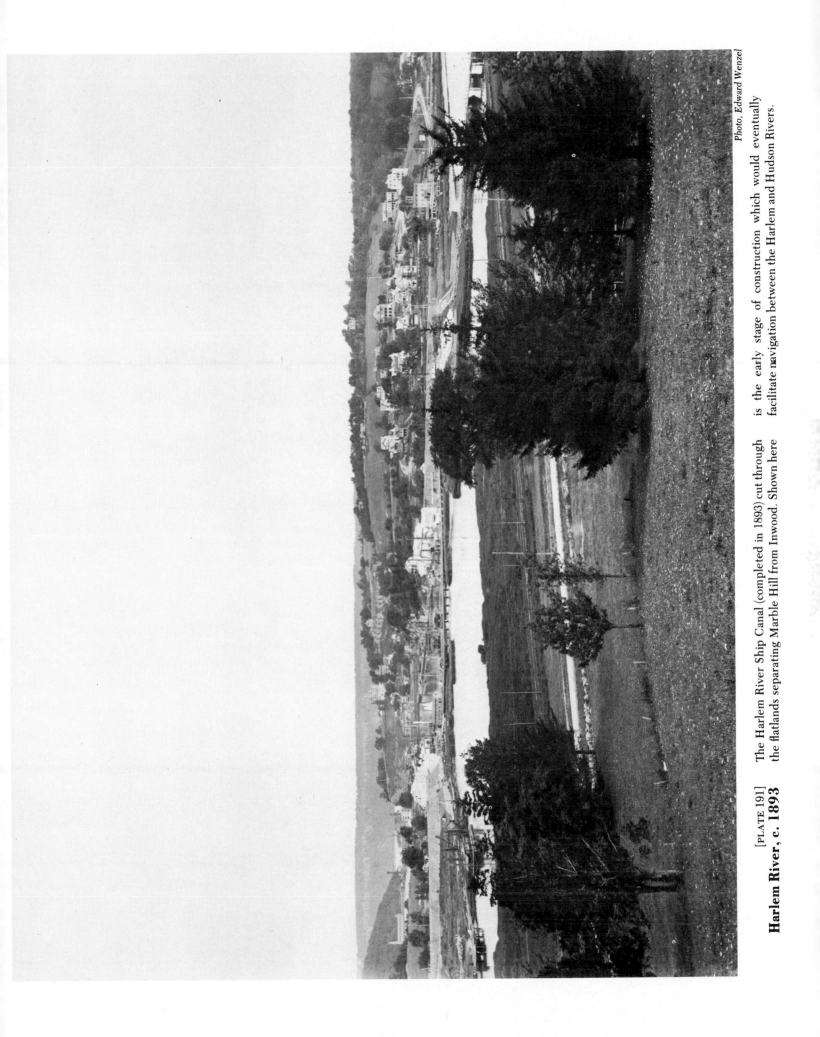

[PLATE 191]

Harlem River, c. 1893

The Harlem River Ship Canal (completed in 1893) cut through the flatlands separating Marble Hill from Inwood. Shown here is the early stage of construction which would eventually facilitate navigation between the Harlem and Hudson Rivers.

INDEXES

Index of Identified Photographers

Chronological Index of Photographs

Photograph Reference Numbers

General Index

Index of Identified Photographers

This index lists alphabetically the individual photographers and photographic firms whose names appear on the originals of the photographs included in this book. In each case, the date in parentheses (in most instances preceded by the photographer's address) is that of the photographer's earliest dated work in this selection. Each New York City address is from the *New York City Directory* of approximately the same year as the corresponding earliest dated work. The numbers following the colons are the illustration numbers.

Chronological Index of Photographs

Photograph Reference Numbers

PLATE NO.	N-YHS NEG. NO.	PLATE NO.	N-YHS NEG. NO.	PLATE NO.	N-YHS NEG. NO.	PLATE NO.	N-YHS NEG. NO.	PLATE NO.	N-YHS NEG. NO.	PLATE NO.	N-YHS NEG. NO.	PLATE NO.	N-YHS NEG. NO.
1	50593	31	34899	61	47758	91	50713	121	50932	151	50909	181	36173
2	50746	32	33551	62	26134	92	26133	122	50931	152	41279	182	975
3	2528	33	50766	63	26115	93	26117	123	27750	153	32471	183	50775
4	50729	34	50776	64	50763	94	15304	124	1017	154	50916	184	50774
5	26116	35	51232	65	33565	95	20157	125	50924	155	8046	185	47594
6	21176	36	50748	66	50221	96	49253	126	9285	156	50904	186	1089
7	39250	37	50778	67	50217	97	3252	127	33535	157	50765	187	28612
8	15212	38	50737	68	33536	98	3250	128	37180	158	5083	188	50929
9	50223	39	50793	69	4578	99	3253	129	26149	159	7331	189	28609
10	26145	40	50917	70	4576	100	3690	130	41221	160	50224	190	1066
11	50730	41	50918	71	50218	101	50716	131	50905	161	33507	191	1080
12	47635	42	393	72	31705	102	23611	132	391	162	46013	5-part panorama	
13	2790	43	4851	73	50222	103	1995	133	23709	163	46098	in Introduction	
14	50927	44	396	74	48135	104	50911	134	47799	164	31047	32183–87	
15	50921	45	21184	75	37378	105	50743	135	485	165	50755		
16	2773	46	47530	76	33544	106	50220	136	33506	166	30119		
17	47596	47	51228	77	33520	107	26140	137	1034	167	50767		
18	44117	48	26129	78	50226	108	26114	138	1032	168	18880		
19	44279	49	26119	79	33524	109	392	139	47557	169	50764		
20	51230	50	37602	80	37363	110	1010	140	37954	170	429		
21	47636	51	51231	81	50923	111	1009	141	50747	171	26142		
22	475	52	33563	82	50731	112	50785	142	50906	172	50086		
23	2769	53	50922	83	33482	113	50786	143	1023	173	1092		
24	2771	54	50709	84	50773	114	43387	144	6670	174	50771		
25	355	55	15129	85	49469	115	50736	145	388	175	1788		
26	33494	56	50742	86	1951	116	50915	146	50839	176	1789		
27	50741	57	50756	87	1094	117	50912	147	3258	177	33618		
28	1954	58	50928	88	50780	118	50772	148	44634	178	47798		
29	47783	59	50768	89	37603	119	49251	149	15320	179	47795		
30	50901	60	16930	90	50779	120	384	150	50725	180	50423		

General Index

This index includes all persons (except for photographers, listed in a separate index), businesses, buildings, constructions, monuments, statues, squares, and parks mentioned in the captions to the illustrations. The numbers used are those of the illustrations. Streets, rivers, and other sites are not included.

Dover Books on Art

Dover Books on Art

PRINCIPLES OF ART HISTORY, H. Wölfflin. This remarkably instructive work demonstrates the tremendous change in artistic conception from the 14th to the 18th centuries, by analyzing 164 works by Botticelli, Dürer, Hobbema, Holbein, Hals, Titian, Rembrandt, Vermeer, etc., and pointing out exactly what is meant by "baroque," "classic," "primitive," "picturesque," and other basic terms of art history and criticism. "A remarkable lesson in the art of seeing," SAT. REV. OF LITERATURE. Translated from the 7th German edition. 150 illus. 254pp. 6⅛ x 9¼. 20276-3 Paperbound $2.50

FOUNDATIONS OF MODERN ART, A. Ozenfant. Stimulating discussion of human creativity from paleolithic cave painting to modern painting, architecture, decorative arts. Fully illustrated with works of Gris, Lipchitz, Léger, Picasso, primitive, modern artifacts, architecture, industrial art, much more. 226 illustrations. 368pp. 6⅛ x 9¼. 20215-1 Paperbound $3.00

METALWORK AND ENAMELLING, H. Maryon. Probably the best book ever written on the subject. Tells everything necessary for the home manufacture of jewelry, rings, ear pendants, bowls, etc. Covers materials, tools, soldering, filigree, setting stones, raising patterns, repoussé work, damascening, niello, cloisonné, polishing, assaying, casting, and dozens of other techniques. The best substitute for apprenticeship to a master metalworker. 363 photos and figures. 374pp. 5½ x 8½.
22702-2 Paperbound $3.50

SHAKER FURNITURE, E. D. and F. Andrews. The most illuminating study of Shaker furniture ever written. Covers chronology, craftsmanship, houses, shops, etc. Includes over 200 photographs of chairs, tables, clocks, beds, benches, etc. "Mr. & Mrs. Andrews know all there is to know about Shaker furniture," Mark Van Doren, NATION. 48 full-page plates. 192pp. 7⅞ x 10¾. 20679-3 Paperbound $2.75

LETTERING AND ALPHABETS, J. A. Cavanagh. An unabridged reissue of "Lettering," containing the full discussion, analysis, illustration of 89 basic hand lettering styles based on Caslon, Bodoni, Gothic, many other types. Hundreds of technical hints on construction, strokes, pens, brushes, etc. 89 alphabets, 72 lettered specimens, which may be reproduced permission-free. 121pp. 9¾ x 8. 20053-1 Paperbound $1.50

THE HUMAN FIGURE IN MOTION, Eadweard Muybridge. The largest collection in print of Muybridge's famous high-speed action photos. 4789 photographs in more than 500 action-strip-sequences (at shutter speeds up to 1/6000th of a second) illustrate men, women, children—mostly undraped—performing such actions as walking, running, getting up, lying down, carrying objects, throwing, etc. "An unparalleled dictionary of action for all artists," AMERICAN ARTIST. 390 full-page plates, with 4789 photographs. Heavy glossy stock, reinforced binding with headbands. 7⅞ x 10¾. 20204-6 Clothbound $12.50

ART ANATOMY, Dr. William Rimmer. One of the few books on art anatomy that are themselves works of art, this is a faithful reproduction (rearranged for handy use) of the extremely rare masterpiece of the famous 19th century anatomist, sculptor, and art teacher. Beautiful, clear line drawings show every part of the body—bony structure, muscles, features, etc. Unusual are the sections on falling bodies, foreshortenings, muscles in tension, grotesque personalities, and Rimmer's remarkable interpretation of emotions and personalities as expressed by facial features. It will supplement every other book on art anatomy you are likely to have. Reproduced clearer than the lithographic original (which sells for $500 on up on the rare book market.) Over 1,200 illustrations. xiii + 153pp. 7¾ x 10¾.

20908-3 Paperbound $2.50

THE CRAFTSMAN'S HANDBOOK, Cennino Cennini. The finest English translation of IL LIBRO DELL' ARTE, the 15th century introduction to art technique that is both a mirror of Quatrocento life and a source of many useful but nearly forgotten facets of the painter's art. 4 illustrations. xxvii + 142pp. D. V. Thompson, translator. 5⅜ x 8.

20054-X Paperbound $2.00

THE BROWN DECADES, Lewis Mumford. A picture of the "buried renaissance" of the post-Civil War period, and the founding of modern architecture (Sullivan, Richardson, Root, Roebling), landscape development (Marsh, Olmstead, Eliot), and the graphic arts (Homer, Eakins, Ryder). 2nd revised, enlarged edition. Bibliography. 12 illustrations. xiv + 266 pp. 5⅜ x 8.

20200-3 Paperbound $2.00

THE STYLES OF ORNAMENT, A. Speltz. The largest collection of line ornament in print, with 3750 numbered illustrations arranged chronologically from Egypt, Assyria, Greeks, Romans, Etruscans, through Medieval, Renaissance, 18th century, and Victorian. No permissions, no fees needed to use or reproduce illustrations. 400 plates with 3750 illustrations. Bibliography. Index. 640pp. 6 x 9.

20577-6 Paperbound $3.00

THE ART OF ETCHING, E. S. Lumsden. Every step of the etching process from essential materials to completed proof is carefully and clearly explained, with 24 annotated plates exemplifying every technique and approach discussed. The book also features a rich survey of the art, with 105 annotated plates by masters. Invaluable for beginner to advanced etcher. 374pp. 5⅜ x 8.

20049-3 Paperbound $3.00

OF THE JUST SHAPING OF LETTERS, Albrecht Dürer. This remarkable volume reveals Albrecht Dürer's rules for the geometric construction of Roman capitals and the formation of Gothic lower case and capital letters, complete with construction diagrams and directions. Of considerable practical interest to the contemporary illustrator, artist, and designer. Translated from the Latin text of the edition of 1535 by R. T. Nichol. Numerous letterform designs, construction diagrams, illustrations. iv + 43pp. 7⅛ x 10¾.

21306-4 Paperbound $2.00

MASTERPIECES OF FURNITURE, Verna Cook Salomonsky. Photographs and measured drawings of some of the finest examples of Colonial American, 17th century English, Windsor, Sheraton, Hepplewhite, Chippendale, Louis XIV, Queen Anne, and various other furniture styles. The textual matter includes information on traditions, characteristics, background, etc. of various pieces. 101 plates. Bibliography. 224pp. 7⅞ x 10¾.

21381-1 Paperbound $3.00

PRIMITIVE ART, Franz Boas. In this exhaustive volume, a great American anthropologist analyzes all the fundamental traits of primitive art, covering the formal element in art, representative art, symbolism, style, literature, music, and the dance. Illustrations of Indian embroidery, paleolithic paintings, woven blankets, wing and tail designs, totem poles, cutlery, earthenware, baskets and many other primitive objects and motifs. Over 900 illustrations. 376pp. 5⅜ x 8. 20025-6 Paperbound $2.50

AN INTRODUCTION TO A HISTORY OF WOODCUT, A. M. Hind. Nearly all of this authoritative 2-volume set is devoted to the 15th century—the period during which the woodcut came of age as an important art form. It is the most complete compendium of information on this period, the artists who contributed to it, and their technical and artistic accomplishments. Profusely illustrated with cuts by 15th century masters, and later works for comparative purposes. 484 illustrations. 5 indexes. Total of xi + 838pp. 5⅜ x 8½. Two-vols. 20952-0, 20953-0 Paperbound $7.00

A HISTORY OF ENGRAVING AND ETCHING, A. M. Hind. Beginning with the anonymous masters of 15th century engraving, this highly regarded and thorough survey carries you through Italy, Holland, and Germany to the great engravers and beginnings of etching in the 16th century, through the portrait engravers, master etchers, practicioners of mezzotint, crayon manner and stipple, aquatint, color prints, to modern etching in the period just prior to World War I. Beautifully illustrated —sharp clear prints on heavy opaque paper. Author's preface. 3 appendixes. 111 illustrations. xviii + 487 pp. 5⅜ x 8½.

20954-7 Paperbound $3.50

ART STUDENTS' ANATOMY, E. J. Farris. Teaching anatomy by using chiefly living objects for illustration, this study has enjoyed long popularity and success in art courses and home-study programs. All the basic elements of the human anatomy are illustrated in minute detail, diagrammed and pictured as they pass through common movements and actions. 158 drawings, photographs, and roentgenograms. Glossary of anatomical terms. x + 159pp. 5⅝ x 8⅜. 20744-7 Paperbound $1.50

COLONIAL LIGHTING, A. H. Hayward. The only book to cover the fascinating story of lamps and other lighting devices in America. Beginning with rush light holders used by the early settlers, it ranges through the elaborate chandeliers of the Federal period, illustrating 647 lamps. Of great value to antique collectors, designers, and historians of arts and crafts. Revised and enlarged by James R. Marsh. xxxi + 198pp. 5⅝ x 8¼.

20975-X Paperbound $2.00

AN ATLAS OF ANIMAL ANATOMY FOR ARTISTS, W. Ellenberger, H. Baum, H. Dittrich. The largest, richest animal anatomy for artists in English. Form, musculature, tendons, bone structure, expression, detailed cross sections of head, other features, of the horse, lion, dog, cat, deer, seal, kangaroo, cow, bull, goat, monkey, hare, many other animals. "Highly recommended," DESIGN. Second, revised, enlarged edition with new plates from Cuvier, Stubbs, etc. 288 illustrations. 153pp. 11⅜ x 9.

20082-5 Clothbound $2.75

ANIMAL DRAWING: ANATOMY AND ACTION FOR ARTISTS, C. R. Knight. 158 studies, with full accompanying text, of such animals as the gorilla, bear, bison, dromedary, camel, vulture, pelican, iguana, shark, etc., by one of the greatest modern masters of animal drawing. Innumerable tips on how to get life expression into your work. "An excellent reference work," SAN FRANCISCO CHRONICLE. 158 illustrations. 156pp. 10½ x 8½. 20426-X Paperbound $3.00

ARCHITECTURAL AND PERSPECTIVE DESIGNS, Giuseppe Galli Bibiena. 50 imaginative scenic drawings of Giuseppe Galli Bibiena, principal theatrical engineer and architect to the Viennese court of Charles VI. Aside from its interest to art historians, students, and art lovers, there is a whole Baroque world of material in this book for the commercial artist. Portrait of Charles VI by Martin de Meytens. 1 allegorical plate. 50 additional plates. New introduction. vi + 103pp. 10⅛ x 13¼.

21263-7 Paperbound $2.50

HANDBOOK OF DESIGNS AND DEVICES, C. P. Hornung. A remarkable working collection of 1836 basic designs and variations, all copyright-free. Variations of circle, line, cross, diamond, swastika, star, scroll, shield, many more. Notes on symbolism. "A necessity to every designer who would be original without having to labor heavily," ARTIST AND ADVERTISER. 204 plates. 240pp. 5⅜ x 8. 20125-2 Paperbound $2.00

CHINESE HOUSEHOLD FURNITURE, G. N. Kates. A summary of virtually everything that is known about authentic Chinese furniture before it was contaminated by the influence of the West. The text covers history of styles, materials used, principles of design and craftsmanship, and furniture arrangement—all fully illustrated. xiii + 190pp. 5⅝ x 8½.

20958-X Paperbound $2.00

DECORATIVE ART OF THE SOUTHWESTERN INDIANS, D. S. Sides. 300 black and white reproductions from one of the most beautiful art traditions of the primitive world, ranging from the geometric art of the Great Pueblo period of the 13th century to modern folk art. Motives from basketry, beadwork, Zuni masks, Hopi kachina dolls, Navajo sand pictures and blankets, and ceramic ware. Unusual and imaginative designs will inspire craftsmen in all media, and commercial artists may reproduce any of them without permission or payment. xviii + 101pp. 5⅝ x 8⅜. 20139-2 Paperbound $1.50

Dover Books on Art

LANDSCAPE GARDENING IN JAPAN, Josiah Conder. A detailed picture of Japanese gardening techniques and ideas, the artistic principles incorporated in the Japanese garden, and the religious and ethical concepts at the heart of those principles. Preface. 92 illustrations, plus all 40 full-page plates from the Supplement. Index. xv + 299pp. 8⅜ x 11¼.
21216-5 Paperbound $3.50

DESIGN AND FIGURE CARVING, E. J. Tangerman. "Anyone who can peel a potato can carve," states the author, and in this unusual book he shows you how, covering every stage in detail from very simple exercises working up to museum-quality pieces. Terrific aid for hobbyists, arts and crafts counselors, teachers, those who wish to make reproductions for the commercial market. Appendix: How to Enlarge a Design. Brief bibliography. Index. 1298 figures. x + 289pp. 5⅜ x 8½.
21209-2 Paperbound $2.00

THE STANDARD BOOK OF QUILT MAKING AND COLLECTING, M. Ickis. Even if you are a beginner, you will soon find yourself quilting like an expert, by following these clearly drawn patterns, photographs, and step-by-step instructions. Learn how to plan the quilt, to select the pattern to harmonize with the design and color of the room, to choose materials. Over 40 full-size patterns. Index. 483 illustrations. One color plate. xi + 276pp. 6¾ x 9½.
20582-7 Paperbound $2.50

LOST EXAMPLES OF COLONIAL ARCHITECTURE, J. M. Howells. This book offers a unique guided tour through America's architectural past, all of which is either no longer in existence or so changed that its original beauty has been destroyed. More than 275 clear photos of old churches, dwelling houses, public buildings, business structures, etc. 245 plates, containing 281 photos and 9 drawings, floorplans, etc. New Index. xvii + 248pp. 7⅞ x 10¾.
21143-6 Paperbound $3.00

A HISTORY OF COSTUME, Carl Köhler. The most reliable and authentic account of the development of dress from ancient times through the 19th century. Based on actual pieces of clothing that have survived, using paintings, statues and other reproductions only where originals no longer exist. Hundreds of illustrations, including detailed patterns for many articles. Highly useful for theatre and movie directors, fashion designers, illustrators, teachers. Edited and augmented by Emma von Sichart. Translated by Alexander K. Dallas. 594 illustrations. 464pp. 5⅛ x 7⅛.
21030-8 Paperbound $3.00

Dover publishes books on commercial art, art history, crafts, design, art classics; also books on music, literature, science, mathematics, puzzles and entertainments, chess, engineering, biology, philosophy, psychology, languages, history, and other fields. For free circulars write to Dept. DA, Dover Publications, Inc., 180 Varick St., New York, N.Y. 10014.